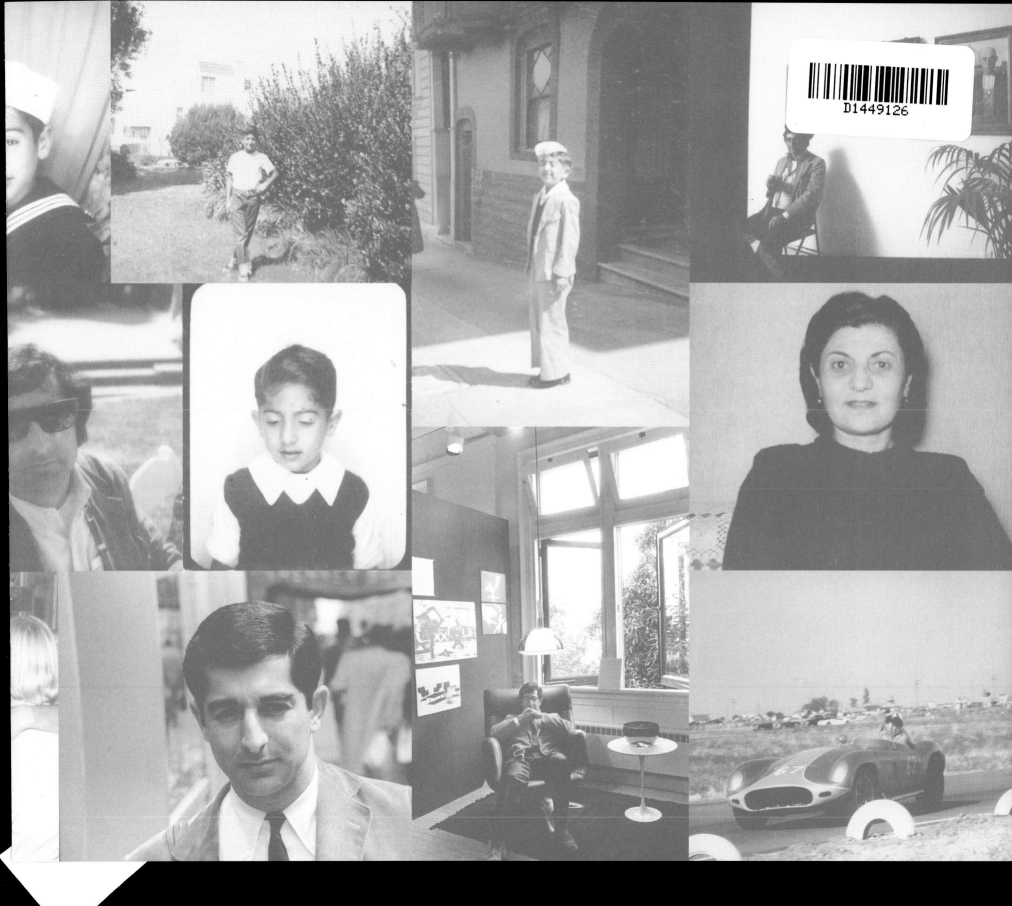

Scooter
Bling Bling
Version

JIM MARSHALL

SHOW ME THE PICTURE

JIM MARSHALL SHOW ME THE PICTURE

IMAGES AND STORIES FROM A PHOTOGRAPHY LEGEND

BY AMELIA DAVIS

ESSAYS BY **AMELIA DAVIS, KAREN GRIGSBY BATES, MICHELLE MARGETTS, JOEL SELVIN, AND MEG SHIFFLER**

CHRONICLE BOOKS
SAN FRANCISCO

Essays copyright © 2019 by the individual writers.
All other text copyright © 2019 by Amelia Davis.
Photography copyright © 2019 by Jim Marshall Photography LLC.

Page 6: Jim Marshall's Leica camera. Photo by Alex Ramos.

Library of Congress Cataloging-in-Publication Data

Names: Marshall, Jim, 1936-2010, photographer. | Davis, Amelia, 1968- writer of added commentary.
Title: Jim Marshall : show me the picture : images and stories from a photography legend / by Amelia Davis ; essays by Amelia Davis, Karen Grigsby Bates, Michelle Margetts, Joel Selvin, and Meg Shiffler.
Other titles: Show me the picture
Description: San Francisco : Chronicle Books, [2019] | Includes index.
Identifiers: LCCN 2018056849 | ISBN 9781452180373 (hardcover)
Subjects: LCSH: Photography, Artistic. | United States—Social life and customs—Pictorial works. | Musicians—Pictorial works. | Marshall, Jim, 1936-2010. | Photographers—United States—Biography.
Classification: LCC TR655 .M37437 2019 | DDC 779.092—dc23 LC record available at https://lccn.loc.gov/2018056849

Manufactured in China.

MIX
Paper from
responsible sources
FSC™ C008047

Design by Allison Weiner.

10 9 8 7 6 5 4 3 2

Chronicle books and gifts are available at special quantity discounts to corporations, professional associations, literacy programs, and other organizations. For details and discount information, please contact our premiums department at corporatesales@chroniclebooks.com or at 1-800-759-0190.

Chronicle Books LLC
680 Second Street
San Francisco, California 94107
www.chroniclebooks.com

FOR JIM.

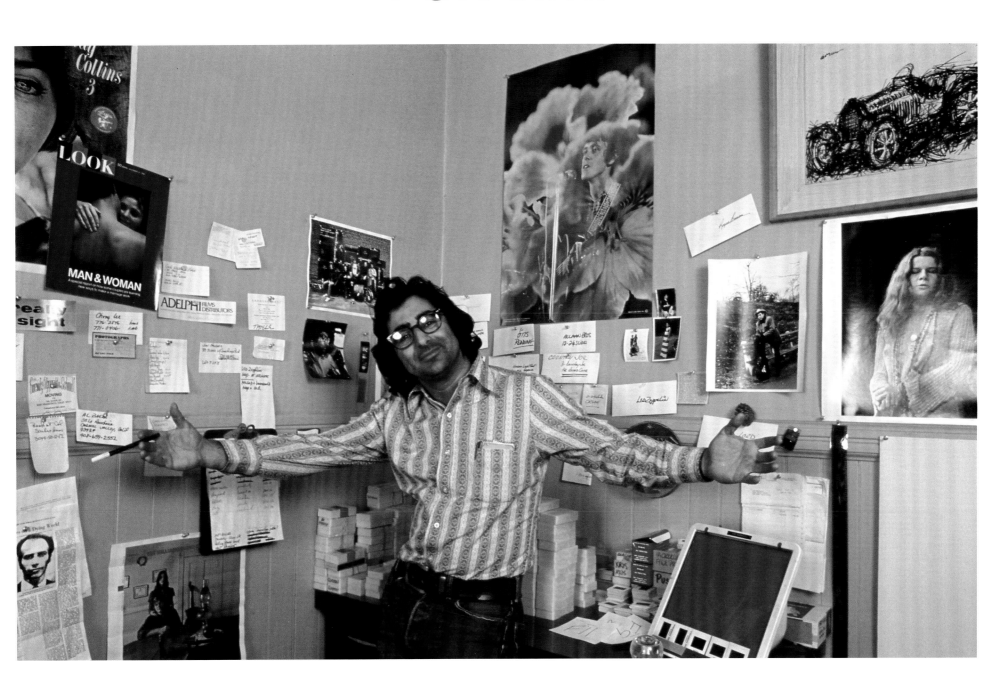

CONTENTS

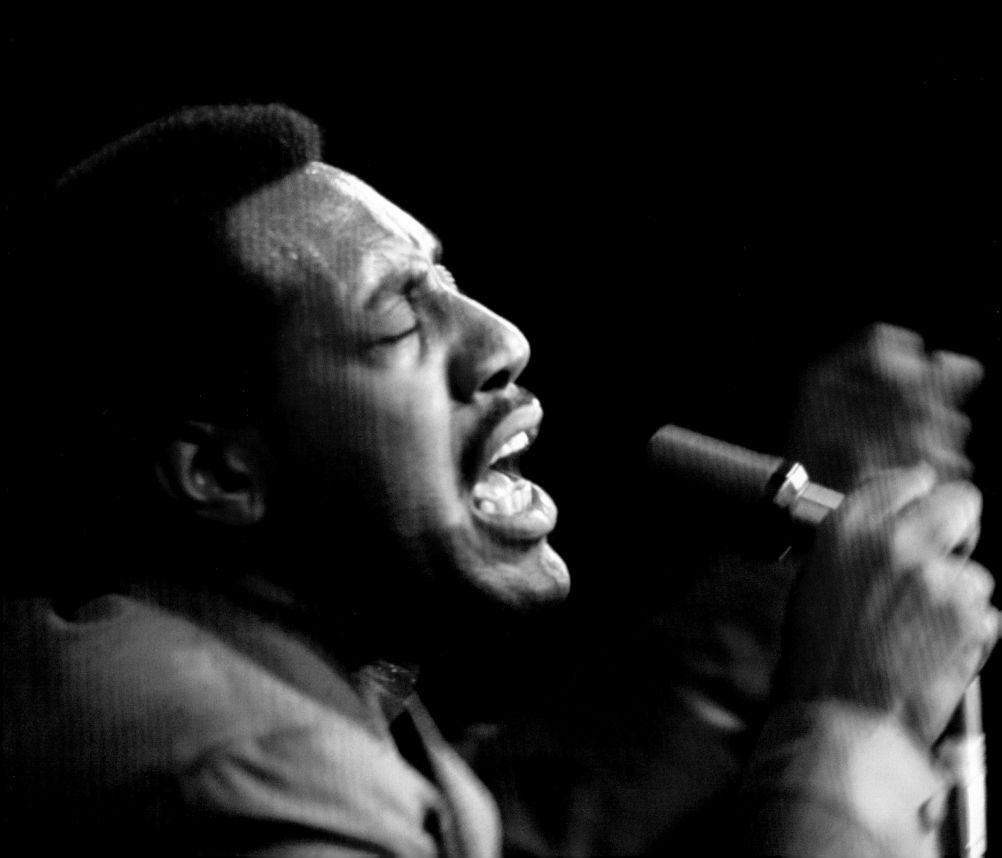

There's a lot of cats running around with cameras, but there's only a few *PHOTOGRAPHERS*. And, you know, Marshall was one of those *CATS*. . . . Jim didn't have to be competitive. He knew he was the best one in the room, and the people who were in the room knew he was the best one in the room.

BRUCE TALAMON

THE EARLY YEARS: DRIVE, VISION, AND INTEGRITY

MEG SHIFFLER

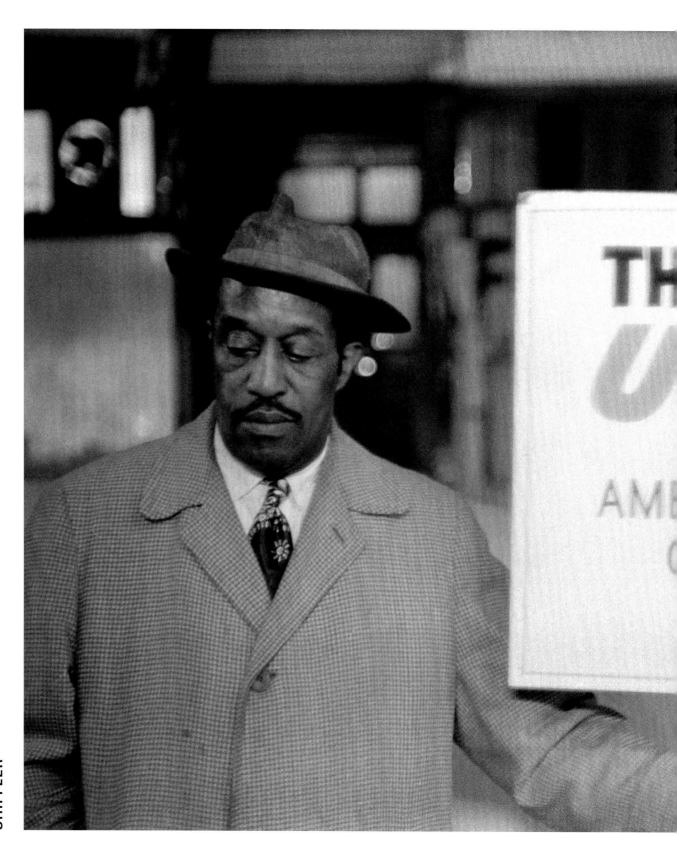

WHEN HISTORIANS CONSIDER JIM MARSHALL, it is as both a master documentary photographer intent on capturing concerts, musicians, and audiences over a fifty-year period and as a photojournalist on assignment to illustrate particular stories. But Marshall's work also included capturing events associated with civic and social movements that changed the course of American history. Marshall's early work illuminates how he honed the technical skills and unique visual storytelling that define his iconic portfolio.

Working with the Jim Marshall estate to curate the 2017 exhibition *Jim Marshall's 1967*, I took a deep dive into the five hundred thousand–plus image archive and discovered both the breadth of his practice as well as the consistency of his aesthetic. The earliest images in the archive, taken by Marshall as a teenager in San Francisco, feature young women at Bay Area drag races, presaging his lifelong interest in beauty, fast cars, and American subcultures. After Marshall was honorably discharged from the Air Force in 1959, he moved into his mother's house in the Fillmore neighborhood of San Francisco, bought his first Leica camera, and started his life as a photographer in earnest.

During the day, Marshall photographed life on the streets and in cafés across the Bay Area, and developed his extraordinary ability to shoot his subjects using only available light sources, a technical choice he was devoted to throughout his career. In these early candid shots, he focused mostly on people rather than architecture or landscape, placing his subjects at the forefront or midframe so that facial expressions and small gestures take center stage.

Street photographers are anonymous to their subjects, but they are not always unseen. In some of Marshall's most successful images from this time period, individuals catch him in the act of

Black musicians still had to fight to perform in venues in non-black neighborhoods, even though the black and white locals of the American Federation of Musicians had merged. North Beach, San Francisco, 1960.

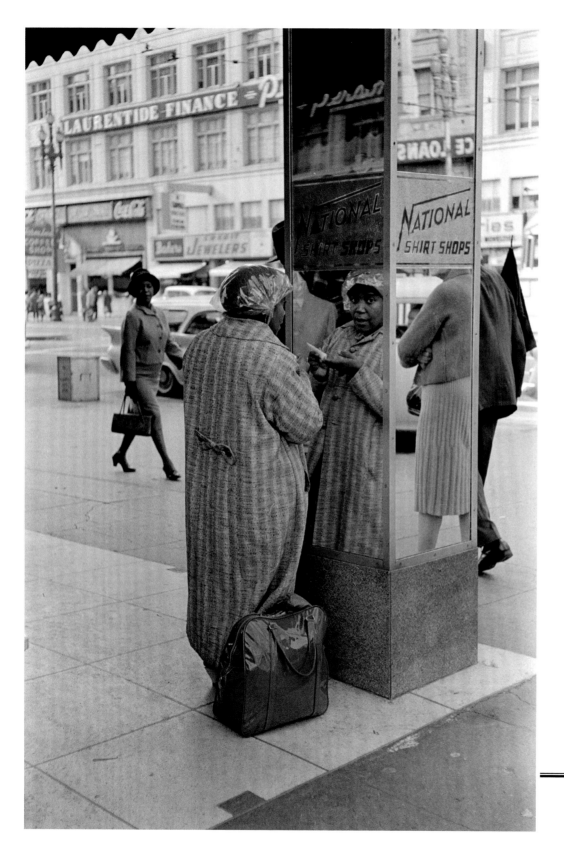

pointing his lens their way. In a particularly masterful image from 1960, Marshall is very close to a couple outside a ravioli factory in the Italian neighborhood of North Beach. The woman is unconcerned or unaware of the camera, but the man brings a cigarette to the corner of his mouth, turns toward the lens, and raises one inquisitive eyebrow at Marshall just as the shutter clicks. Dramatic late-afternoon light, a charming setting complete with an unaware passerby, a vaguely mysterious and handsome couple, and high black-and-white contrast make this shot absolutely cinematic in scope.

In 1961, Marshall captured a woman standing in front of a mirror attached to a column on Fillmore Street. She has set her bag down and is squeezing cream onto her hand. Just before the shot is captured, she sees the photographer reflected in the mirror. Her eyes shift, her mouth parts, and she is caught mid-thought and mid-action in a moment of vulnerability. There is a lot going on in this photograph—buildings, advertisements, cars, foot traffic, reflections—but the eyes of Marshall's knowing subject draw viewers into the very center of the frame, and everything else becomes secondary.

Magazines and newspapers often licensed images like these to accompany articles and advertisements. However, Marshall

compulsively shot life around him regardless of any intended commercial use. In the archive, contact sheets of early street photography illustrate a preternatural ability to identify a subject, find the light, compose the shot, and frame a complex narrative on the spot.

When the sun went down, Marshall photographed Beat poets and folk musicians performing their latest works in bars and smoky coffeehouses, stand-up comedians at small venues across San Francisco, and jazz musicians gigging in North Beach and the Fillmore District. He was at home in these venues, bastions that welcomed racially and economically diverse performers and enthusiasts. Marshall partied hard, and he nurtured a public persona often described as loud, stubborn, aggressive, blunt, and rude. Those who worked to scratch the surface, however, encountered his generosity, humor, kindness, and absolute devotion to individuals he respected. Performers, and musicians in particular, gave him both onstage and offstage access. They trusted that he would deliver images full of compassion and admiration, and never release unflattering shots to the public. In a 2007 interview, Marshall explained, "You want to become accepted, like as a member of the band, only your instrument is the camera." While in San Francisco from 1959 to 1962, he established what would

become lifelong relationships with some of the most influential musicians of the day, including John Coltrane and Miles Davis.

As his street photography demonstrates, Marshall liked to be close to his subjects, so he most frequently shot performances either onstage or from the front row. In his 1961 portrait of blues singer Estelle "Mama" Yancey, viewers are positioned to gaze up at her from an extreme angle that emphasizes both the pain and the power inherent in her artistry. She is not looking at the camera or the audience. Instead, her eyes are closed, and the venue lights are reflected in her glasses, giving her an otherworldly quality. This is not simply a performance document; it is an insistent call for the respect and adoration of a legend.

In contrast to the emotional image of Yancey, Marshall's 1960 portrait of John Coltrane, shot during an interview at music critic Ralph Gleason's house in Berkeley, is quiet and gentle. Coltrane's eyes appear unfocused, his thoughts turned inward, as light through a window softly kisses his raised hand. This career-changing shot perfectly balances on the line between being so intimate it's almost uncomfortable to look at and so revealing that one can't look away. It also shifts our perception of an industry giant renowned for his intense, laser-sharp onstage focus by providing a view of an unguarded Coltrane at

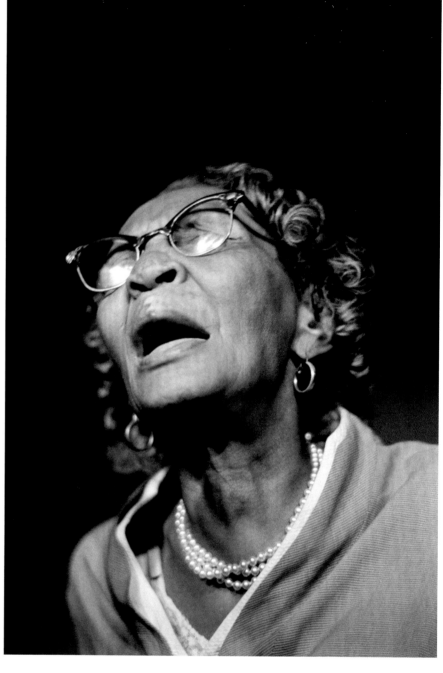

Gospel Concert, Riker's Island, New York, 1963

MAMA YANCEY at a club in North Beach, San Francisco, 1961.
This image was later used as the cover for the album *Mama Yancey Sings, Art Hodes Plays Blues*, 1965.

14

rest. These are the type of photographs that put Marshall on the map; they reflect his confident skill as well as his deep respect for artists and his commitment to representing them with vision and integrity.

Local recording labels began to license Marshall's work for promotions and album covers, and he sought ways to further expand his growing business. He quickly became recognized as part of a network of Bay Area photographers covering the jazz scene, including Steve Jackson, David Johnson, Ricardo Alvarado, and most influentially, Jerry Stoll. A fixture at jazz clubs, Stoll was also the Monterey Jazz Festival's resident photographer for eight years, beginning at its inception in 1958. Stoll became a mentor to Marshall, teaching him some of the practical aspects of running a business, like organizing his studio and developing a system to catalog negatives. With increasing professional drive, and the support of Stoll, Marshall photographed the 1960 Monterey Jazz Festival, capturing iconic onstage and offstage images of Coltrane, Ornette Coleman, Miriam Makeba, Jimmy Witherspoon, Odetta, Duke Ellington, Helen Humes, and more. The resulting portfolio shows Marshall fine-tuning some of the strategies he shot with for the rest of his life: depicting per-formers onstage lost in moments of passion and deep concentration, marking space and time by photographing venue details and diverse audience members, and, most notably, getting up close and personal with performers offstage. Marshall went on to shoot the Monterey Jazz Festival five more times, as well as the 1962 Newport Jazz Festival, the 1967 Monterey International Pop Music Festival, and Woodstock in 1969.

Marshall moved his studio to New York's Greenwich Village in late 1962, with a desire to make his name known outside of the Bay Area. With very few connections, he relied on professional references from West Coast promoters and publishers, as well as musicians making recommendations to other artists. Doors opened quickly as soon as prospective employers saw the quality of his work. The year 1963 became one of the busiest of his career. He had regular assignments from national publications, including the *Saturday Evening Post* and *Look*, and major record labels such as Capitol, Columbia, and Blue Note. He continued to shoot emerging and established jazz musicians at both dive bars and major venues, and he also established enduring professional relationships with folk superstars, including the Mamas and the Papas, Bob Dylan, Hedy West, and Judy Collins. Portraits

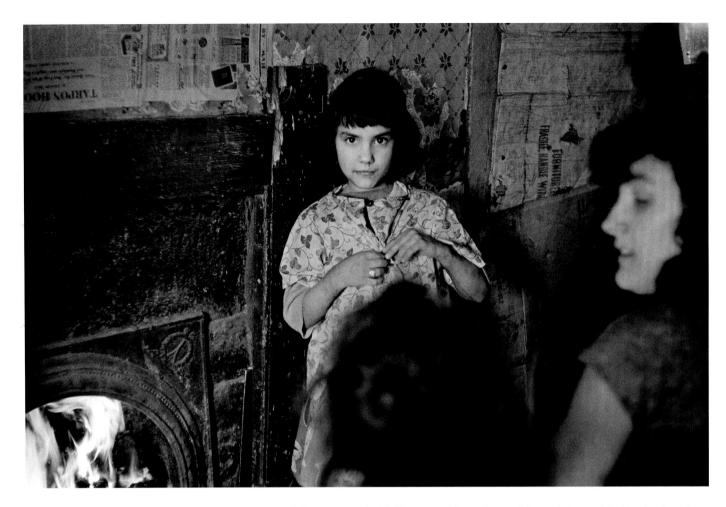

of writers, directors, and actors, from Broadway and film, were a lucrative and frequent part of his workload. When Marshall wasn't on assignment, he would pitch photo essays to publications. For one such story, pitched to *Look*, he shot a dozen contact sheets of Woody Allen performing stand-up.

In the middle of this productive year, Marshall was sent to Hazard, Kentucky, to document the daily challenges of living in poverty in America. It was an atypical assignment, but it is easy to understand why Marshall committed to it. He was twenty-seven in 1963, and before moving to New York, he had spent most of his life in his mother's house. He had a difficult upbringing tinged with financial and personal hardships. His parents were immigrants from Iran and Armenia; his mother worked in a laundry; and his father, a house painter, left when he was a boy. Marshall

felt like an outsider and moved through the world with a hardened exterior, often numbing himself in order to cope. This assignment invited him to tell a story that must have resonated.

While in Hazard, Marshall lived with and photographed an extremely poor coal-mining family and members of their community. The images are heartbreakingly truthful, but do not cross over into dissecting or exploiting human suffering. Depicting trauma was never part of Marshall's agenda with this shoot or any other in his career. The portraits are framed with incredible sensitivity, and every man, woman, and child is afforded the same dignity as all of Marshall's subjects. Soft light from a window casts a halo around a seated matriarch. A father affectionately holds his children, and his half smile and friendly eyes are welcoming. An exhausted mother shares the frame with two of her children in a

Girl in Hazard, Kentucky, 1963

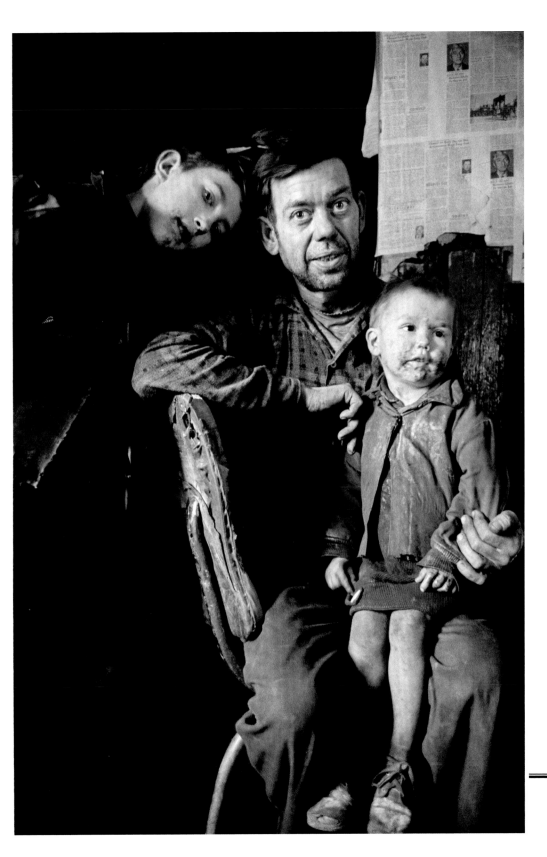

tableau that is both raw and beautiful. The journalist assigned to the story never visited Hazard, and ultimately Marshall was not pleased with the way the community and its residents were represented in the text, so he never released his photographs to the publication.

Tackling a variety of assignments, including Hazard, helped Marshall hone a personal aesthetic and point of view, while solidifying professional parameters that defined what he would and would not do. He would get as close as his subjects allowed, and he would never compromise his integrity or their dignity. He would retain ownership of his images and would not be bullied by gatekeepers. His work would be honest and would not be sensational. He would be wholly and completely himself, for better or worse, and would not put on airs for anyone. He would aggressively push for what he wanted, and he would be loyal to those who supported him along the way. He would acknowledge and sometimes embrace darkness in his life and in the world, yet he would work tirelessly to frame and nurture beauty in every shot. Works from Marshall's early years mix seamlessly with those he created later. Together, they form an archive that informs and illuminates sociopolitical and cultural history as well as everyday life over a fifty-year span.

17 Coal-mining family, Hazard, Kentucky, 1963

"Preacher" parked near Bridgeway and El Portal in Sausalito,
California, 1961

18

Three little kids on a park bench in Sausalito, 1962

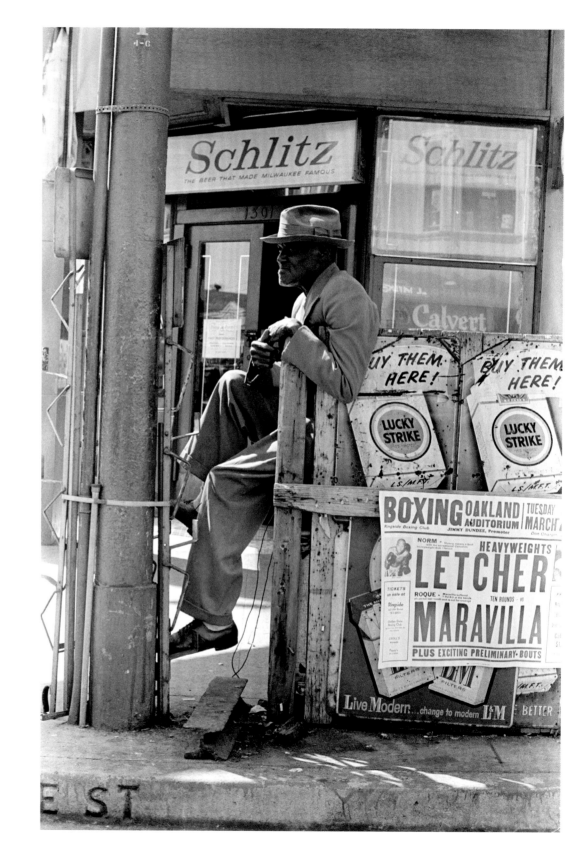

Man outside a liquor store in Oakland, California, 1962

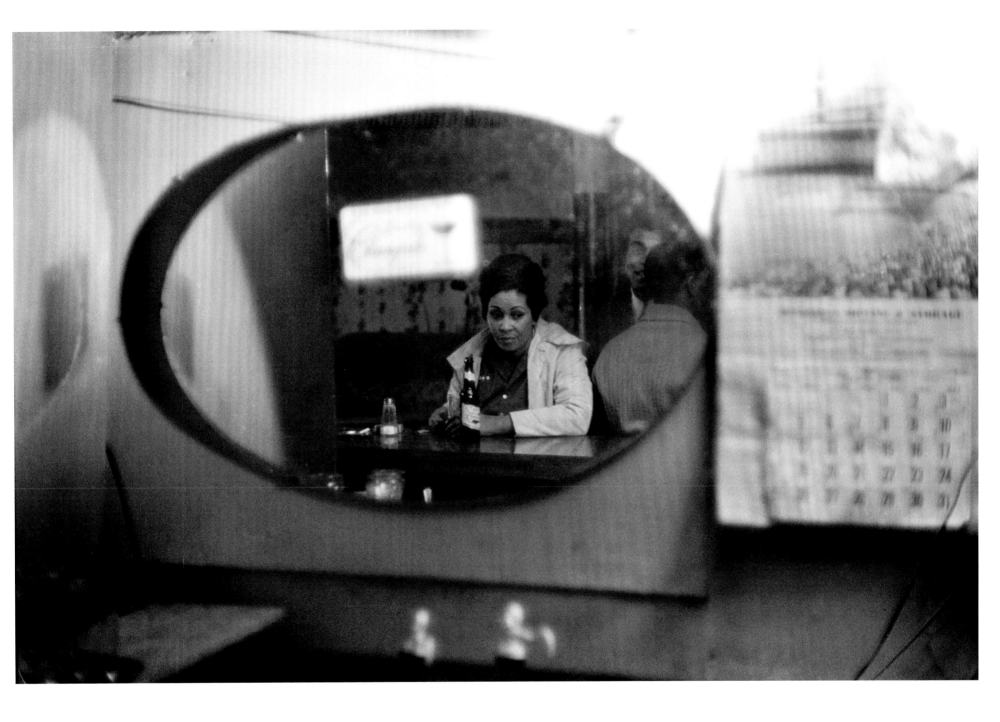

Woman's reflection in a bar mirror on Powell Street in San Francisco, 1962

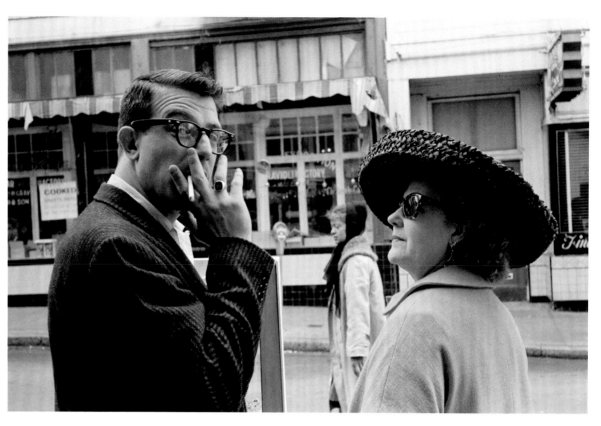

Outside the Coffee Gallery Jazz Club in North Beach,
San Francisco, 1960

Taking a stroll in Sausalito, 1962

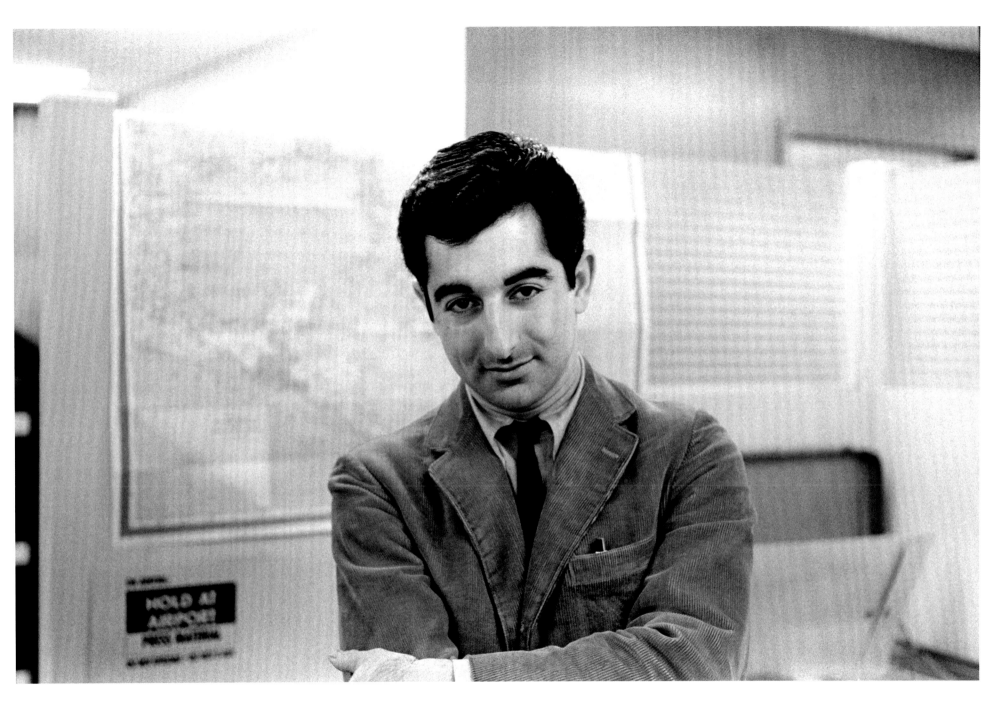

JIM MARSHALL, 1962

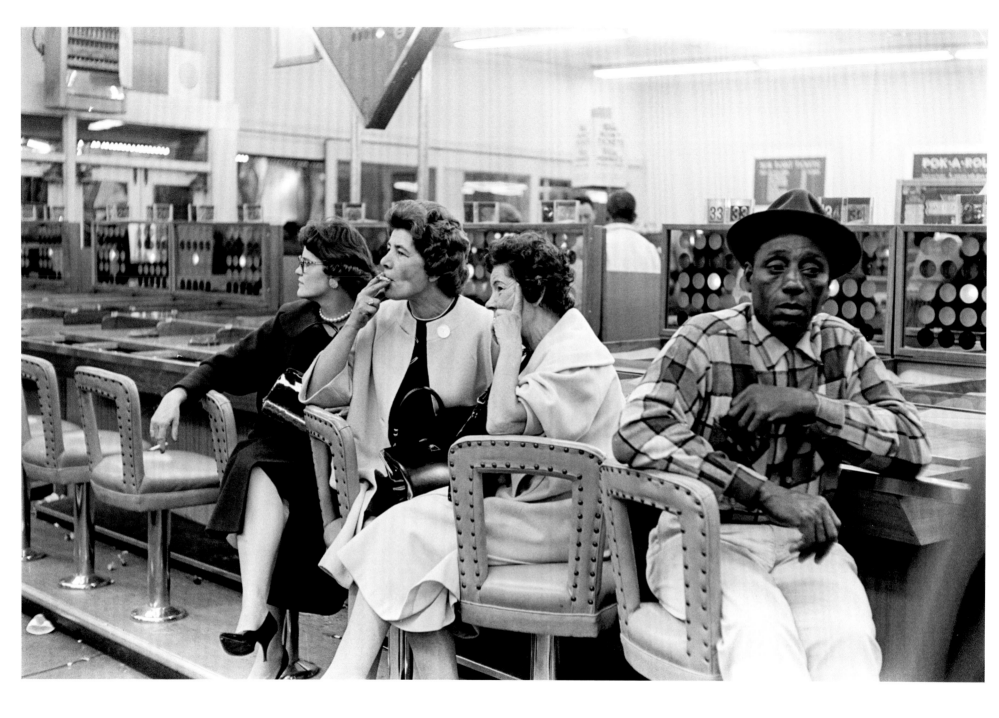

Lunch counter in Sausalito, California, 1962

"WINNING THE PEACE IS A LONELY BATTLE." Market Street,
San Francisco, 1961

PETER, PAUL, AND MARY performing in New York City, 1963

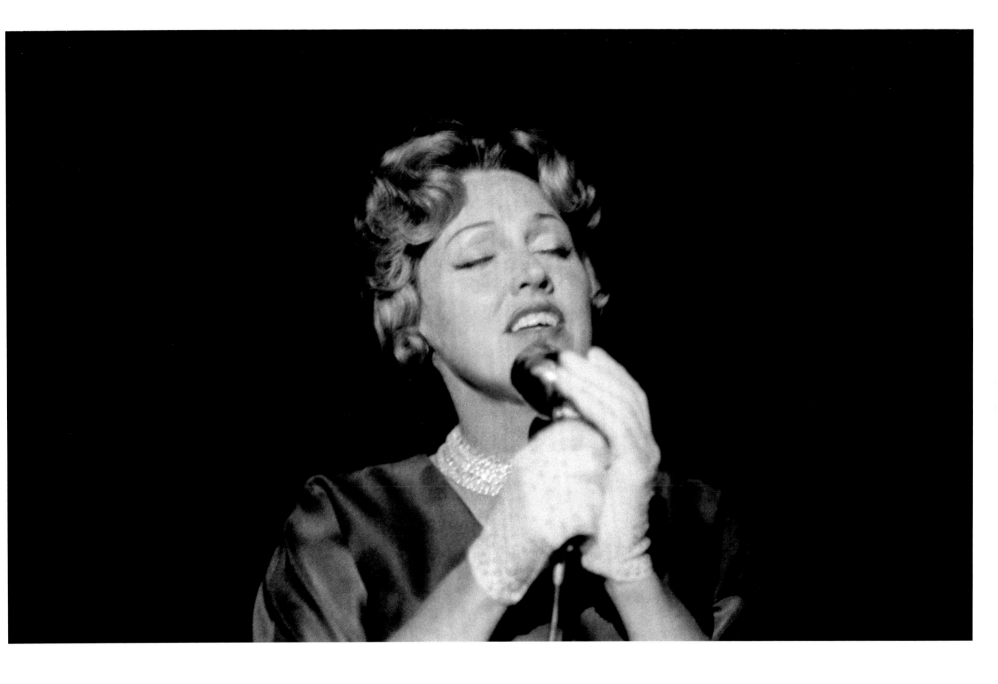

ANITA O'DAY was known for shattering the image of "the girl singer." She left a broken home at fourteen and cultivated a tough, cool, jazz hipster image, which was at the time quite unique and risky. Known for her rhythmic, edgy style, O'Day went on to sing with the Gene Krupa, Woody Herman, and Stan Kenton big bands to much fanfare before going solo. Despite the signature white gloves and late-1960s heroin addiction (which she managed to kick), O'Day was considered indestructible.

27

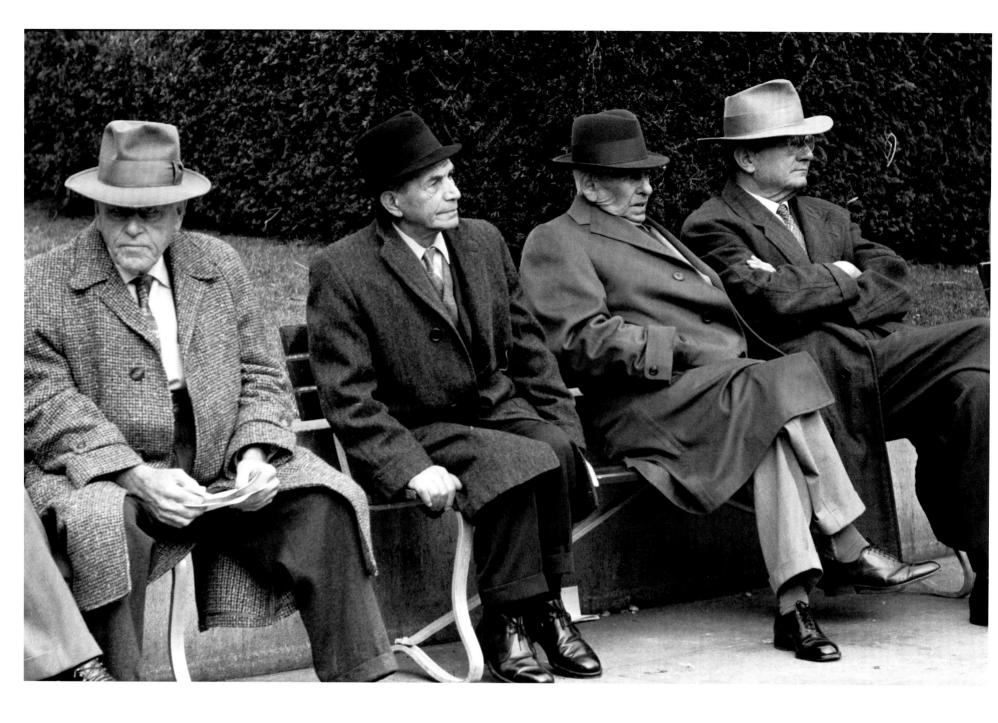

A group of older gentlemen sitting on the sidelines observing a
"Hands Off Cuba" protest in Union Square, San Francisco, 1960

Soldier at pinball machines in Mike's Pool Hall in North Beach,
San Francisco, 1961

Dancer at a Ray Charles concert at the Oakland Auditorium
Arena, Oakland, California, 1961

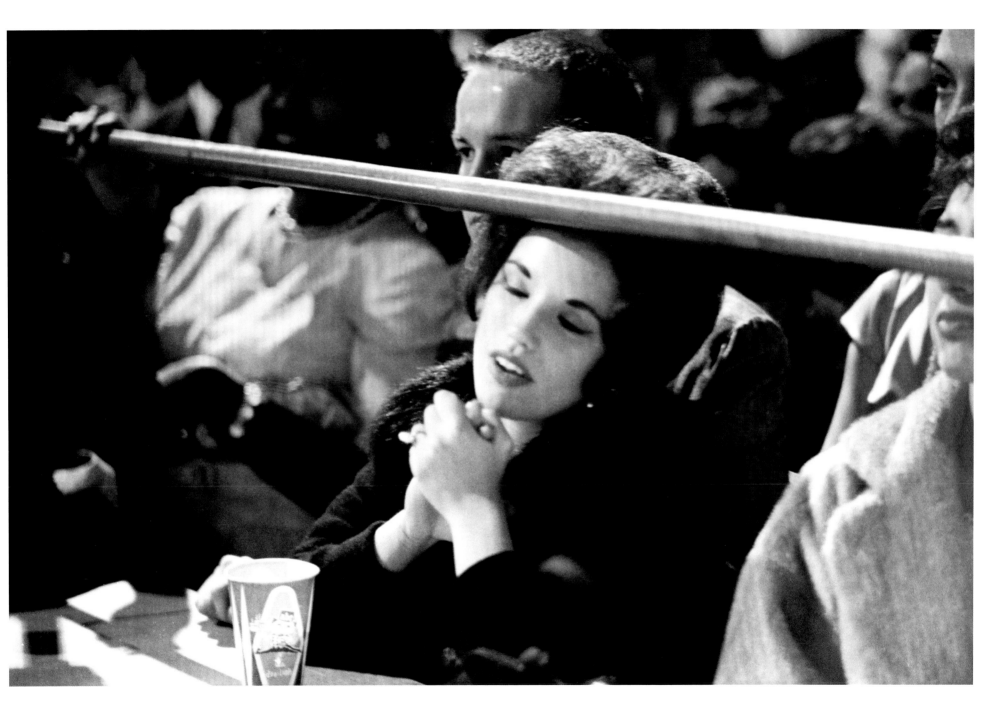

Woman listening to Ray Charles play at Longshoreman's Hall in
San Francisco, 1961

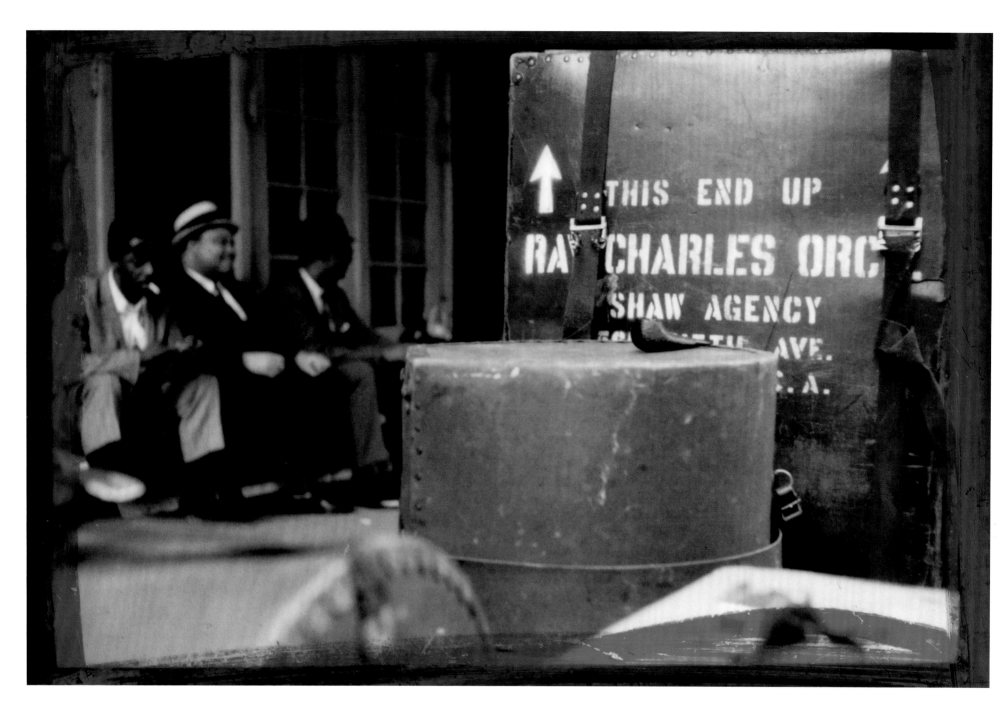

Marshall traveled with the **RAY CHARLES BAND** on and off from
1960 to 1963. This photo was taken in New York City in 1963.
Opposite is the full proof sheet.

32

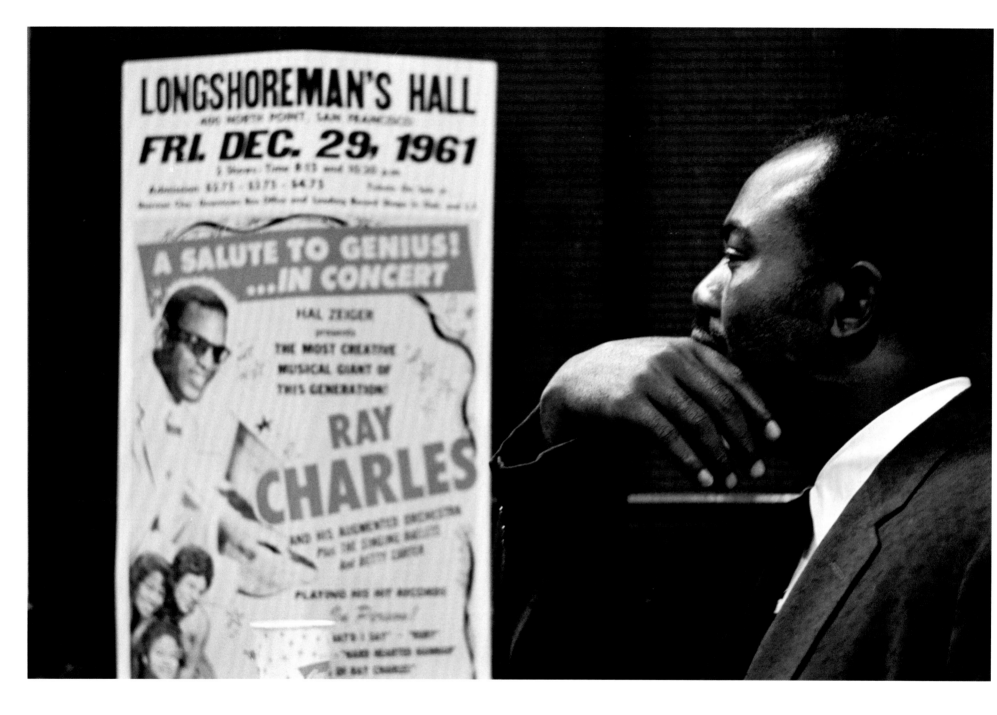

Ray Charles concert poster at Longshoreman's Hall,
San Francisco, 1961

Woman at a North Beach Festival in San Francisco, 1961

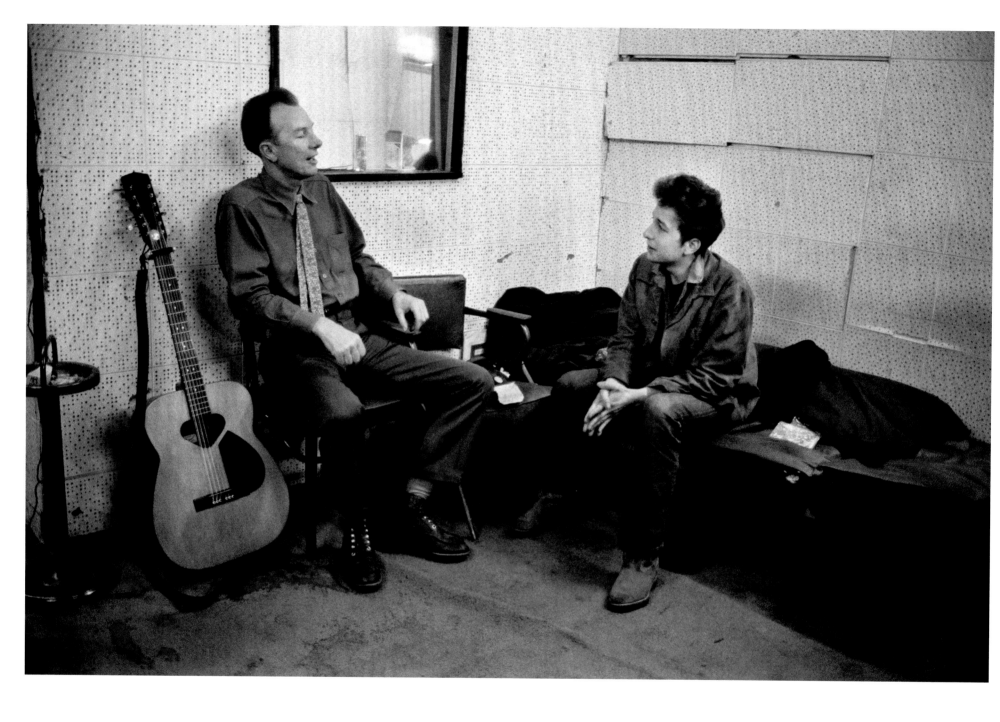

BOB DYLAN and **PETE SEEGER** backstage at the Village Gate,
New York City, 1962

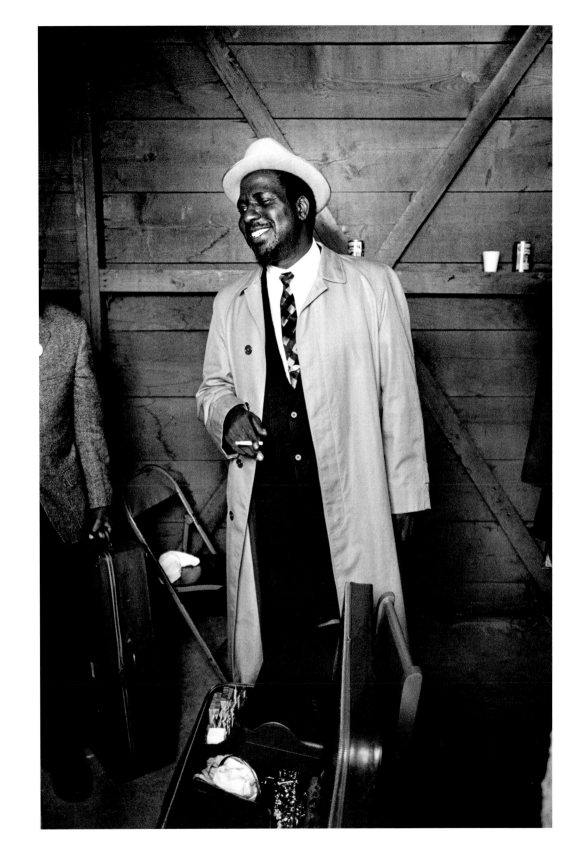

THELONIOUS MONK backstage at the Monterey Jazz Festival, Monterey, California, 1964. A colorized version of this image was used as an album cover.

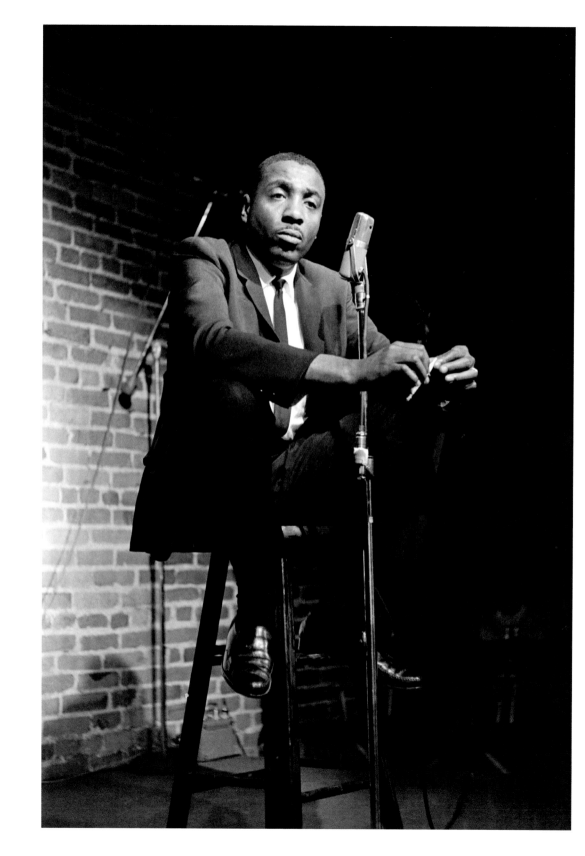

DICK GREGORY performing at the hungry i nightclub, which played a big role in the history of stand-up comedy. Dick Gregory was the first black comedian to successfully cross over to white audiences. North Beach, San Francisco, 1961.

MAVIS STAPLES recording session in Chicago, 1963

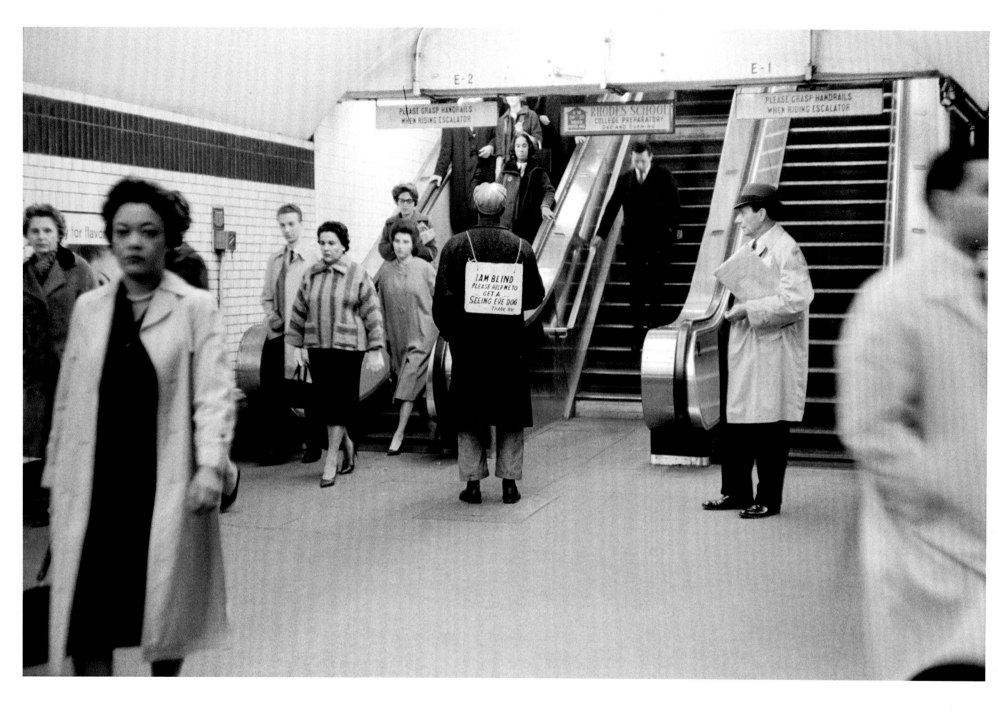

A blind man asking for help to get a security dog in the subway,
New York City, 1963

New York City, 1962

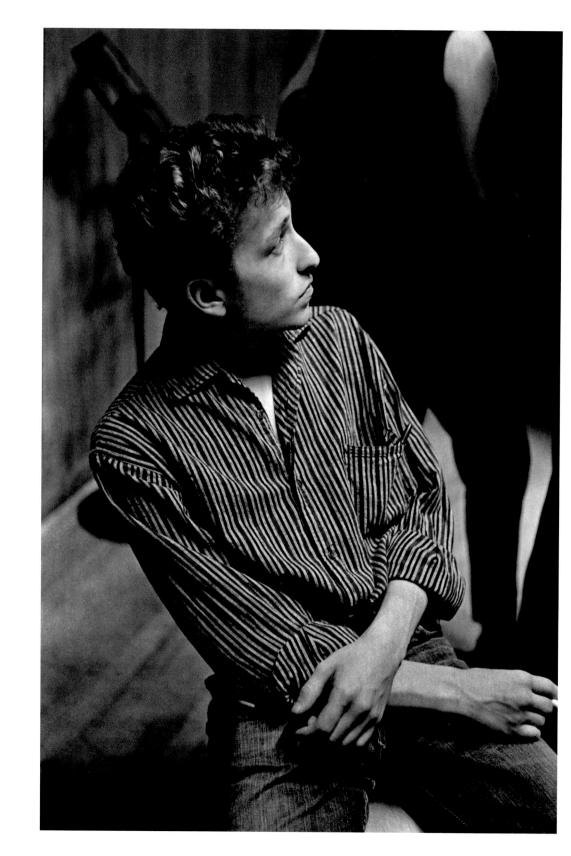

BOB DYLAN in a Greenwich Village café, New York City, 1963

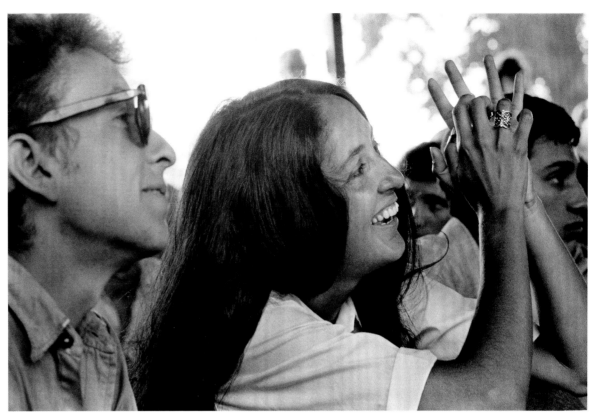

You can't talk about **BOB DYLAN**'s early career without acknowledging **JOAN BAEZ**'s catalytic effect on his work, his outlook, and his emotions. They met at Gerde's Folk City in Greenwich Village in 1961. The twenty-year-old Baez was already a big star on the folk scene; Dylan, the same age, was just a compelling wannabe.

But the erudite Baez, already considered the "Queen of Folk," seems to have immediately recognized his unique gifts as a lyricist and was, by all accounts, extraordinarily generous in opening doors, recording his songs, and letting Dylan perform with her. It wasn't long before Joan and Bob were romantically involved. The Queen now had a King.

Marshall had his own lifelong love affair with Baez (unconsummated). If you want still images of this mutual admiration society, look no further than these lovely fly-on-the-wall images of Baez and Dylan at the Newport Folk Festival in 1963.

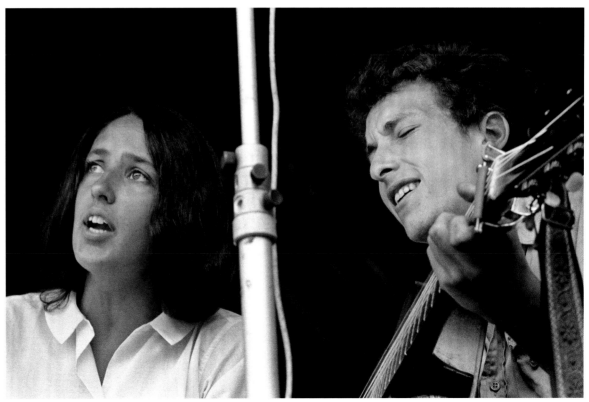

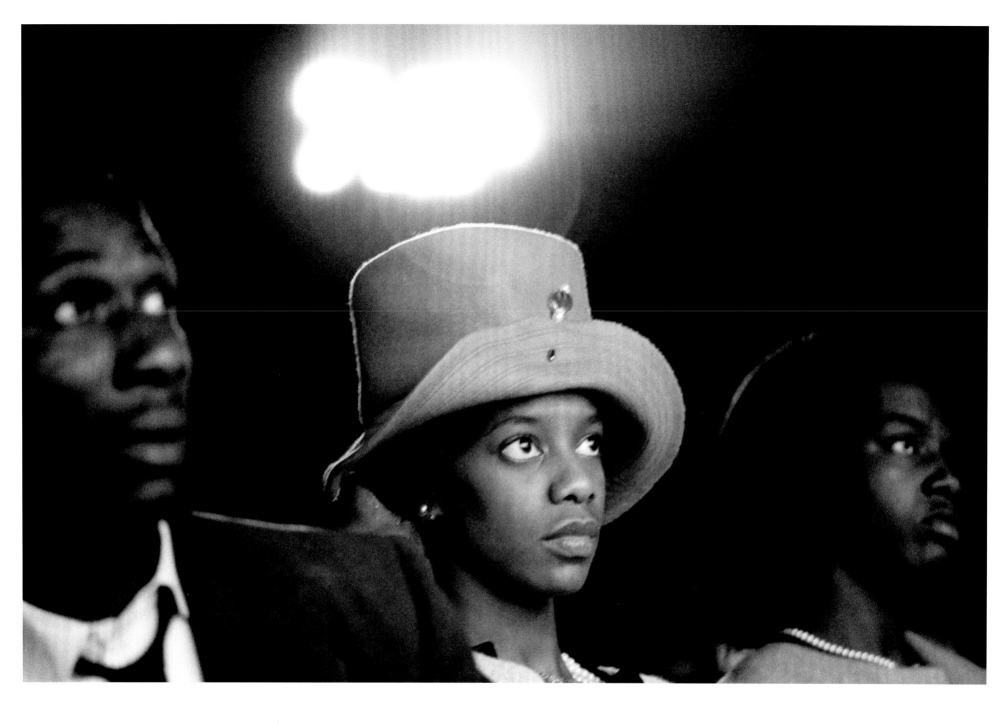

Woman in the audience at "The Greatest Gospel Event in
History," held in Randall's Island Stadium, New York City, 1963

44

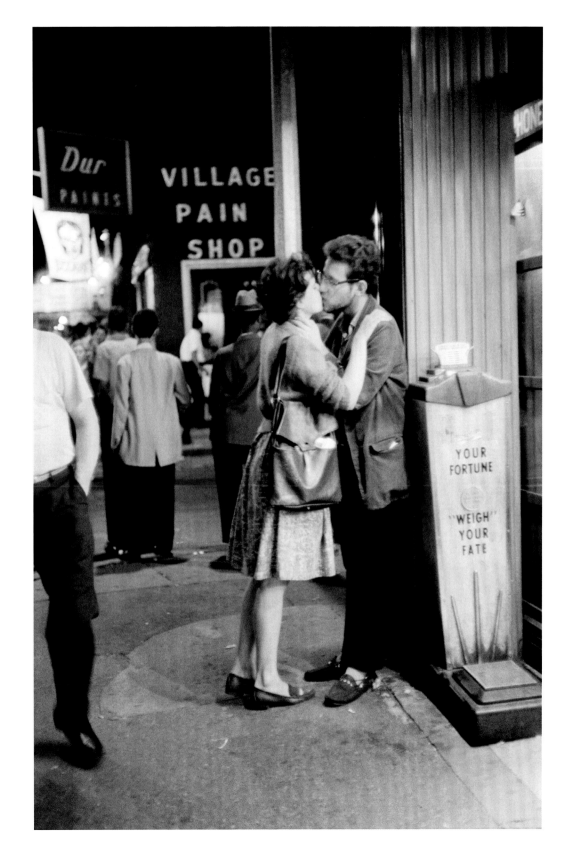

Couple kissing in front of Village Pain Shop in Greenwich
Village, New York City, 1963

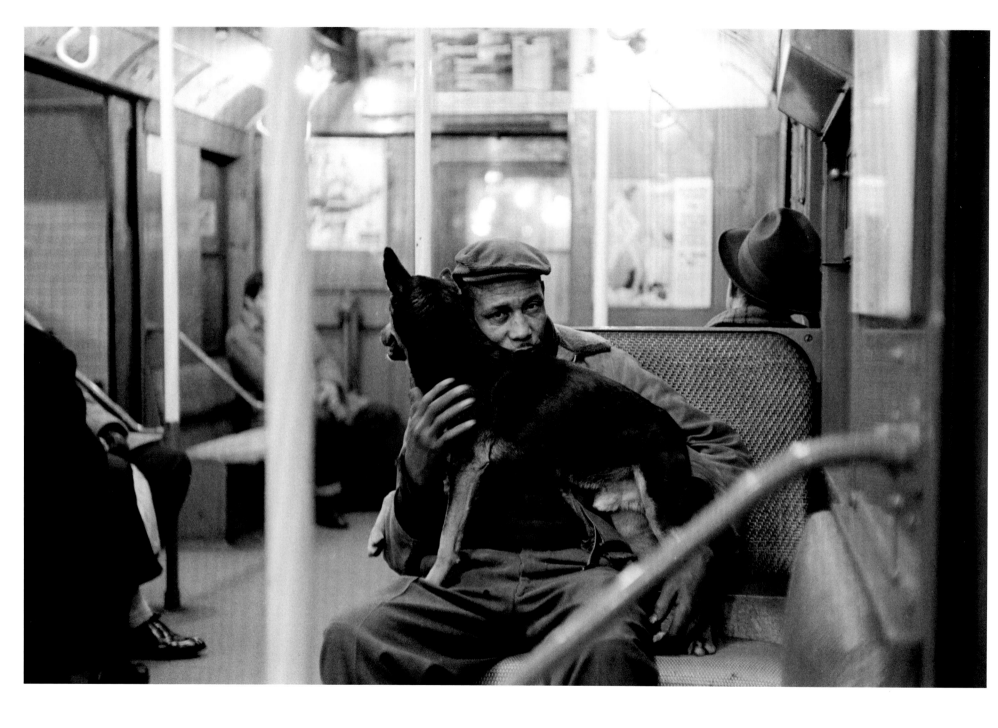

Riding the Broadway Local, New York City, 1963

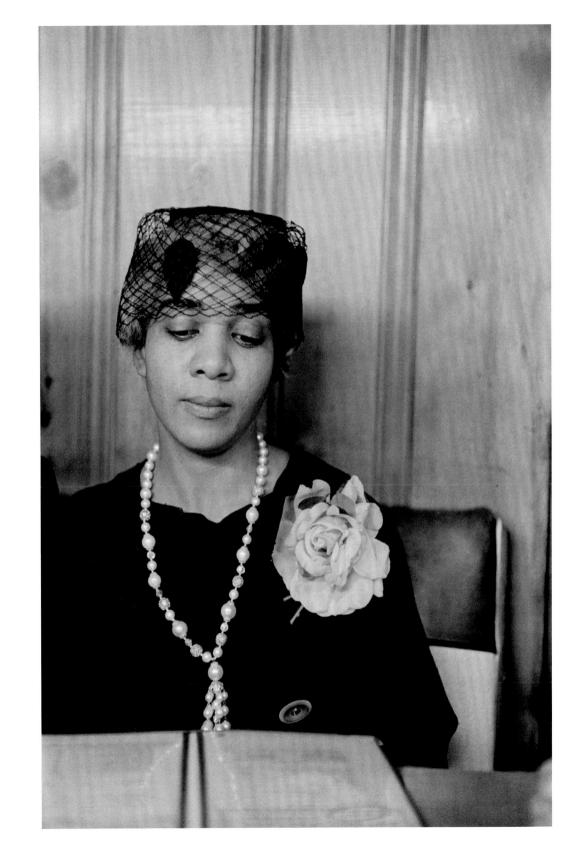

Restaurant in Harlem, New York City, 1963

JOHN COLTRANE listening to playback at Rudy Van Gelder's
studio for Impulse Records, New York City, 1963

48

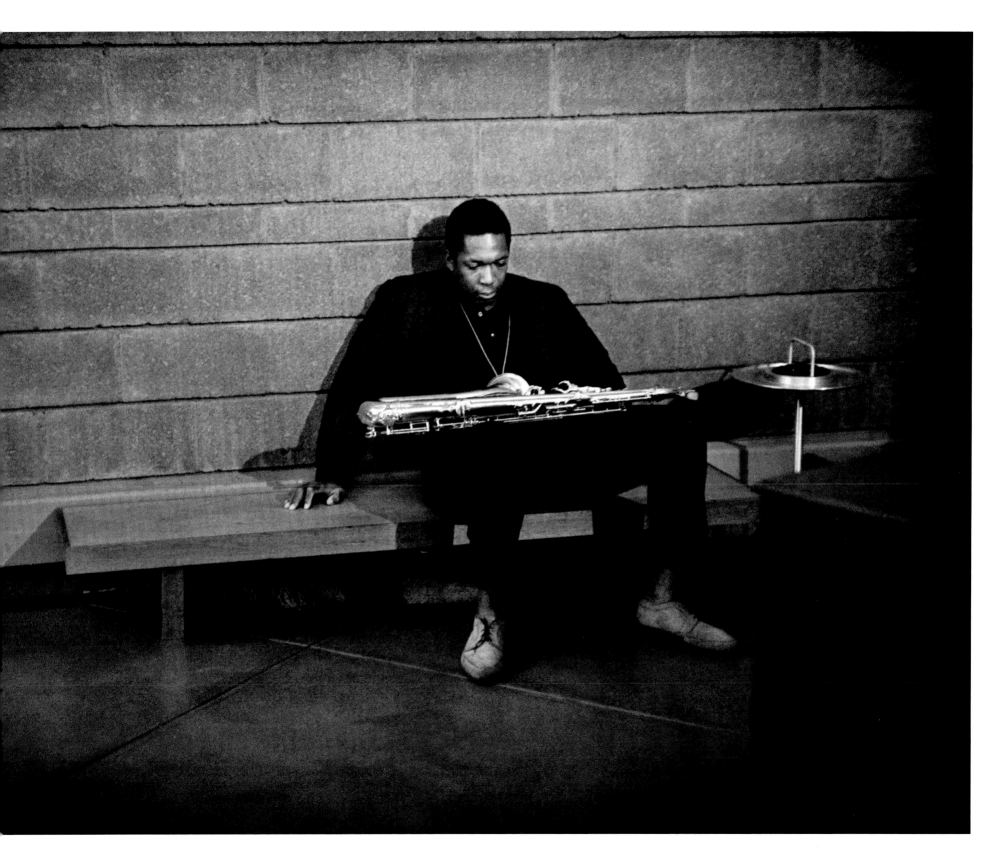

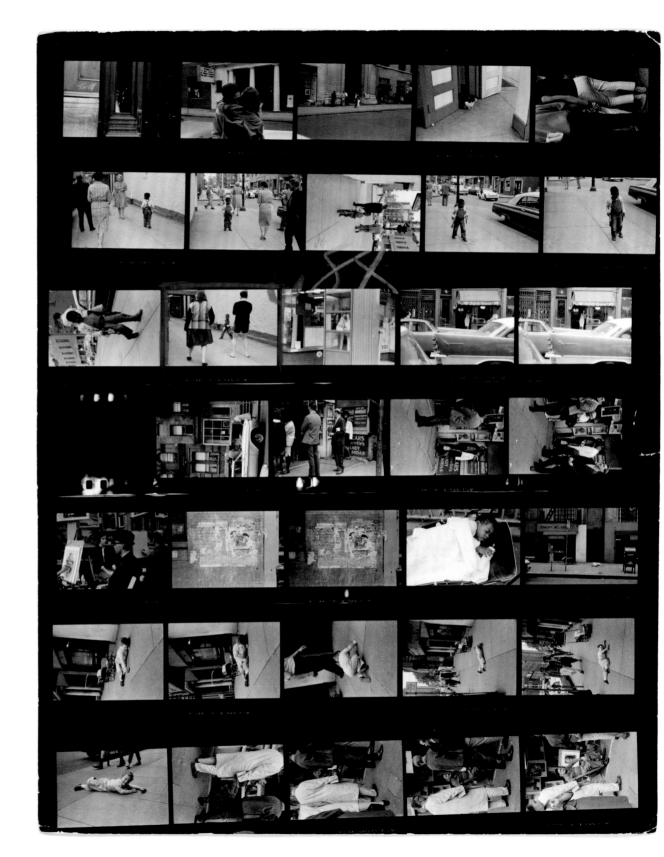

The streets of New York City, 1963: a little boy playing with a toy gun

The streets of New York City, 1963: a man outside
the Judson Church Community Center

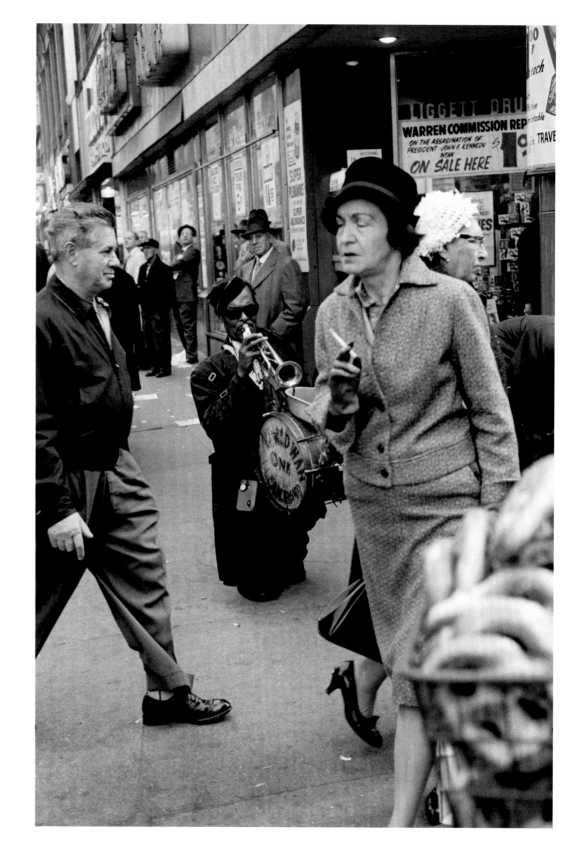

"Warren Commission Report On Sale Here," New York City, 1964

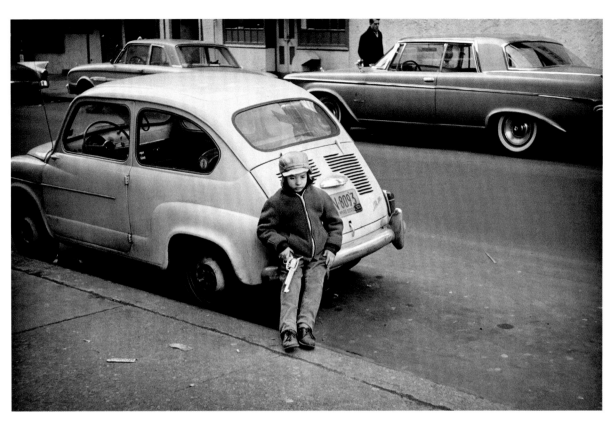

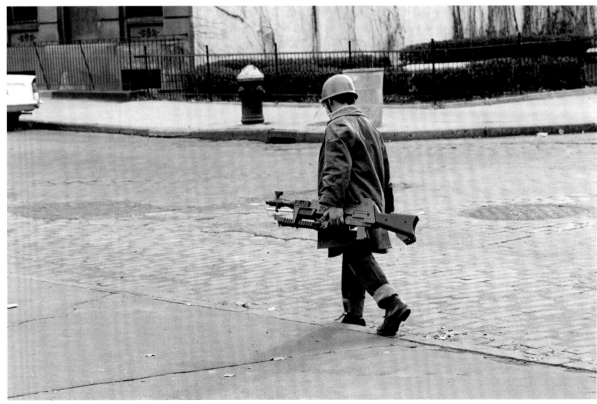

Little boy playing with a gun, New York City, 1963

Outside a recording studio in New York City, 1964

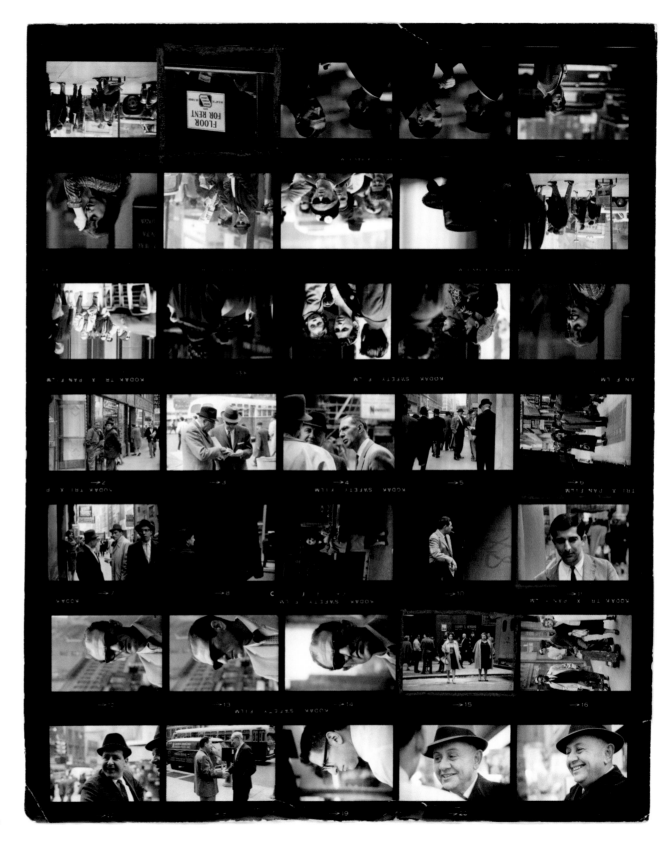

The streets of New York City, 1963: a proof sheet
that also captured a very young **JIM MARSHALL**

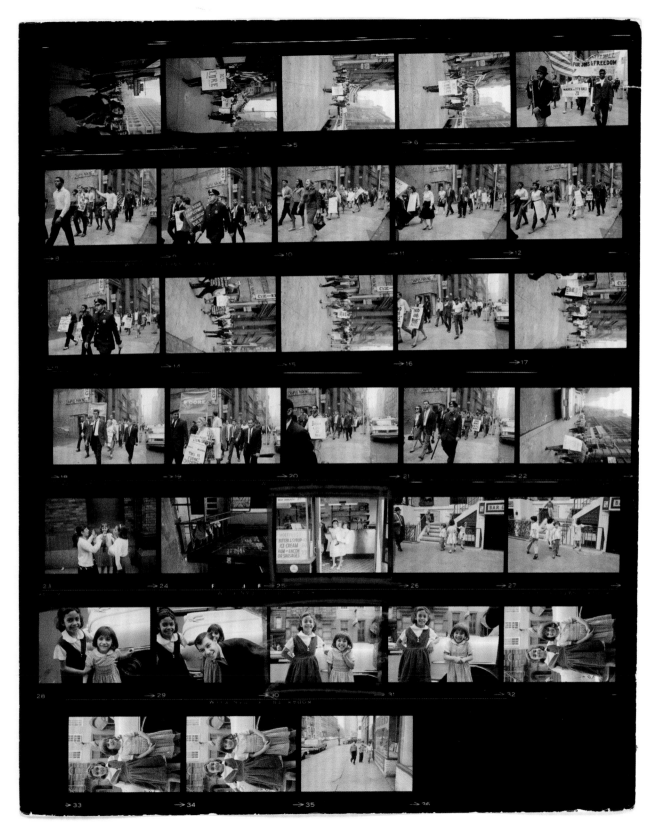

The streets of New York City, 1963: Marshall was always fascinated with children and capturing their playful moments.

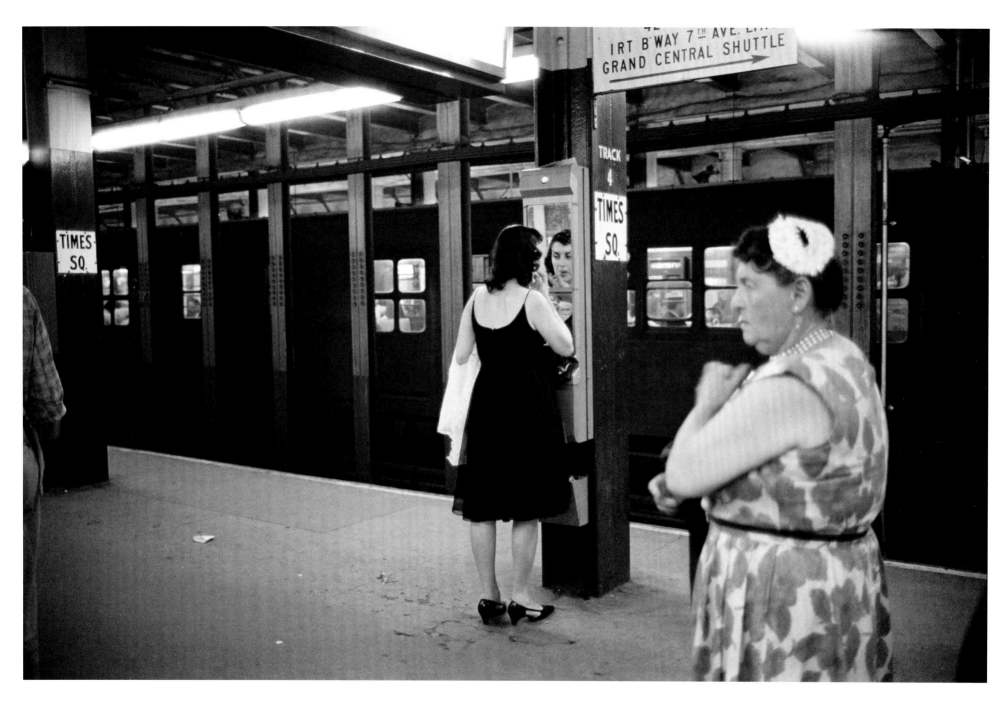

"Times Square Track 4," New York City, 1963

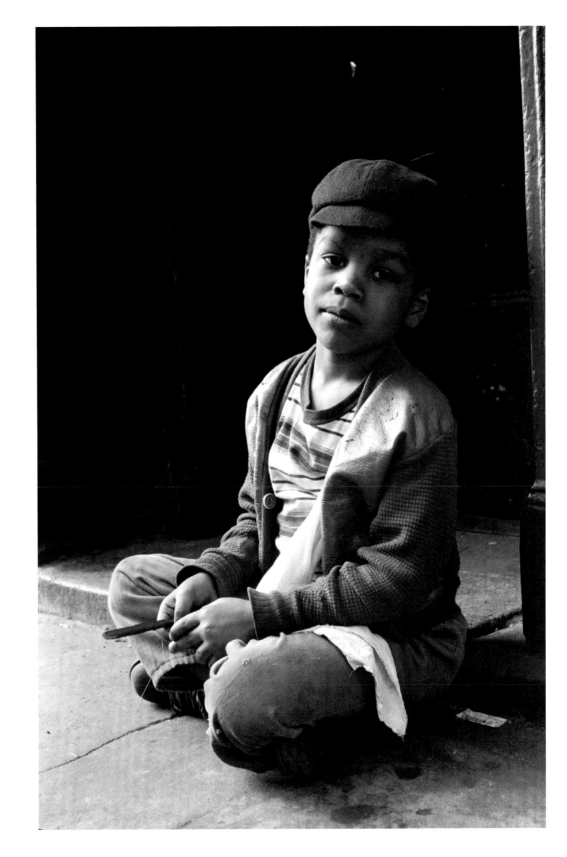

New York City, 1963

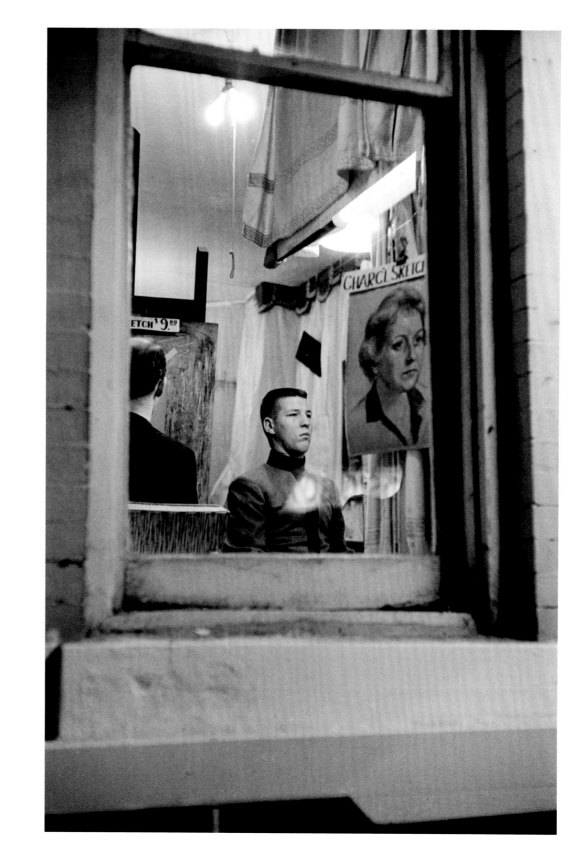

Cadet getting his portrait drawn in New York City, 1963

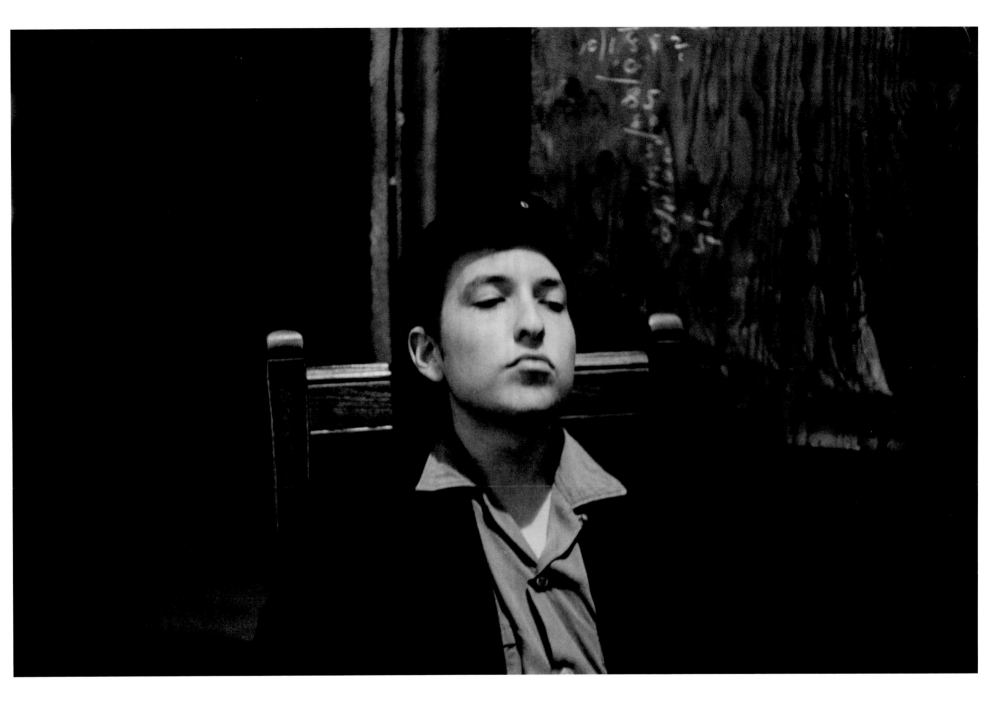

BOB DYLAN in a Greenwich Village café, New York City, 1962 *59*

Marshall took this shot very, very early in his career, backstage at the Ringling Bros. and Barnum & Bailey Circus. He always said it was one of his absolute favorites. It was one of his first rolls of film during his first time in New York City. He probably wasn't on assignment but rather just roaming around, doing his Henri Cartier-Bresson, Dorothea Lange, W. Eugene Smith street photographer thing. And he was likely paying for the film out of his own pocket. You can see how economical he is with his shot selection and also how many other amazing shots there were on just that one roll.

60

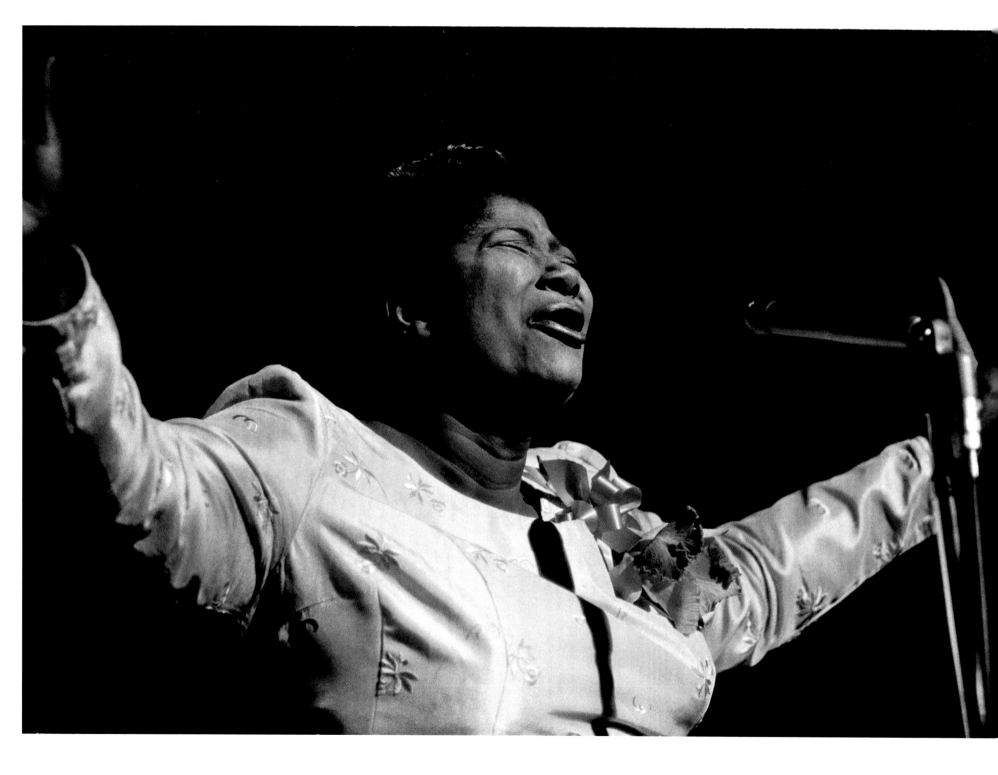

MAHALIA JACKSON performing at Carnegie Hall in
New York City, circa 1960

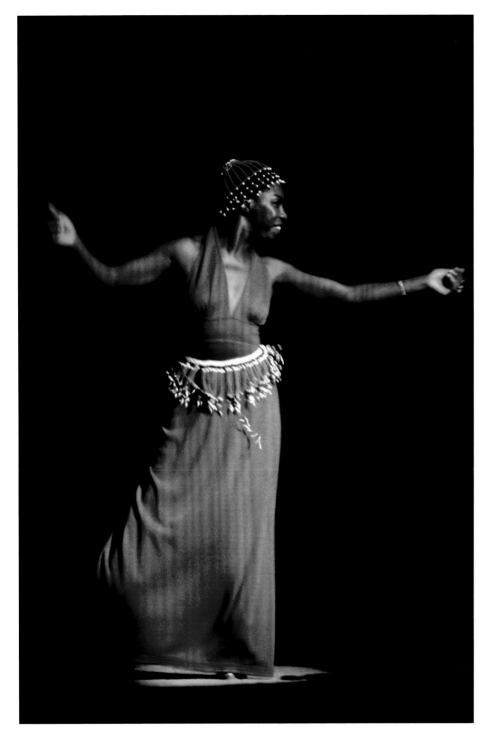

ARMS
WIDE OPEN

MICHELLE MARGETTS

Jim had a thing for photos that showed his subjects (usually singers and often women) with their arms flung wide open. Both in his shot selection in the moment, and later, when he was poring over proof sheets looking for unsung "hero shots," Jim's eye and his heart were tuned to recognize these moments.

As a great visual artist, he's certainly not alone in that fascination. The arms-wide-open move can become a performer's signature gesture, and there isn't a music photographer alive who hasn't snapped away trying to capture it. Yet, as usual, Jim's perfect moments take the pose out of the classic performer move, and make it feel more like a raw, all-encompassing embrace: passionate, giving, and full of potential to hurt or heal, just like him.

If I had to pick just one of these iconic images to muse upon, I'd choose Jim's color shot of Nina Simone at Town Hall in New York in 1960. It's a lesser-known shot of a complex, misunderstood artist. As a Simone fan, I can't quite decide what I love most about this picture: the unmitigated joy in her face or her unbelievable style in blending couture with more roots-related accessories. Jim loved this picture—though oddly he only shot one roll of film of this performance—and he really loved Simone's work, especially "Lilac Wine" and "Wild Is the Wind."

NINA SIMONE in New York City, circa 1960

DYLAN
WITH TIRE

MICHELLE MARGETTS

Inarguably, Jim's most famous Bob Dylan shot is the one he called "Dylan With Tire." It captures such an optimistic and ebullient and inspiring time in Dylan's life—and also in Jim's.

"Dylan With Tire" is one of what Jim called his "hero shots," and it has been published in three of his books and included in nearly every article and interview that was ever done on Jim. It's an image so iconic and mysteriously compelling that it became much bigger than itself from the moment it was first printed; people have been trying to imbue it with meaning since the *Saturday Evening Post* ran it more than four decades ago.

Here are a couple of versions of Jim's story about how this moment was captured. They were published twelve years apart, and you may note the difference in Jim's tone and mood from one recounting to the next.

From his 2009 book *Trust*:

Bobby Dylan lived right around the corner from me in Greenwich Village and I hooked up with him around the neighborhood. The famous shot of him rolling the tire from 1963 happened when we were just going

for breakfast one morning. There was me, Bobby, his girlfriend Suze, Dave Van Ronk, and his wife Terri. The tire was in the fucking street, Bob picked it up, kicked it twice, end of fucking story, no big deal. Fuckers been reading into it for some meaning, the song was never going to be called "Like a Rolling Tire!" There's a nut that even went through [Dylan's] garbage every day looking for meaning. The *Saturday Evening Post* ran it and it took on a life of its own.

And from *Not Fade Away*, published in 1997:

What did Churchill say about Russia? A riddle wrapped in a mystery inside an enigma? Well, Dylan is an enigma. This particular photo was taken one Sunday morning when Bobby, his girlfriend Suze Rotolo, Dave Van Ronk, and Terri Van Ronk all were going to breakfast in New York. Just two frames were shot—no big deal—but I feel it shows that Bob was still a kid in 1963. Contrary to popular belief, this shot did not inspire the song "Like a Rolling Stone." No one really knows where

BOB DYLAN rolling the tire, Greenwich Village, New York City, 1963

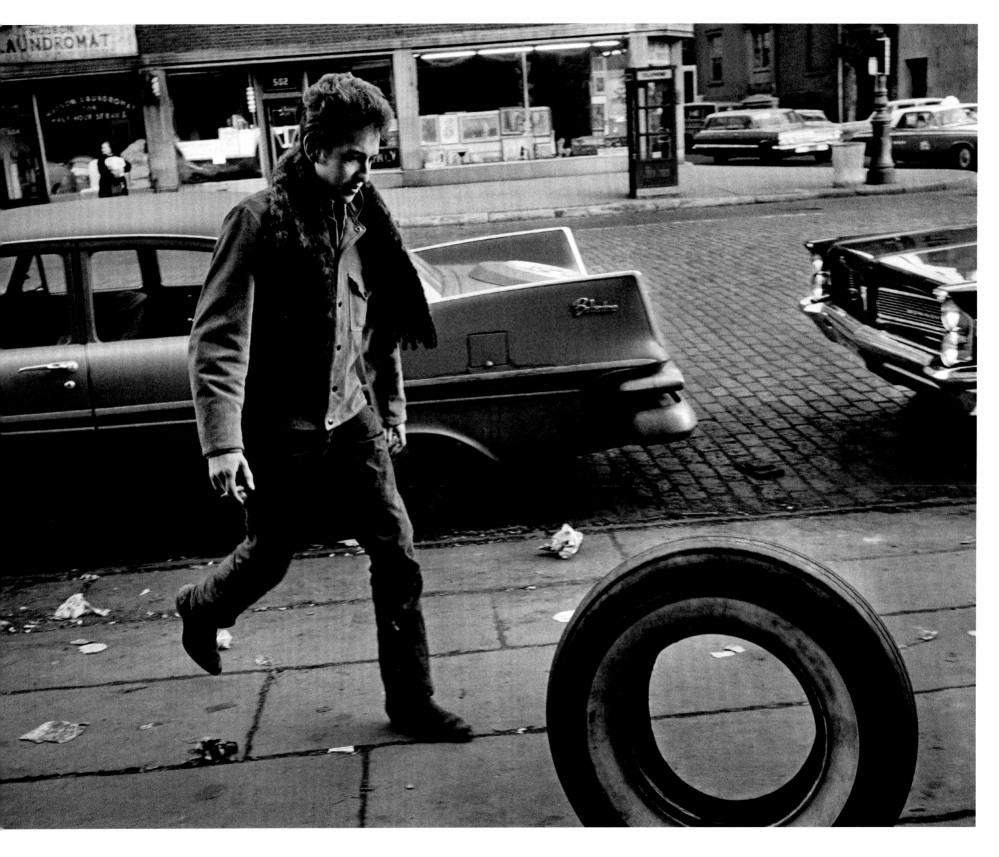

he was coming from, but he's one of the most brilliant songwriters of our time. The last time I photographed him was in 1980.

I'm with Jim on the dumbness of thinking the shot's about "Like a Rolling Stone/Tire." Featuring something that rolls is just way too trite for the way Jim worked, even in the beginning stages of his career. What it makes me think of is another classic song Dylan wrote a decade after he hung out with Jim and some friends, just heading to grab some grub on a sleepy Sunday morning in downtown New York City: "Forever Young."

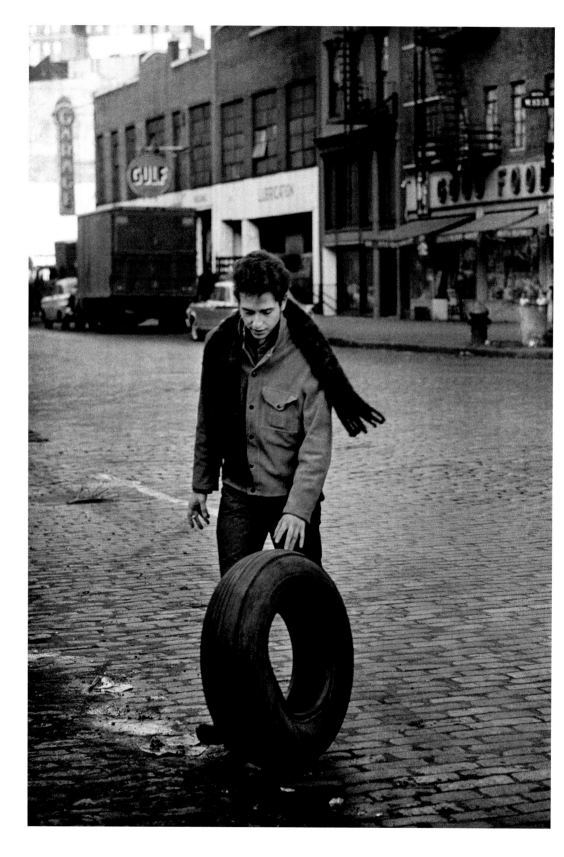

BOB DYLAN rolling the tire, Greenwich Village, New York City, 1963

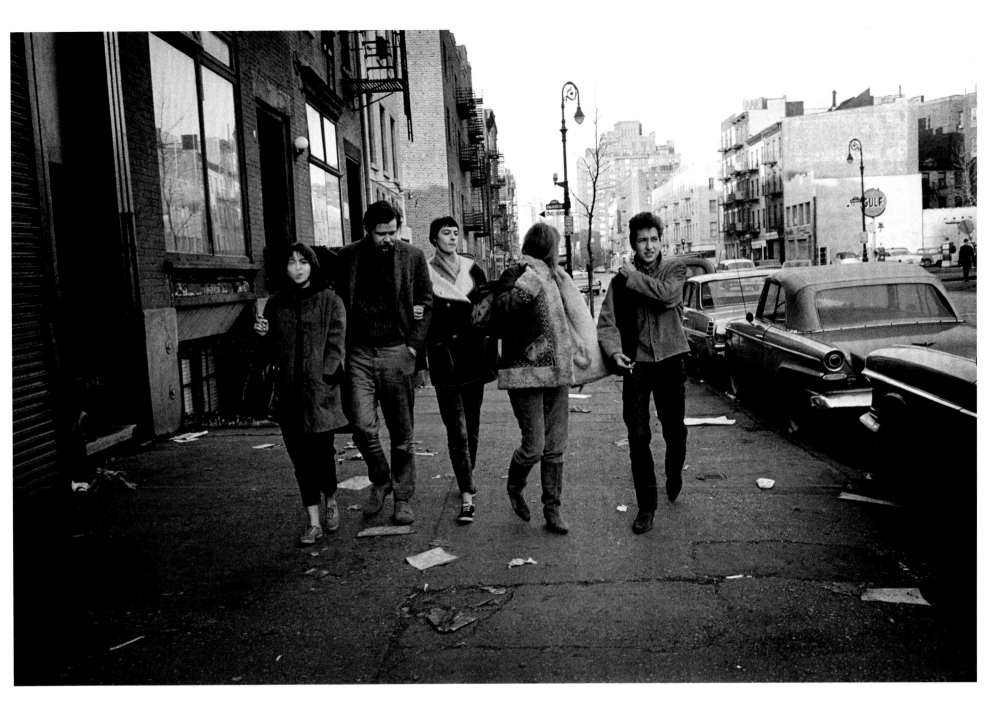

**TERRI VAN RONK, DAVE VAN RONK, UNKNOWN, SUZE
ROTOLO,** and **BOB DYLAN**, walking down the street in
Greenwich Village, New York City, 1963

67

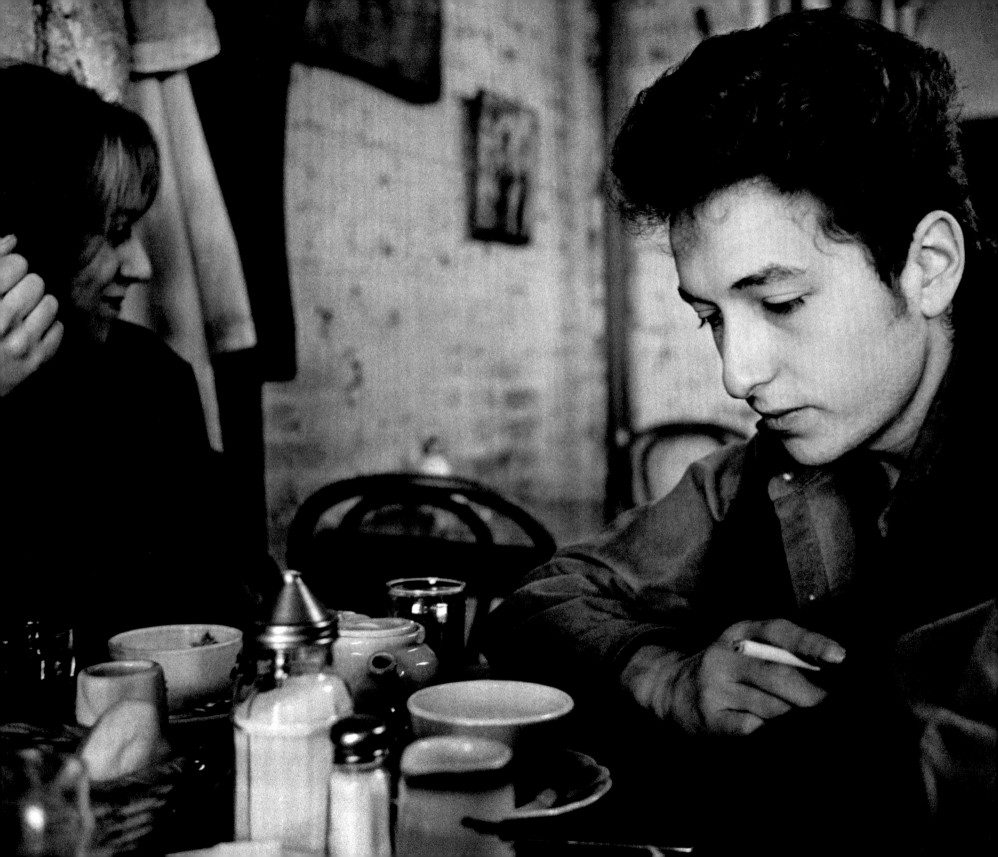

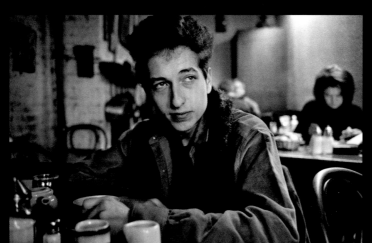

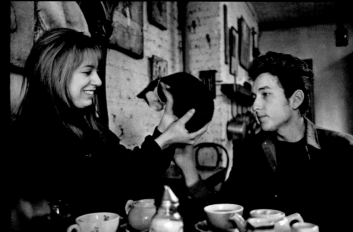

WHAT I LEARNT FROM all these pioneers of
photography is that, no matter how good you are, if you don't have the
access, you don't have the picture. So, you have to have the access,
and I think Jim was just getting access that way. . . . You're part of the
family, and you have moments that other people don't get.

ANTON CORBIJN

SHOWING DIGNITY IN THE DELTA

KAREN
GRIGSBY
BATES

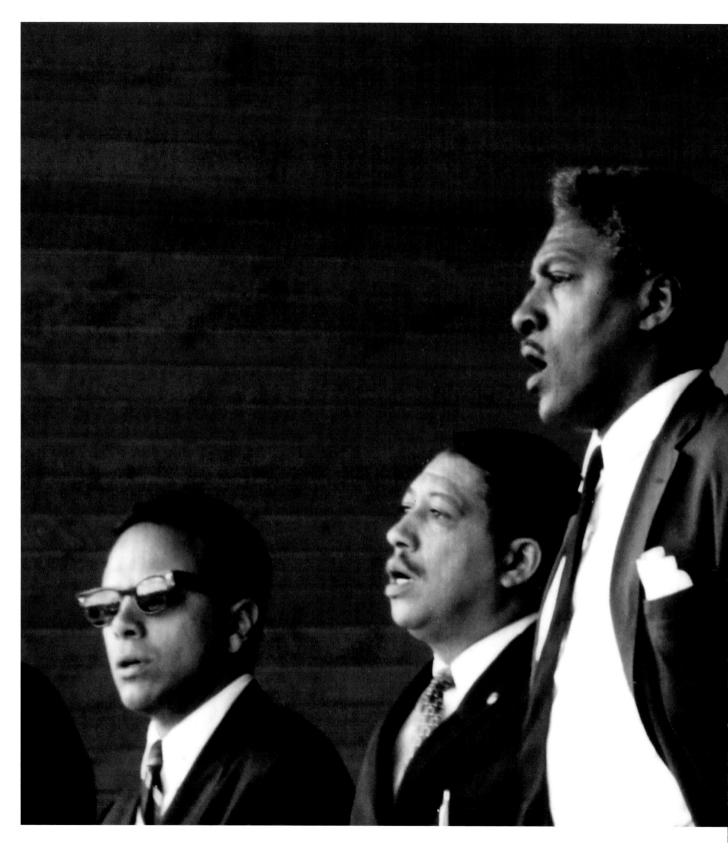

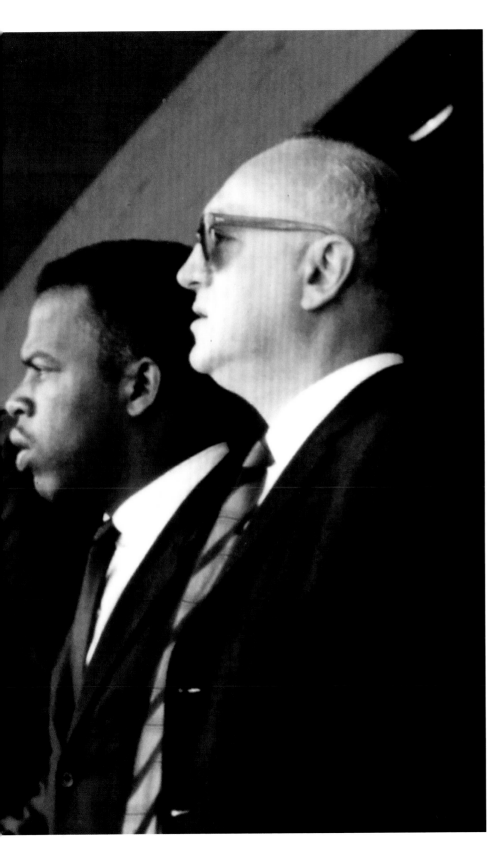

MILLIONS HAVE SEEN JIM MARSHALL'S ROCK PHOTOS, but very few people know the other side of his work, the humanitarian side. I hadn't seen it until recently, and I was shocked at how beautiful these images are. (I can hear him now: "Why the hell are you shocked, Bates? I *took* 'em, didn't I?!")

The same year Jim shot the now-iconic photo of a very young Bob Dylan playfully rolling a tire down a street in Greenwich Village, 1963, would also see him chronicling a dry run for the March on Washington at the Newport Folk Festival. Peter, Paul, and Mary were performing there, as well as Judy Collins, John Lee Hooker, Pete Seeger, and Jim's good friend, Joan Baez. He went for the music and stayed for the meetings.

At these meetings, activists Bayard Rustin, James Forman, and a young John Lewis consulted with other movement strategists to find out what would work and what wouldn't for the grand civil rights march planned for the end of August in Washington, D.C. Jim's photos show the men (and let's be honest, they were almost all men) dressed in white shirts and dark ties, deep in conference. He also photographed groups of people, black and white, marching purposefully through Newport's streets. Back then—especially on non-Festival days—you couldn't get much whiter than Newport. The city's glowing Beaux Arts "cottages" were silent witnesses to the dress rehearsal for the march that soon would occur before the marble government buildings and monuments in the nation's capital—when Joan Baez's silvery soprano would lead a quarter of a million people in "We Shall Overcome."

Jim also spent part of the summer of 1963 in Mississippi, recording another trial run, this time for the Freedom Summer of 1964. This was an effort to register black citizens—most of them poor, many of them generations-long residents of their small

JOHN LEWIS and **BAYARD RUSTIN** with other members of CORE and SNCC, speaking at the Freedom Vote trial run, Newport Folk Festival, 1963

towns—who had consistently been denied their most basic constitutional rights. Jim took photos of fathers in overalls holding children close in the dusty front yards of their tarpaper-roofed homes. A series of shots show a sleeping infant on a battered cot in a room with walls made of discarded wooden doors.

But after the triumphal optimism of the March on Washington came the fall of 1963. Jim was in New York in the Time-Life Building, probably hanging out and jawing with other photographers, maybe angling to see one of the photo editors, when news broke that President John F. Kennedy had been assassinated in Dallas. Jim probably grabbed his Leicas, hopped in the elevator, raced to ground level, and waded out into the crowded midtown street to record people's shock and disbelief as the news began to spread. The resulting photos—of a dazed woman clutching her pearls, a stunned man sitting on a stack of papers at a newsstand, an older man in a doorway, hands raised in prayer—permanently crystallized the shock many of us felt when we heard the awful news.

In the summer of 1964, Jim was in Mississippi again. He took a lot of photos of community life. His crisply defined black-and-white photos show carefully dressed ladies in a voter education class, primly standing behind their wooden chairs. Other shots highlight the modest headstones in a segregated country graveyard ("Ida E. Proctor, 1877–1929 . . . Mother of Five Children"), and a laundry with the word "COLORED" boldly painted on its front door. (Looking at these and Jim's other social documentarian work, I am reminded of the cool elegance of the great Walker Evans. With writer James Agee, Evans had traveled through some of the same territory about thirty years earlier to produce starkly moving photographs of white tenant farmers during the Depression for *Fortune* magazine.)

Jim's pictures recorded the circumstances of these impoverished lives without demeaning the people who led them— no small feat. It was documentation without voyeurism, and it couldn't be done without the trust between him and his subjects that would become his signature. The people in these small Delta towns opened their homes to him.

He, in turn, showed them a courtesy local white people couldn't—or dared not. He addressed the men as "Sir" and the women as "Ma'am" and spoke to them without condescension. They might have wondered about this strange white guy from California who had waded into their lives. But they let him in and trusted him to treat them fairly.

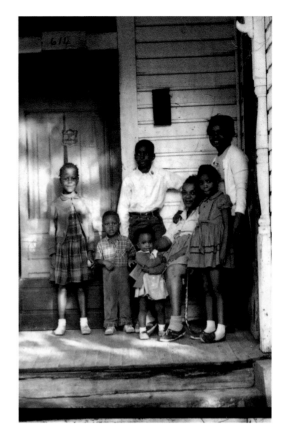

On one occasion, Jim visited Mrs. Fannie Lee Chaney, taking portraits of her and her children as she waited to hear about the fate of her son James. He'd disappeared with fellow volunteer Mickey Schwerner and new arrival Andrew Goodman weeks earlier, as they joined local residents to begin a historic and dangerous effort to register black voters. The summerlong education and registration drive brought students from the North down to the Delta to work with the Student Nonviolent Coordinating Committee (SNCC) and the Congress of Racial Equality (CORE). Leaders like James Forman figured, correctly, that the presence of white organizers in Mississippi would capture national attention in ways that the state's black organizers could not.

The state's white power structure had already boasted of their intent to meet enfranchisement efforts with whatever violence would be necessary to maintain the status quo. Black Mississippians feared the worst, even as they tried to hold onto a shred of hope. Jim was with the Chaneys when the news came that James's brutalized body had been pulled out of a bulwark of a dam that was being constructed in Neshoba County (the same Neshoba County in which Ronald Reagan would announce his presidential candidacy four decades later).

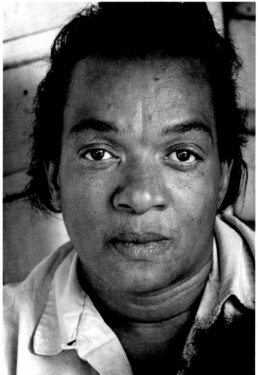

Above: **MRS. FANNIE LEE CHANEY** and her family outside their house. *Below:* **MRS. FANNIE LEE CHANEY** outside her house, hearing of the death of her son, James Chaney, Mississippi, "Mississippi Eyewitness," *Ramparts* magazine, 1964

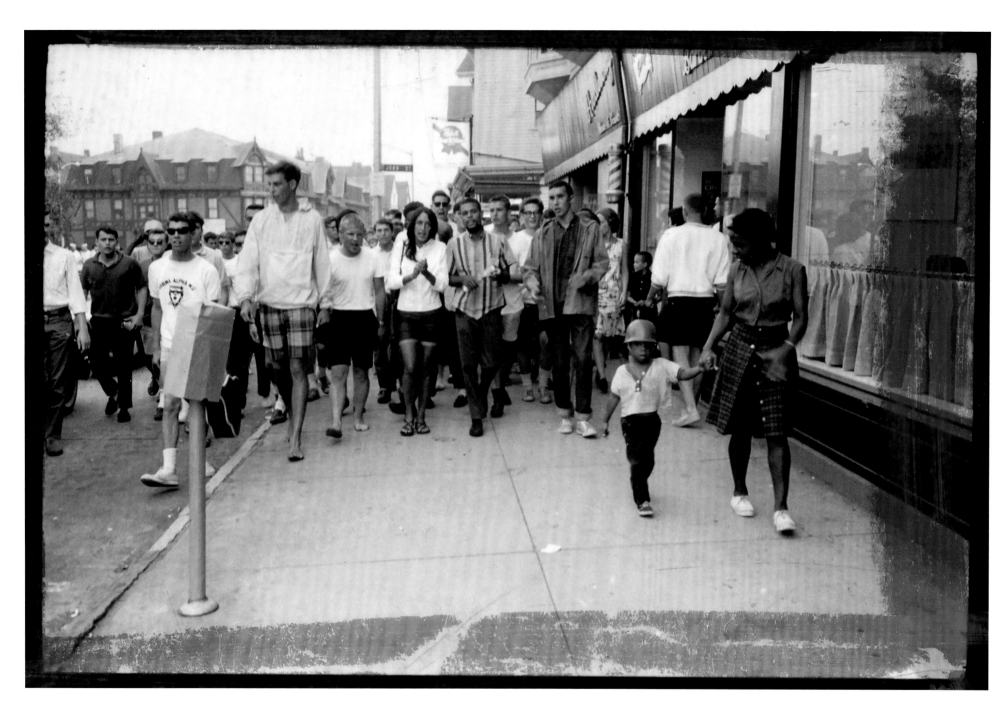

Selection from a proof sheet: **JOAN BAEZ** and **FREEDOM SINGERS** participating in the trial run for the March on Washington through the town of Newport, Rhode Island, Newport Folk Festival, July 1963

The photos taken earlier that day, of Mrs. Chaney with her toddler daughter in her lap, of the Chaney children arranged on the front porch, ended up illustrating a special issue of *Ramparts* magazine called "Mississippi Eyewitness," which infuriated segregationist Southerners who heard about it. They thought the articles and Jim's pictures were purposefully smearing a way of life that had worked perfectly well (for them) before outside agitators came along and spoiled everything. But Jim wasn't telling lies about Mississippi; his photographs were exposing an ugly truth about the Delta's black residents' separate and definitely unequal lives to the outside world.

Jim took these photographs before he became known as *the* chronicler of rock royalty. The quiet dignity of the Mississippi Delta residents stands in stark contrast to his later photos of the Summer of Love, when thousands descended upon a woefully unprepared San Francisco to tune in, turn on, and drop out. The Mississippi photos came before Jim Morrison strutted across the stage. Before Janis Joplin made crowds fall in love with her raspy, revivalist voice and her leave-it-all-on-the-stage energy. Before tens of thousands took the world's largest communal mud bath at Woodstock. Before the Beatles made San Francisco's Candlestick Park reverberate with joy and grief at their last concert.

Jim would probably say that these pictures from 1963 and 1964, of people great and small who tried to rearrange the country's architecture of injustice to form a more perfect union, are just as important. And woe to the person who can't or doesn't get that. Jim might be dead—but friend, do not underestimate his reach.

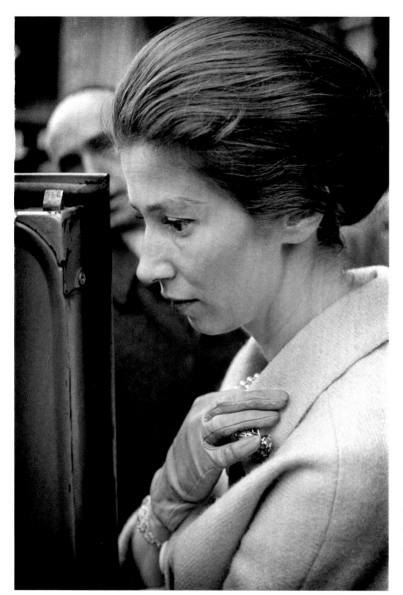

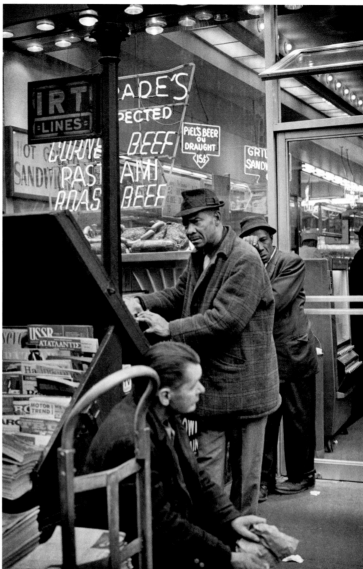

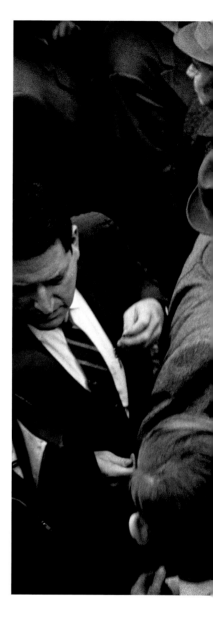

Woman clutching her pearls in reaction to JFK's assassination,
New York City, November 22, 1963

Men's reactions to JFK's assassination, New York City,
November 22, 1963

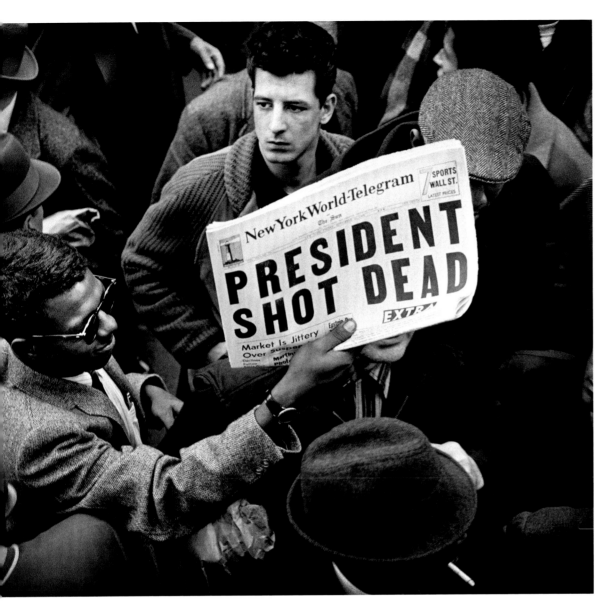

"PRESIDENT SHOT DEAD," New York City, November 22, 1963

Selection from a proof sheet: Man praying in doorway in reaction to JFK's assassination, New York City, November 22, 1963

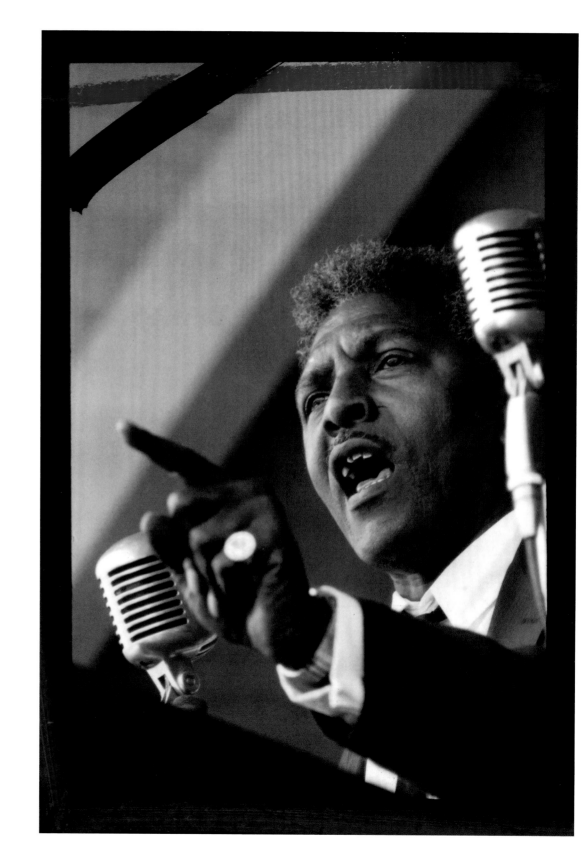

Selections from proof sheets: **BAYARD RUSTIN** (this page) and **JAMES FORMAN** (opposite) speaking at the CORE and SNCC Freedom Vote trial run, Newport Folk Festival, Rhode Island, 1963

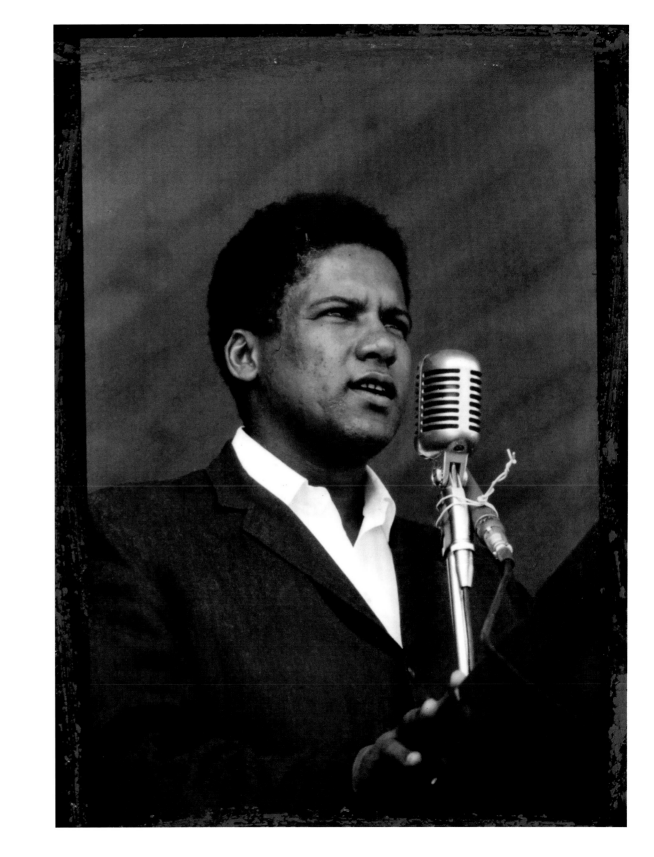

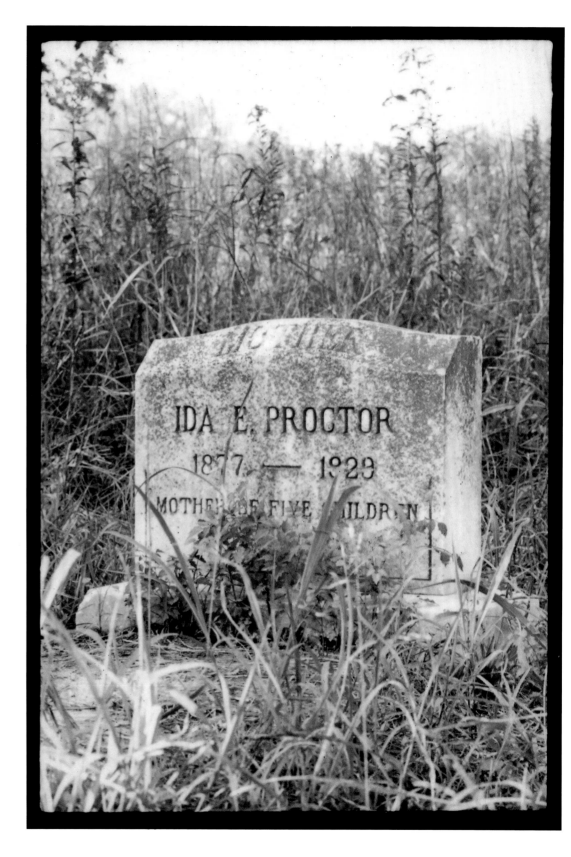

Selection from a proof sheet: Headstone for Ida E. Proctor, Mississippi, "Mississippi Eyewitness," *Ramparts* magazine, 1964

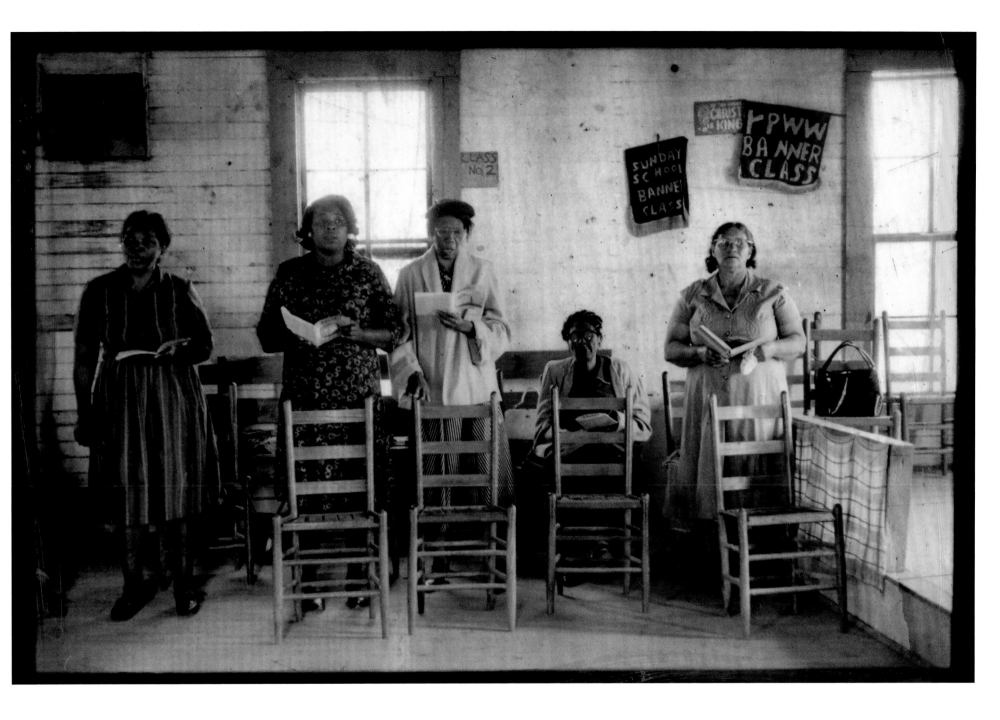

Selection from a proof sheet: Women during voter registration
training, CORE and SNCC Freedom Vote trial run, Mississippi, 1963

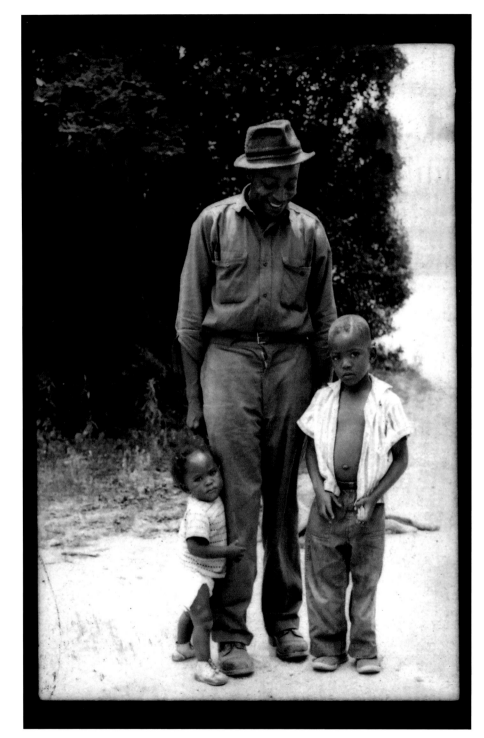

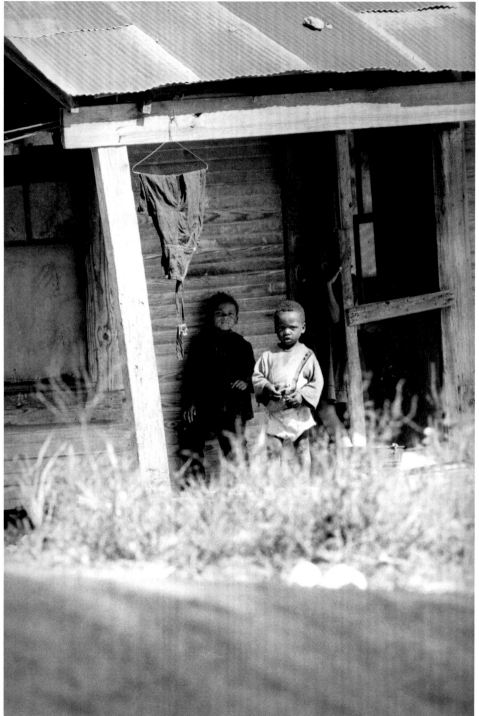

Selection from a proof sheet: Proud father with children during
the CORE and SNCC Freedom Vote trial run, Mississippi, 1963

Mississippi, 1964

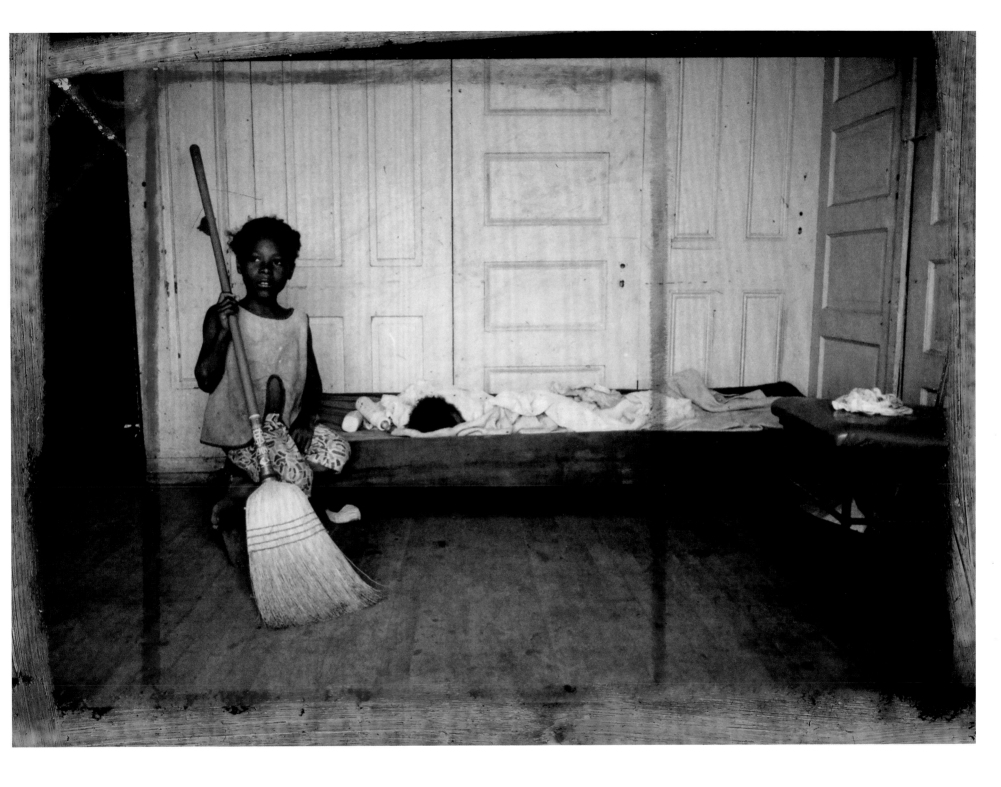

Selection from a proof sheet: Little girl and her sister sleeping on a cot at the CORE and SNCC Freedom Vote trial run, Mississippi, 1963

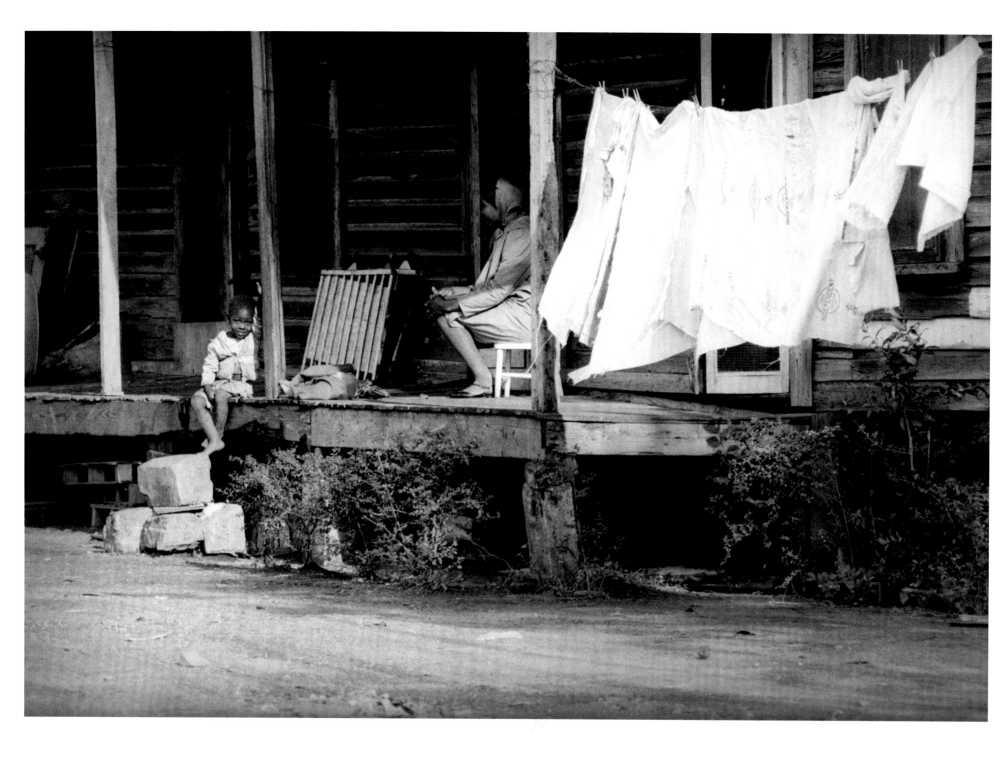

Mississippi, 1964

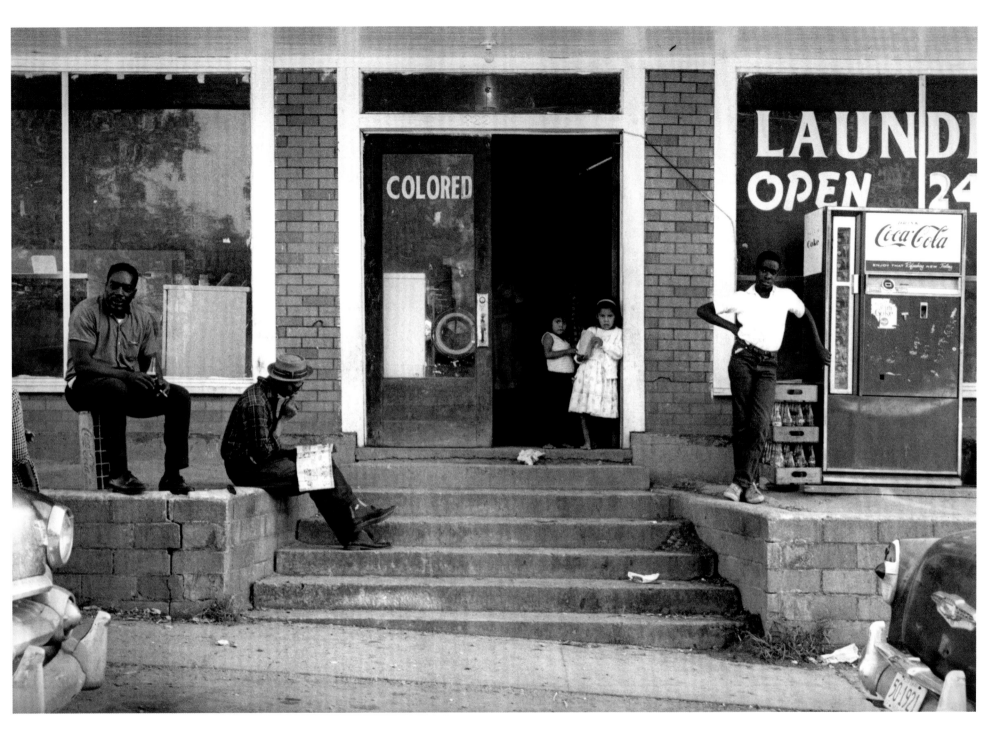

"Colored" laundry, Mississippi, "Mississippi Eyewitness,"
Ramparts magazine, 1964

MUSIC
FESTIVALS

MICHELLE MARGETTS
with *AMELIA DAVIS*

Searching Jim's archives using "music festivals" as the filter is at once exhilarating and overwhelming. From 1960 to the early 1970s, Jim seemed to never stop shooting.

He must have been a blur of non-flashing Leicas, using 35 mm film and a handful of fixed lenses (a 50 mm lens more often than not for the offstage stuff) to seemingly be everywhere, perfectly positioned, all the time, snapping one great moment after another.

And music festivals across all genres—onstage and off— were the source of some of his best, most exhilarating moments and discoveries, and some of his greatest work.

This body of work exists because of the trust and relationships that Jim built with these artists and their managers, agents, roadies, spouses, families, groupies, record labels— really the whole swirling maelstrom of money and magic that accompanied these artists and underpinned these moments.

If you ever hung out with Jim for more than ten minutes in a club, bar, or restaurant when he was "on," you saw his networking ability in action. Because he was such a weird combo of renaissance man and street kid, he seemed to be able to connect with just about anybody, nearly instantly. And once that connection was made, trust was right around the corner.

BRIAN JONES and **JIMI HENDRIX** sharing a moment, walking backstage at the Monterey Pop Festival, Monterey, California, 1967

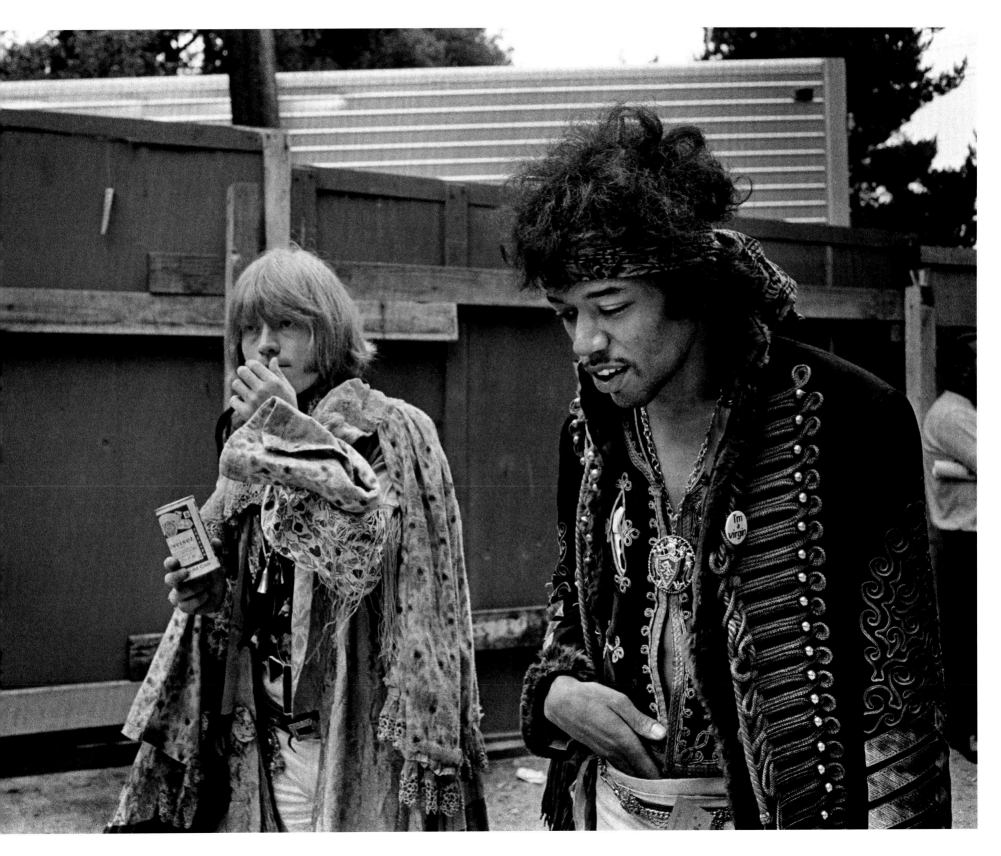

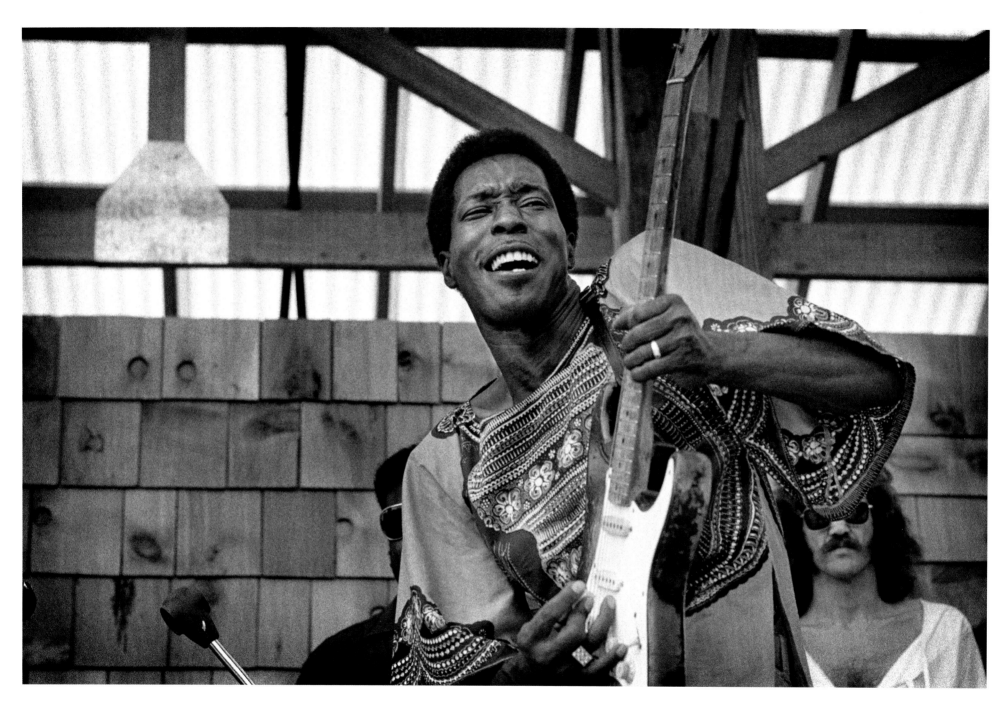

BUDDY GUY performing at the Ann Arbor Blues Festival, Ann
Arbor, Michigan, 1969

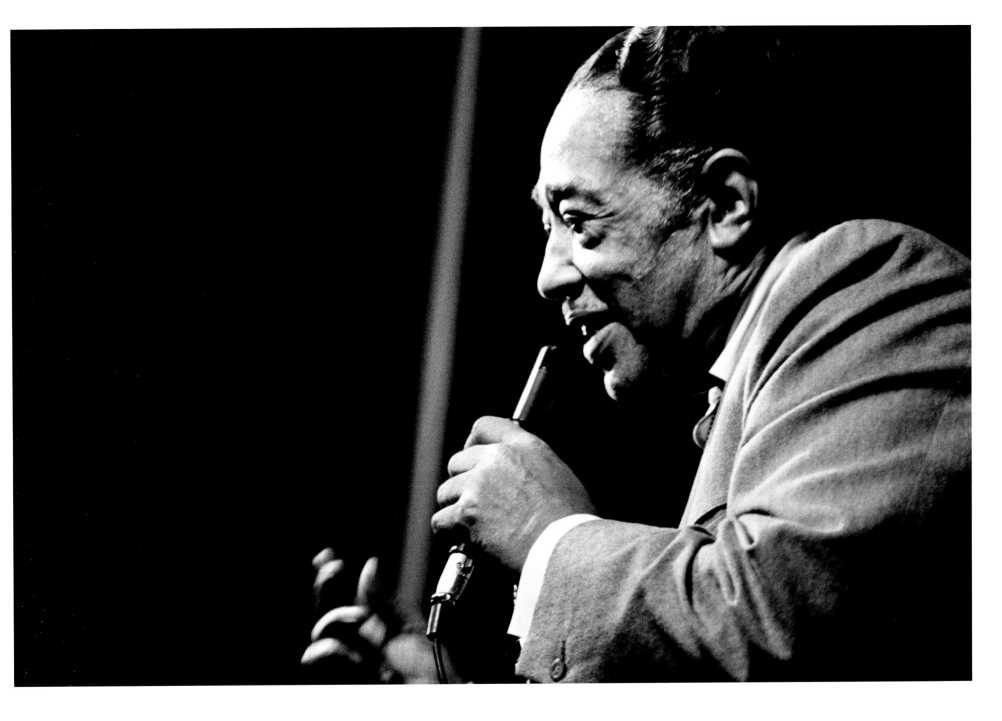

DUKE ELLINGTON at the Monterey Jazz Festival,
Monterey, California, 1964

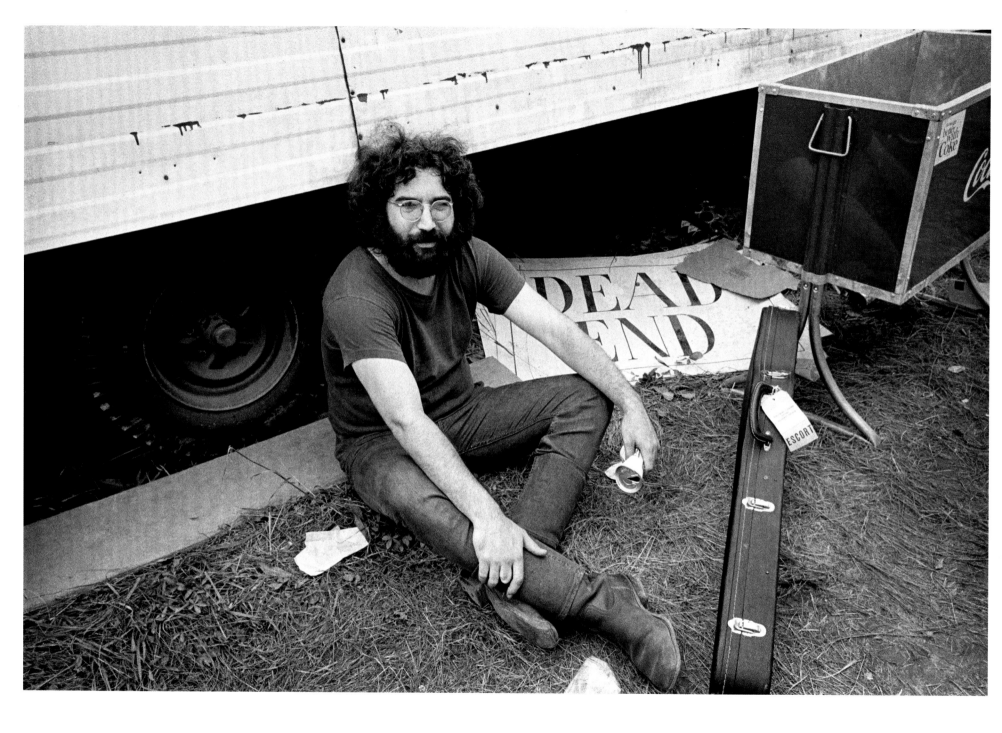

JERRY GARCIA backstage at the Woodstock Festival, Bethel, New York, 1969

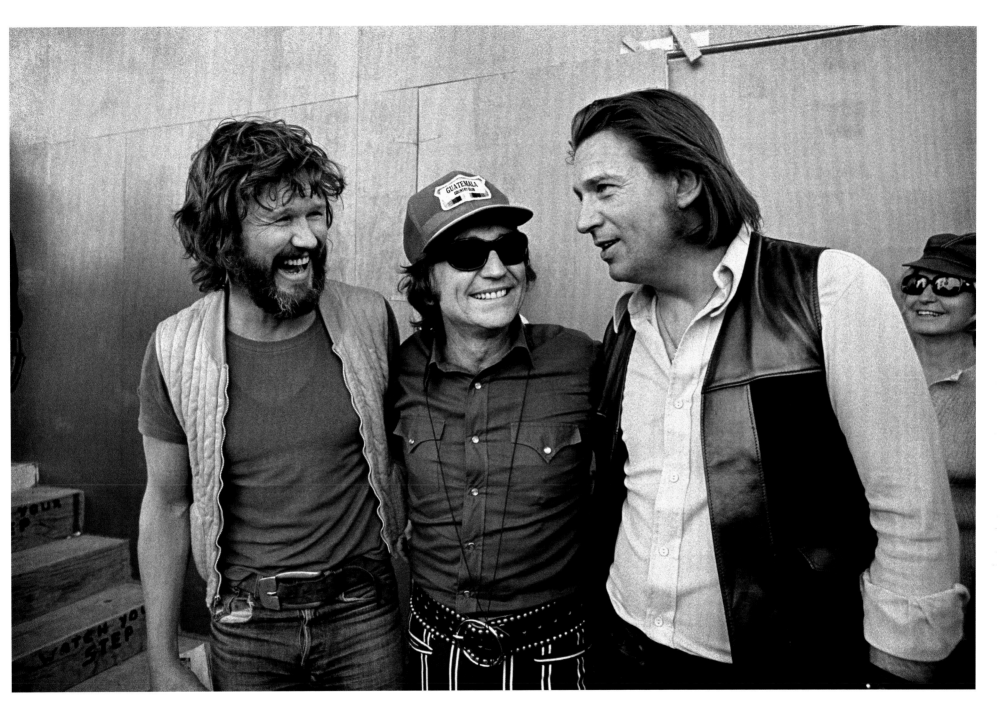

KRIS KRISTOFFERSON, WILLIE NELSON, and **WAYLON JENNINGS** offstage at the Dripping Springs Festival (the first of Nelson's Fourth of July picnics), Dripping Springs, Texas, 1972

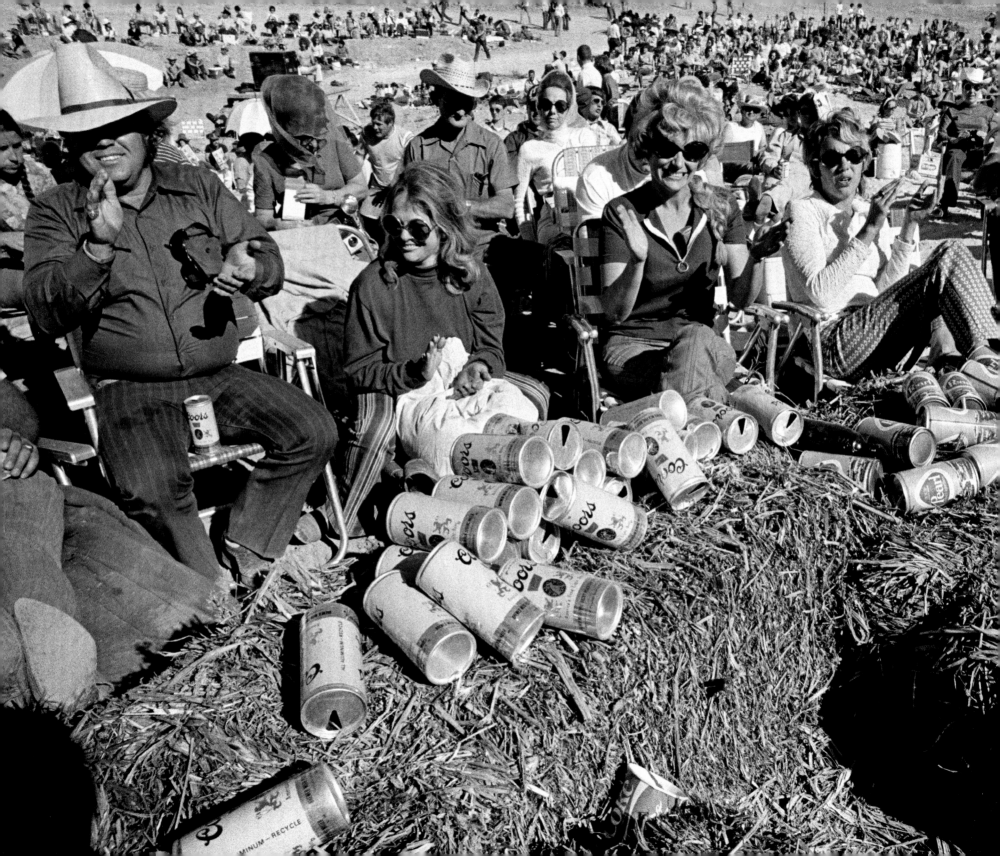

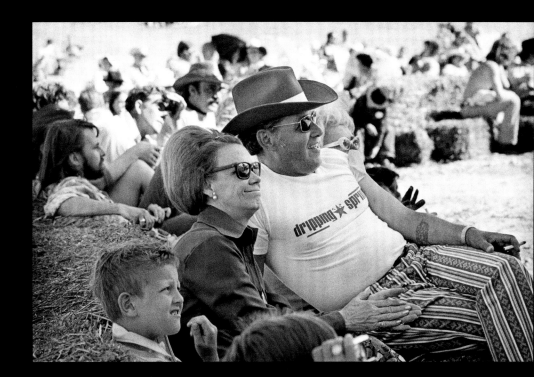

I THINK WHAT DROVE JIM as a photographer was a search for a life that he could connect with. . . . I saw him several times talking to people, and he would literally drop into their vernacular. It wasn't his own voice. He would kind of drop into their accent or their style of talking to connect with them, and it worked for him. He then felt a part of them. Through that, he expanded his own life experience through his photographing of people.

PAUL RYAN

Dripping Springs Festival,
Dripping Springs, Texas, 1972

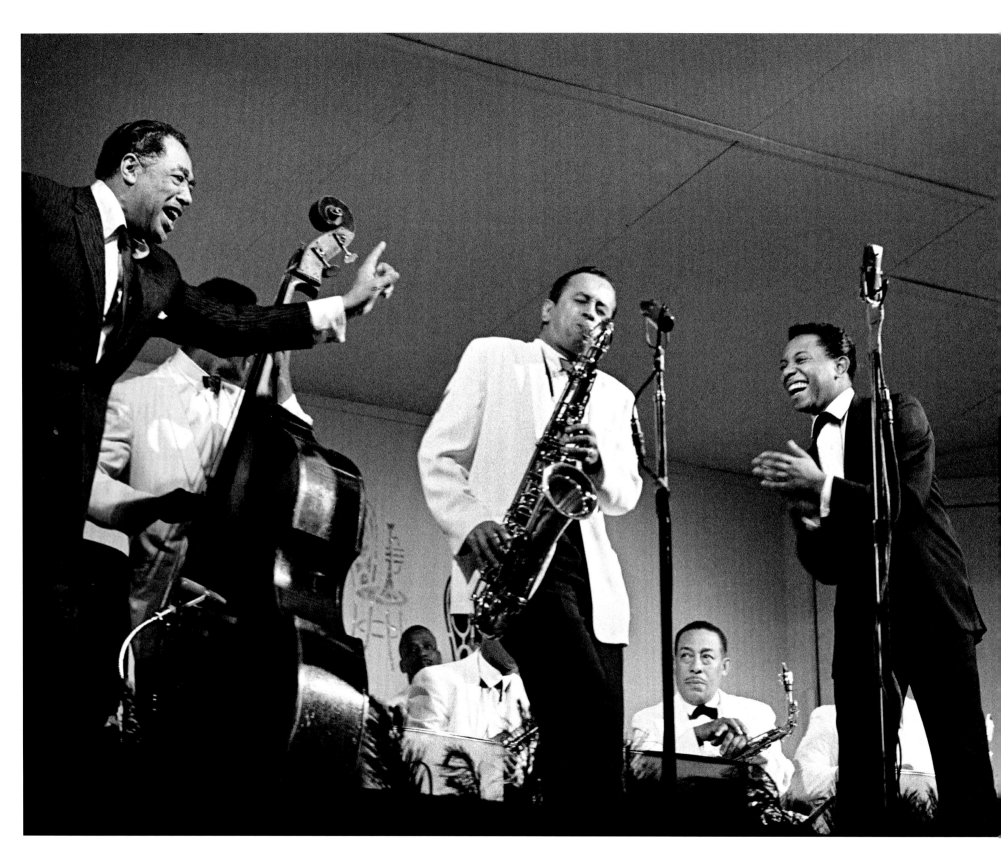

THE MONTEREY
JAZZ FESTIVAL

MICHELLE MARGETTS

Jim's exemplary work capturing the Monterey Jazz Festival in 1960 and 1963 bookended his intensely productive sojourn in New York City. The Monterey Jazz Festival was the brainstorm of Jimmy Lyons, a prominent jazz radio broadcaster in San Francisco, and it pioneered the use of the twenty-acre Monterey Fairgrounds as a major musical venue, starting on October 3, 1958. It's one of the longest consecutively running jazz festivals.

In my mind's eye I can see corduroy-coated, desert boot–wearing Jim prowling around the fog-shrouded, oak-studded Monterey Fairgrounds with his Leica M2 and his 50 mm lens in 1960, a relative nobody in the photography world at the time. It was so early in his career. Jim was fresh out of the Air Force, and I'm quite sure he didn't have but a few fixed lenses and a couple of camera bodies, if that. Most likely he was relying on his 50 mm lens, wide open, and Tri-X film to be pushed later in the darkroom.

I seem to remember Jim telling me he preferred the "normal lens" because it came closest to capturing what you saw with your own eyes. He shot full frame, editing through the lens in real time with no lighting equipment and no net. Jim never even *cropped* a shot. He used to say, "It's either in the negative or it's not."

DUKE ELLINGTON BAND, PAUL GONSALVES solo, at the
Monterey Jazz Festival, Monterey, California, 1960

Hat seller at the Monterey Jazz Festival, Monterey, California, 1960

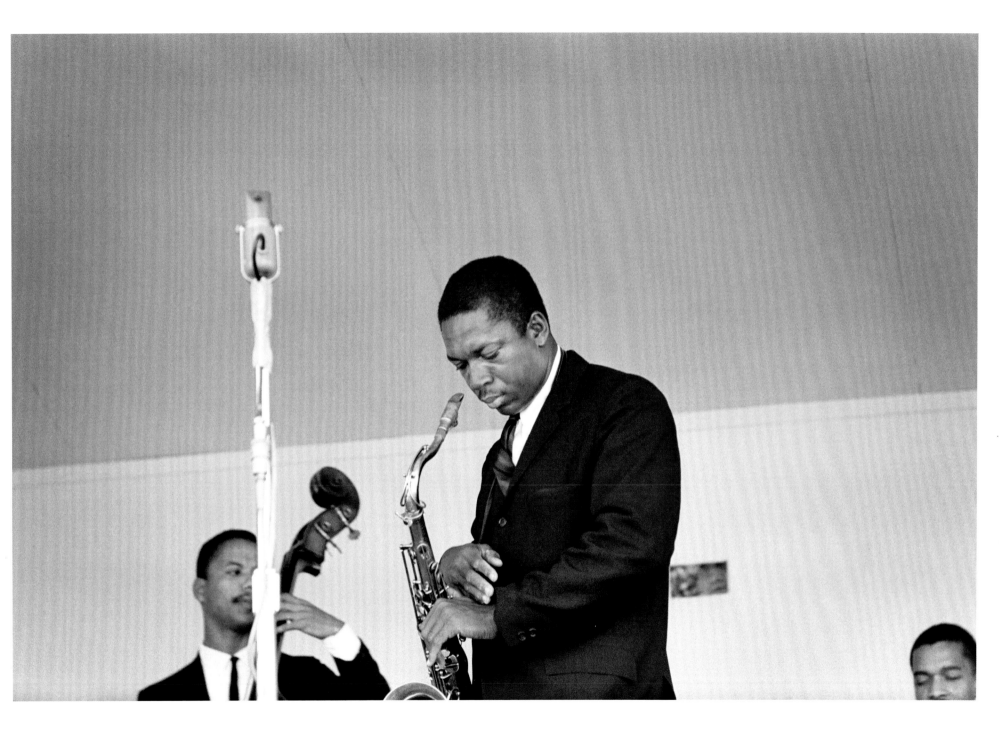

JOHN COLTRANE on stage at the Monterey Jazz Festival,
Monterey, 1960

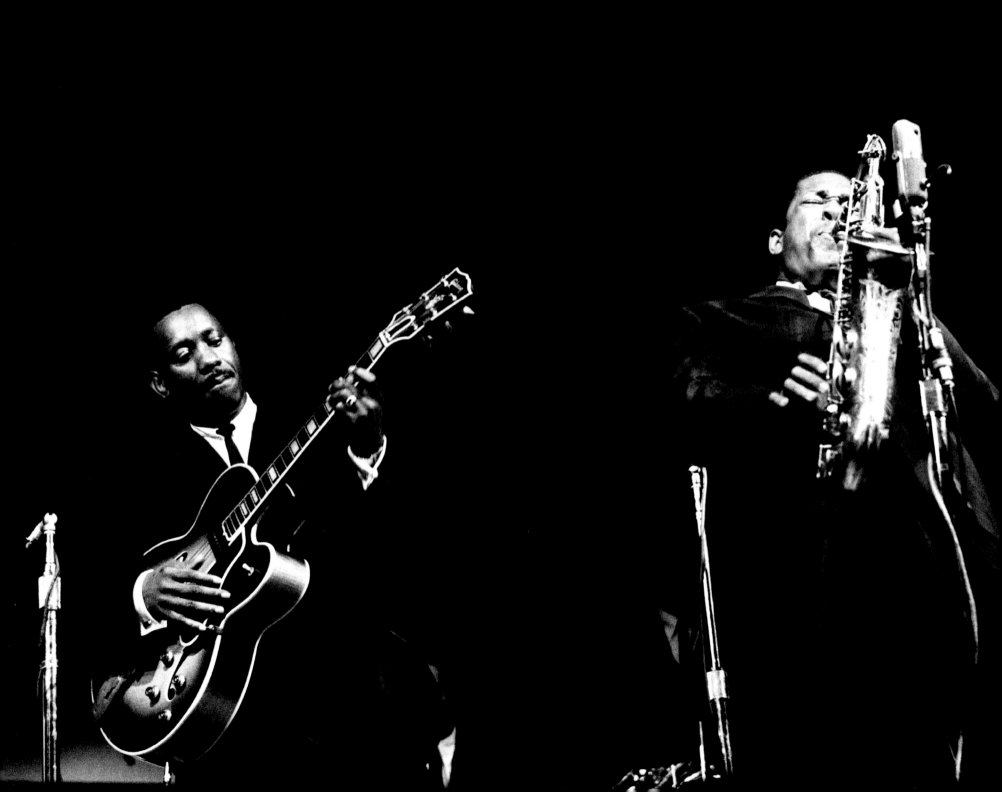

Jim Marshall's photographs represent *WHAT MUSIC MEANS* to me. The way he shot these people is the way I hear these people . . . I don't know that you could even say Jim was performing, but he was with them. When you look at the shot of *COLTRANE* and *WES MONTGOMERY* performing together at Monterey, Jim is not separate; Jim is with them. Jim is part of it.

JEFF GARLIN

WES MONTGOMERY and **JOHN COLTRANE,**
Monterey Jazz Festival, Monterey, California, 1961

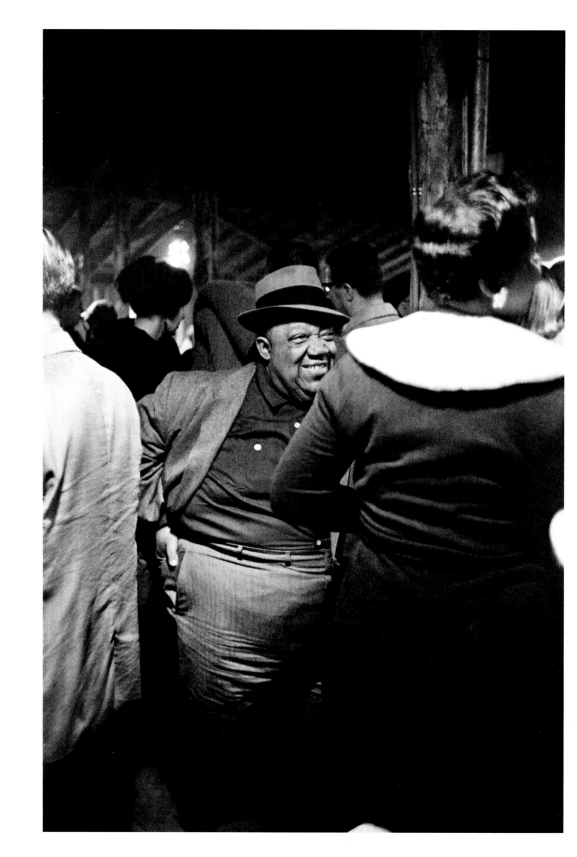

JIMMY RUSHING backstage at the Hunt Club, Monterey Jazz
Festival, Monterey, California, 1960

THE ADDERLEY BROTHERS watching a performance at the
Monterey Jazz Festival. Monterey, 1960

101

THE GOLDEN YEARS

JOEL SELVIN

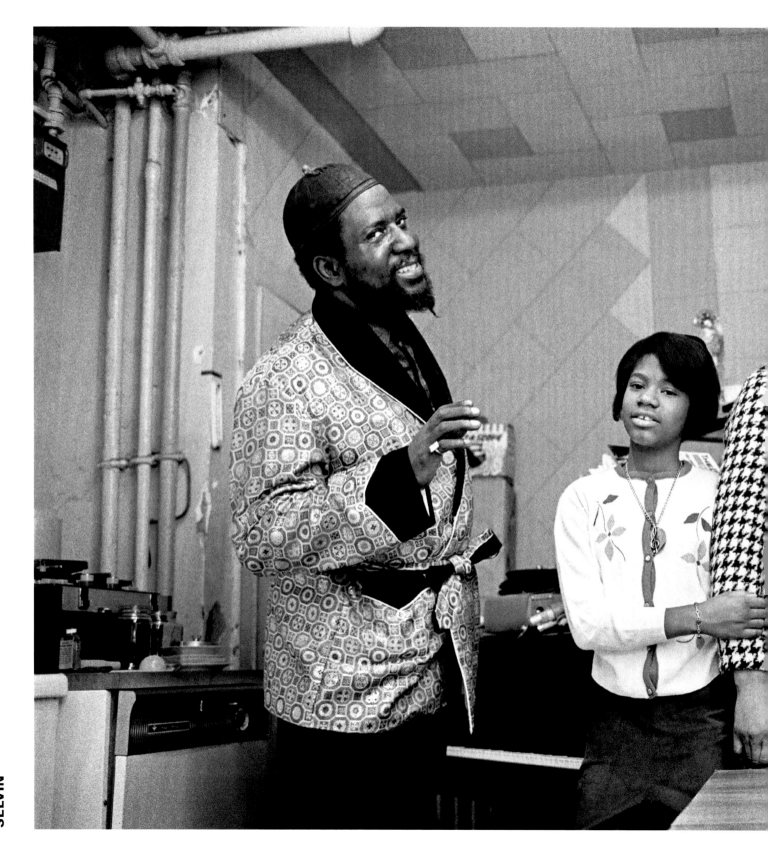

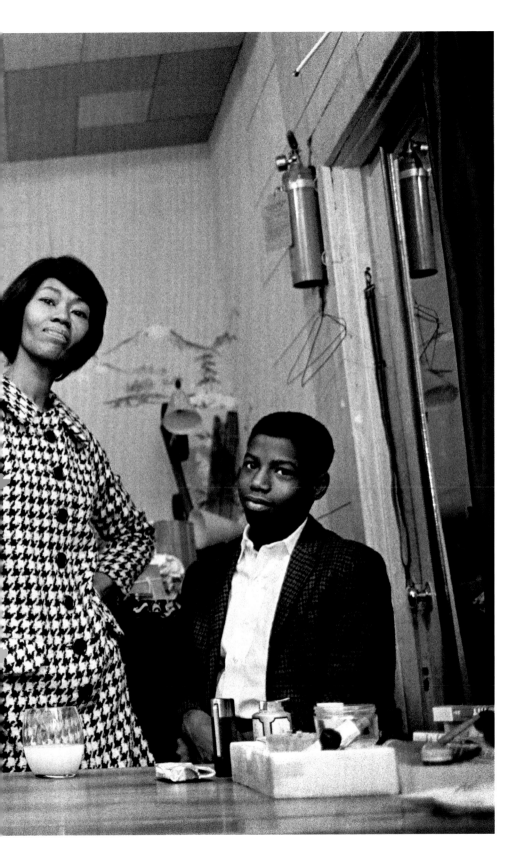

JIM MARSHALL RETURNED TO SAN FRANCISCO in late 1964, humbled, if not necessarily chastened. He had gone to New York City two years before to make it as a music photographer in the big city and succeeded admirably. He took album covers for famous jazz musicians. He snapped indelible images of young folk performers in Greenwich Village. He traveled the country shooting assignments for the big glossy magazines of the day like *Life*, the *Saturday Evening Post,* and *Look*. But Marshall returned home in ignominy. He left New York after getting out of jail and being strongly advised to leave town.

He had pleaded guilty to charges of making obscene phone calls to women and having an unlicensed firearm and had been sentenced to ninety days for the phone calls and another month for the gun to Riker's Island, although he did not serve the full sentence. Marshall came back to San Francisco and moved in with his mother and aunt in the childhood home he had left to move to New York. Compared to the heft, depth, and breadth of New York City in the jet age, San Francisco in 1964 was a sleepy, provincial backwater. Marshall must have despaired over this fall from grace, snatching him from the height of his world—mingling with Thelonious Monk, Miles Davis, Bob Dylan, and Joan Baez in the center of the hip universe—to the remote nothingness of the Richmond District in the fog belt of San Francisco. He had no idea what he was about to stumble into.

In the next three years, he would vault into being the premier music photojournalist of his time with images of Dylan, Jimi Hendrix, Johnny Cash, Janis Joplin, the Grateful Dead, and even the Beatles, whose final concert he photographed. These signature images would make him world famous. A volcanic eruption only coalescing when Marshall arrived home was

THELONIOUS MONK and his family in their apartment's kitchen, New York City, 1963. This photo was shot for a *Saturday Evening Post* story.

about to explode San Francisco into the center of a new universe. Back in New York, he would have missed it all.

San Francisco was a different city from the one Marshall had left. The jazz scene in North Beach had almost dried up and blown away. Broadway had been taken over by topless bars. Marshall kept his connections to New York magazines and record company publicity offices, but he hardly knew where to start back in San Francisco. He did know to attend the Bob Dylan press conference held by television station KQED in November 1965. Dylan was one of his great subjects in New York, and he had once caught a bit of lightning walking to breakfast with Dylan, Dave Van Ronk, and their girlfriends in the Village when Dylan paused to kick an errant tire down the street.

In November 1965, Dylan had raised so much intense interest in the burgeoning subculture around San Francisco and Berkeley that *San Francisco Chronicle* jazz and pop columnist Ralph Gleason arranged for Dylan to appear before a brief televised press conference. Marshall squatted in the front row, clicking away.

Also attending the press conference was the impresario and office manager of the San Francisco Mime Troupe, trying to get some publicity for an upcoming legal defense fundraiser.

He hit the jackpot when Dylan plucked a poster advertising the show and held it up to the cameras. It was the first time Marshall laid eyes on Bill Graham, and the fundraiser was Graham's first concert at the Fillmore Auditorium. Things were only just starting to happen.

Marshall tagged along and shot Dylan and his band's guitarist, Robbie Robertson, in a North Beach alley with beat poets Allen Ginsberg and Michael McClure. He photographed the concert at the Masonic Auditorium. Dylan was an old client, one of his New York contacts, but something seemed to be stirring in the bushes.

INITIALLY, MARSHALL STAYED CLOSE to his established connections. In Palo Alto, shortly after arriving home, he photographed his old friend Joan Baez, who would remain one of his most inspired subjects for the rest of his life. He brought her along backstage to meet the Rolling Stones in May 1965 at San Francisco Civic Auditorium.

Marshall attended the obvious public events—anti-war rallies, marches, speeches in the park. Whizzing around town on an Italian motor scooter with a pair of cameras dangling from

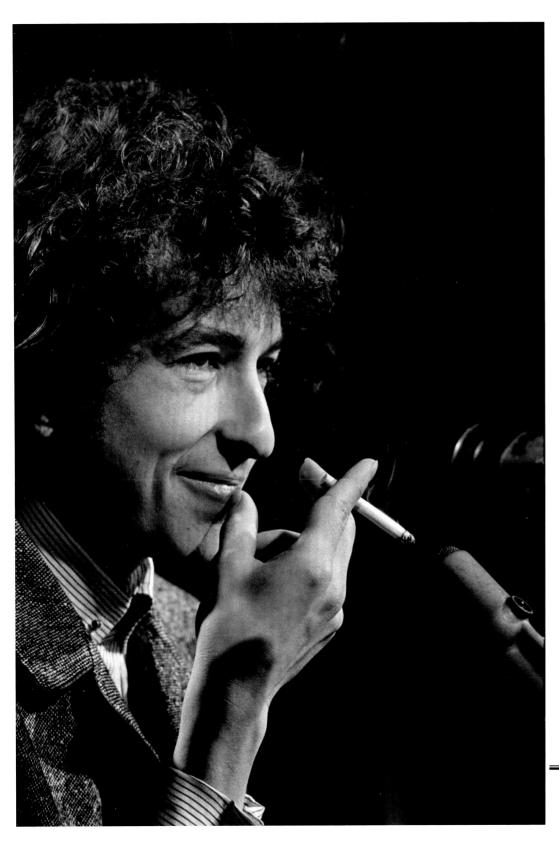

his neck, Marshall covered a lot of territory. He took an interest in the growing street life of the Haight-Ashbury, where a lot of this new energy seemed to be emanating from. He moved out of his mother's place and rented an apartment nearby in the Lower Haight.

He first photographed Jefferson Airplane at the Monterey Jazz Festival in September 1966, when Signe Anderson was still the band's female vocalist. He shot the Paul Butterfield Blues Band with guitarist Mike Bloomfield the same afternoon. Both the Butterfield Band and the Airplane had been playing extensively that year to ecstatic audiences at the Fillmore Auditorium and elsewhere in San Francisco.

With a leg still on each side of the musical fence, Marshall also photographed jazz immortals Duke Ellington and Louis Armstrong that weekend in Monterey.

The San Francisco music scene was starting to explode that fall. He first shot Big Brother and the Holding Company and their vocalist Janis Joplin at a large open-air concert in the Golden Gate Park Panhandle on the October day when LSD became illegal. He caught the first performance by new Jefferson Airplane vocalist Grace Slick with the band later in October at a small Marina district nightclub called the Matrix. By January 1967, he

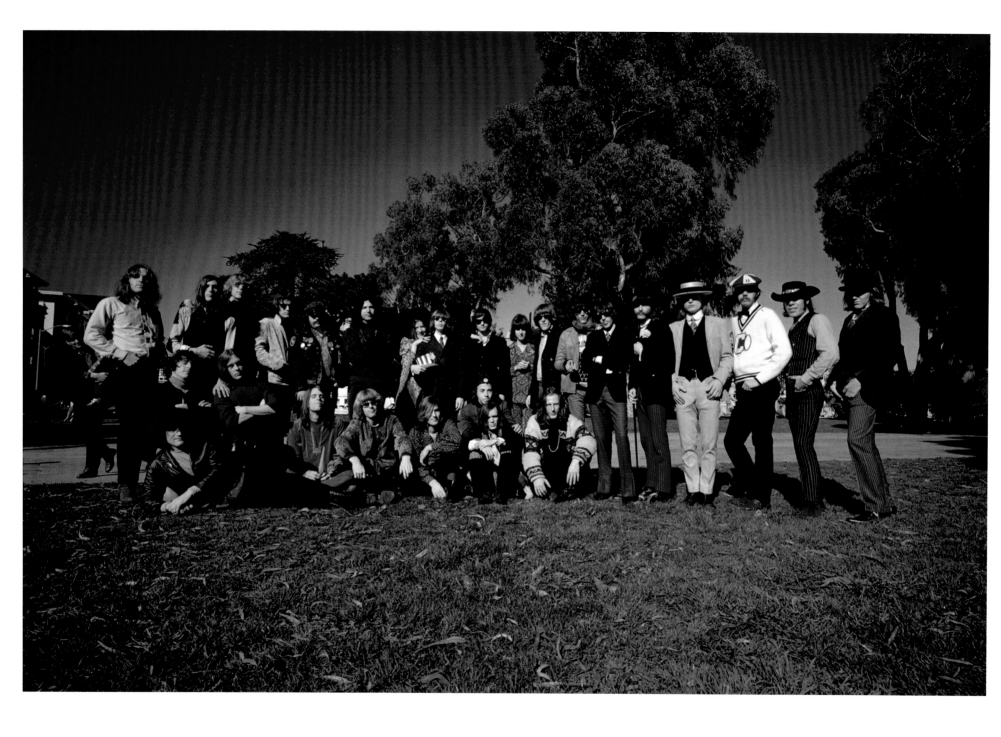

THE FIVE ORIGINAL BANDS: Jefferson Airplane, the Grateful
Dead, Quicksilver Messenger Service, Big Brother and the
Holding Company, and the Charlatans, 1967

was fully on the scene, documenting key events such as the Trips Festival at Longshoreman's Hall and the Human Be-In at Golden Gate Park.

Like a lot of people, Marshall was captivated by the irresistible energy, but he was no hippie. He dressed invariably in a well-worn corduroy sport coat, button-down dress shirts, and either desert boots or penny loafers. He sported an aggressive, in-your-face attitude at odds with the tenor of the hippie community. Still, he recognized the deep musical roots of musicians like Jorma Kaukonen of the Airplane or Jerry Garcia of the Grateful Dead and plunged himself into this exciting new music.

Marshall's photos from the Monterey Pop Festival in June 1967 sealed the deal. His color image of Jimi Hendrix bent over his guitar after he set it on fire with lighter fluid was a stunning evocation of not just the event, but the entire new rock movement. Ironically, the mainstream media at the time paid so little attention to the event that Marshall covered the show for *Teen Set* magazine. He shot a ton of photographs for that magazine, of bands like the Byrds, Buffalo Springfield, the Who, Cream, and other teen pop stars on their way through San Francisco, long before the mass circulation magazines showed interest in the new music.

He also took photos of Jimi Hendrix at the Sunday morning sound check at Monterey. Marshall instinctively knew the young unknown guitarist from London was something special. All by himself, Marshall wandered around the stage that morning, taking pictures of Hendrix face-to-face, catching him sitting behind the drum kit or soaring into some sustained note on his Stratocaster, wearing that Sergeant Pepper military coat. These photos snapped in the foggy morning before the gates were even open would be among the most enduring photos ever taken of Hendrix.

The week after Monterey, Marshall photographed Jimi Hendrix playing an impromptu free concert in the Golden Gate Panhandle before a crowd of several hundred, in what would become one of the signal images of the so-called Summer of Love, broadcast around the world to advertise the summer's opening in San Francisco. The following week, the Summer of Love officially started, and Marshall took a memorable shot of the Charlatans playing in front of a sign reading "Summer of Love."

He maintained his professional connections from New York. He took publicity photos and covered recording sessions for record companies. When Columbia Records signed the new San Francisco band Moby Grape, they turned to Marshall for

the album cover on the strength of the many covers he had done for them before, when he was still in New York. When *Life* magazine wanted a group photograph of the five original bands—Jefferson Airplane, the Grateful Dead, Quicksilver Messenger Service, Big Brother and the Holding Company, and the Charlatans—Marshall got the assignment.

He was in the thick of the action, buzzing around town everywhere, always with the cameras around his neck. He did studio sessions with the Grateful Dead, and they dosed him with LSD. He took pictures while the Dead lip-synched on local TV. He shot cheesecake with Big Brother vocalist Janis Joplin. Marshall photographed the two queens of the scene—Joplin and Grace Slick—at Slick's house one afternoon. He took Jefferson Airplane out for a stroll around their neighborhood for some group portraits in a mod vein. Marshall was shooting wonderful photos every day.

HE COULD BE CONTENTIOUS and surly. It could get in his way. At the suggestion of Ralph Gleason, a young ex–*Daily Californian* rock critic named Jann Wenner approached Marshall about becoming the staff photographer for a new magazine he was starting called *Rolling Stone*. But he begged off after learning that Marshall was banned from shooting at the Fillmore following a beef with Bill Graham. Marshall and Graham were destined to battle. Both men had outsize egos and proprietary senses of their territory.

And Marshall could be a bare-knuckle competitor. Herb Greene, another photographer on the rock scene who specialized more in studio portraits, had lined up his longtime clients the Charlatans for a studied shot in the park. He had the band in their full Edwardian gear posed against an antique automobile they rented for the shoot. Marshall was watching from the sidelines. With Greene's permission, he took a few shots from the periphery, but it was Marshall who sold the photo from the session to the record company for the album cover.

But Marshall was driven by passion. He took up photography in the first place simply to get closer to the music. Musicians were heroes to Marshall. In a dark, unforgiving, and treacherous world, musicians represented a purity of human enterprise to Marshall. They were like noble warriors from a mythic underworld. He somehow learned to inhabit that world through his lens. His passion showed in every frame—and there were no accidental or even poorly composed frames—as if he could see the music.

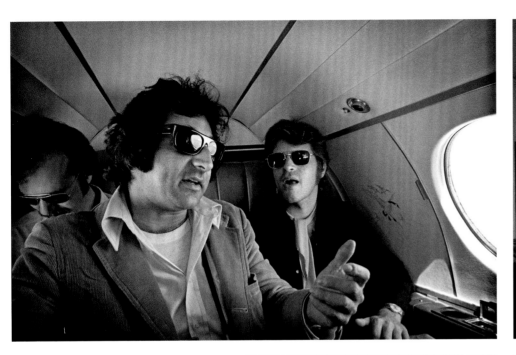

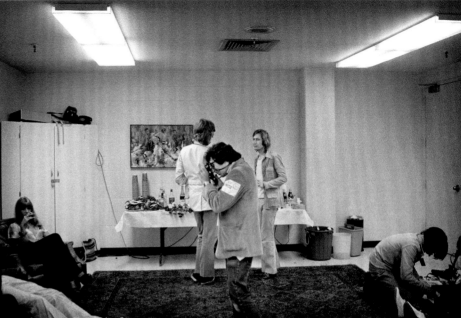

JIM MARSHALL in the private jet for the Creedence Clearwater Revival Final Tour, 1971

MARSHALL with Tri-X eyes, early 1970s

MARSHALL backstage at the Rolling Stones tour, 1972

MARSHALL with **CARLOS SANTANA** and **RON ESTRADA** backstage at Winterland, San Francisco, 1969

Prickly Marshall explained his philosophy to radio journalist David Gans in 1978. "I like to shoot something that is emotionally exciting," Marshall said, "and people that are visually exciting. When the music is right, when the access is right and the light is good, I really get off on it. I'll only photograph people I like. You couldn't pay me enough to photograph someone I didn't like or an event I didn't want to go to."

Marshall developed relationships with his subjects, relationships that he acted out through the camera. His photos resonated with love and respect. He was irascible, abrasive, and profane, but if he liked you, you had a friend for life. He never came out of character.

Marshall quickly became the scene's leading photojournalist, and his images often helped define the world's view of what was happening in San Francisco. In March 1968, when the Grateful Dead decided to move out of the Haight-Ashbury and threw a giant unannounced farewell concert right in the middle of Haight Street, Marshall was everywhere—at the back of the stage, on a rooftop across the street, in front of the stage. He chronicled this extraordinary happenstance as thousands of people flooded the street for blocks and the Dead turned a page. His photographs of that Saturday afternoon went worldwide

long before appearing on the album cover for *Live/Dead*, an irrefutable image of the music's Pied Piper appeal seen around the world well ahead of Woodstock.

The success he sought in New York he found in San Francisco. He drove a new Shelby Mustang—Marshall always loved fast cars—and lived in an apartment overlooking chic Union Street. He was making good money with the Leicas around his neck and he didn't mind letting the other photographers in town know about it. They all already knew what others would find out only later: There was only one Jim Marshall.

Marshall had first met Johnny Cash hanging out with Bob Dylan in Greenwich Village in 1962 and stayed in touch after he moved to San Francisco. In January 1968, Cash called Marshall to shoot a concert in a California prison, which he would make into the famed *Live at Folsom Prison* album. The only photographer on the scene that day, Marshall photographed Cash getting off his tour bus inside the prison walls as the gates slammed shut behind them. "That has the sound of permanence," said Cash.

A year later, he was invited back when Cash recorded another prison album at San Quentin Prison on the San Francisco Bay. During sound check, Marshall was kidding around with Cash.

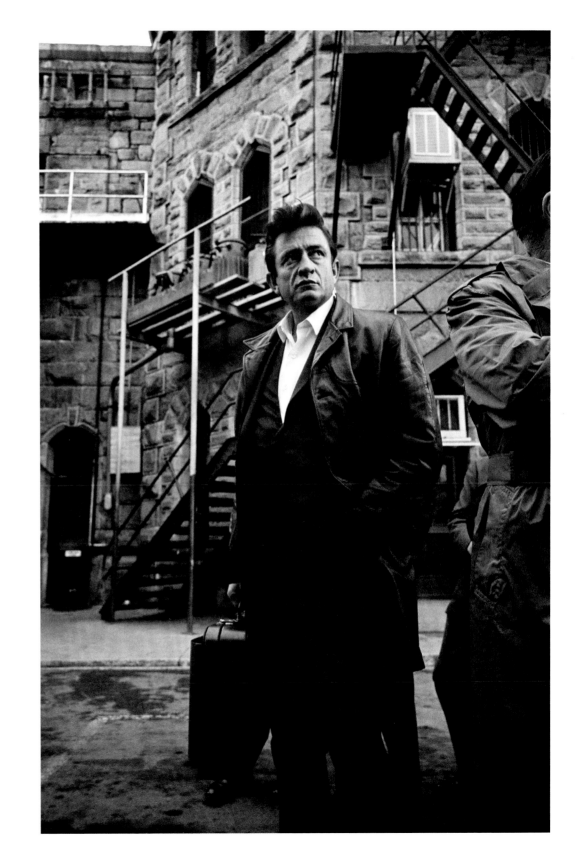

JOHNNY CASH off the bus at Folsom State Prison,
Folsom, California, 1968

"Let's shoot one for the warden," he said. Cash turned around, bent over his guitar, snarled into the camera, and flipped him off. The resulting photograph, Marshall always figured, was the most bootlegged photo in history. Indeed, when the youth group who overthrew the Egyptian government in the Arab Spring posed for the front page of the *New York Times,* one of the young rebels sported a T-shirt with the bootlegged photo.

In June 1969, Dylan made his return to public performing after an absence of more than a year, on the opening night of the new Johnny Cash TV show. With his long-standing relationship with both Cash and Dylan, Marshall knew he had to be on the set. One of Dylan's handlers told Marshall to leave the set but was admonished by no less than June Carter Cash, who said that Marshall could shoot where he wanted. As the two musicians rehearsed for the number, Marshall snuck up until he was standing just behind their shoulders and caught the moment.

He developed these deeply personal relations with many of his subjects. His photographs pulse and glow, even though they are suffused more with truth than beauty. Marshall showed the whole person.

He followed Mike Bloomfield to Los Angeles to shoot the May 1968 recording session that would become the million-selling *Super Session*. He had photographed Bloomfield since the Paul Butterfield Blues Band. His portraits of Bloomfield's band Electric Flag had adorned the band's album. But in the one night Bloomfield would spend in the studio for *Super Session*, Marshall caught him wan and depleted, lying on the studio floor, barely there, presaging Bloomfield's sudden departure the next morning from the sessions. In September 1968, having patched up his relationship with Bill Graham, Marshall shot Bloomfield's concerts at Winterland for the *Super Session* follow-up, *The Live Adventures of Mike Bloomfield and Al Kooper.* This concert is now notable for the introduction of a young, unknown guitarist named Carlos Santana, who had just started a band called Santana.

Photographer Michael Zagaris first met Marshall at the May 1968 Northern California Folk Rock Festival in Santa Clara, where Marshall was threatening a frat-boy security guard with a bowie knife. "Is that knife real?" Zagaris asked. Marshall assured him it was and then produced a gun. Zagaris followed Marshall past the flimsy rope barrier backstage, only to see vocalist Jim Morrison of the Doors dragging on a cigarette and greeting Marshall. "What the fuck are you doing here?" Morrison asked, as Marshall snapped what would become one of the most famous portraits ever taken of the singer.

Marshall was armed and dangerous. In 1968, he shot a male friend of his wife, somewhat accidentally—the bullet hit the man in the stomach after ricocheting off the floor. Although the weapon may have discharged without his intending it, there was no doubt that Marshall meant to threaten the man. He was fined sixteen hundred dollars and given five years' probation on attempted murder charges. It was not his proudest moment, but Marshall lived his life without apologies. And Marshall, who counted policemen among his closest friends, was no peace-and-love hippie freak.

IN THE WAKE OF THE SUMMER OF LOVE, San Francisco had become an alternative media center, the hub of a worldwide underground. Marshall's photographs appeared in national magazines such as *Esquire* and *Newsweek* and underground papers like *Rolling Stone,* which used tons of his photos. His photos were telling the world the story of San Francisco. They were unbelievable images from a psychedelic frontier, shown in often unsparing detail. His famous shot of Janis Joplin backstage at Winterland cradling a bottle of Southern Comfort may have been unsettling, but the subject understood. "Yeah, Jim,

that's the way it is sometimes," Joplin told Marshall about the shot.

He caught Joplin and the rest of Big Brother and the Holding Company goofing around backstage at Winterland with headline act Jimi Hendrix. Marshall took stunning photos of Hendrix that weekend at what would be one of the finest performances of his brief career. Marshall would also photograph Hendrix at the Isle of Wight in August 1970, in his final public performance, a few days before his death—Miles Davis having flown Marshall to the British rock festival to shoot his set.

Marshall, *Rolling Stone* photographer Baron Wolman, and writer Jerry Hopkins traveled the country during the summer of 1969 collecting photos for *Festival*, the first book about music festivals, which chronicled the growing phenomenon that would culminate at Woodstock in upstate New York.

Marshall made the most of the Woodstock festival. As one of the festival's official photographers, he was onstage when Richie Havens opened the concert, and he collapsed backstage three days later when Jimi Hendrix closed the festival. He had grabbed a few hours of sleep in the backseat of a rented red Triumph backstage and never made it to his motel room twenty miles away. He took historic photos that weekend in August

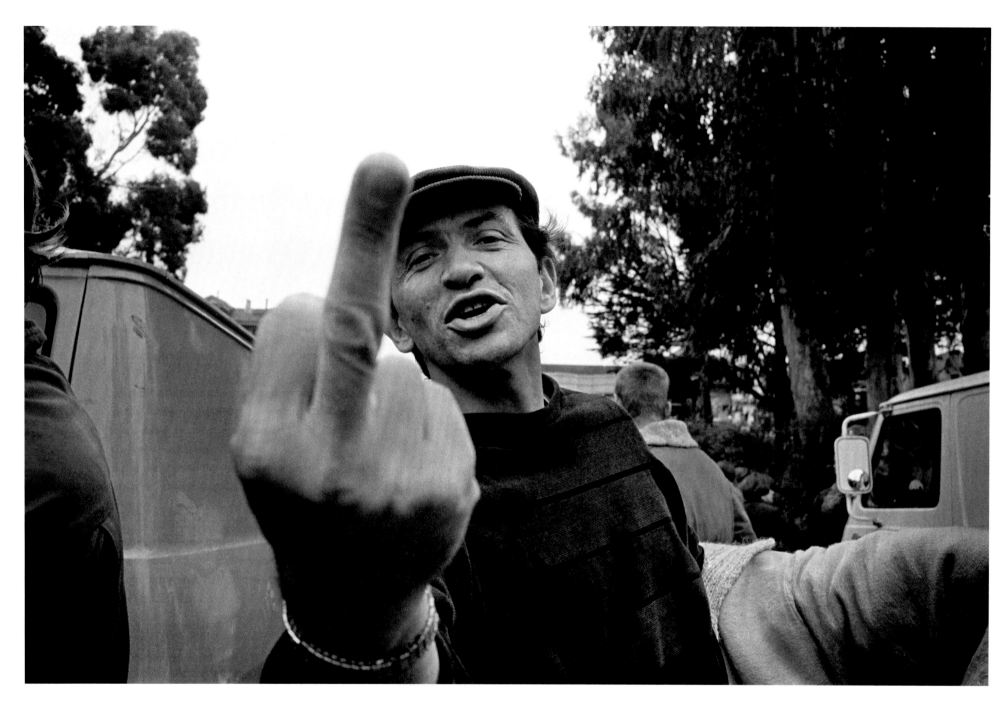

BILL GRAHAM giving Jim Marshall the finger at
the Jimi Hendrix free concert in the Panhandle,
San Francisco, 1967

1969—Pete Townshend of the Who flying into outer space, Grace Slick of Jefferson Airplane greeting the dawn, Sly Stone exhorting the half-million to go "Higher." *Newsweek* used one of his shots on the magazine's cover.

Marshall and San Francisco were on top of the rock world. He took a golden-hued, fish-eye shot of the unknown San Francisco band Santana that blew the festival away, and it was used for the triple-fold illustration on the Woodstock soundtrack album. Marshall was at the peak of his powers that weekend, brilliantly capturing the historic performances in fine-point detail.

Three months later, in December 1969, Marshall, like many others, was overwhelmed by the conditions at the Rolling Stones free concert at the Altamont Speedway. Baron Wolman of *Rolling Stone* simply left. Intimidated by the ultra-violence of the Hells Angels and the deplorable crowded conditions, Marshall hovered around the amplifiers at the back of the stage, safe from most of the violence. He never even saw most of the photos he took that day because the lab destroyed fifteen rolls of his film during processing.

AS THE SAN FRANCISCO SCENE RECEDED from center stage in pop music, Marshall remained the photographer of choice. In February 1970, Ralph Gleason produced a live broadcast for local television from the Family Dog at the Great Highway, with Jefferson Airplane, the Grateful Dead, and Santana, and the cameras caught Marshall lurking in the corners of the stage. Marshall posed Creedence Clearwater Revival on a boat in the middle of a river and almost drowned when he fell overboard taking the photos. In Macon, Georgia, he took the cover shot of the Allman Brothers Band's landmark March 1971 live recordings from the Fillmore East, cracking up the band by threatening to cut off their drugs. That same month, he took all the album photographs for the live recordings by Aretha Franklin and the King Curtis band at the Fillmore West.

When Miles Davis played the Fillmore that May, Marshall not only shot the performance, but also caught remarkable images of Davis working out in a boxing ring at Newman's Gym in San Francisco. He had earned Davis's trust years before in New York when he presented the jazz great with his portraits of John Coltrane. Davis didn't take a lot of people inside his world, but Marshall was welcome.

Bill Graham closed the Fillmore West in July 1971, two weeks after shutting down his New York operation. The golden days of San Francisco rock were over, and, in ways, so were the golden days of Jim Marshall. He was all over the place the final night of the Fillmore West, which starred Santana and Creedence Clearwater Revival. If he never took another photograph after shooting the massive, sprawling late-night jam session that ended the Fillmore era, his reputation would be secure.

But Marshall was still at the top of his game. On the Rolling Stone's triumphant 1972 U.S. tour, when they ruled as the scene's top rock band, *Life* magazine contacted Marshall to cover the front end of the tour. He caught the band in some pre-tour recording sessions at a Hollywood recording studio, putting the finishing touches on their next album, *Exile On Main Street*.

Marshall shot the four shows at Winterland in San Francisco and traveled to Los Angeles with the tour party on the band's private jet. They did shows at various locations around Los Angeles and flew to San Diego with Marshall still onboard. When the editors saw Marshall's stunning photos of Jagger onstage and the rest of the band captured in intimate ease backstage, they moved the story to the cover of the magazine.

ONCE HE WAS ESTABLISHED, Marshall never went into a darkroom again. Somebody else handled all his developing and printing (take that, Ansel Adams). After he clicked the shutter, his work was done. His contact sheets are a marvel—no poorly composed shots, nothing out of focus, nothing extraneous. He

March 23, 1978

Dear Mr. Marshall,

I am in receipt of your latest letter regarding the payment
of a rather old bill for a Muddy Waters shooting. Please
let me assure you that I am doing my goddamned best to get
the fucking thing paid. Furthermore, I hope that you will
trust in me enough to assume that I am trying to pay off your
cocksucking bills so I don't have to have Arab assholes like
you sending me letters through the U.S. Mail. I do appre-
ciate your patience in this matter and hope that you will have
the time to pound five pounds of salt up your ass prior to
your next visit to Polk Street.

Most sincerely,

PS/bjl

connected with the images through the viewfinder and never wasted a shot. Some were better than others, but there were no bad shots. And they never needed cropping.

He lived with his second wife in a busy apartment on Union Street, a neighborhood bustling with nightlife. The apartment was something of a salon, with musicians, scenesters, and drug dealers coming and going at all hours. Dr. Hook and the Medicine Show once stopped by Marshall's apartment after midnight in a big hurry to shoot an album cover. Marshall posed the band in his living room, their heads all pushed together, and sent them packing with the cover for the band's second album, *Sloppy Seconds*. Marshall's wife slept through the entire event.

He worked for record labels, shooting Loggins & Messina for CBS Records and Led Zeppelin for Atlantic Records in Hollywood. He worked for magazines, shooting Randy Newman at his home for *Rolling Stone* and Captain Beefheart in the Santa Cruz mountains for the *Los Angeles Times Magazine*. He took album covers, like the multi-exposure, color cover of the Rahsaan Roland Kirk album *Bright Moments*, recorded at Keystone Korner in San Francisco. He toured Europe in a Learjet with the three-piece edition of Creedence Clearwater Revival on the band's final tour.

Re: Payment of an old bill, 1978. Names redacted for privacy.

S.F. Photographer, Weapons Seized

By Joseph Pereira

James Marshall, a nationally acclaimed photographer of musical artists, was arrested yesterday at his Marina District home for threatening two neighbors with a gun last week.

Arresting officers said they

JAMES MARSHALL
Quarrel with neighbors

found nine pistols, two rifles, two dozen knives and more than 50 pounds of Teflon-coated bullets in his Union Street apartment.

The 47-year-old Marshall was booked on two counts of assault with a deadly weapon, two counts of brandishing a weapon and one count of possessing an illegal type of bullet — able to pierce bulletproof vests because of its Teflon coating.

Marshall, who in 1968 was sentenced to five years' probation and fined $1600 for attempting to murder a male friend of his wife, also was charged with possession of a weapon by an ex-convict.

A Bay Area photographer with a large following, Marshall has shot covers for Life and Rolling Stone magazines. He has been acclaimed for his impressionistic portraits of such musical celebrities as Mick Jagger, Janis Joplin, Paul Simon and Art Garfunkel.

Four policemen with guns drawn arrested Marshall at his apartment at 8 a.m. yesterday after two neighbors complained last week that he threatened to shoot them in the heat of a quarrel.

Inspector Robert Shepherd

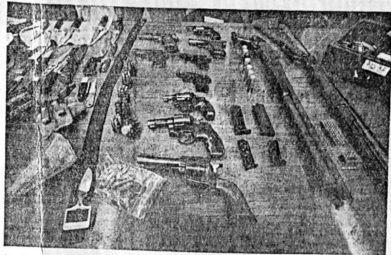

San Francisco police seized an arsenal — including knives, rifles, bullets and pistols — from the Union Street apartment of photographer James Marshall
By Gary Fong

said that Marshall traded angry words with the other occupants of the building and then chased them into their apartments while brandishing a gun and threatening to shoot them.

"At one point the suspect crouched in a shooting stance and told the two victims that he would blow their brains out," Shepherd said.

The neighbors bolted their doors and called police.

The four arresting officers, who had search and arrest warrants, entered Marshall's apartment and found him asleep, they said. "He was awakened but surrendered without any resistance," said Shepherd.

The inspector declined to disclose the identity of the neighbors because he said he feared retaliation against them.

Police said they found scattered in Marshall's bedroom and living room two .22 automatic pistols, a .45 revolver, two .38s, two .357s, two 9mm pistols and a 12-gauge shotgun in addition to 22 knives.

Marshall, a lifelong San Franciscan, has had his photographs on about 500 album covers in the last decade and on a number of music and photography books.

San Francisco Chronicle 5
★ Thurs., March 24, 1983

Oakland Policeman Shot in Head

An Oakland policeman was shot in the head yesterday while chasing a man who had been disturbing an East Oakland neighborhood.

Patrolman James L. Green, 36, was listed in stable condition after surgery at Highland Hospital. The bullet did not pierce his skull.

The suspect, Tyron James Bowens, 28, of 1352 87th Avenue, was arrested shortly after the shooting and is being held.

Green was dispatched to Bowens' residence just after 11 a.m. because neighbors complained of shouted obscenities at the East Oakland address. Police said Bowens dashed out the back door as Green entered his home.

The officer ran after Bowens who suddenly stopped while climbing a fence, pointed a small-caliber pistol at Green, and fired one or two shots, investigators said. Other officers captured the suspect in the basement of a nearby building.

Police said Bowens has had frequent run-ins with Oakland officers in the past.

Marshall, who had been a fixture at music festivals since Monterey Pop, attended the Dripping Springs Reunion thrown by Willie Nelson in 1972, which was so successful that Nelson started his annual Fourth of July picnic the next year. Marshall captured both years, photographing Nelson, Leon Russell, Waylon Jennings, John Prine, and others at the very beginning of the outlaw country movement. He kept up his old contacts. He spent some time in 1974 making photos with Johnny Cash, his family, and guests like Waylon Jennings at the Cashes' Hendersonville, Tennessee, home.

Although Marshall was no longer a ubiquitous presence on the San Francisco rock scene, he did photograph a number of the massive Day on the Green concerts produced by Bill Graham at the Oakland Coliseum Stadium. He caught Peter Frampton in midair doing the splits at his 1976 coronation as the year's top new rock star following the release of *Frampton Comes Alive*.

But Marshall was descending ever deeper into a morass of drugs, guns, and paranoia. His abrasive approach to human relations had cost him work. Other photographers, perhaps not as talented, were easier to get along with and less demanding. His wife made good money as a banker. He spent a lot of time in his apartment. He began to deal drugs, but he used as much as he sold. He took still photos on the set of the TV show *Streets of San Francisco* in 1975, but that didn't interfere with his habits. By then, he only occasionally made the scene, cameras dangling from his neck. He tried to maintain long-standing relationships. He shot Joan Baez at her sister Mimi Farina's Bread and Roses benefit at UC Berkeley's Greek Theatre in 1977. He drove down

San Francisco Chronicle article about Jim Marshall's arrest in 1983

to San Jose in his Shelby to show his car to fellow motorsports enthusiast Jeff Beck in 1978 and got a speeding ticket on the way. But Marshall didn't take a lot of photographs through the rest of the decade.

One day in December 1981, his wife left for work, taking twenty thousand dollars with her, and never came back. Enough was enough, and she left him a note in his sock drawer. A year later, he received divorce papers in the mail from Minnesota. She had been his last claim to stability, and with her gone, Marshall only accelerated his downward spiral. Fifteen months later, in March 1983, the violence burst into public. After a woman in his apartment building tripped a burglar alarm, Marshall rushed into the hall, screaming obscenities and waving around a gun. A week later, a half-dozen cops and an assistant district attorney raided his home and uncovered an enormous arsenal of weapons—nine pistols, two rifles, two dozen knives, a samurai sword, and mounds of ammo. He was charged with two counts of assault with a deadly weapon and two counts of brandishing a weapon at his neighbors. He was also charged with owning more than fifty pounds of Teflon-coated, armor-piercing bullets. And he was a former felon in possession of a firearm, another felony charge.

A police officer friend of Marshall's had tumbled to the raid before it happened and offered to intercede. He convinced Marshall to surrender without resistance. No telling what would have happened if the cops had broken down his door and come for him. He pleaded guilty to being an ex-felon in possession of a firearm and received a suspended sentence and five years' probation. He also agreed to move out of the neighborhood where he had threatened his victims and never return to his Union Street apartment building. Marshall always considered the bust to be overblown. A week after the arrest, he was having dinner with his police officer friend at his home.

Marshall was released to work furlough. He moved into a four-dollar-a-day barracks in San Francisco and took a $150 a week job doing menial tasks around a photo studio, under strict admonition to not speak to the clients or show them his work. Marshall took his humble and put up with the random drug tests because he knew it was better than prison. In February 1984, he was released from work furlough, one day after his forty-eighth birthday, and he began his new life.

JOAN BAEZ talking with **MICK JAGGER** backstage at the San
Francisco Civic Auditorium, San Francisco, 1965

120

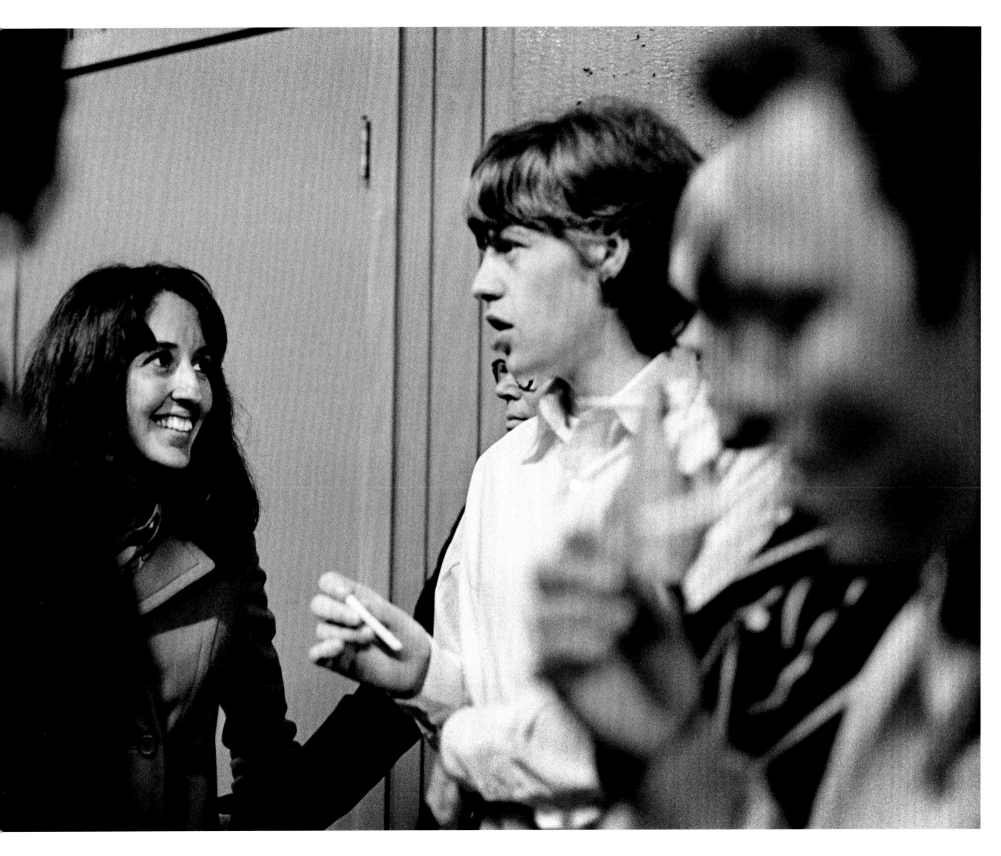

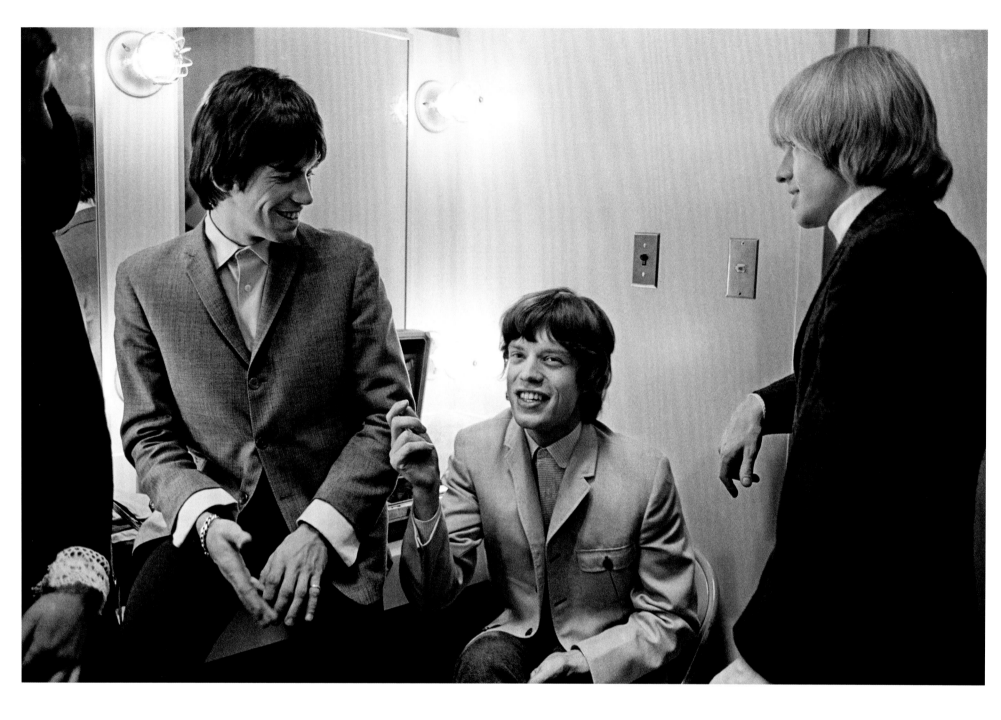

THE ROLLING STONES backstage at the San Francisco Civic
Auditorium, 1965

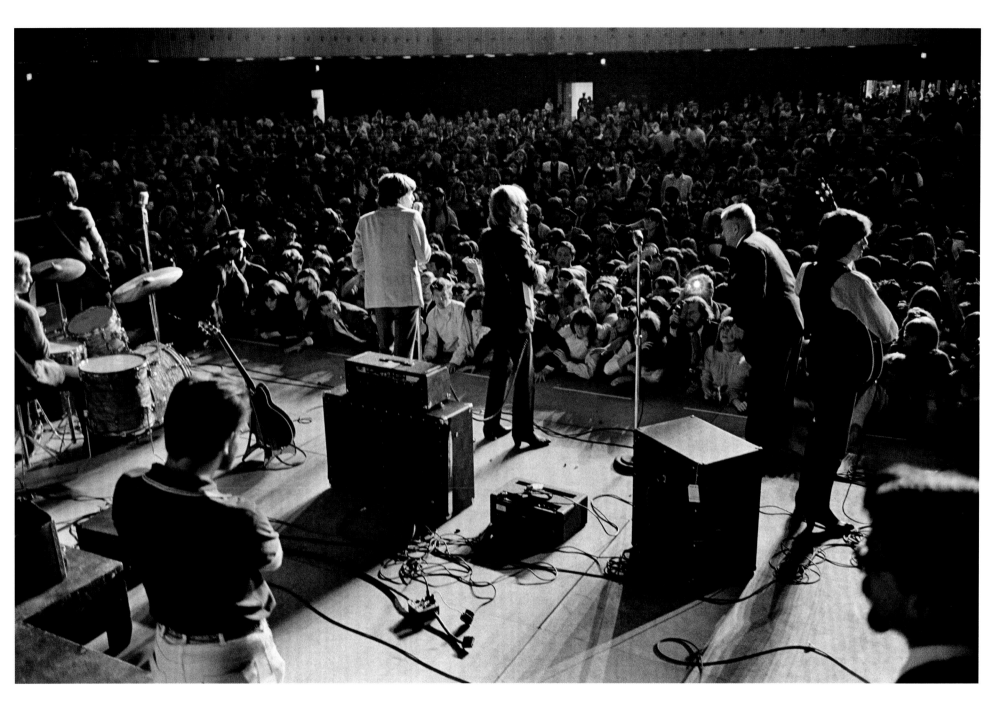

THE ROLLING STONES performing at the San Francisco Civic
Auditorium, 1965

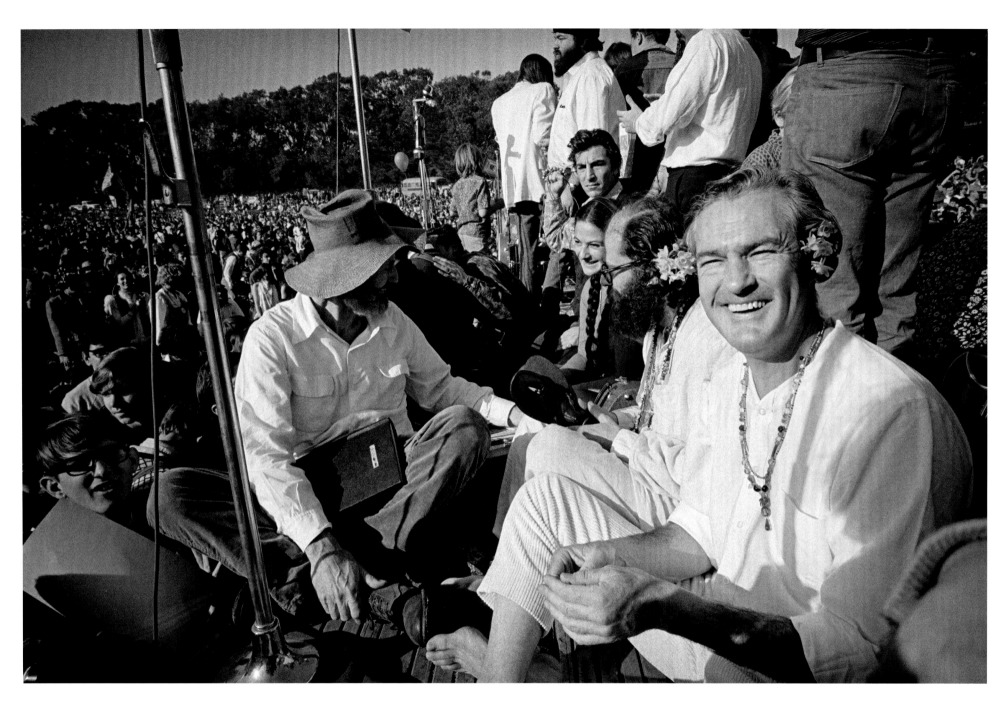

GARY SNYDER, ALLEN GINSBERG, and **TIMOTHY LEARY**
at the Human Be-In, Golden Gate Park, San Francisco, 1967

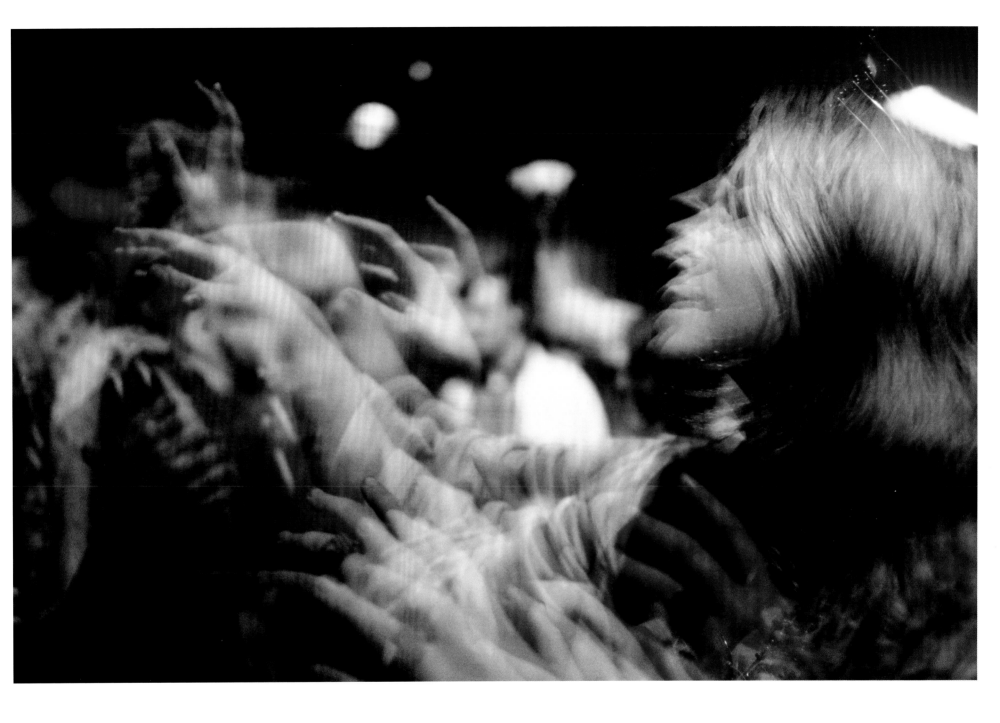

The Trips Festival, Longshoreman's Hall,
San Francisco, 1966

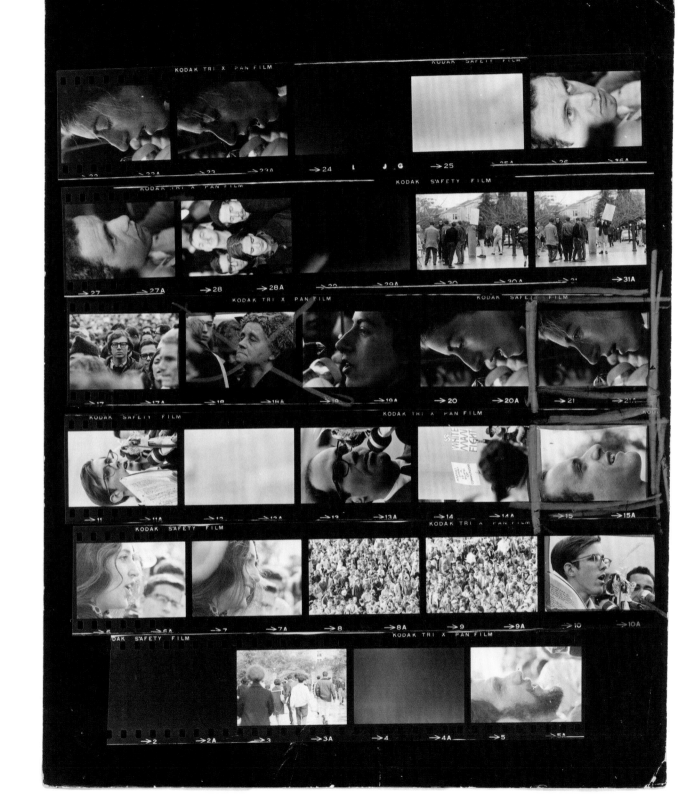

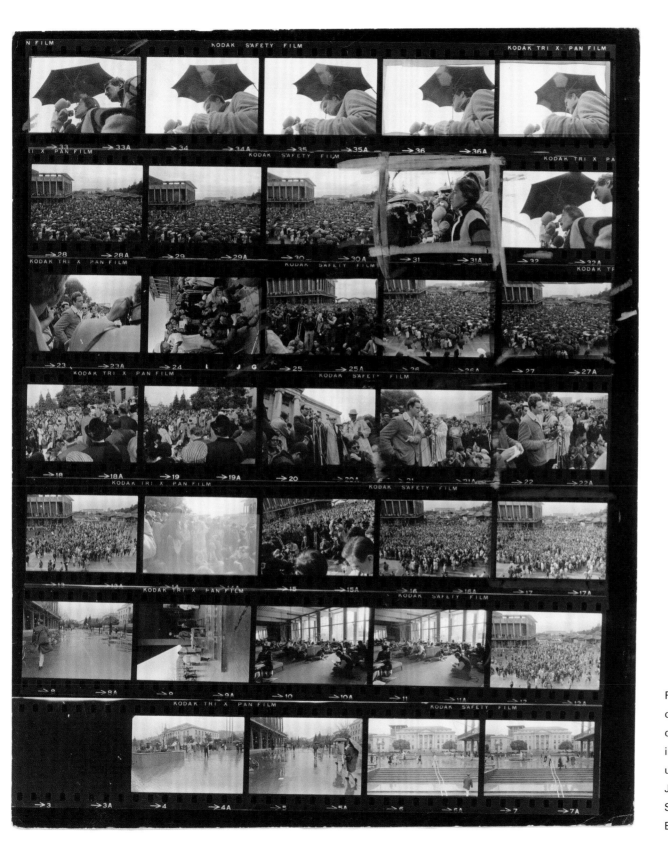

Free Speech Movement (FSM) demonstrations at the University of California, Berkeley, 1964. This large student protest took place during the 1964–65 academic year on the campus. The FSM was informally under the central leadership of Mario Savio, a graduate student. Other student leaders included Bettina Aptheker, Jack Weinberg, Michael Rossman, George Barton, Brian Tucker, Steve Weissman, Michael Teal, Art Goldberg, and others. Joan Baez was also part of the FSM.

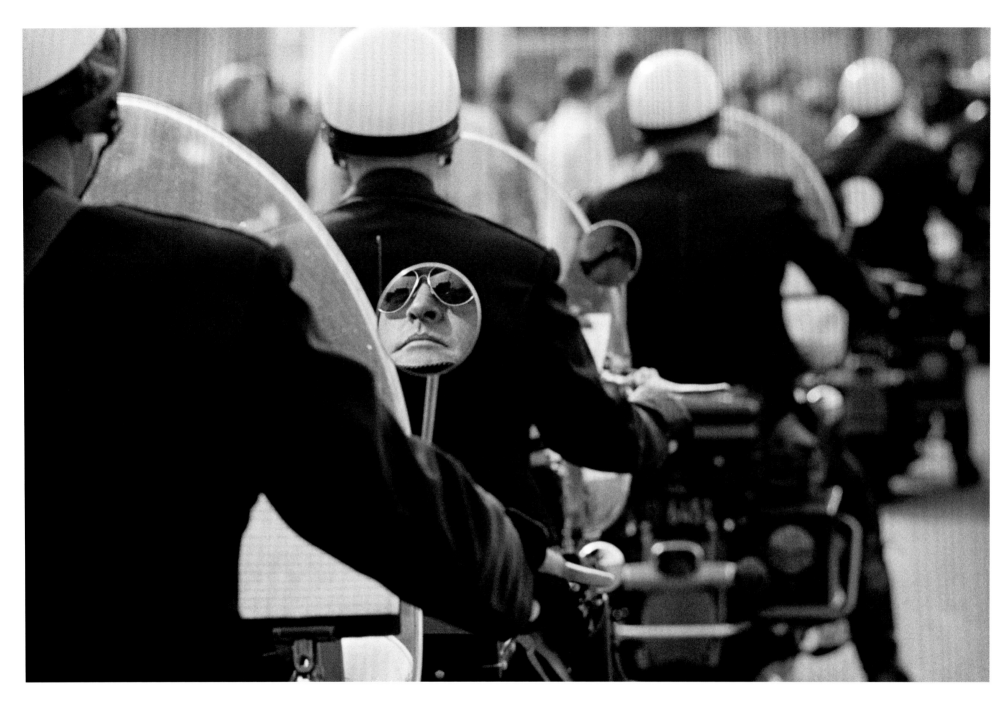

Oakland Motorcycle Police at an anti-war protest,
Oakland, California, 1965

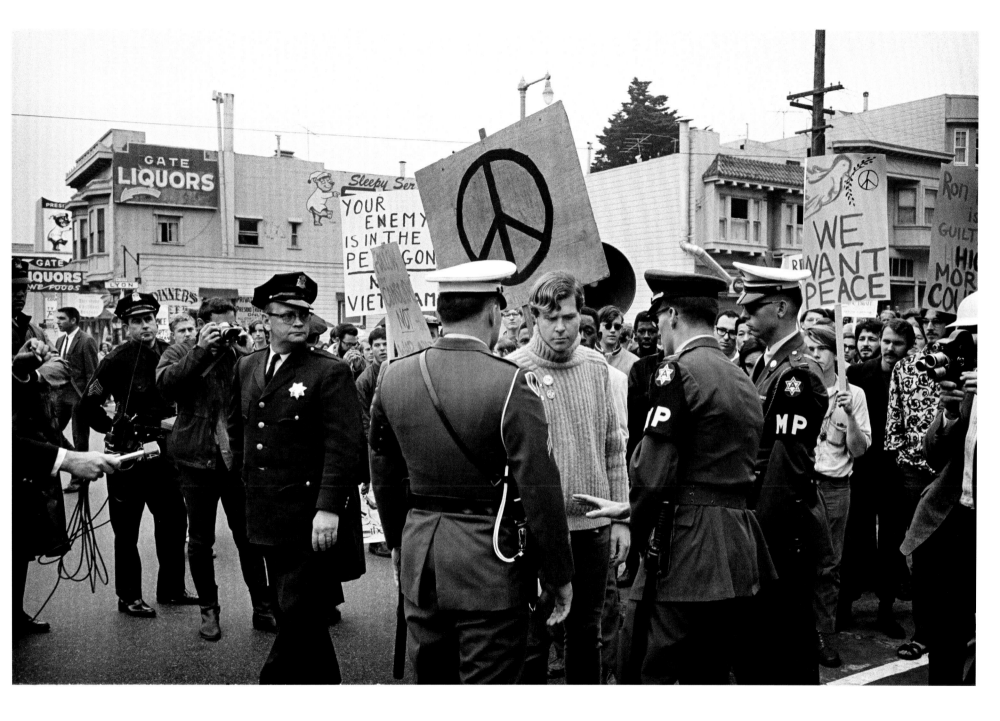

"Your Enemy Is the Pentagon." Anti-war protest outside the
Presidio, San Francisco, 1967

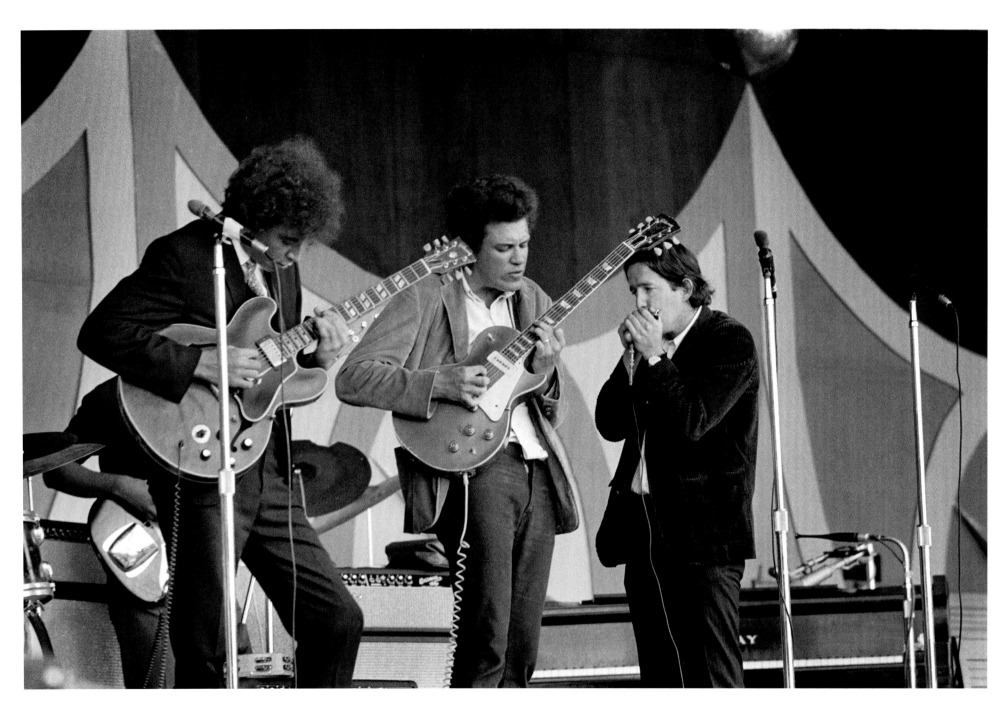

ELVIN BISHOP, MICHAEL BLOOMFIELD, and **PAUL BUTTERFIELD** performing at the Monterey Jazz Festival, Monterey, California, 1966

130

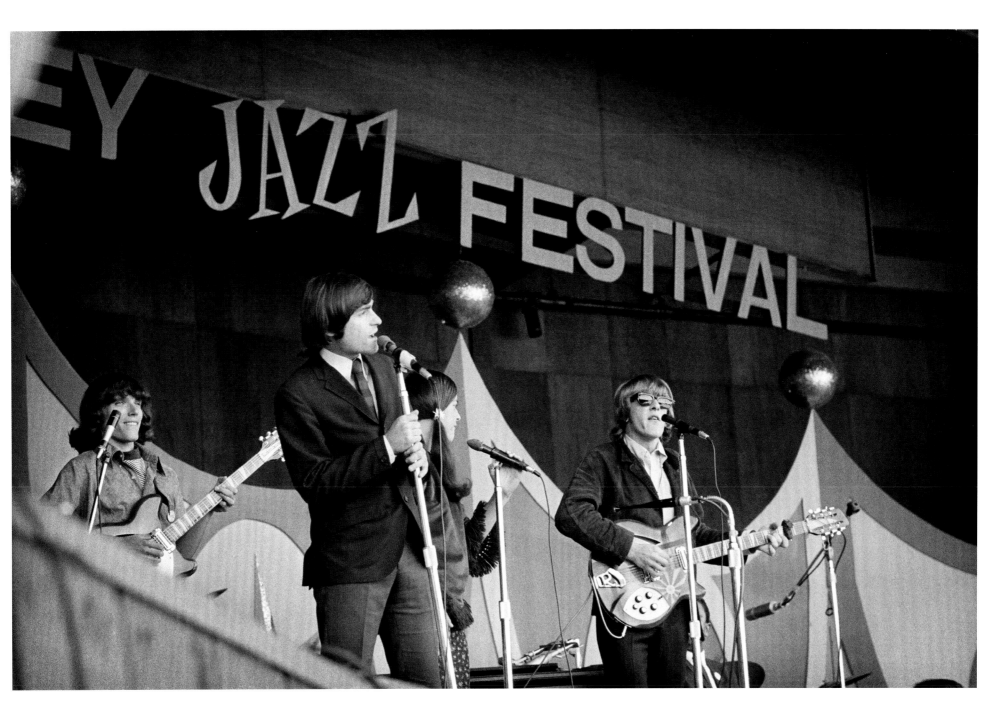

JEFFERSON AIRPLANE performing at the Monterey Jazz
Festival, Monterey, California, 1966

131

SIGNE ANDERSON of **JEFFERSON AIRPLANE** performing at
the Monterey Jazz Festival, Monterey, California, 1966

JIM MARSHALL in his Union Street apartment, San Francisco,
early 1970s

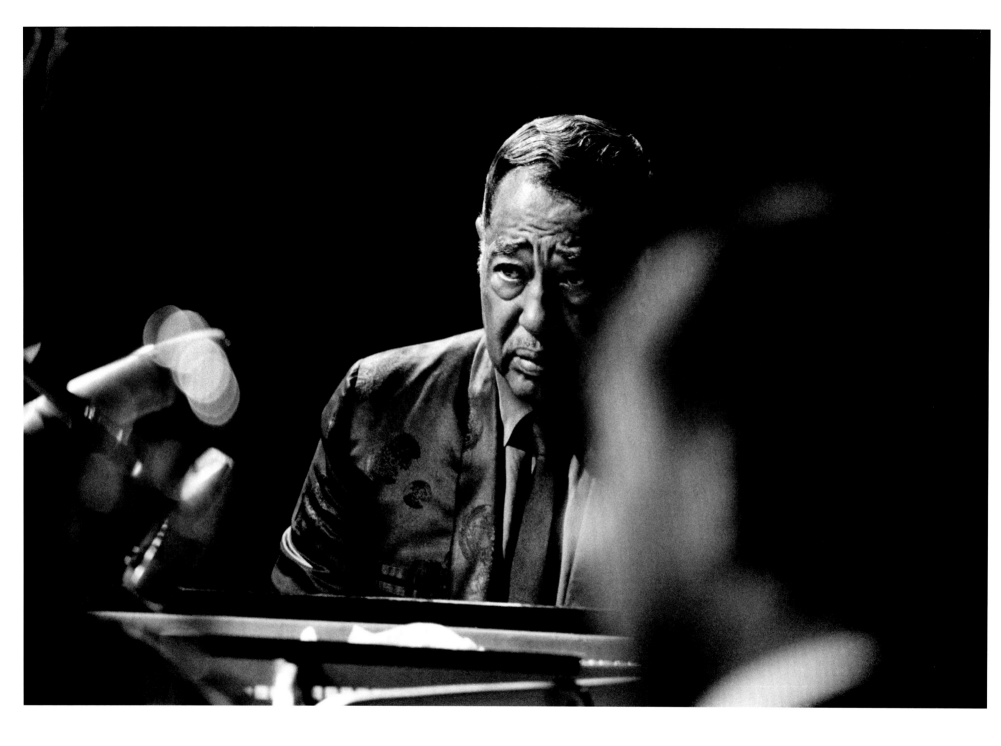

DUKE ELLINGTON at the piano, Monterey Jazz Festival,
Monterey, California, 1966

134

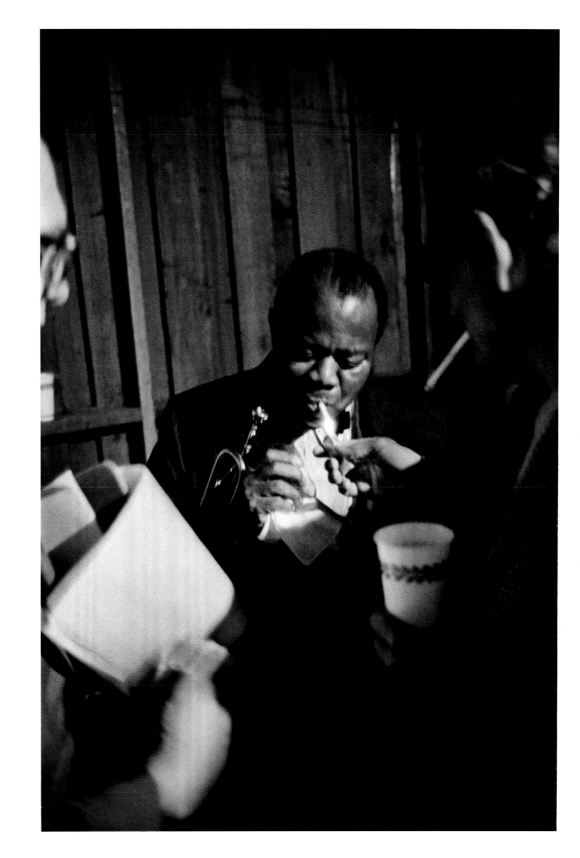

LOUIS ARMSTRONG backstage at the Hunt Club, Monterey
Jazz Festival, Monterey, California, 1966

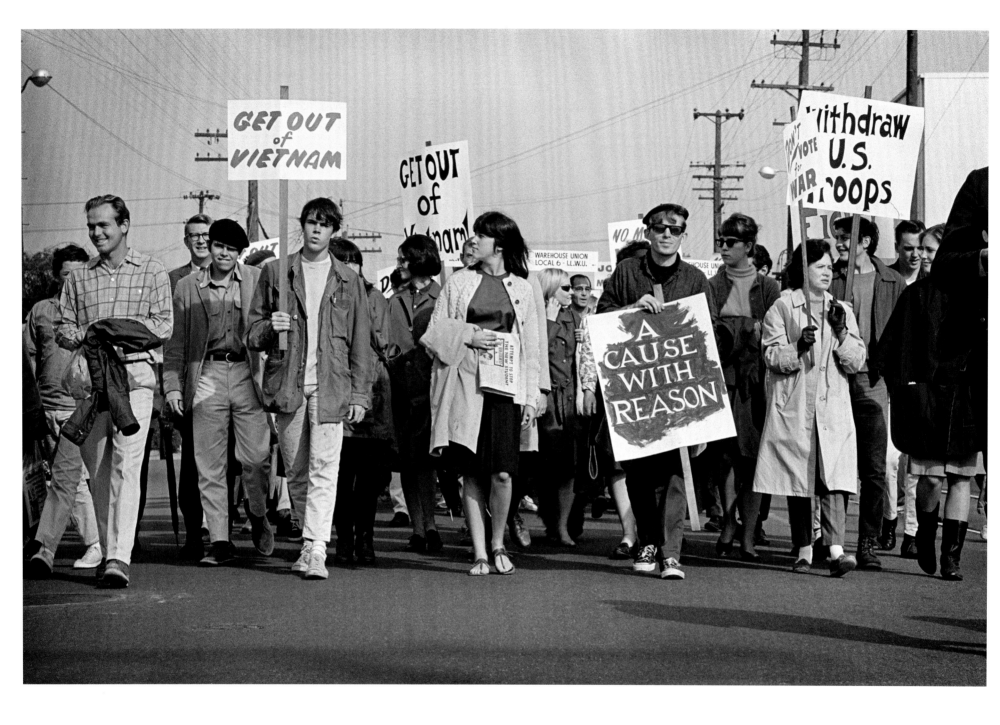

Anti-war protest, Oakland, California, 1965

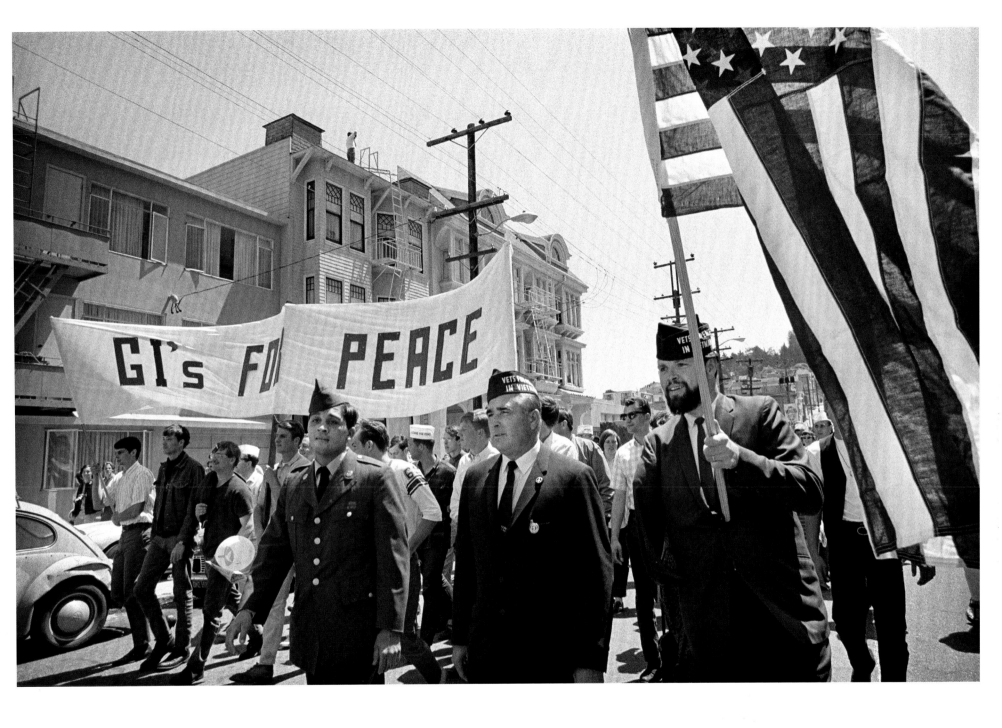

GIs for Peace, San Francisco, 1967

He would get what he *WANTED*; he would *GO FOR IT*. No shyness there. . . . He and Bob Seidemann got all the good pictures because the rest of us were *TOO SHY*.

ELAINE MAYES

Dancers at the Human Be-In,
San Francisco, 1967

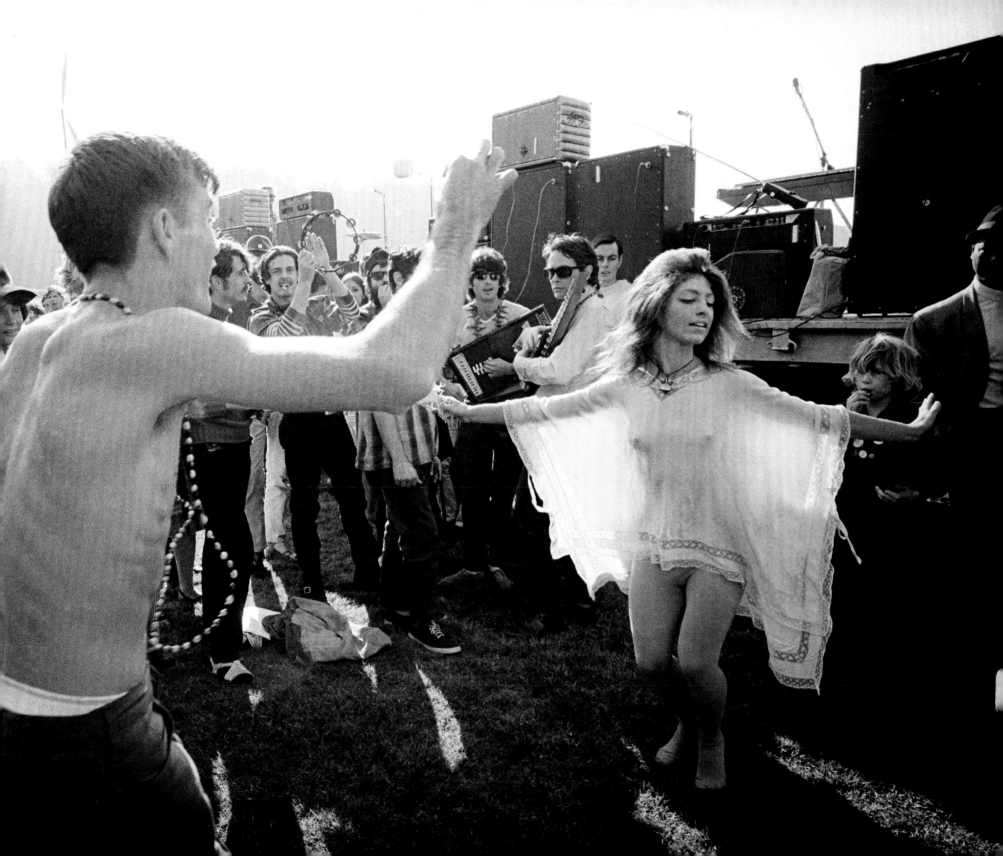

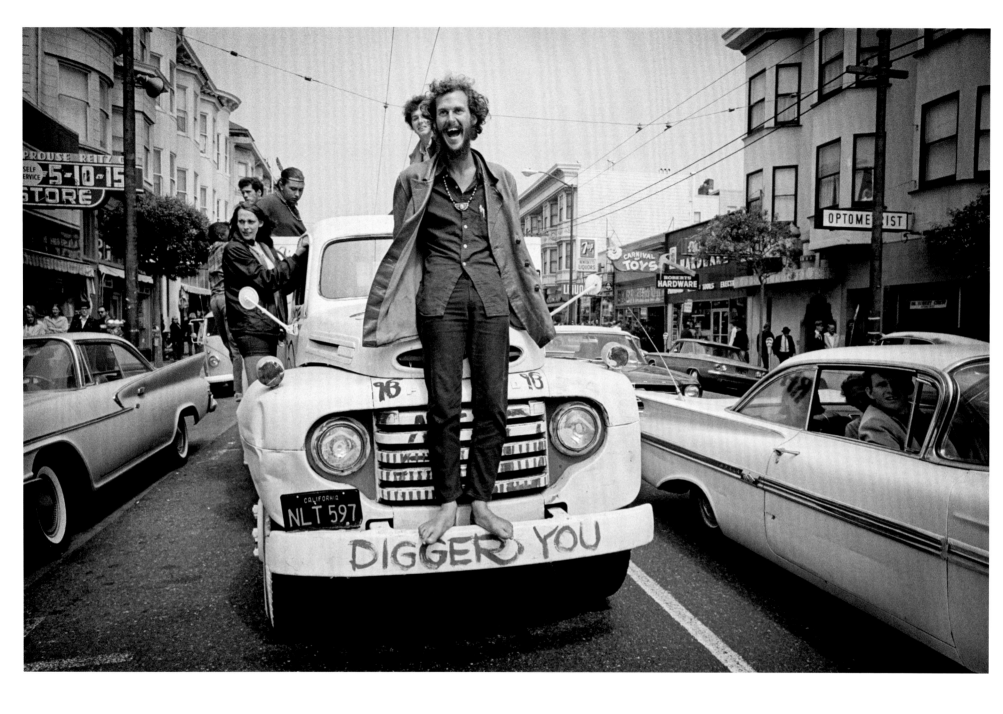

Digger Truck at the Rathayatra Festival, Haight Street,
San Francisco, 1967

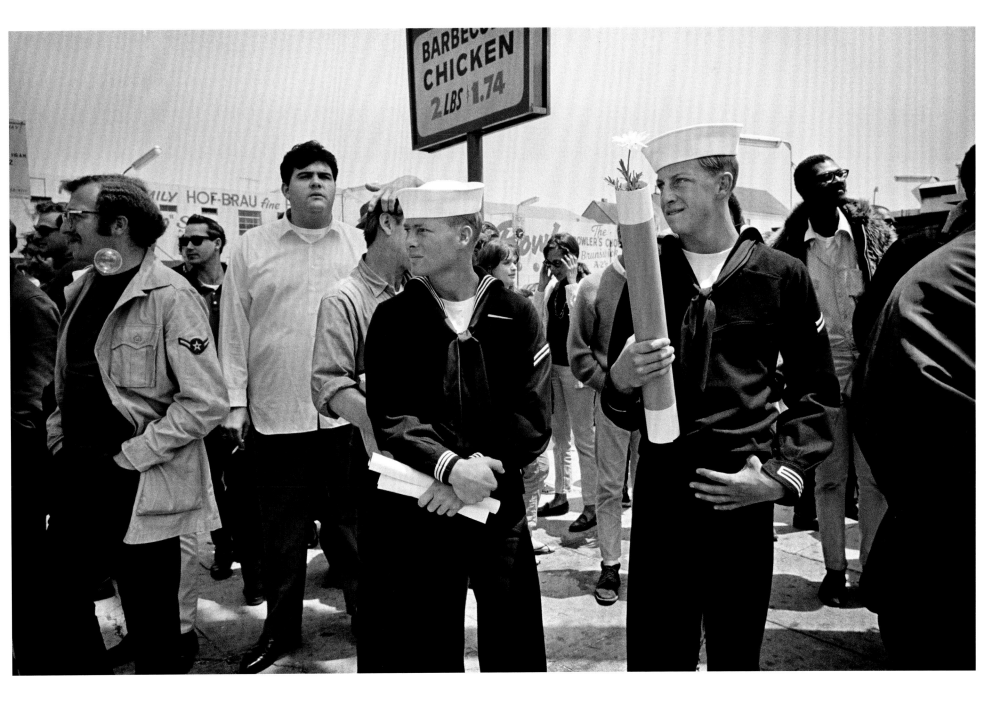

Sailors watching the Rathayatra Festival, Stanyan Street,
San Francisco, 1967

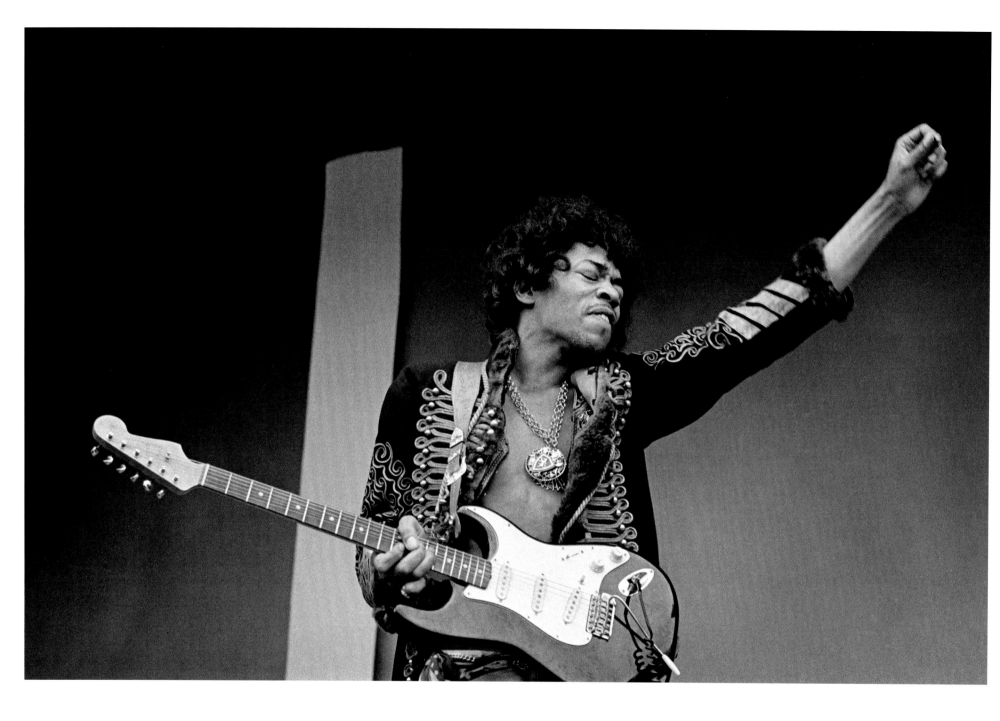

This page and opposite: **JIMI HENDRIX** during his sound
check, Monterey Pop Festival, Monterey, California, 1967

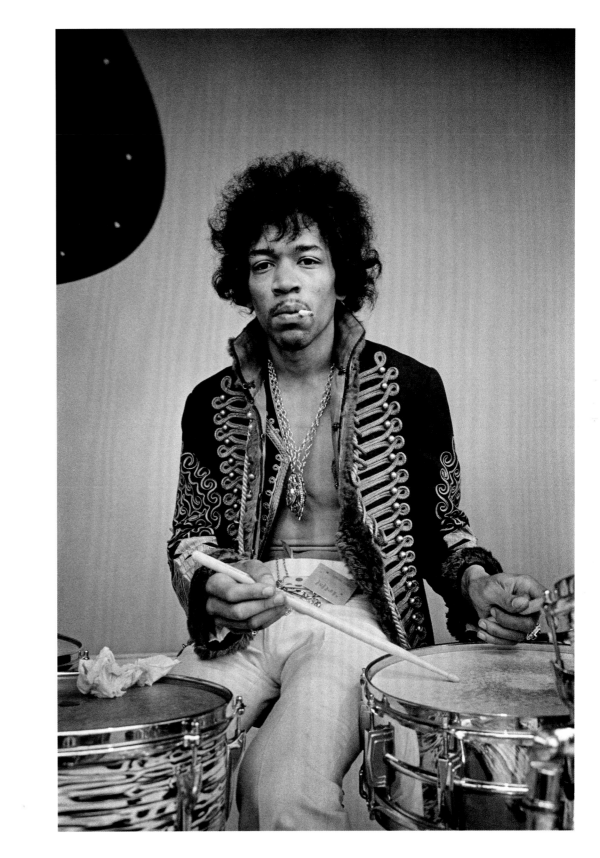

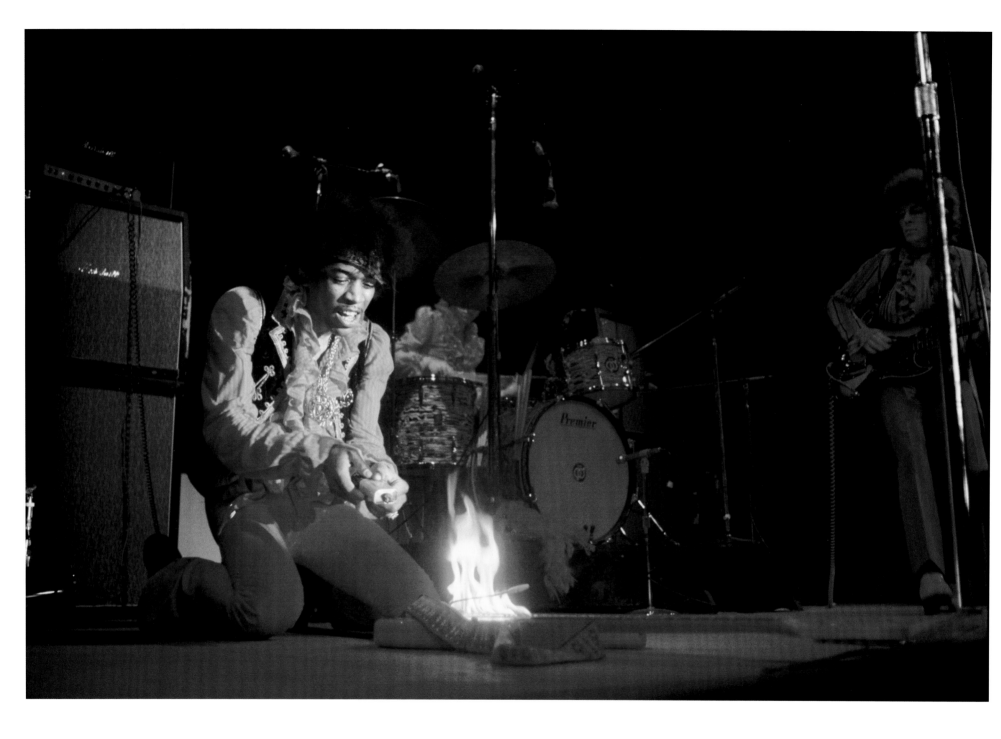

JIMI HENDRIX lighting his guitar on fire, Monterey Pop
Festival, Monterey, California, 1967

MICHAEL BLOOMFIELD, San Francisco, 1967

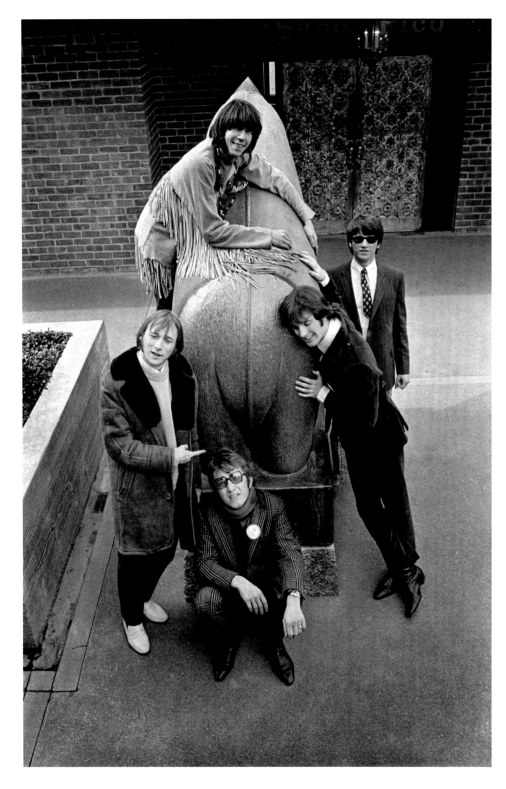

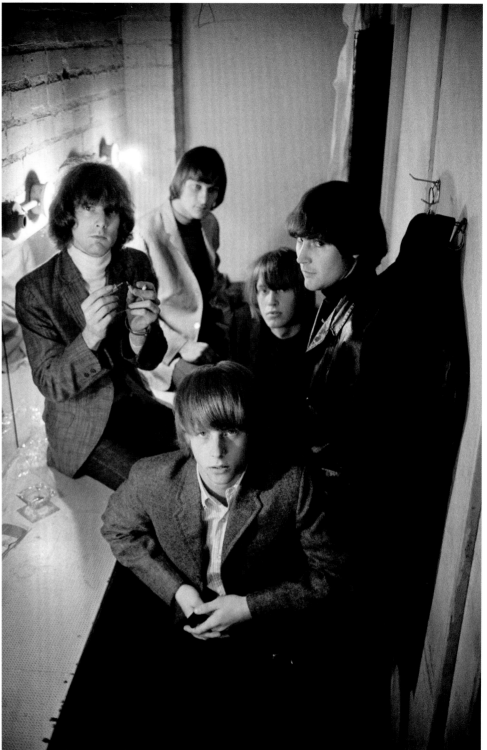

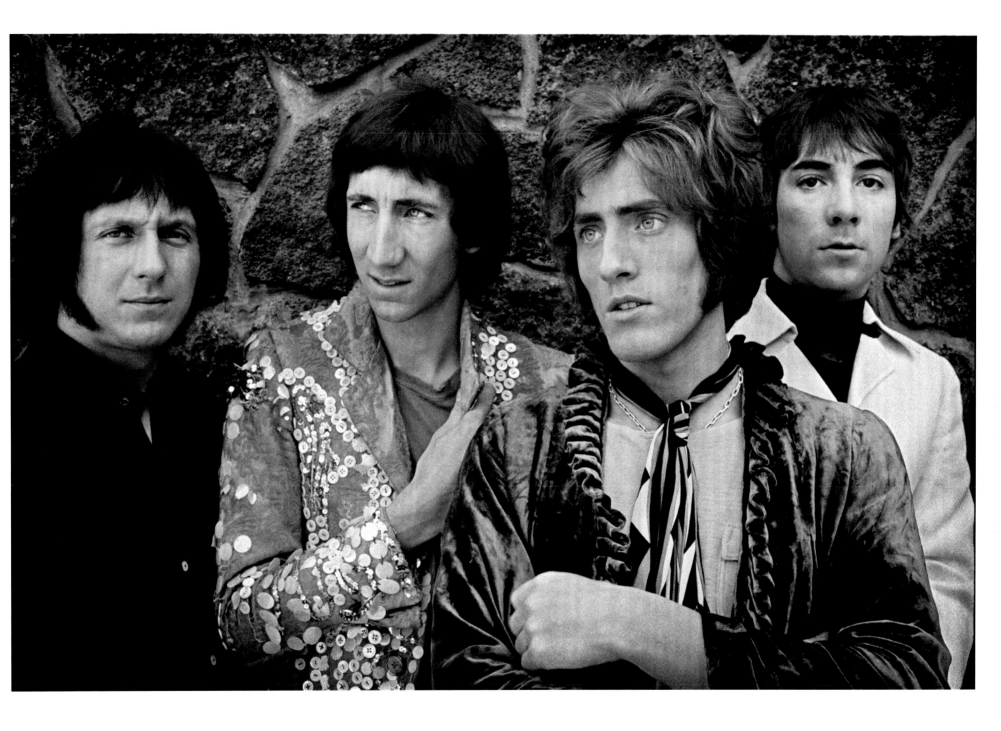

BUFFALO SPRINGFIELD, Ghirardelli Square,
San Francisco, 1967

THE WHO outside their hotel in the Tenderloin,
San Francisco, 1967

THE BYRDS backstage at the San Francisco Civic Auditorium,
San Francisco, 1965

147

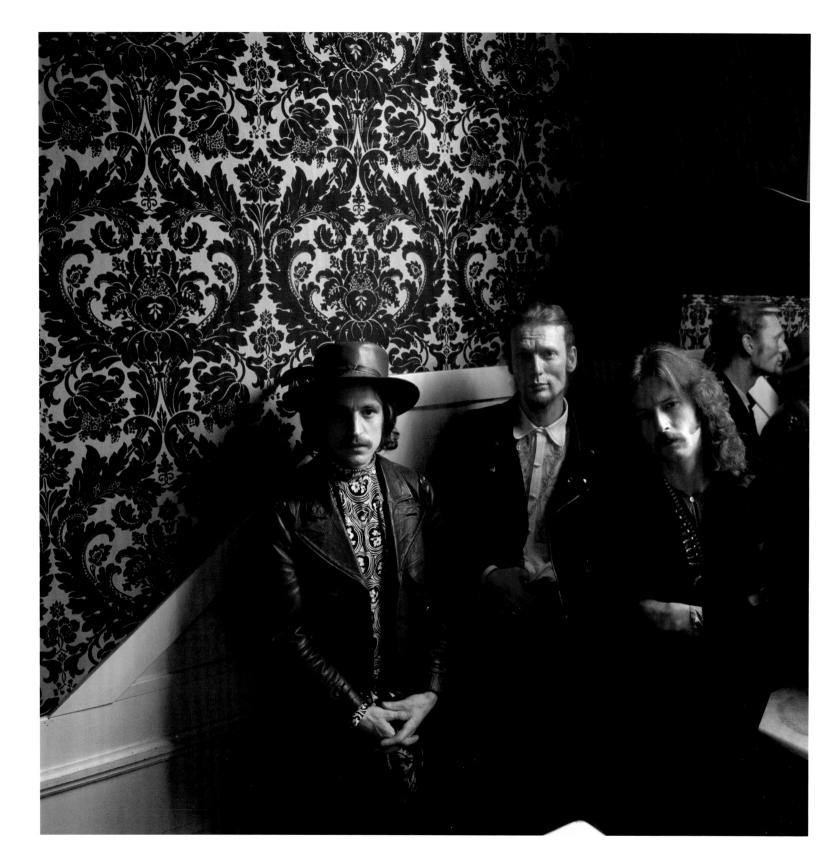

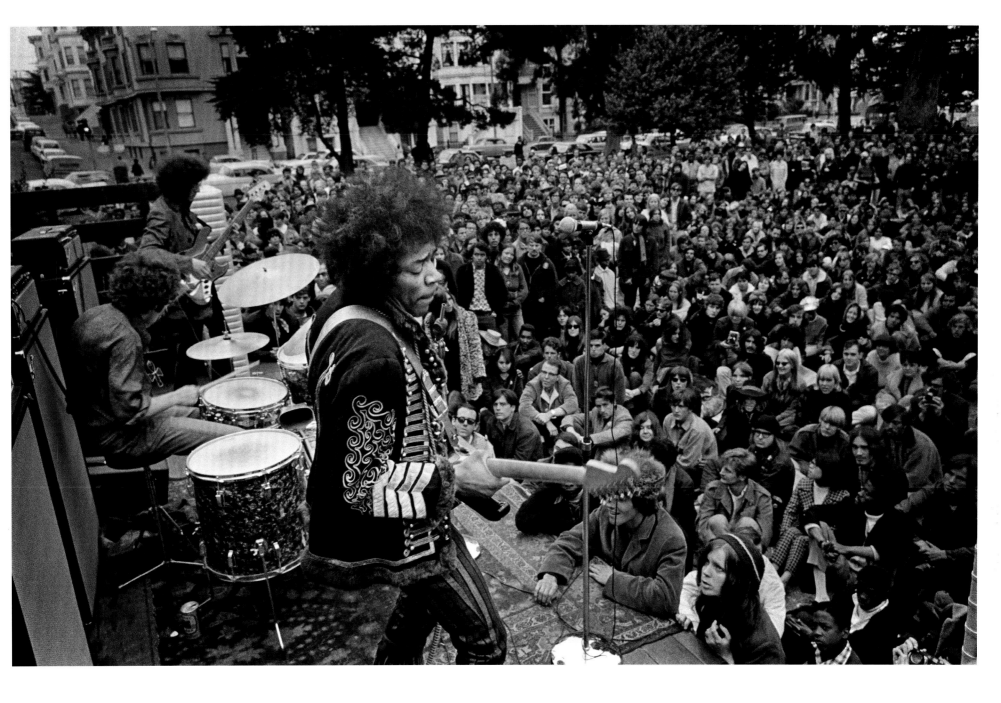

CREAM in the stairwell of a hotel, Sausalito, California, 1967

JIMI HENDRIX playing at a free concert in the Panhandle,
San Francisco, 1967

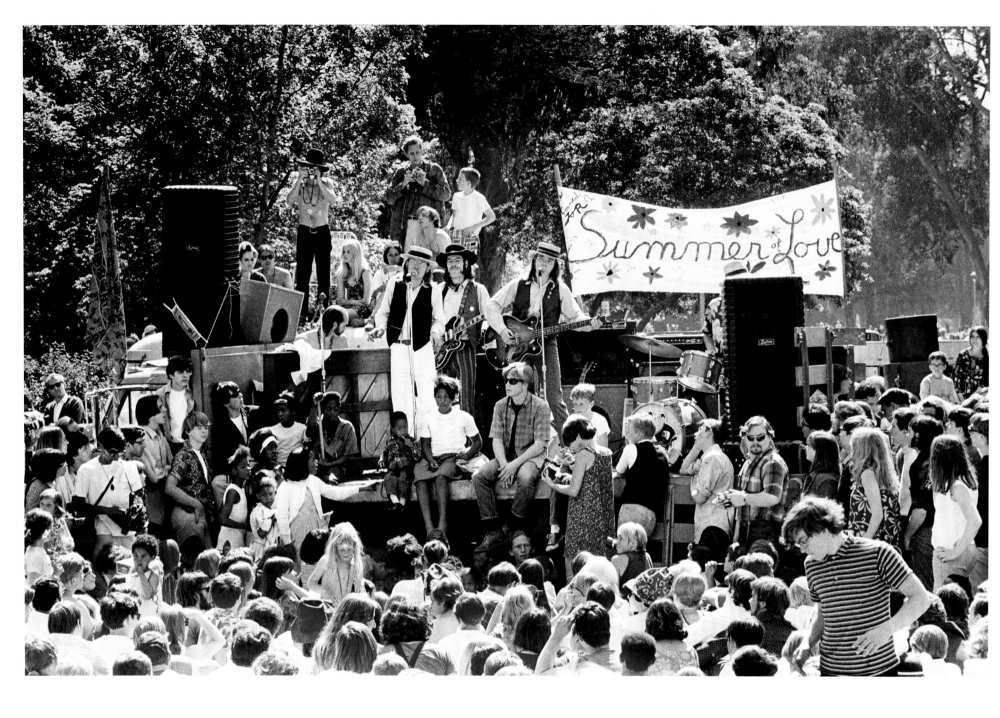

THE CHARLATANS playing at the Summer of Love concert in
Golden Gate Park, San Francisco, 1967

150

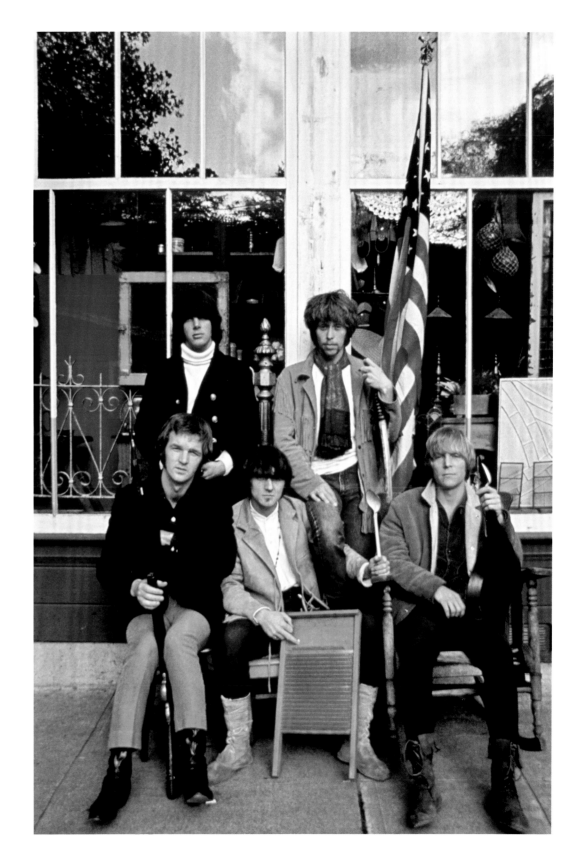

MOBY GRAPE album cover for Columbia Records, 1967

ARETHA FRANKLIN, RAY CHARLES, and **KING CURTIS,**
live at the Fillmore West, San Francisco, 1971

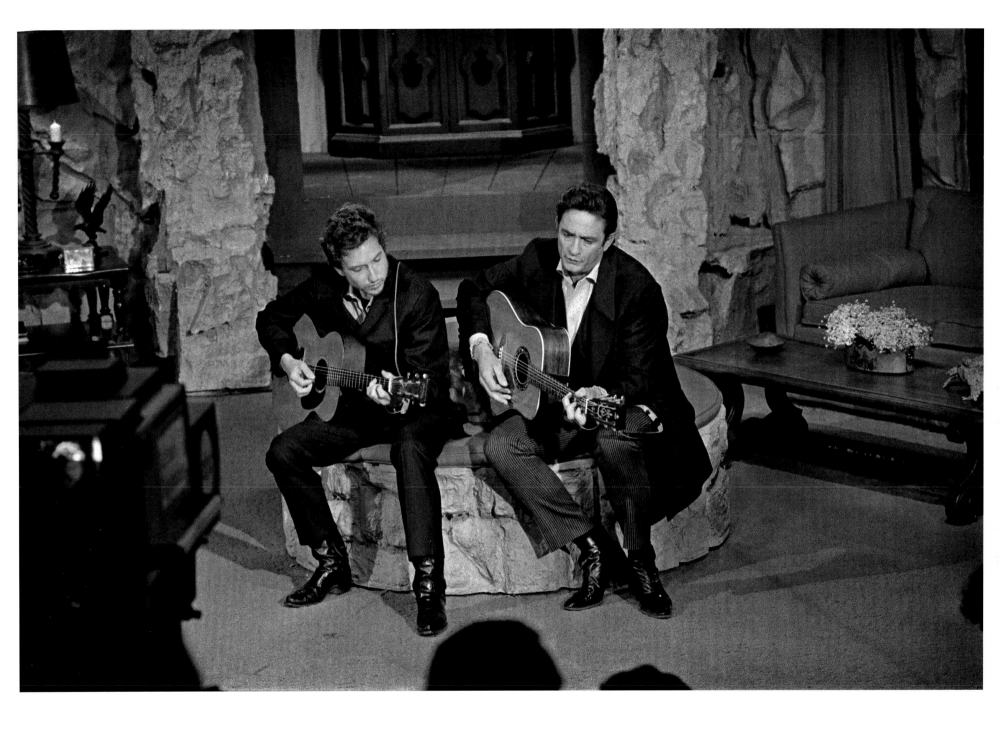

JOHNNY CASH and **BOB DYLAN** performing for Johnny
Cash's TV show, Nashville, Tennessee, 1969

153

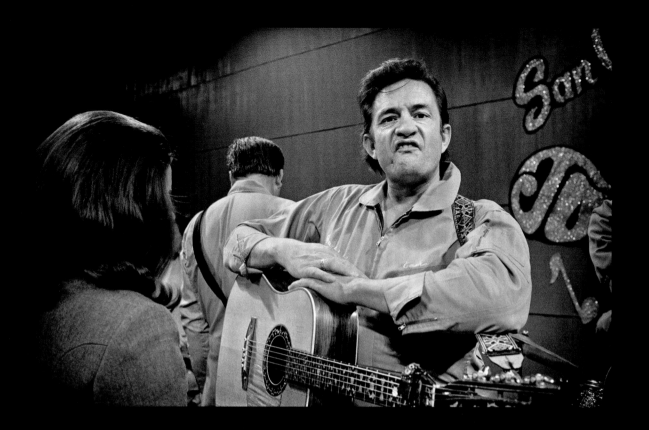

JIM WAS A MASTER of capturing reality through a particular lens and that lens, not being on the camera, could only magically come from his eye. . . . When I look at the famous picture of my father with his middle finger raised at Jim Marshall's lens, I feel the energy of the moment, I feel my father's sense of defiance.

JOHN CARTER CASH

Opposite: **JOHNNY CASH** "giving one to the warden"

Above: Cash getting ready to "shoot one for the warden," San Quentin State Prison, San Quentin, California, 1969

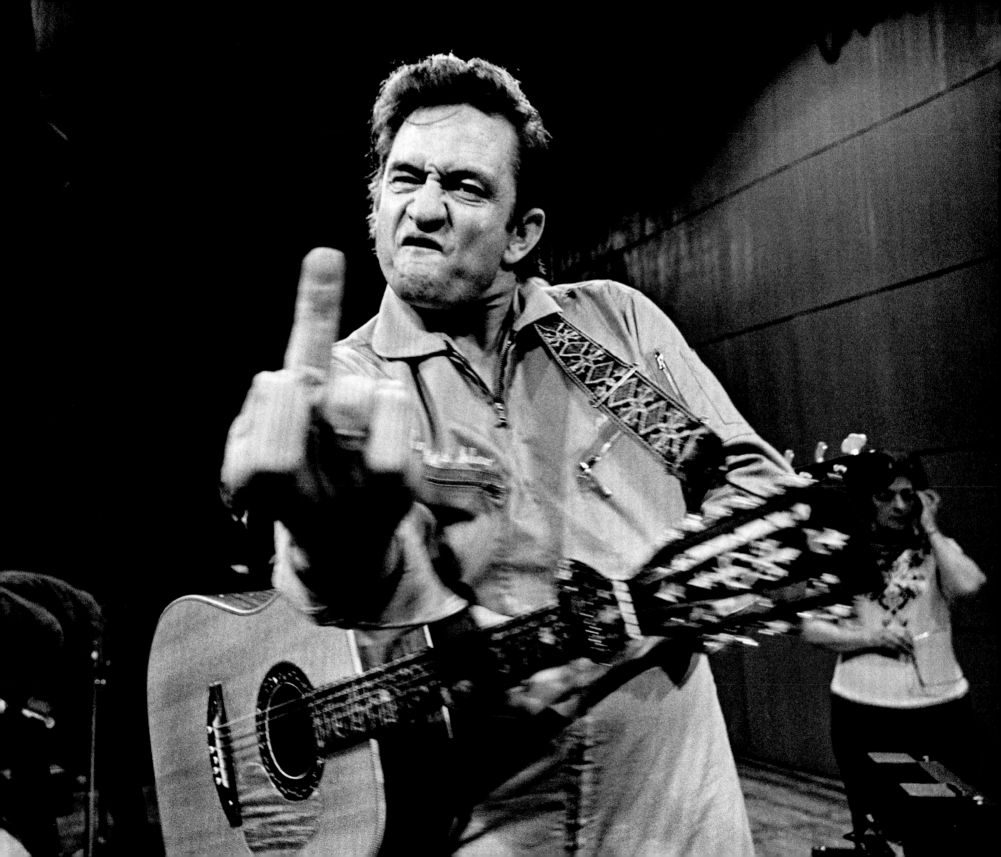

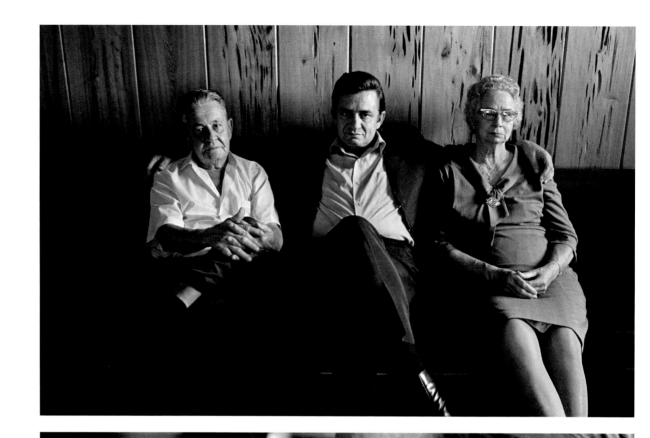

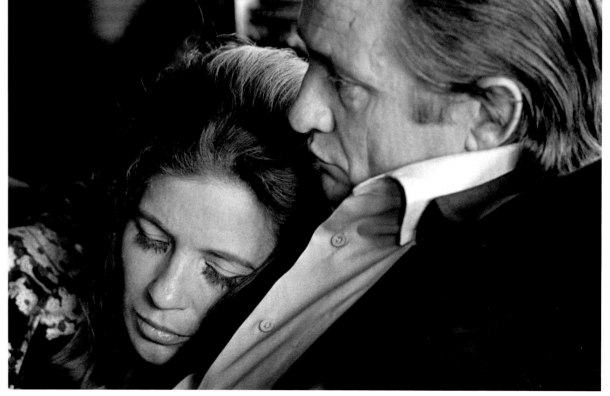

THE CASH FAMILY embraced Marshall and allowed him into their lives and their Hendersonville, Tennessee, home just like he was one of the family. And the intimate, powerful portraits that emerged—many taken during the Carter Family Thanksgiving of 1969—are the legacy of that trust. Clockwise from top left: **JOHNNY CASH** with his beloved parents, **RAY** and **CARRIE CASH**, singer-songwriter Renaissance men **KRIS KRISTOFFERSON** and **SHEL SILVERSTEIN,** and his adored wife, **JUNE CARTER CASH**.

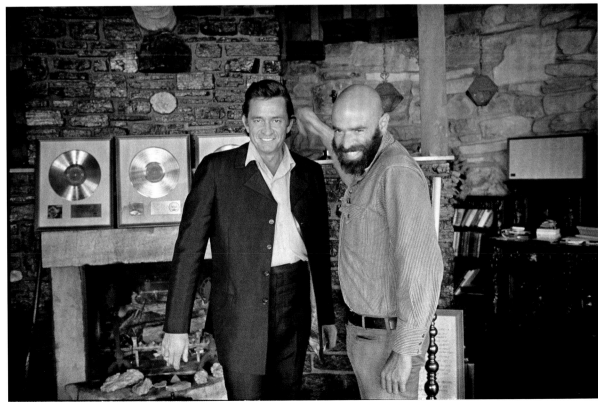

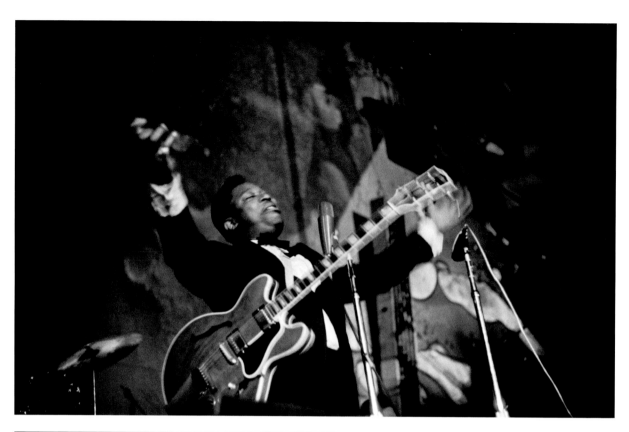

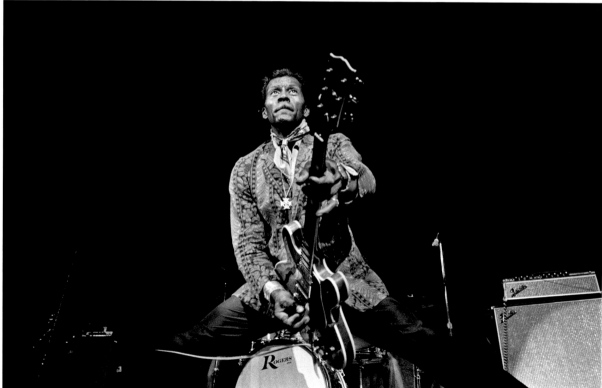

B.B. KING performing at the Fillmore West, San Francisco, 1968

CHUCK BERRY performing at Madison Square Garden, New York City, 1969

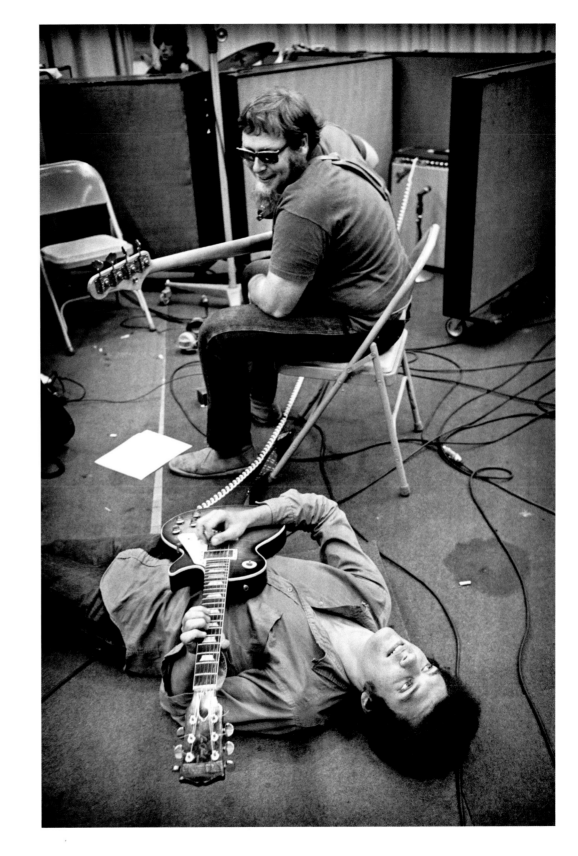

MICHAEL BLOOMFIELD at a recording session for *Super Session* at Columbia Records Studio, Los Angeles, 1968

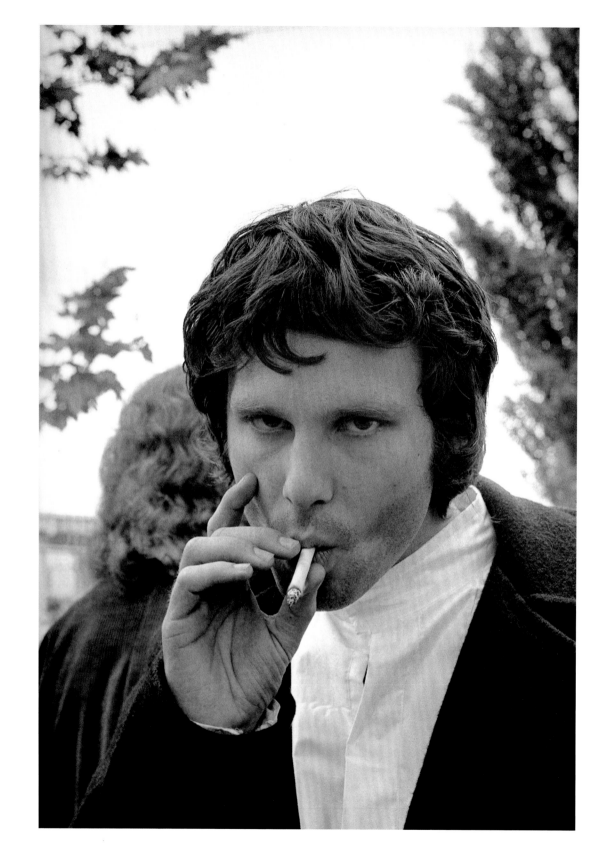

JIM MORRISON at the Northern California Folk Rock Festival,
Santa Clara, California, 1968

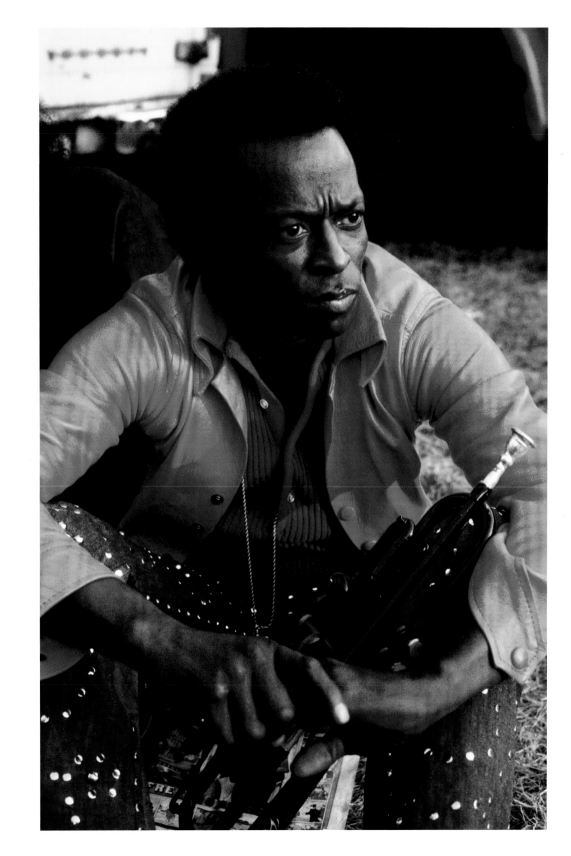

MILES DAVIS, Isle of Wight Concert,
Isle of Wight, United Kingdom, 1970

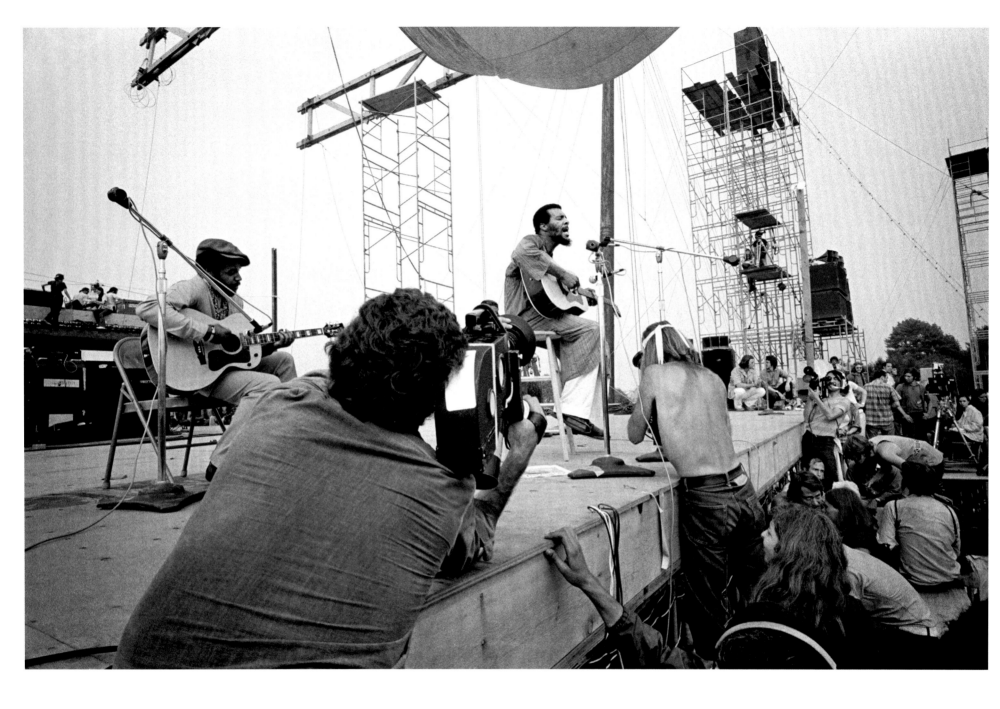

RICHIE HAVENS opening the Woodstock Festival,
Bethel, New York, 1969

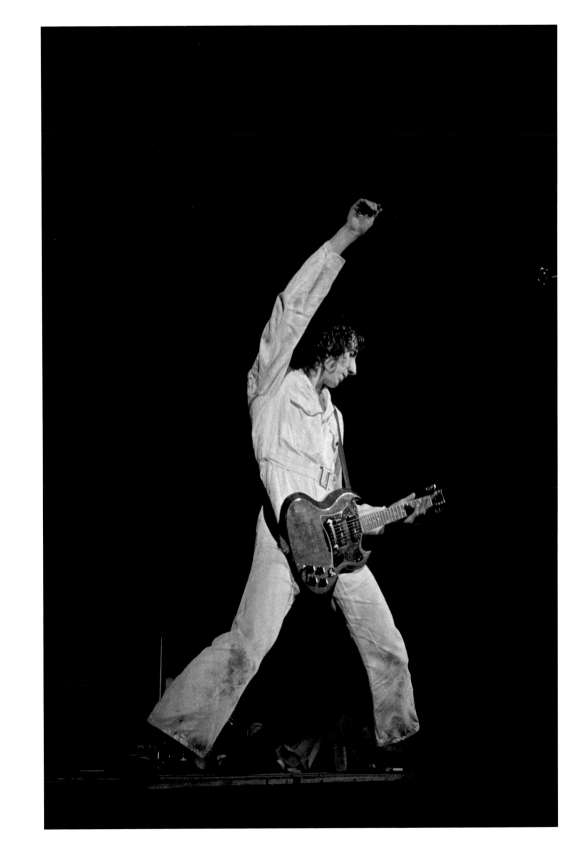

PETE TOWNSHEND of the Who performing at the
Woodstock Festival, Bethel, New York, 1969

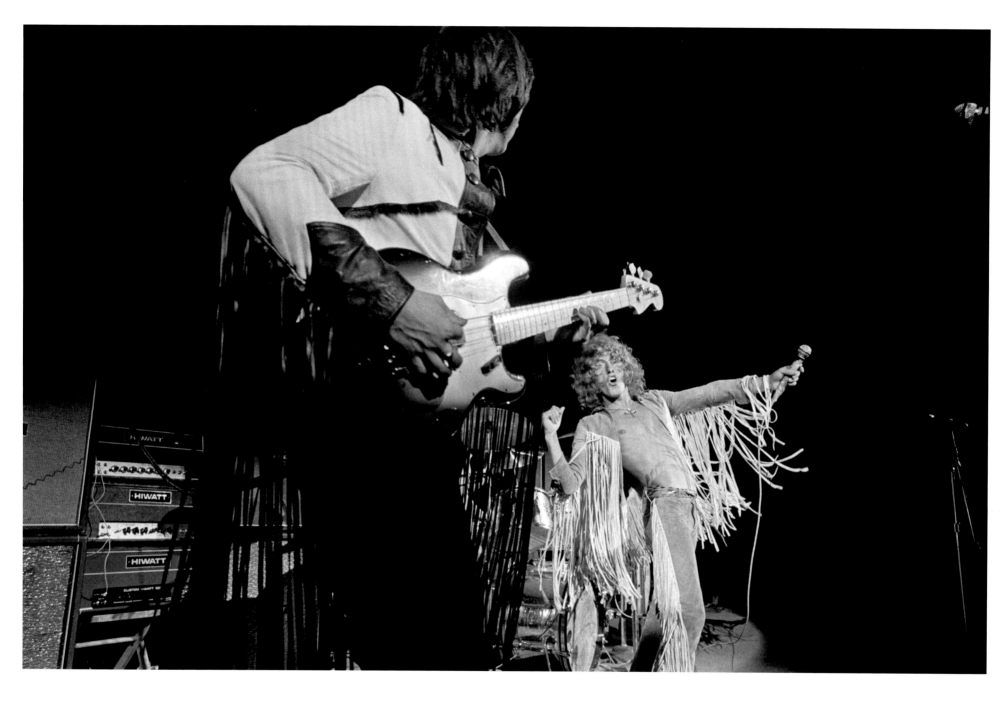

THE WHO, Woodstock Festival, Bethel, New York, 1969

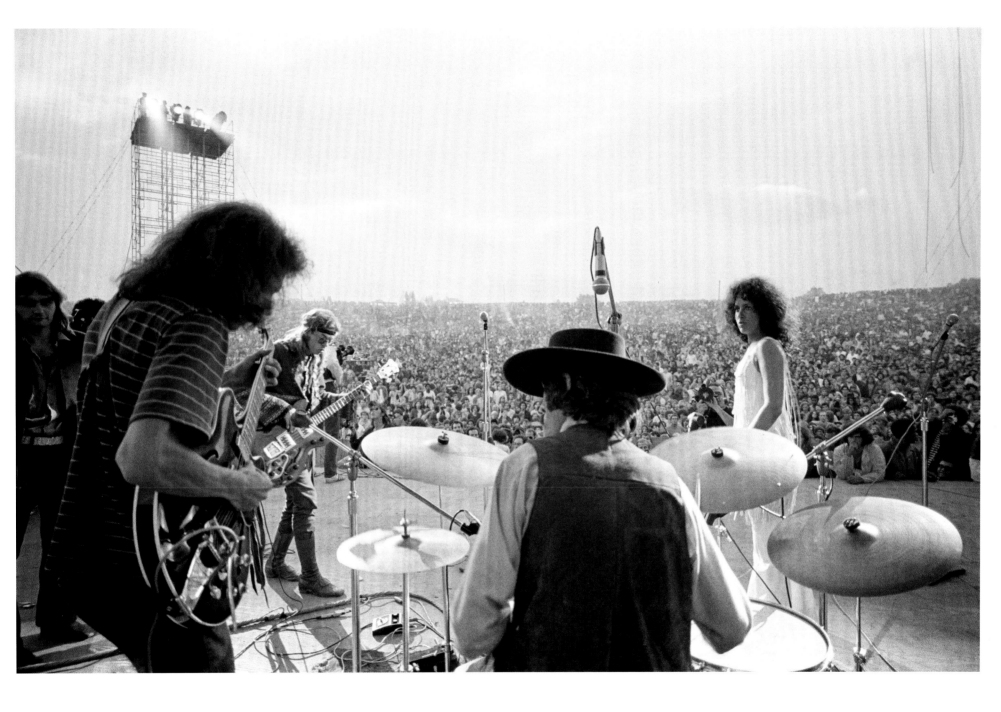

JEFFERSON AIRPLANE, Woodstock Festival, Bethel, New York, 1969 *165*

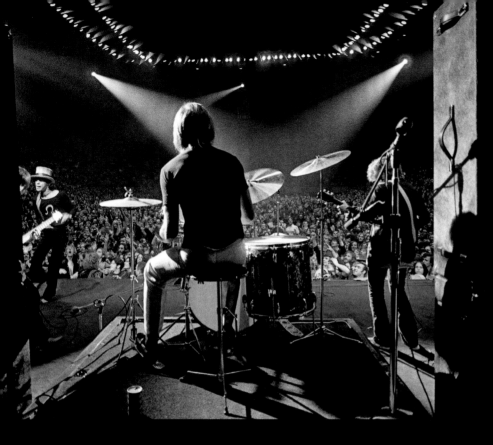
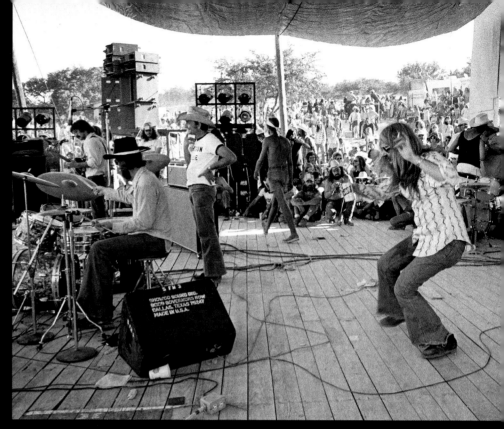
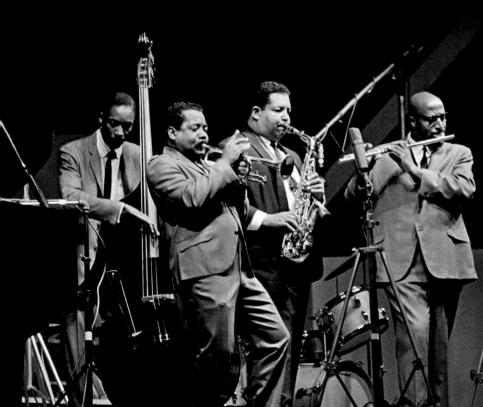
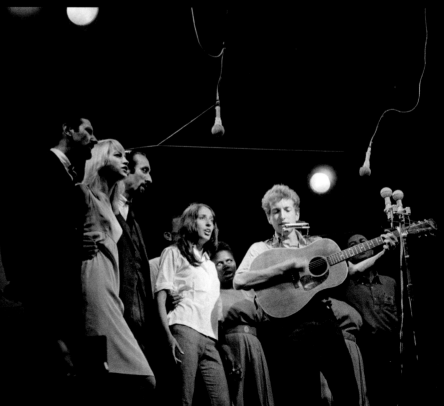

Basically, the camera is a kind of *MEMOIR*; it is a diaristic tool. And that's what I think when you look at a whole, the collection of images: It is a *DIARY* of a life in *MUSIC*. And what a beautiful thing.

JEFF ROSENHEIM

THE ROLLING STONES on tour, 1969

CANNONBALL ADDERLEY SEXTET at the Newport Jazz Festival, Newport, Rhode Island, 1963

WILLIE NELSON and **LEON RUSSELL** at the Dripping Springs Festival, Dripping Springs, Texas, 1973

PETER, PAUL, AND MARY, FREEDOM SINGERS, JOAN BAEZ, and **BOB DYLAN** at the Newport Folk Festival, Newport, Rhode Island, 1963

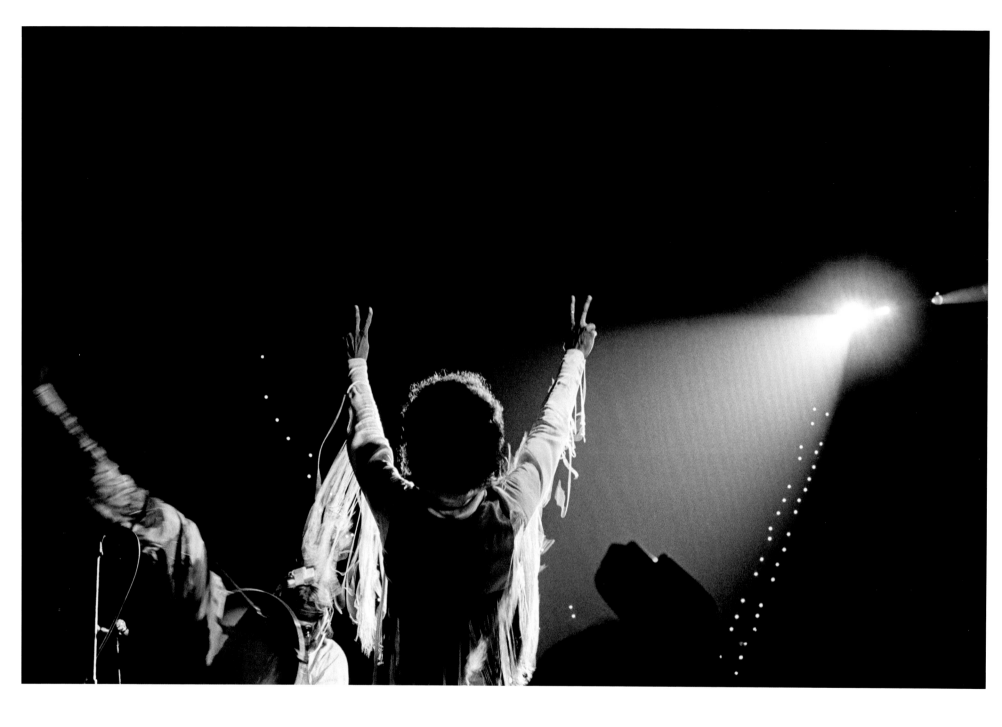

SLY STONE, Woodstock Festival, Bethel, New York, 1969 *168*

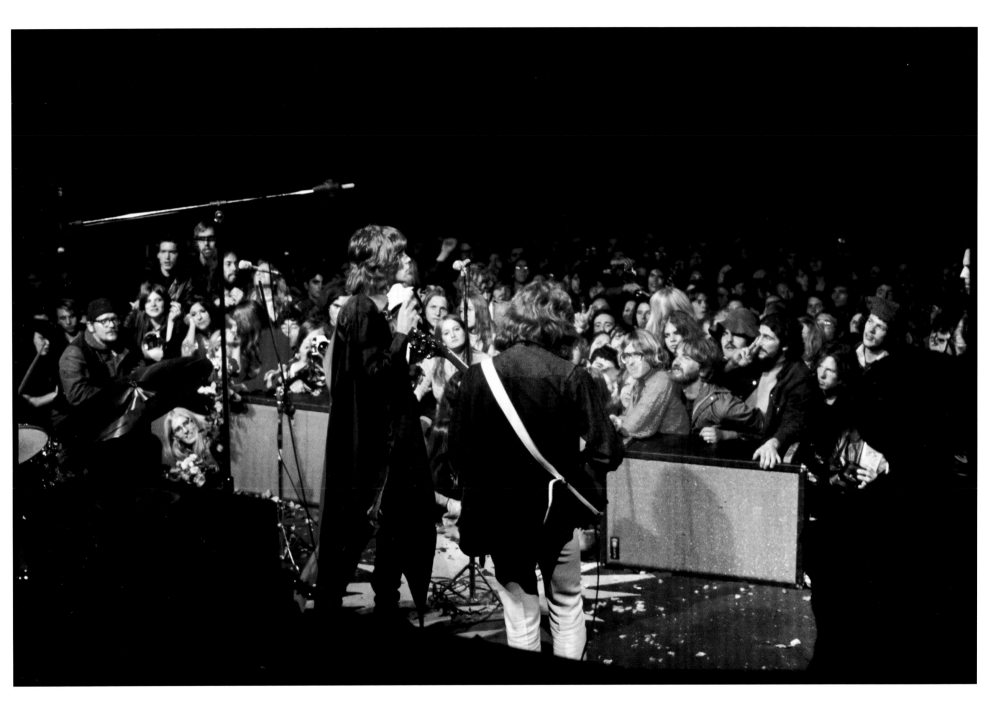

THE ROLLING STONES, Altamont Free Concert,
Altamont Speedway, California, 1969

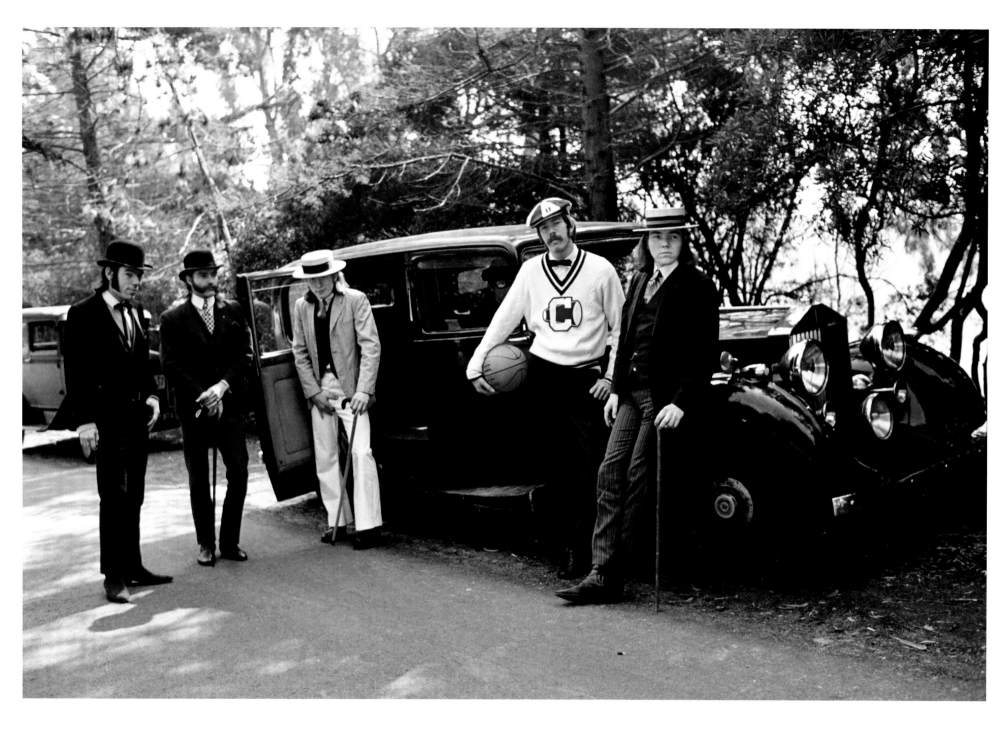

THE CHARLATANS, San Francisco, 1967 *170*

LOGGINS & MESSINA, San Francisco Bay Area, 1971.
This photo was shot for the album *Loggins & Messina.*

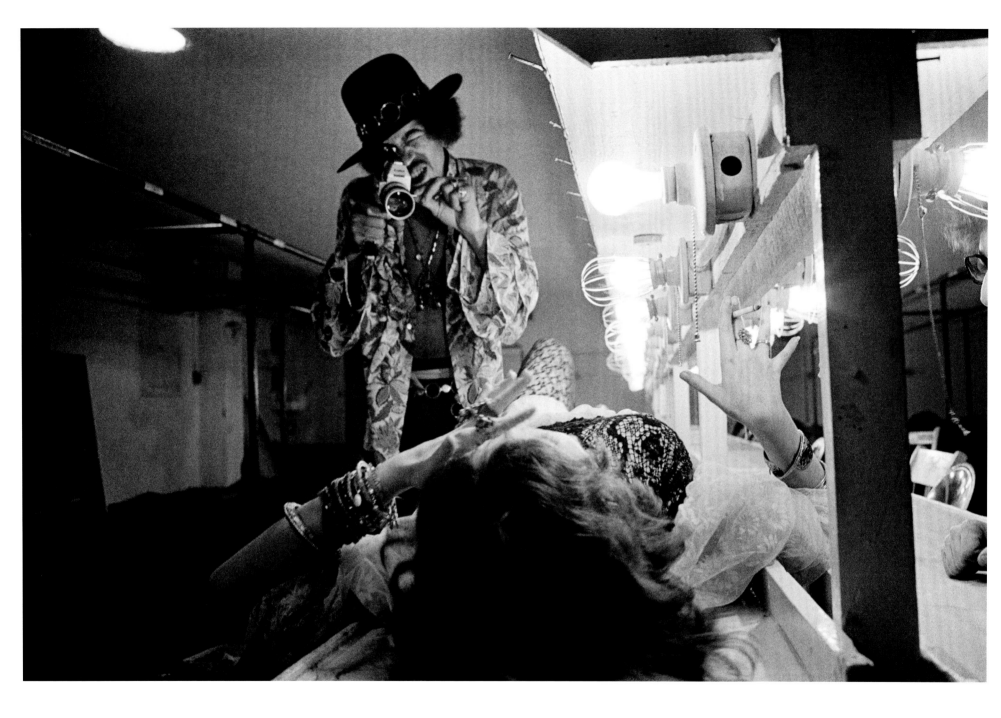

JIMI HENDRIX filming **JANIS JOPLIN** backstage at
Winterland, San Francisco, 1968

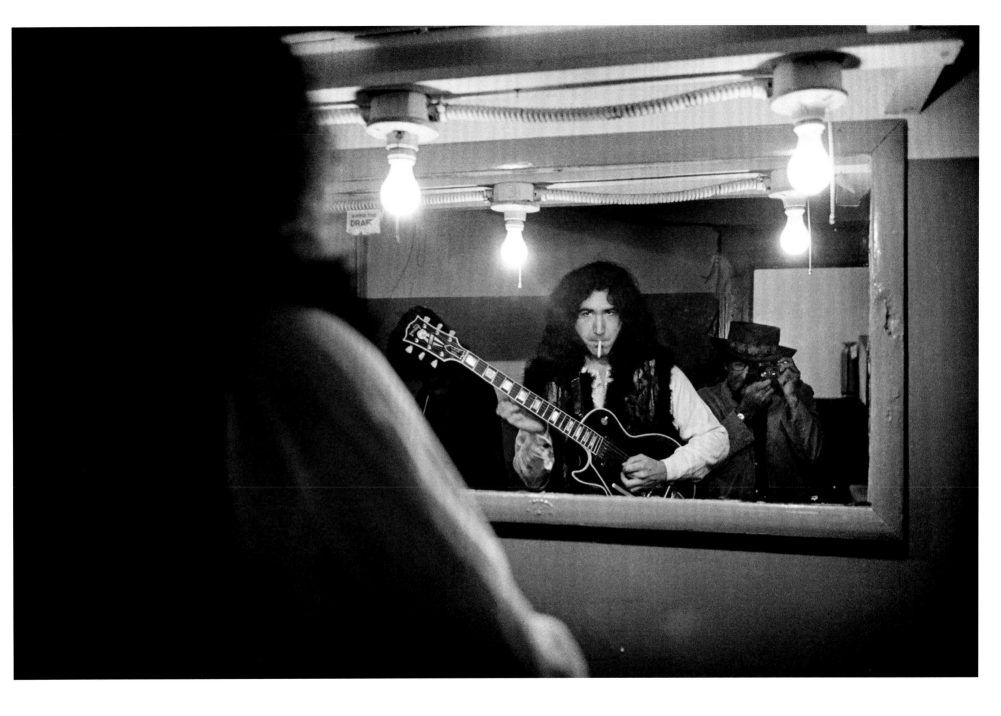

JIM MARSHALL reflected in a mirror while photographing
JERRY GARCIA backstage at Winterland, San Francisco, 1967.

173

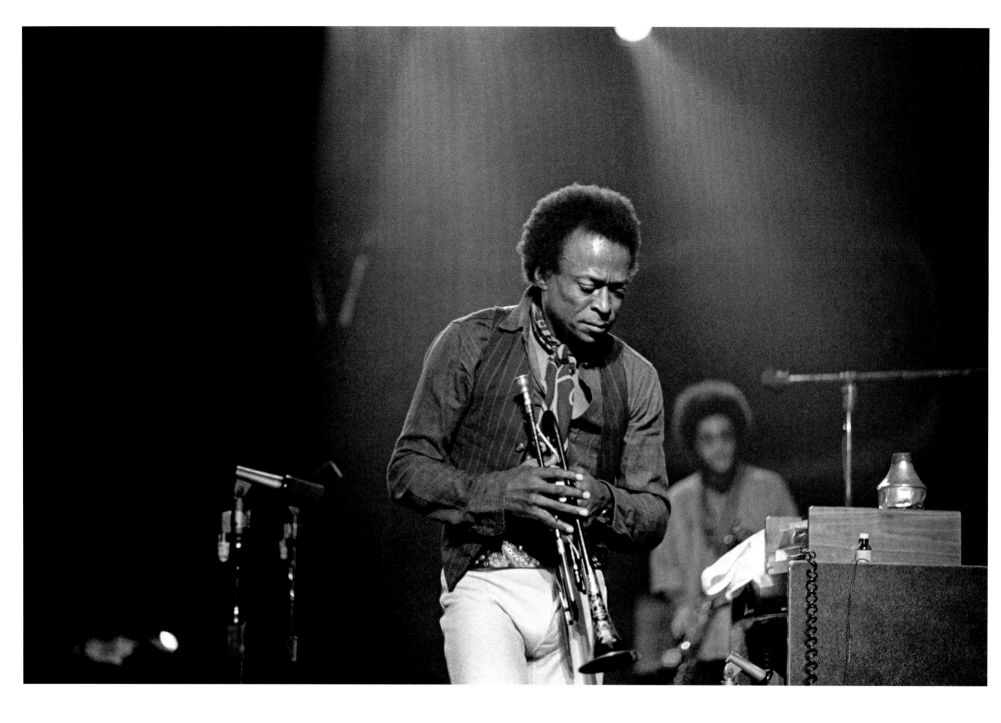

MILES DAVIS, the Fillmore, San Francisco, 1971 *174*

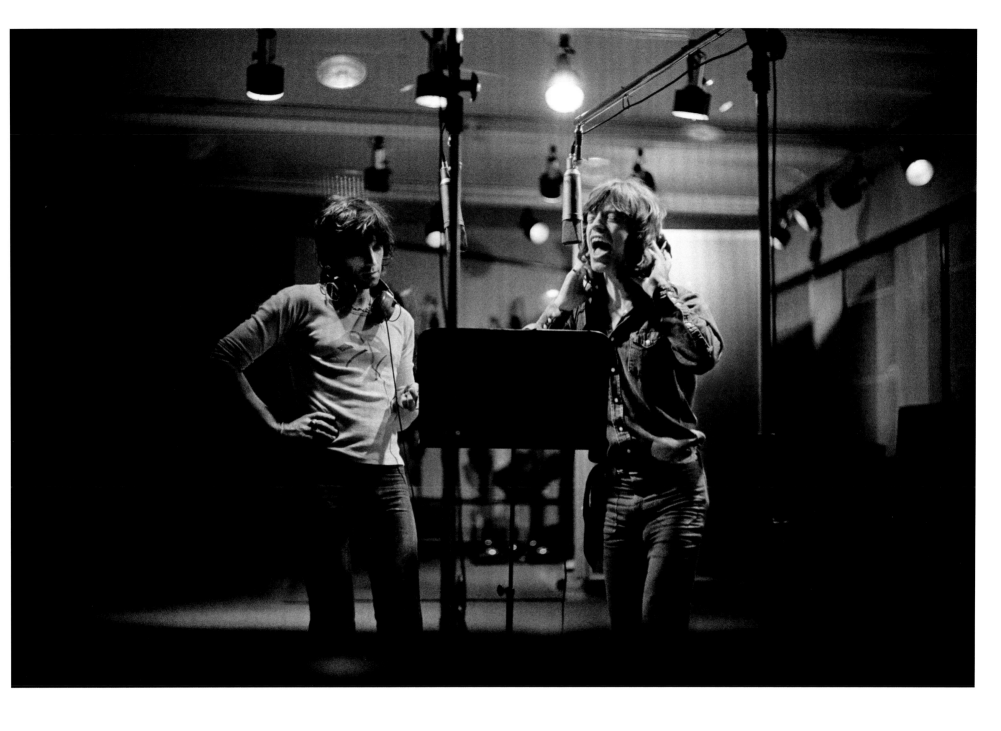

MICK JAGGER and **KEITH RICHARDS** in the recording studio,
Sunset Sound, Los Angeles, 1972

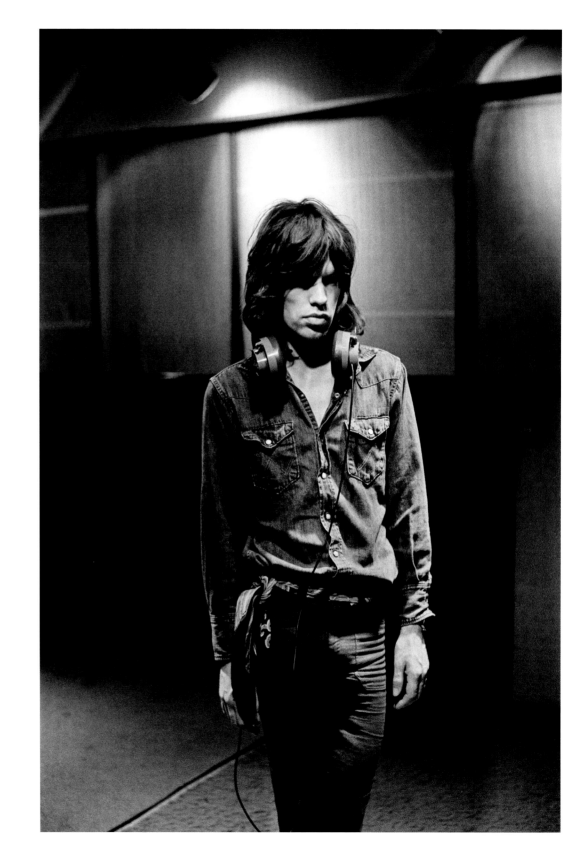

MICK JAGGER, Sunset Sound, Los Angeles, 1972

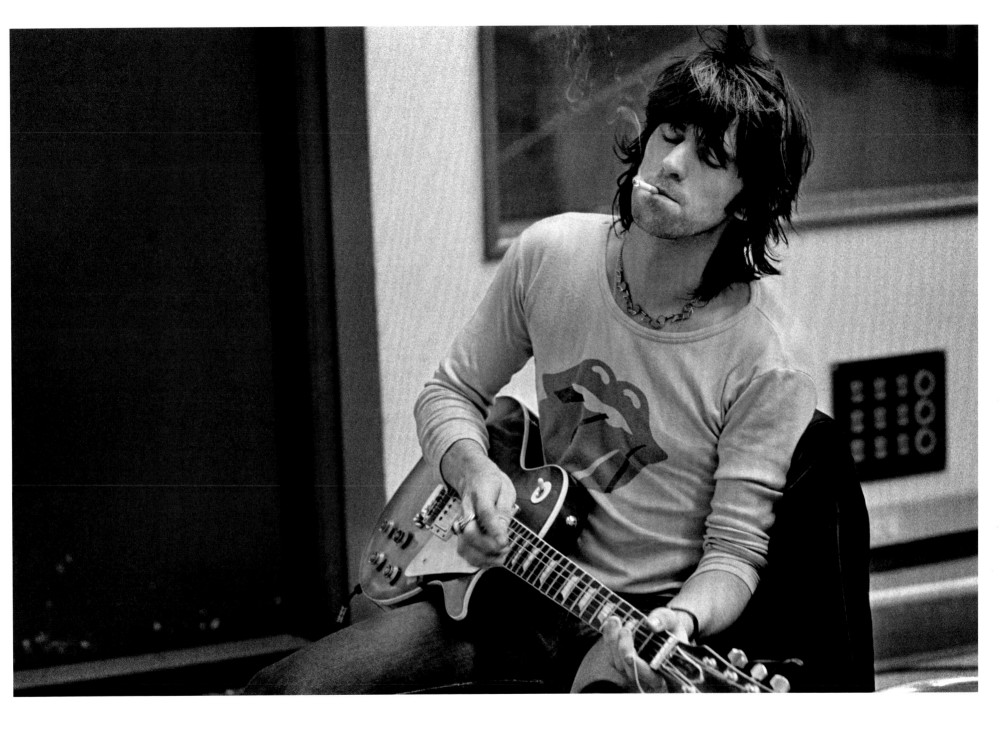

KEITH RICHARDS, Sunset Sound, Los Angeles, 1972

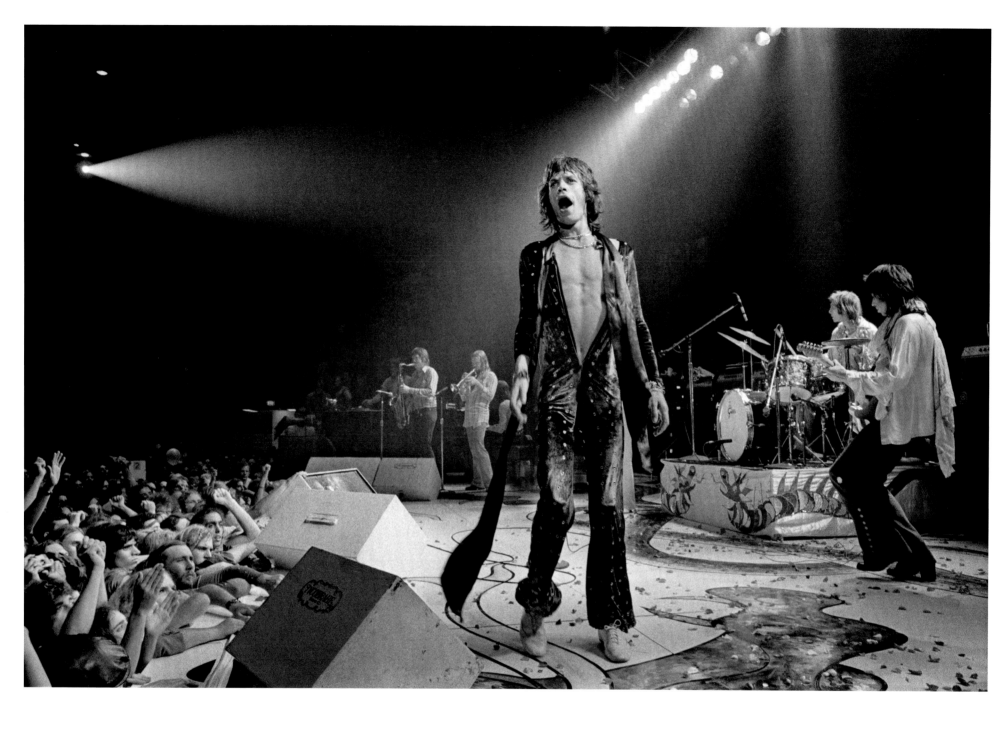

THE ROLLING STONES, Winterland, San Francisco, 1972 *178*

KEITH RICHARDS backstage at Winterland, San Francisco, 1972

MICK JAGGER on a plane to Southern California, 1972

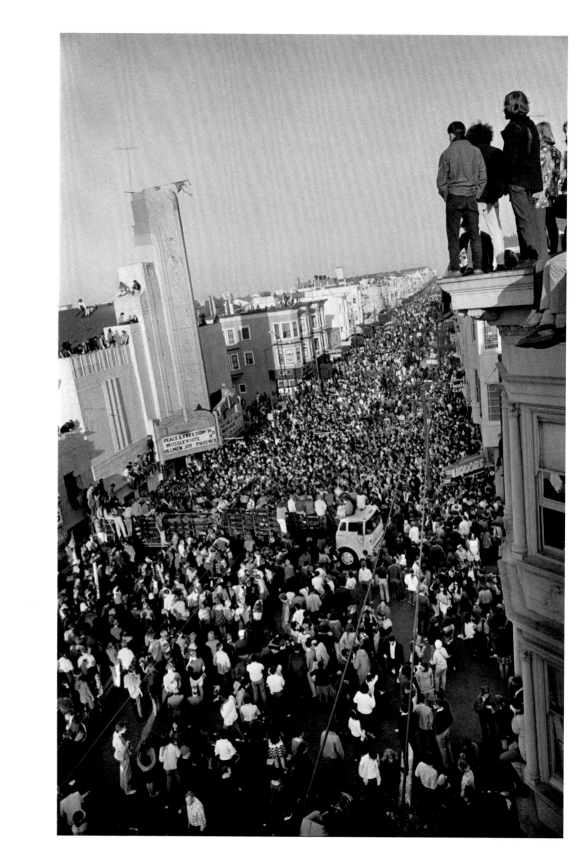

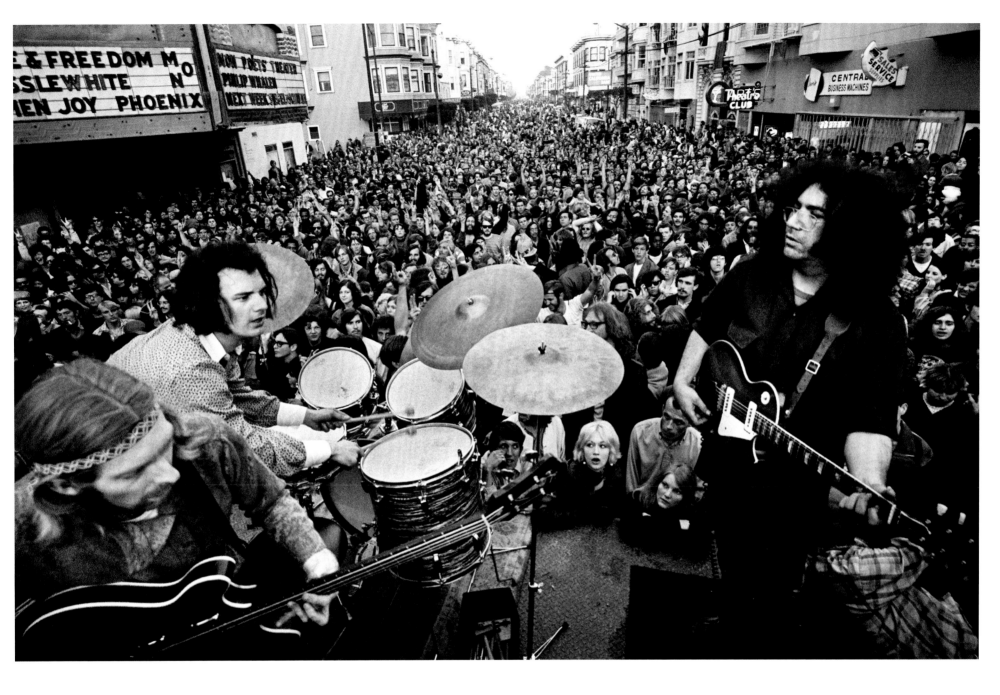

This page and opposite: **THE GRATEFUL DEAD**'s last free concert on Haight Street, San Francisco, before they moved to Marin County, 1968

181

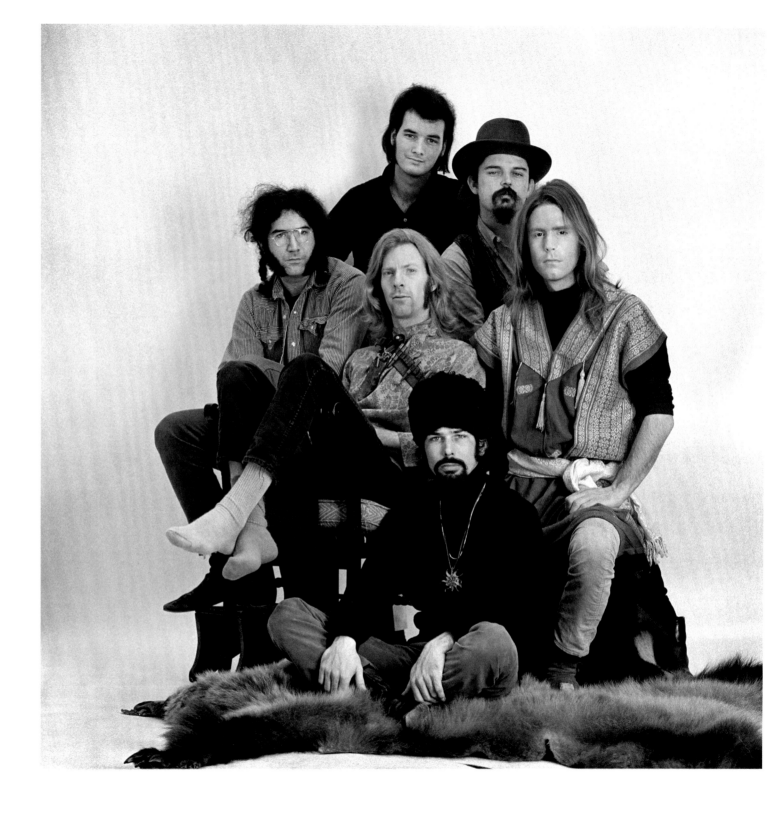

THE GRATEFUL DEAD in the studio, San Francisco, 1967

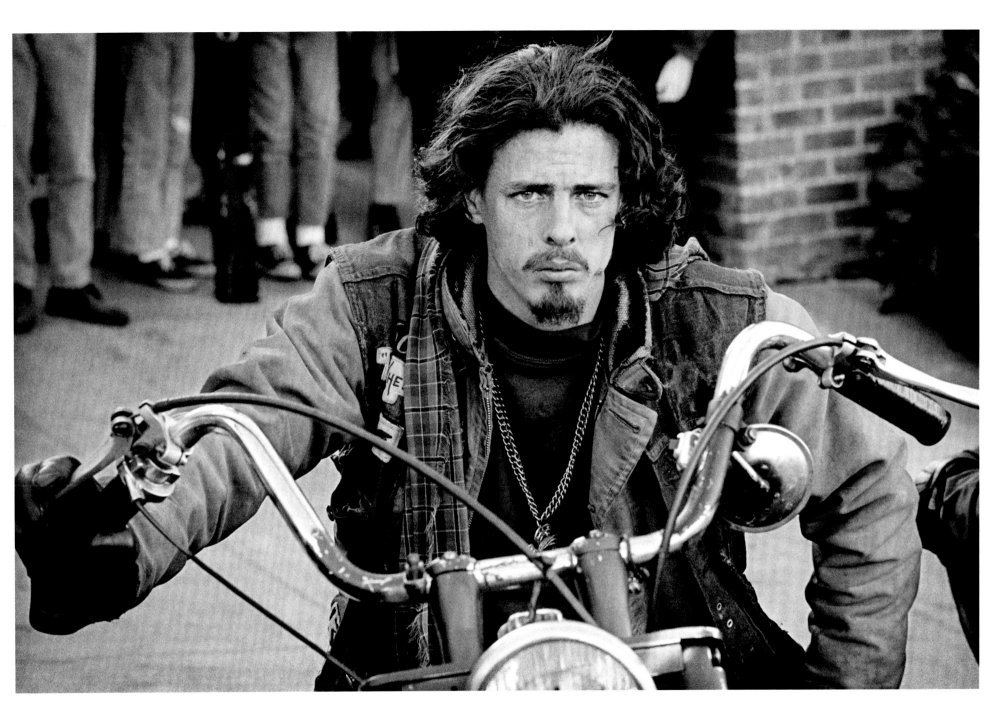

FREEWHEELIN' FRANK, secretary of the San Francisco
chapter of the Hell's Angels, who also collaborated with
musician Michael McClure, San Francisco, 1967

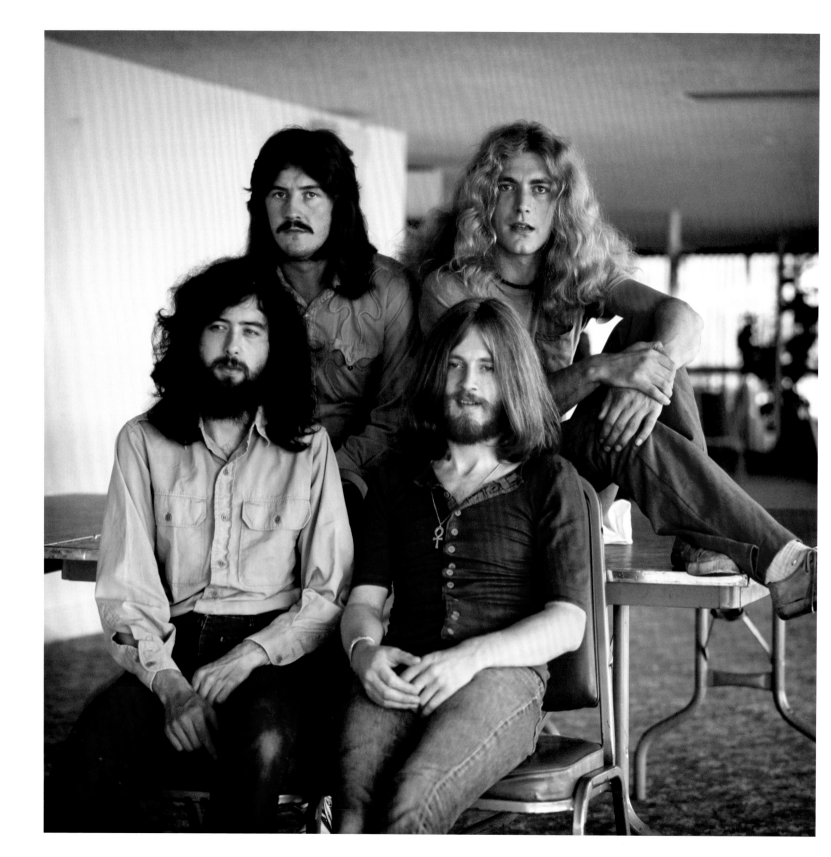

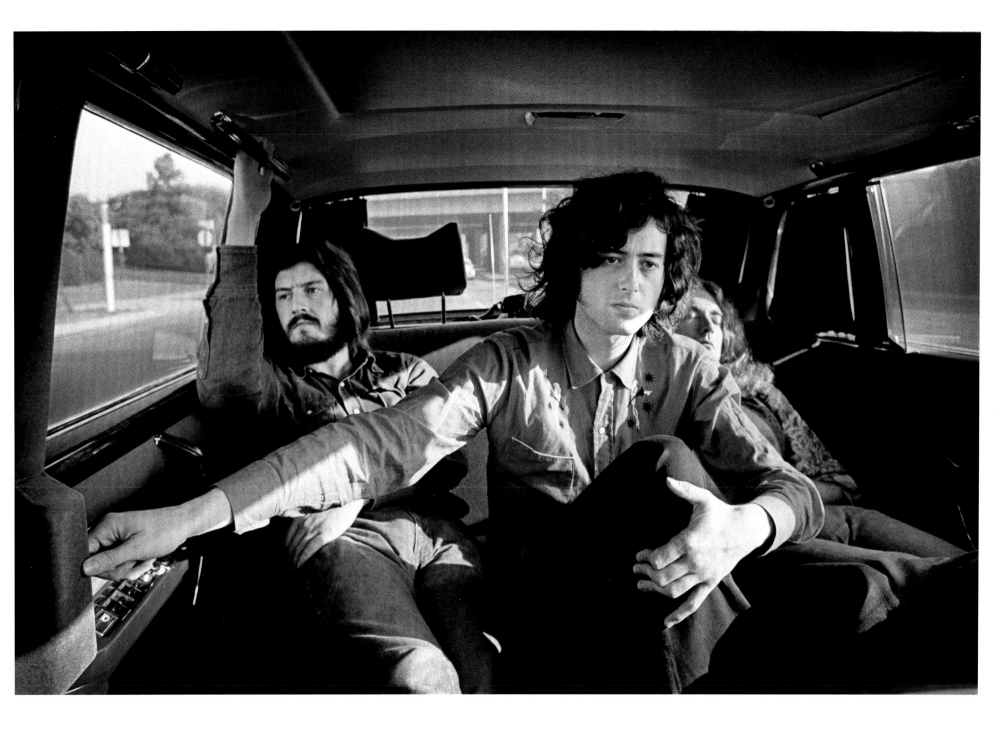

Opposite: **LED ZEPPELIN,** Hyatt House, Los Angeles, 1970

This page: **LED ZEPPELIN** in the back of a limo, Los Angeles, 1971

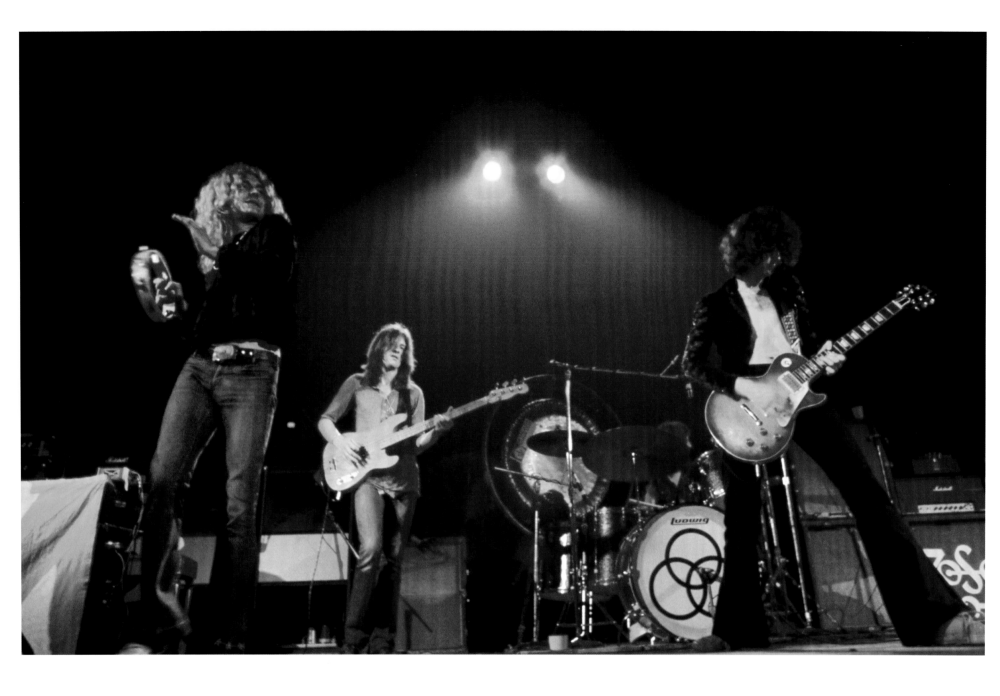

LED ZEPPELIN onstage, Los Angeles, 1971

RAHSAAN ROLAND KIRK, Keystone Korner, San Francisco, 1973 *187*

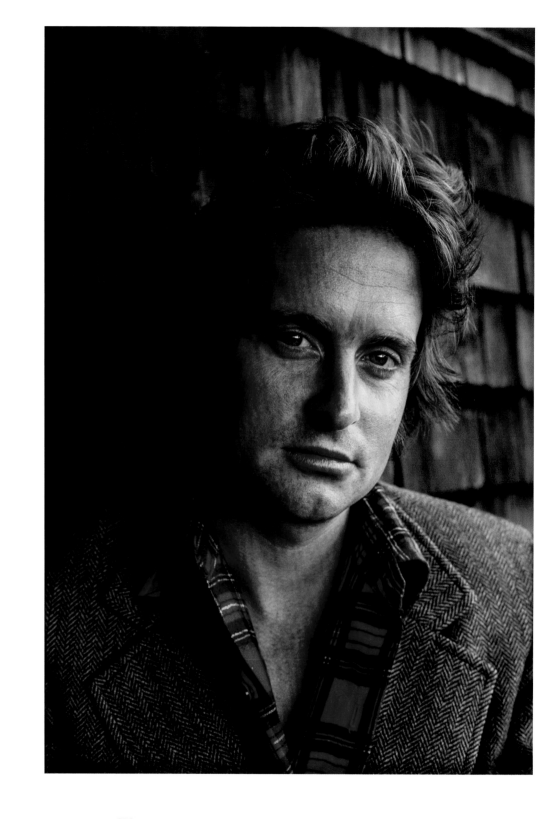

MICHAEL DOUGLAS, photographed for the magazine *City of San Francisco,* San Francisco, 1975

ERIC CLAPTON in Jim Marshall's apartment on Union Street, San Francisco, 1967

JEFF BECK, San Jose, California, 1978

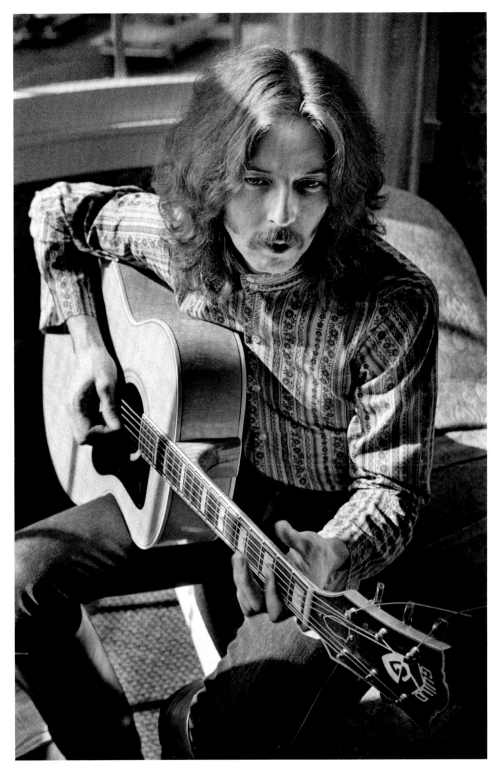
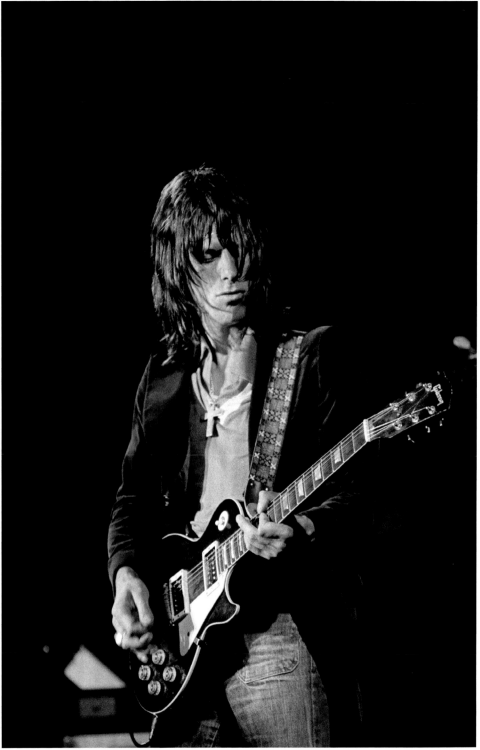

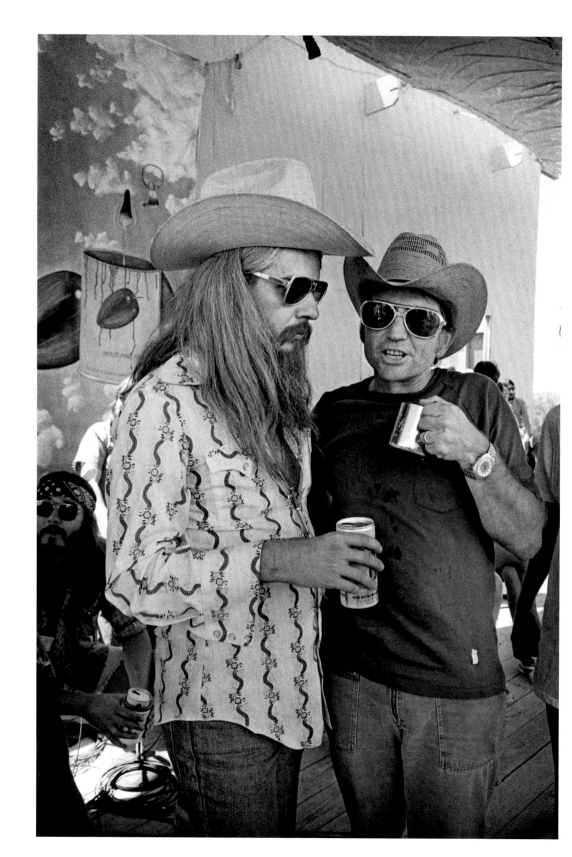

LEON RUSSELL and **WILLIE NELSON,** Willie Nelson's Fourth of July Picnic, Dripping Springs, Texas, 1973

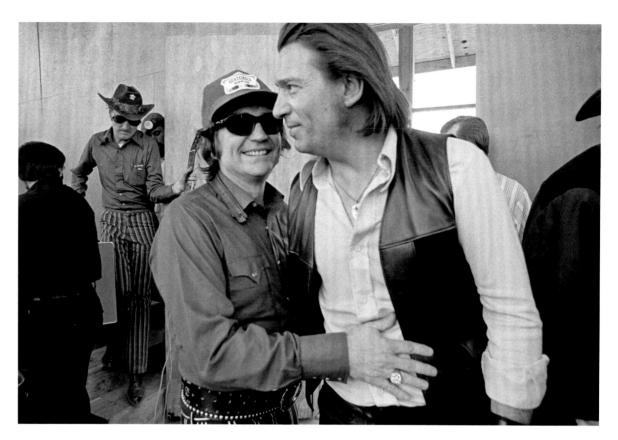

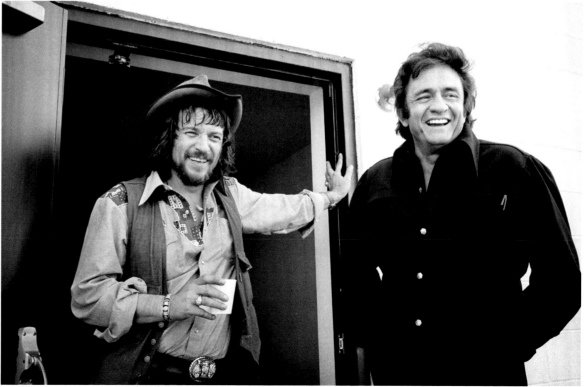

WILLIE NELSON and **WAYLON JENNINGS,** Dripping
Springs Festival, Dripping Springs, Texas, 1972

WAYLON JENNINGS and **JOHNNY CASH** at Cash's home
recording studio, Hendersonville, Tennessee, 1974

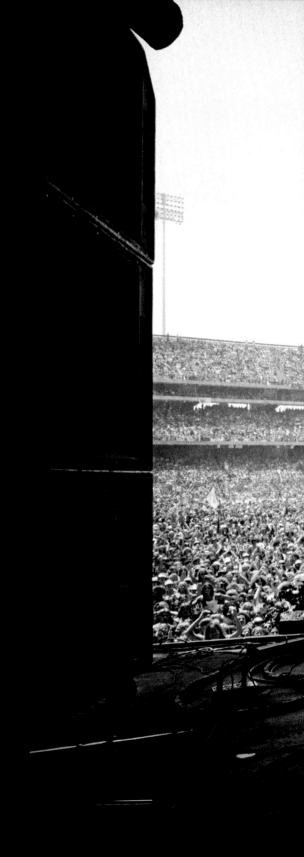

DAY ON THE GREEN, 1975. It was the first time we did Day on the Green, because I am wearing the white outfit. I see that photo everywhere now. I just wish I had my legs a little straighter from my gymnastics. It was a 3.1 jump. It wasn't a Townshend jump—do you know what I mean? Can we re-do that?

PETER FRAMPTON

PETER FRAMPTON, 1975

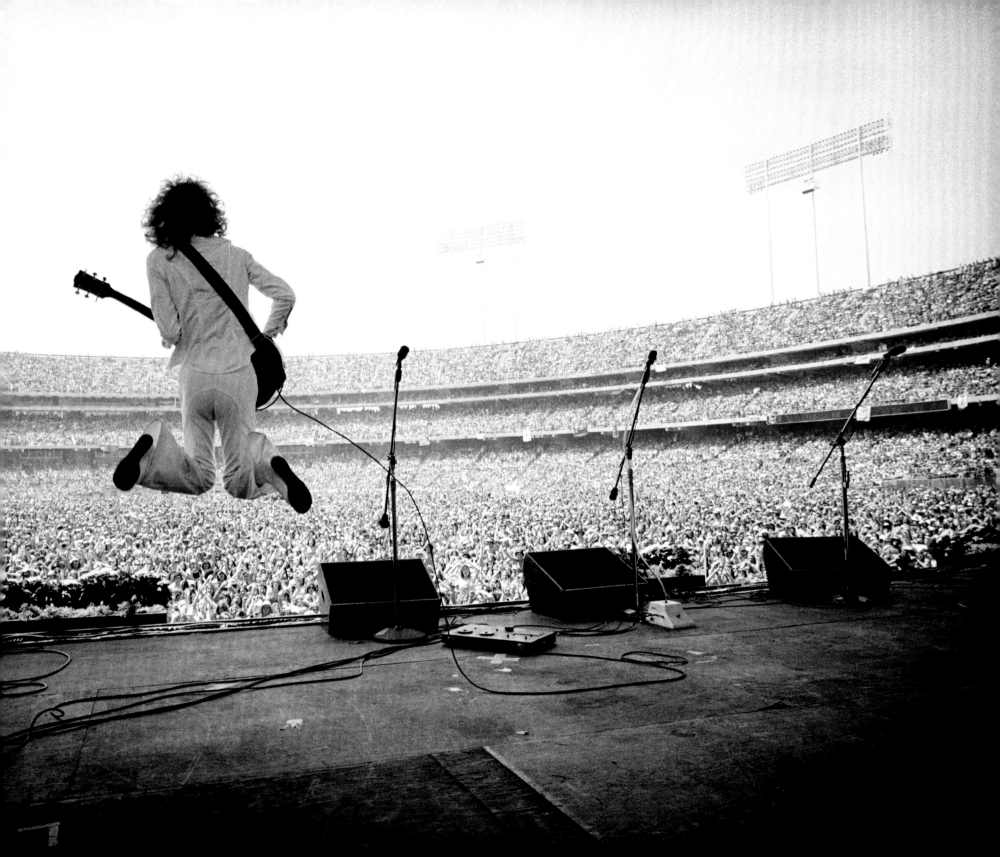

THE MONTEREY POP FESTIVAL

MICHELLE MARGETTS

I learned so much from Jim about the dark and the light sides of life, living in the moment, taking advantage of what the world presents to you. Just being in his orbit, I saw how instinctual choices can make all the difference and how one never knows where the next person you meet in life will take you.

Nowhere is Jim's approach to work and life more evident than in the way he chose to document the myriad festivals, across all major musical genres, of the 1960s and early 1970s.

While the precise number of people who came to Monterey Pop will never be known, total attendance for the three-day event was estimated at two hundred thousand with a peak of ninety thousand on Saturday night. A three-day festival held June 16–18 at the Monterey County Fairgrounds in northern California, Monterey Pop was organized in seven weeks by some of rock's L.A. royalty: promoter Lou Adler, John Phillips of the Mamas and the Papas, producer Alan Pariser, and publicist Derek Taylor. The goal was to bring together the most eclectic assortment of musical lights to ever grace a stage and elevate rock music's standing from pop gimmick to world-class, world-changing art form.

The promoters and organizers behind Monterey had a big vision and the savvy to pull it off. In my opinion, one of the smartest things they did was let Jim have full run of the place. His pictures capture this magnificently. And I bet that if you were somehow able to poll the collectors of Jim's work, shots made at Monterey would be in the majority of those hanging on walls around the world.

BRIAN JONES and **DENNIS HOPPER** chatting at the fairgrounds at the Monterey Pop Festival, Monterey, California, 1967

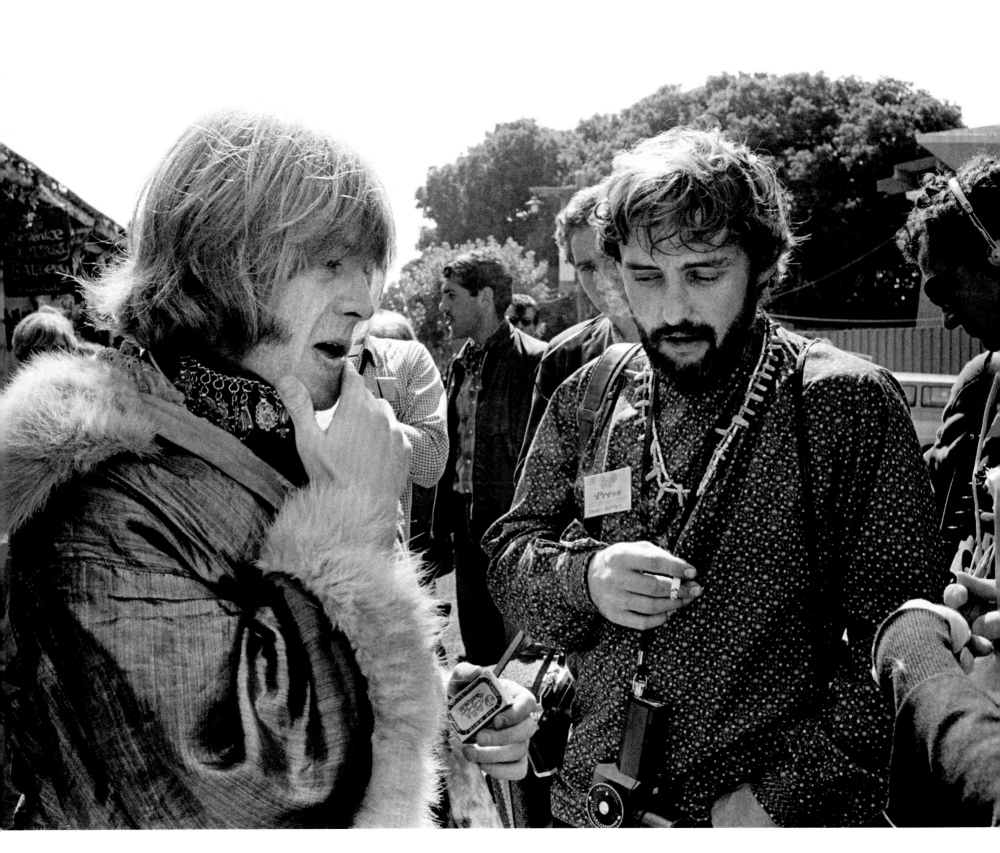

THE WHO, with **PETE TOWNSHEND** destroying his guitar on stage, at the Monterey Pop Festival, Monterey, California, 1967

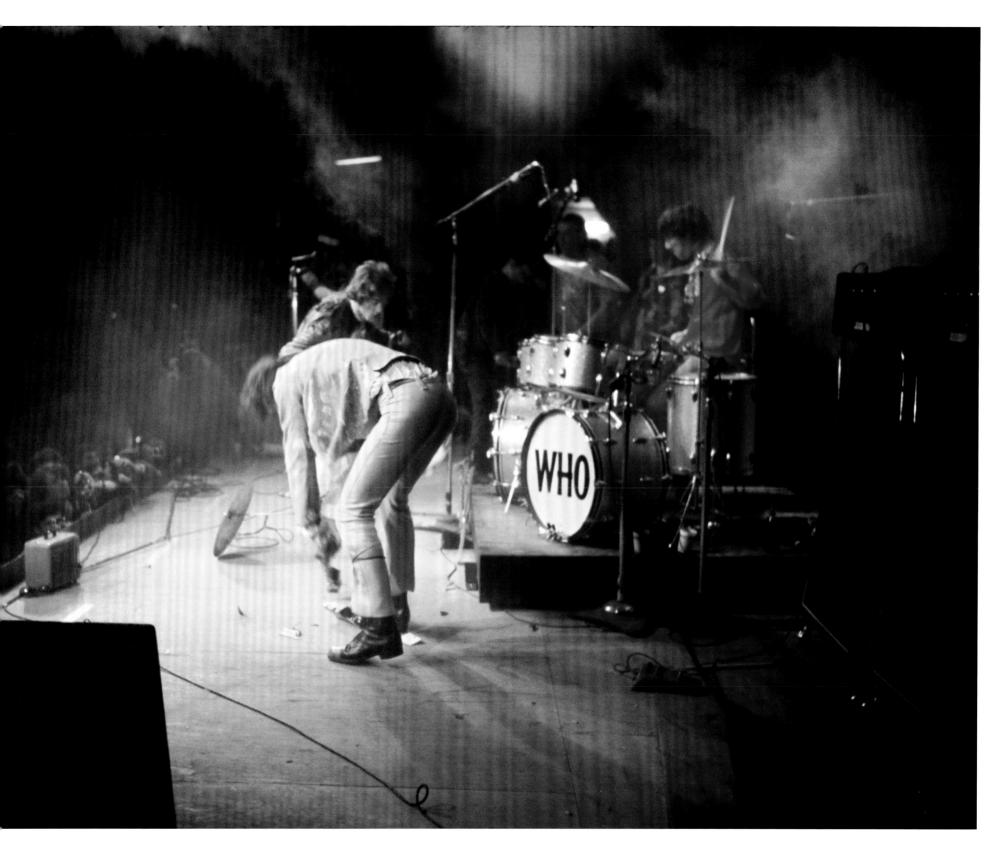

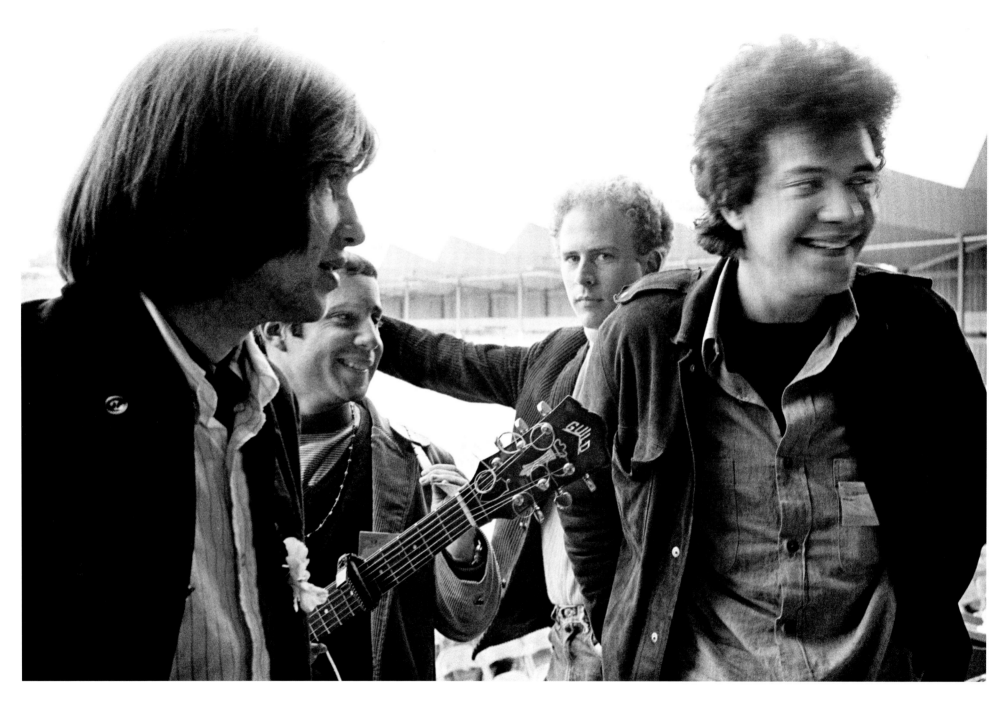

MARK NAFTALIN (Butterfield Blues Band), **PAUL SIMON,**
ART GARFUNKEL, and **MICHAEL BLOOMFIELD** during sound
check at the Monterey Pop Festival, Monterey, California, 1967

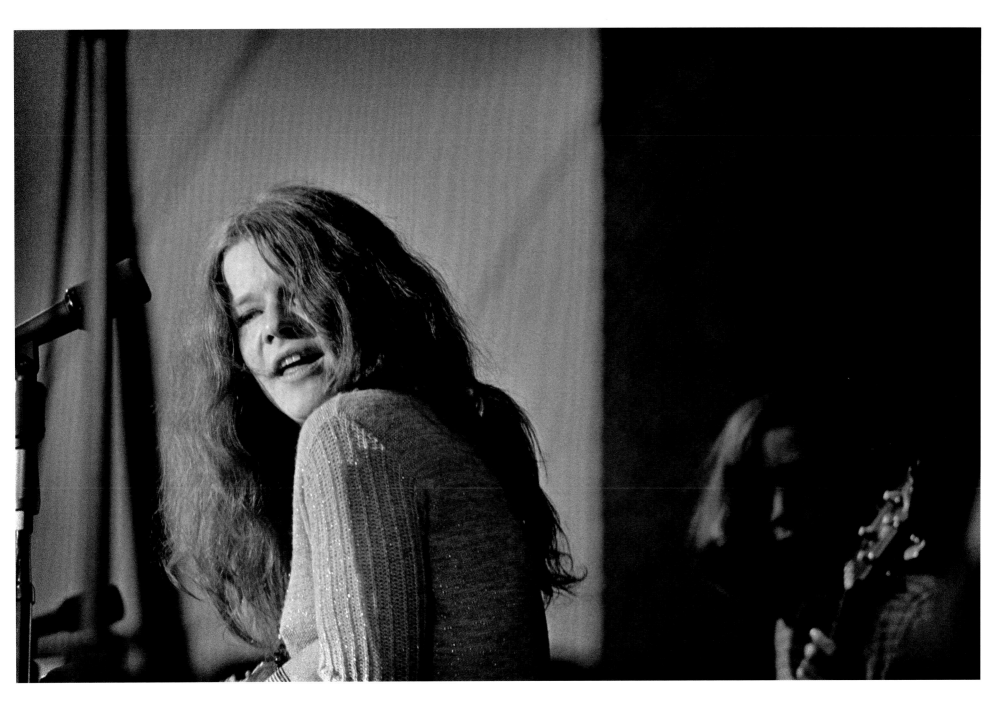

JANIS JOPLIN on stage with **PETER ALBIN** (Big Brother and
the Holding Company) at the Monterey Pop Festival, Monterey,
California, 1967

199

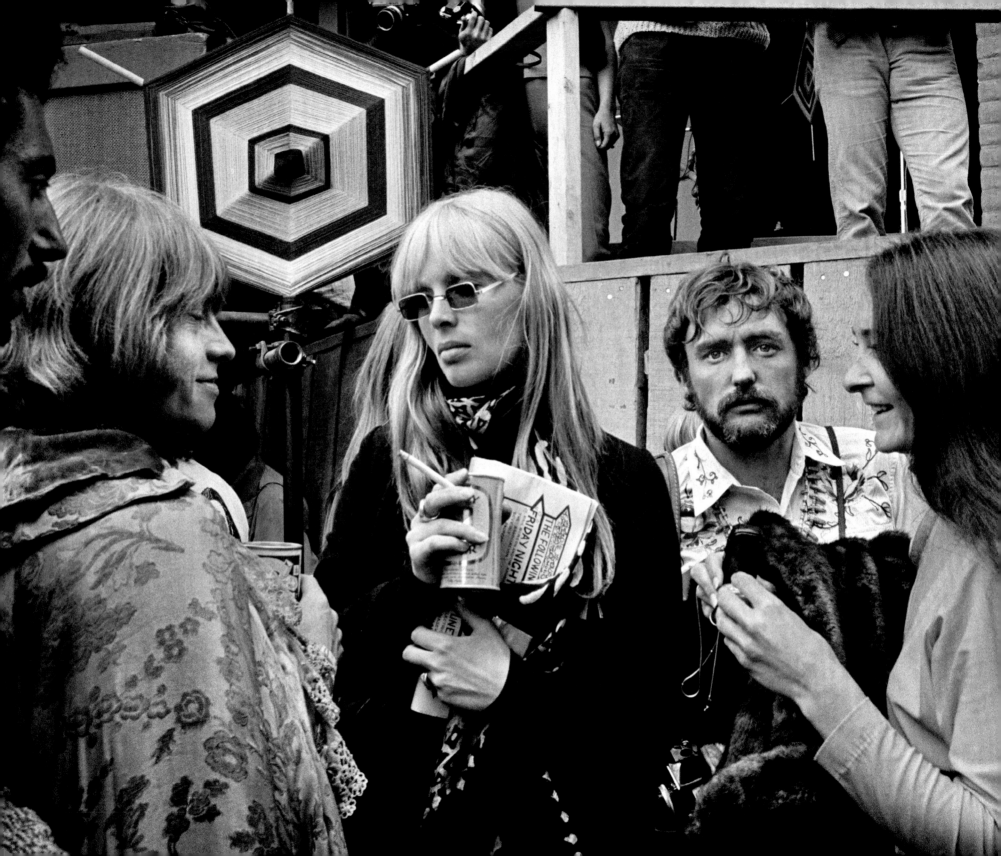

Jim was really *CURIOUS*, he was inquisitive, and more than wanting to just shoot it, you could tell he wanted to be in it. He wanted to jump in it and *EXPERIENCE* it. And he'd capture it too, but he wanted to have the *WHOLE FEEL*. And I think you get that in his pictures.

MICHAEL ZAGARIS

BRIAN JONES, NICO, DENNIS HOPPER, and **JUDY COLLINS**
backstage at Monterey Pop Festival, Monterey, California, 1967

One of Marshall's big-time rock 'n' roll queen crushes was **GRACE SLICK**. Just a few years younger than Marshall, she had it all—looks, talent, charisma, craziness, plus the upper-crust background (she went to "finishing school," and her Daddy was an investment banker who always wore three-piece suits). If you wanted to wrap Marshall around your little finger, all you had to do was look good and act dangerously—but in a ladylike way. And, of course, stick with him through thick and thin.

For a time, Slick seemed to fit that bill. Whether it was guns or drugs (coke, not acid) and booze, she and Marshall saw eye to eye. Marshall delighted in recounting how Slick used to stand on the balcony in front of Jefferson Airplane's manse at 2400 Fulton and shoot her shotgun into the air.

No wonder Marshall got all googly-eyed in her crazy-beautiful presence. It didn't hurt that Grace could write a truly great lyric and sounded like she was singing through a guitar amp from Mount Olympus.

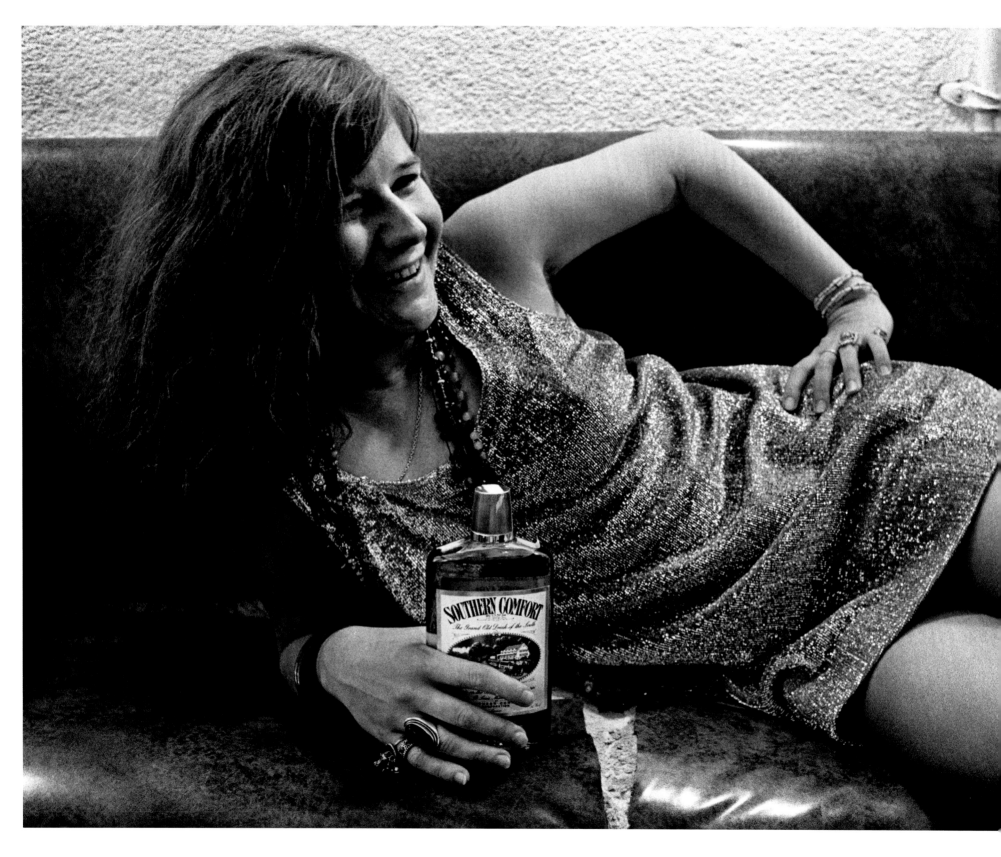

JANIS AND GRACE AND JIM

MICHELLE MARGETTS

Jim seemed on good terms with Grace Slick—he respected her, recognized her talent and beauty and thought she was a class act. But his real connection was with Janis Joplin. Maybe it was just the alchemy that occurs when one mercurial soul magnetizes another, or his admiration for the sheer raw power of what Joplin did on stage, but I think it was the trust she showed him.

With those old Leicas firing away, Jim seemed able to capture Joplin's light, whether onstage or posed—nowhere more powerfully than his now-famous images of her holding the Southern Comfort bottle on the ratty couch backstage. In one frame she's smiling, and in another sprawled and despondent. To her eternal credit, Joplin never once told him when to shoot or what to print, according to Jim. Zits, bad hair, fat thighs, exhaustion—how many of us could have such faith in a man that we would let him see that "realness"?

When Jim showed Joplin the sad-seeming vertical frame from that after-show backstage shoot, she said, "Jim, this is how it is sometimes. Lousy."

JANIS JOPLIN "happy" backstage at Winterland, San Francisco, 1968

JIM MARSHALL and **JANIS JOPLIN** backstage at Winterland, San Francisco, 1968

Jim always seemed so wistful when he spoke of Joplin, even after all the years that passed since she died at age twenty-seven. It was like he was permanently sad at the world's loss. "Janis was wonderful, not the prettiest girl in the world but she was not afraid of the camera. I could've shot her anytime at all, 'Go ahead, baby, and take a picture.' Janis was very important to me, real and honest."

The shots of Joplin and Slick show the Jim who's fascinated with their friendship, determined to debunk the warring rock 'n' roll Queen Bee myth promoted by record labels and publicists to heighten the hype.

In his book *Not Fade Away*, Jim recalls the only formal portrait shoot of Janis and Grace:

It was in 1967 for *Teen Set* magazine for an article on the two Queen Bees of San Francisco Rock. That morning I went over to Grace's house and then had to pick up Janis. Janis wasn't in the mood to do any pictures that day, but I begged her and she came along. Everyone always thought there was a huge rivalry between Janis and Grace, but they were dear friends. This is the only time they were photographed together, and by the end of the session, we were all getting pretty silly and clowning around.

Anybody who spent any amount of (positive) time with Jim realized the man had an intense need for you to see what he saw, hear what he heard, and, ultimately, love what he loved. I always thought it was his rather isolated childhood that made him that way; he really would have benefited from some siblings, especially a sister or two. Instead, he went about collecting them and their moments, and the world is richer for it.

JANIS JOPLIN "sad" backstage at Winterland,
San Francisco, 1968

"The Two Queen Bees of San Francisco Rock," **GRACE SLICK**
and **JANIS JOPLIN,** San Francisco, 1967

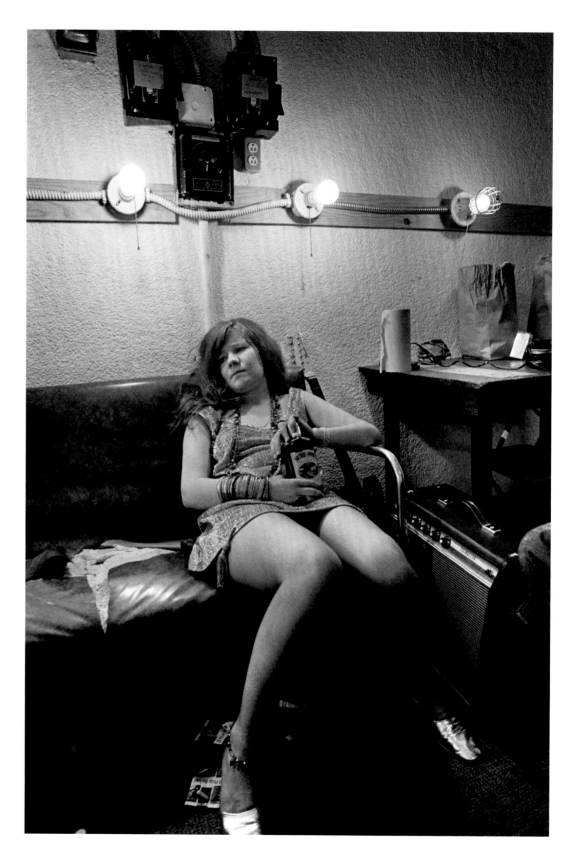

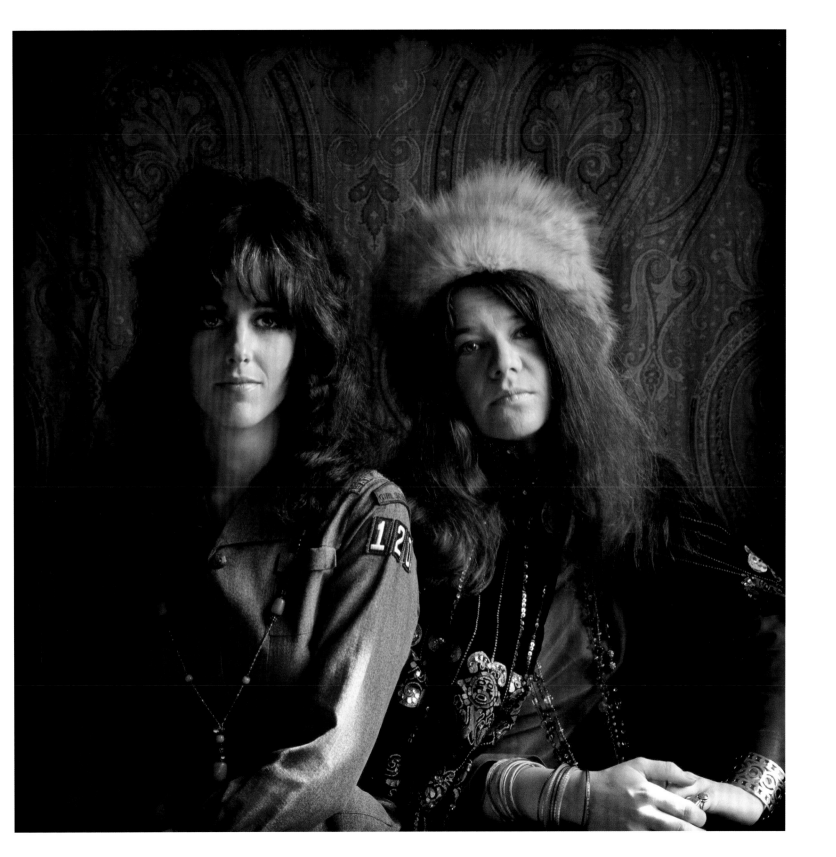

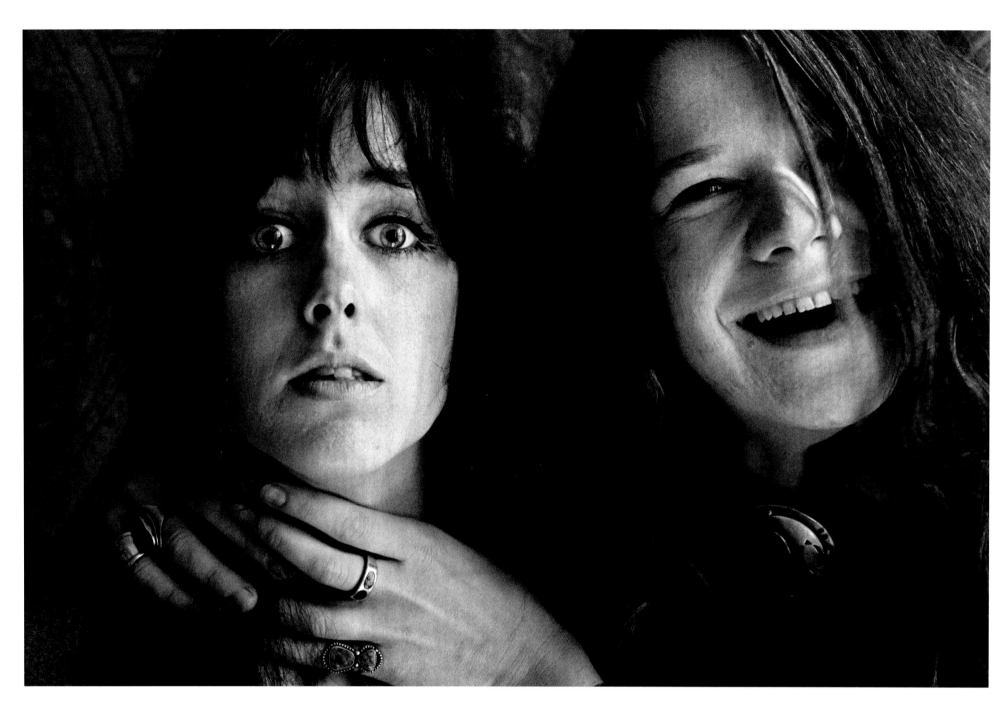

This page: **JANIS JOPLIN** mock-choking **GRACE SLICK**
Opposite: **SLICK** and **JOPLIN** laughing,
San Francisco, 1967

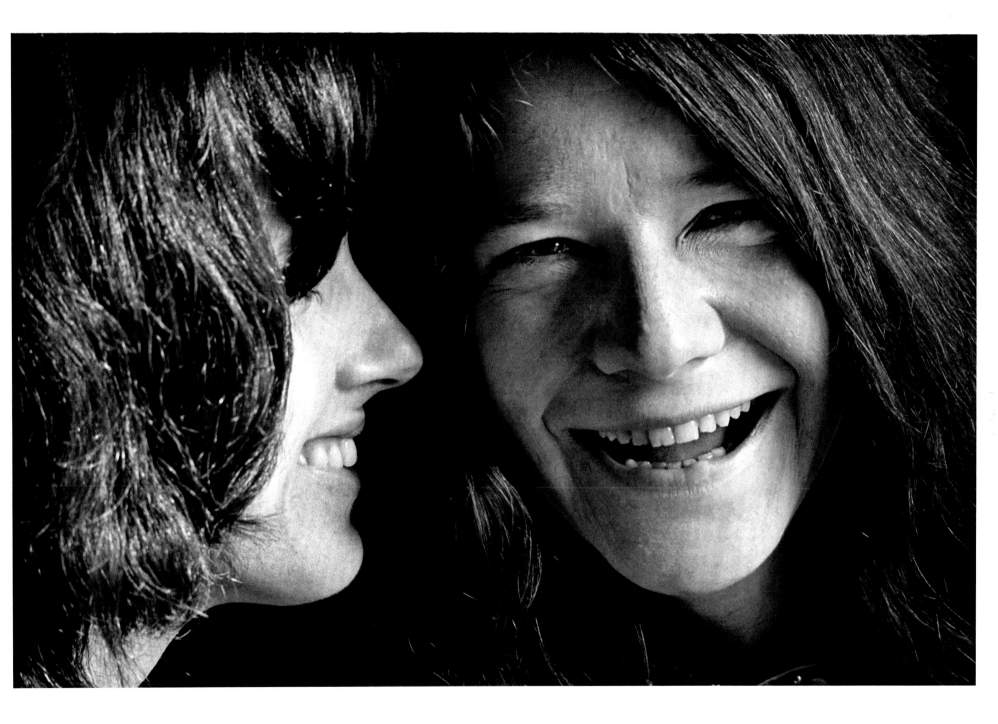

WOODSTOCK

MICHELLE MARGETTS

The most over-the-top festival for social impact, size of crowd, quality of vibe, and quantity of mud, plus nausea-inducing porta-potties, was the 1969 Woodstock Music & Art Fair. It was held on six hundred or so acres leased from Max Yasgur's dairy farm near Bethel, New York (more than forty miles southwest of Woodstock, New York; I guess the "Bethel Festival" just didn't have the right ring to it). The Woodstock festival was three days of cultural and musical experimentation, melded with a very, very heavy dose of, well, doses.

Jim's outpouring of work from the original Woodstock festival was prodigious. His images capture what it was like to be there from all perspectives—onstage, offstage, behind the scenes. He was reportedly a dervish of nonstop shooting until he collapsed in a heap backstage sometime during day three.

On assignment for *Newsweek* magazine, Jim seemed to bring an extra focus to capturing the energy of the crowd, including his incredibly striking shot of the technicolor masses. Jim said he had to climb up one of the huge lighting scaffolds bracketing the stage to get this bird's-eye view, taken with a wide angle "fish-eye" lens. This shot was used as the centerpiece of the live three-album set *Woodstock: The Original Soundtrack and More,* released in 1970. Jim was a bit afraid of heights, but he had been dosed with acid by the Grateful Dead earlier in the day, and that was the only way he had the guts to climb up on the stanchion and get this now world-famous shot.

Crowds at the Woodstock Festival, Bethel, New York, 1969

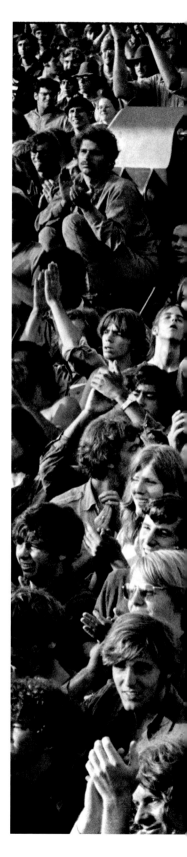

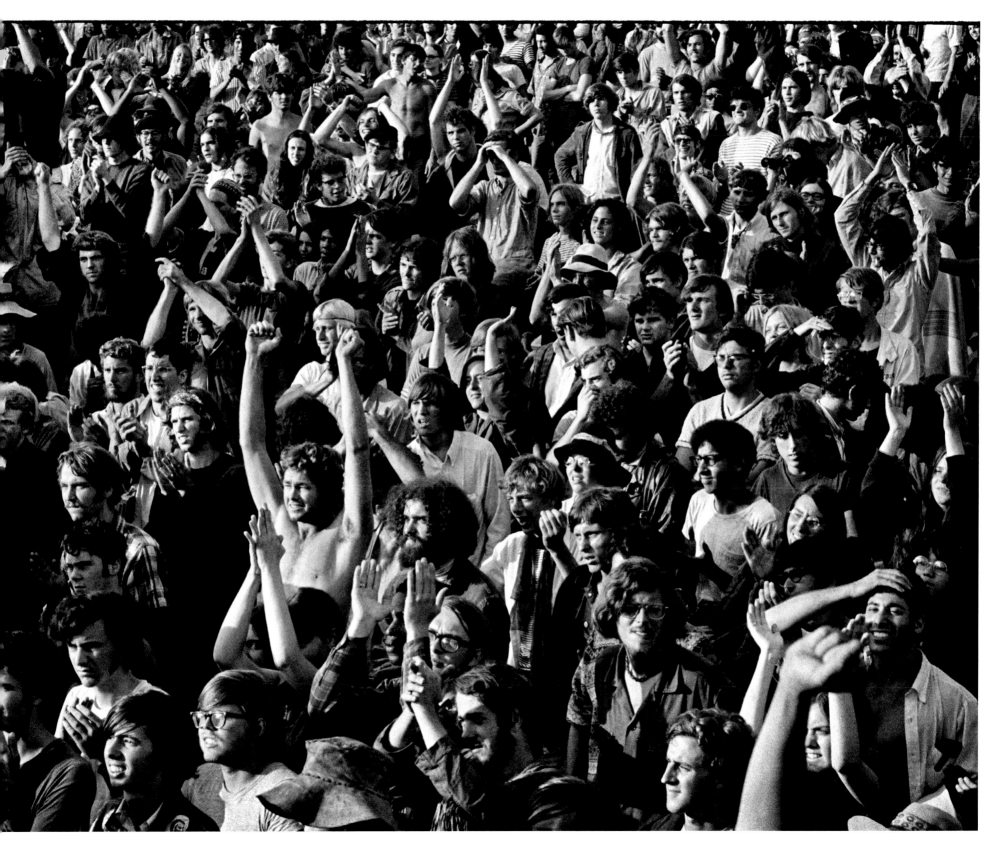

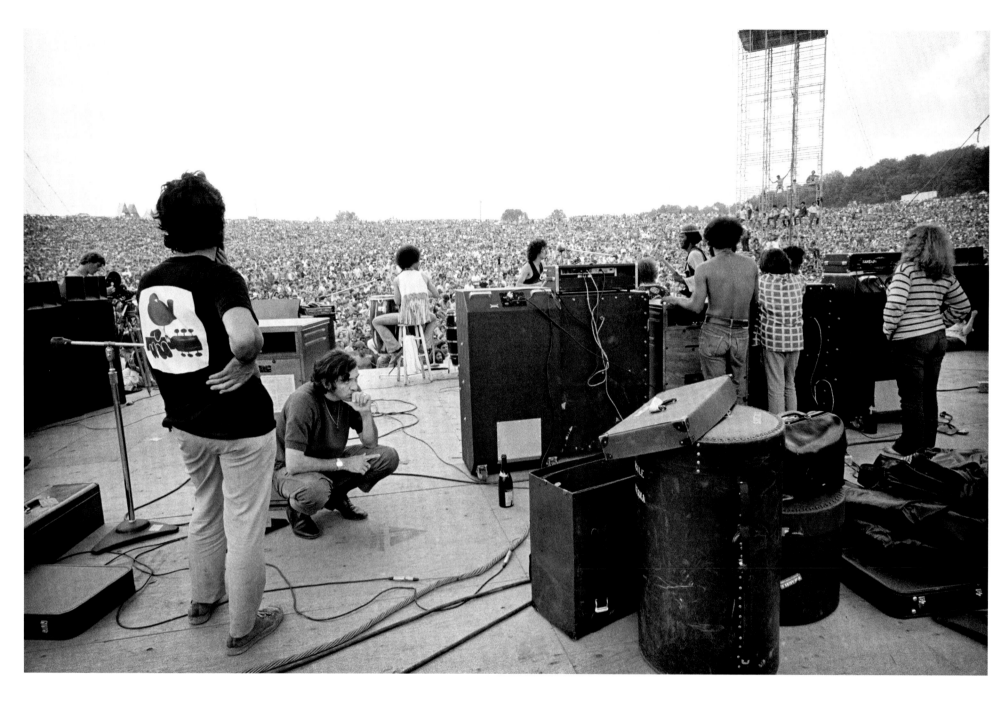

CARLOS SANTANA onstage, with **BILL GRAHAM** crouching
behind a speaker, Woodstock Festival, Bethel, New York, 1969

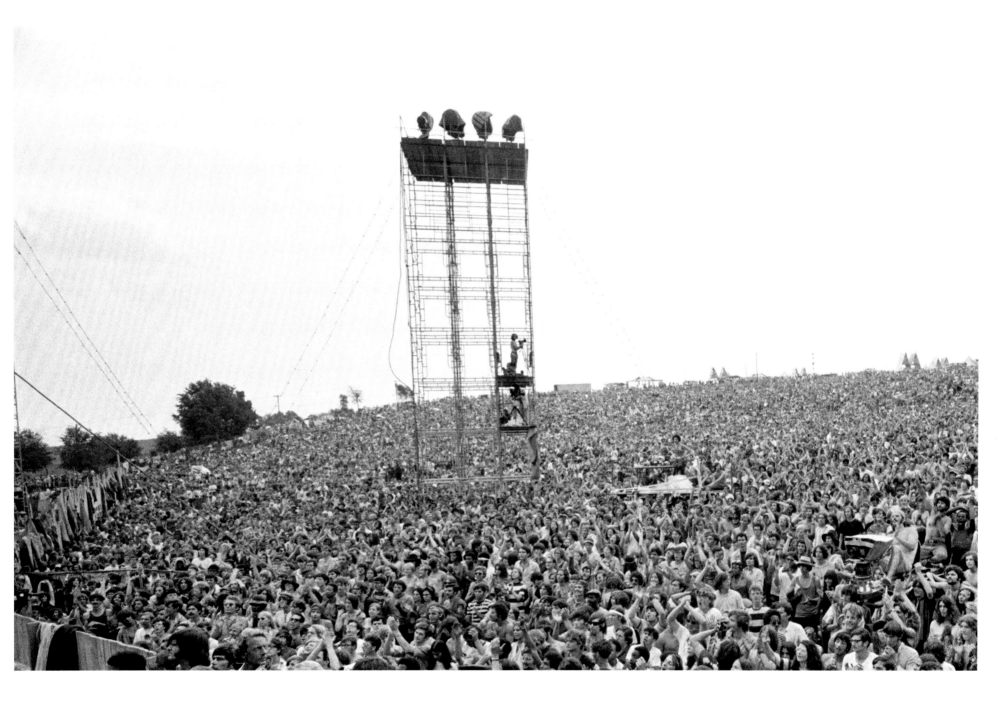

Crowds at the Woodstock Festival, Bethel, New York, 1969

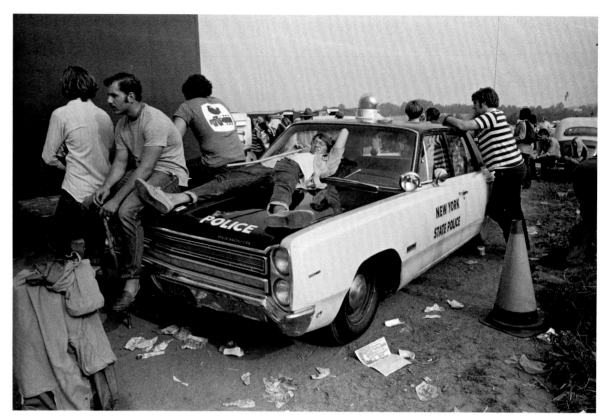

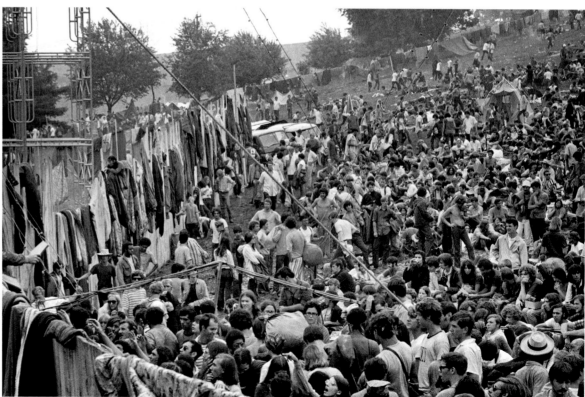

State police, Woodstock Festival, Bethel, New York, 1969

Crowds at the Woodstock Festival, Bethel, New York, 1969

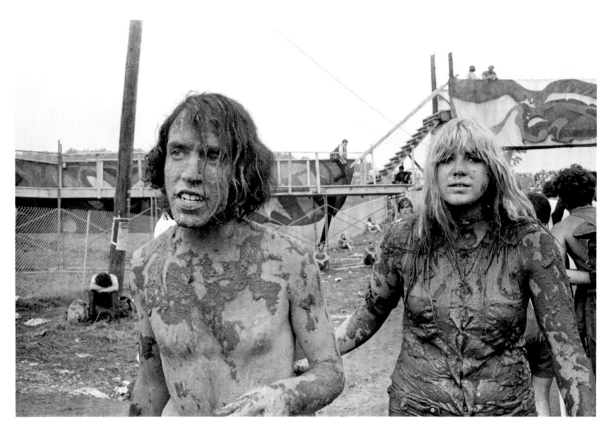

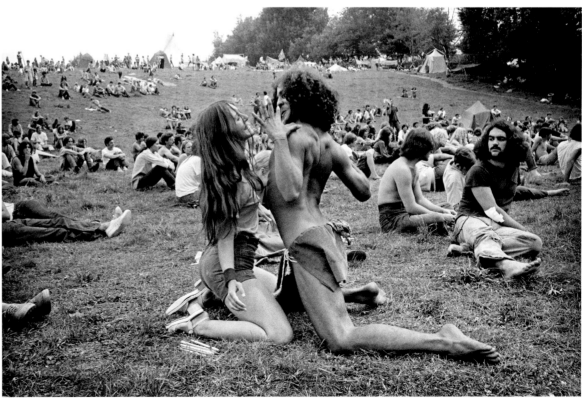

"Mudpeople," Woodstock Festival, Bethel, New York, 1969

Dancing couple, featured on the cover of *Newsweek* magazine,
Woodstock Festival, Bethel, New York, 1969

This page and opposite: **JIM MARSHALL** at the Woodstock
Festival, Bethel, New York, 1969

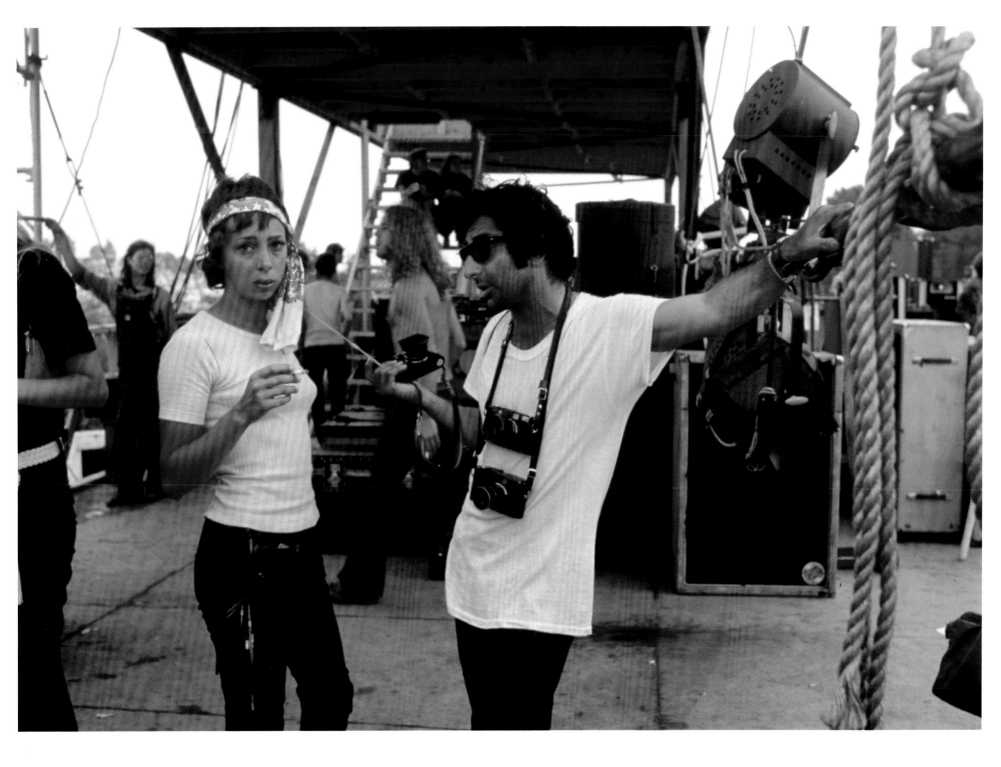

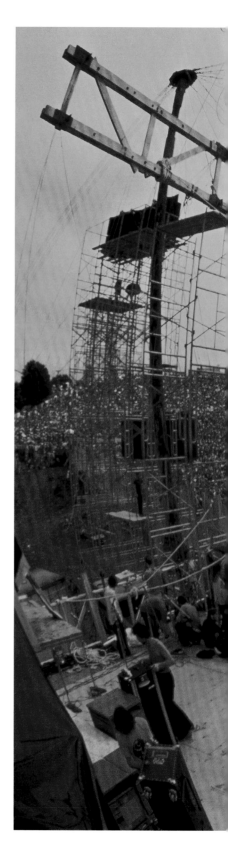

Bird's-eye view with a fish-eye lens and a filter of **CARLOS SANTANA** on stage at the Woodstock Festival (used as the centerpiece of the live three-album set *Woodstock: The Original Soundtrack and More)*, Bethel, NY, 1969

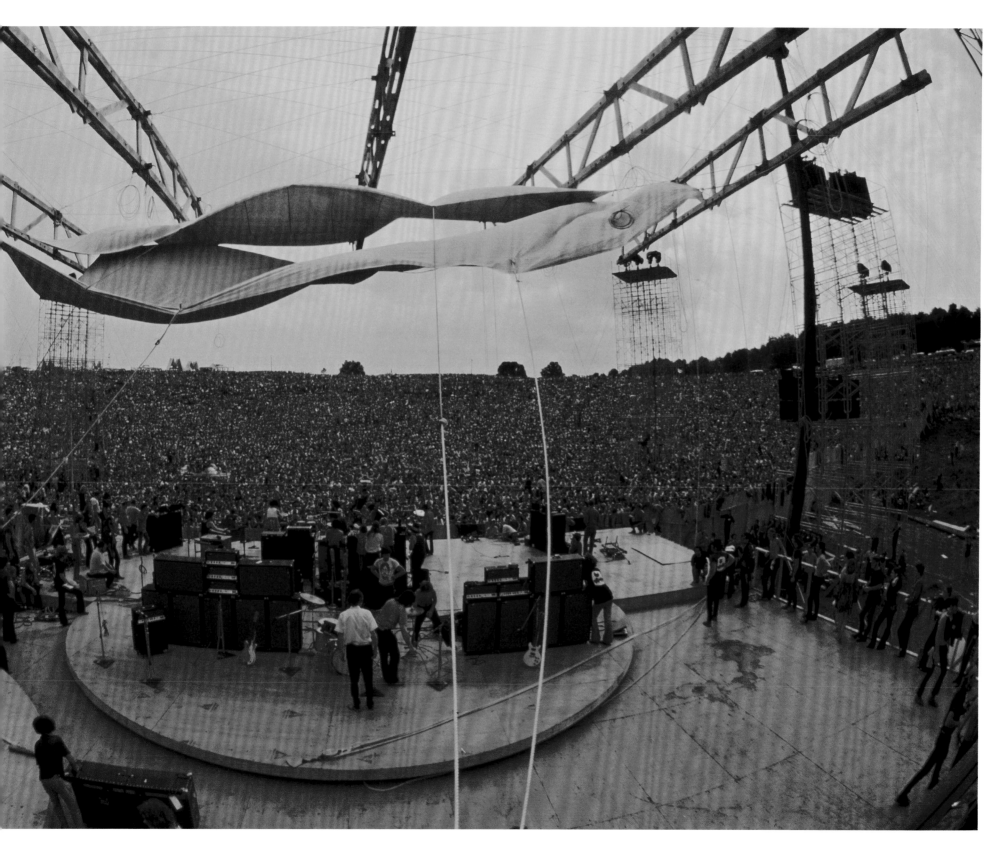

In 1969, only a couple of weeks after Woodstock, Marshall was at the North Carolina Blue Grass Festival. If ever there was proof needed that Marshall's ears and eyes knew no boundaries, this would be it. One week he was pulling all-nighters to grab early dawn shots of Jefferson Airplane and the Who, and the next he was noticing the beautiful symmetry of a line of Good Ole Boys with stand-up basses in North Carolina.

Booking agent and festival promoter Carlton Haney had been putting on these bluegrass gatherings over Labor Day since the mid-1960s. In 1969 he bought several acres at Camp Springs, North Carolina, to give the festival a permanent home. The festival's lineup featured some of the biggest acts working at the time, including Bill Monroe, Ralph Stanley, Josh Graves, and many, many others.

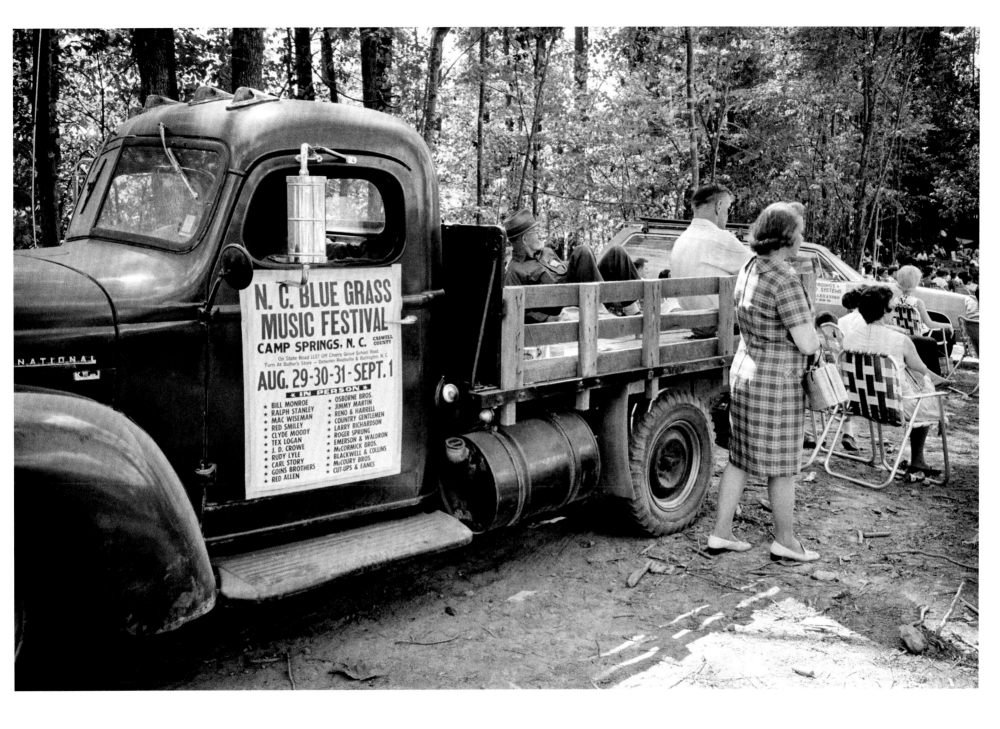

CARLOS SANTANA

MICHELLE MARGETTS

One of the many things that distinguished Jim's ability as a photographer, especially in his early years, was his extraordinary knack for recognizing talent very early, gaining the trust of those talented artists and musicians, and forging lifelong connections and collaborations with them. These connections allowed Jim to do what he did best: observe, listen, and then somehow capture still images that had the impact of entire movies, what Jim used to call the "hero shots." As near as I could tell, what he really meant by "hero" was that, in some nearly mystical way, these images made you feel something powerful. Whether it was in a loud way or a quiet way really didn't seem to matter to Jim.

Often, it's a well-timed whisper that gives you that life-saving smack to the solar plexus, or maybe it's that perfectly framed black-and-white image that comes in at the nick of time to help save your day. I think Carlos Santana has the same approach to his form of creating.

These shots span the first decade or two of Santana's musical career and showcase both of these young men's burgeoning talents. In my opinion, where Jim and Santana were concerned, it was definitely a case of "took one to know one."

Carlos just seemed to bring out the humanity in Jim:

I go back a long way with Carlos, to the year 1965. I remember I was sitting in jail on a drug charge, and the

bail bondsman who helped me get out was also the road manager for the Santana Blues Band. So he asked me to do him a favor and take a picture of the band. Since then I've done a couple of album covers, a lot of magazine work, and a very famous sequence of Carlos in his first recording sessions. I love the guy, and he plays the guitar like nobody else.

CARLOS SANTANA recording his debut album at Pacific Recording Studios, San Mateo, California, 1969

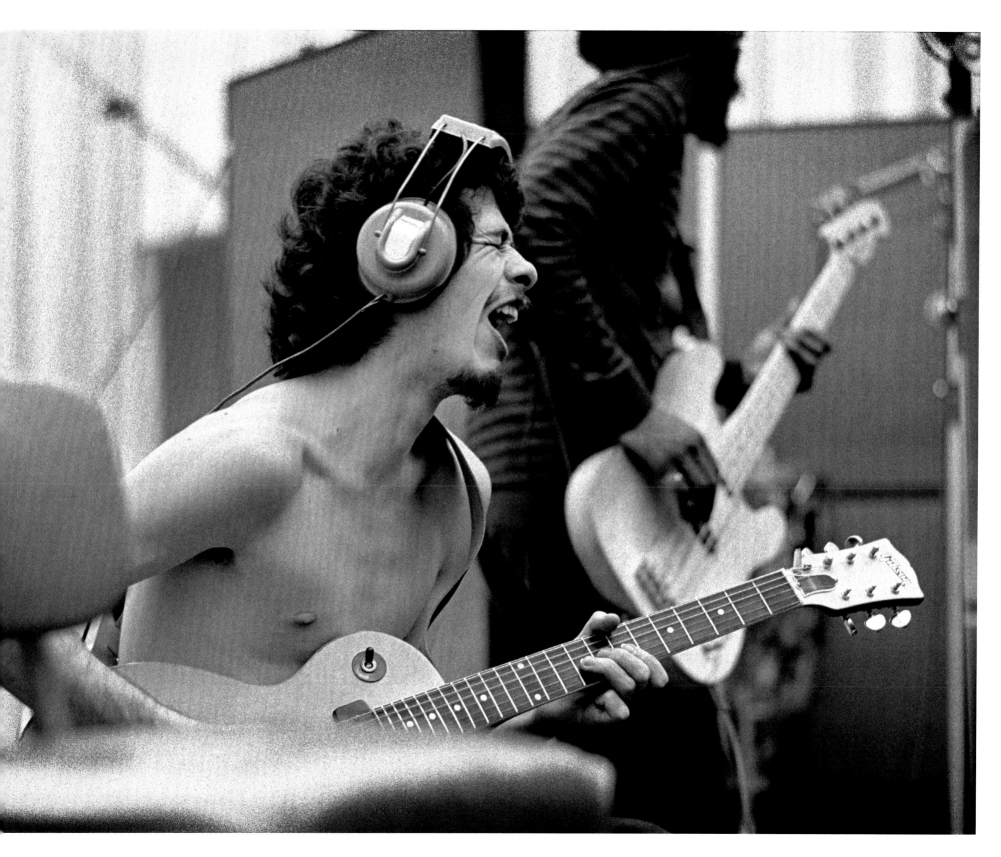

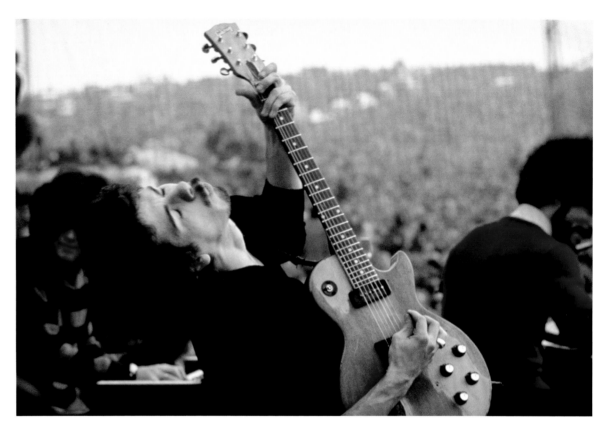

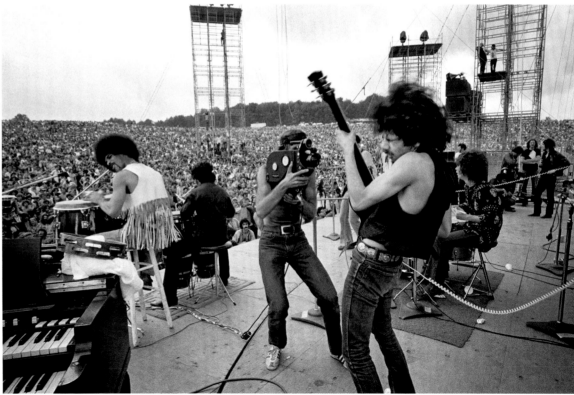

CARLOS SANTANA performing at the Altamont Free Festival, Altamont Speedway, California, 1969

SANTANA performing at Woodstock, Bethel, New York, 1969

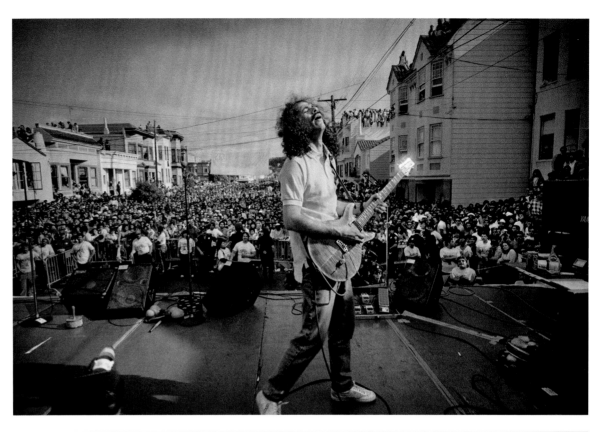

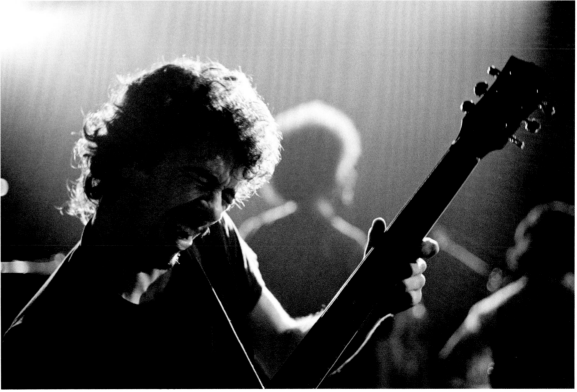

SANTANA performing at the Cinco de Mayo Festival, Mission District, San Francisco, 1988

SANTANA performing at Fillmore West, San Francisco, 1969

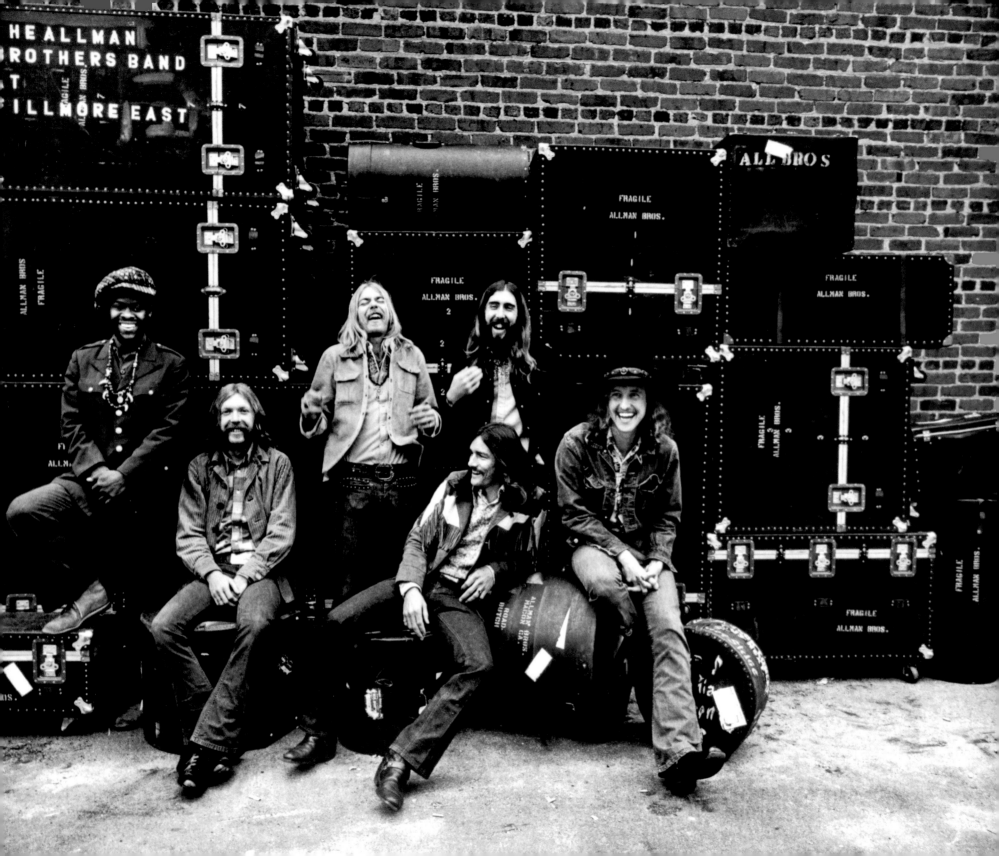

IN SOME WAYS, the visual culture was so important, and the clothes they wore, and all of it had significance. Even wearing your hair long in the South in the early sixties was a risk. And my father's band had a black drummer, and they traveled all throughout the South in a van as an integrated band, and that was risky. I think it shifted the conversation and moved the culture forward. And to have someone like Jim on the scene to document all of that, and to really appreciate that—Jim created a visual culture with his photographs that elevated all of these musicians. . . . I was two years old when my father died in a motorcycle accident, in 1971, which was a huge shock. He was 24 years old. So I really didn't have my own memories of him. . . . The picture Jim had taken of my father in a Holiday Inn bathroom, and he was just alone with his guitar—it was so different from any photo I had seen of my father practicing. I'd always been told my father lived with his guitar around his neck, and Jim just caught it.

GALADRIELLE ALLMAN

THE ALLMAN BROTHERS BAND. This photo was used for the cover of the album *Fillmore East*.

DUANE ALLMAN, Holiday Inn, San Francisco, 1969

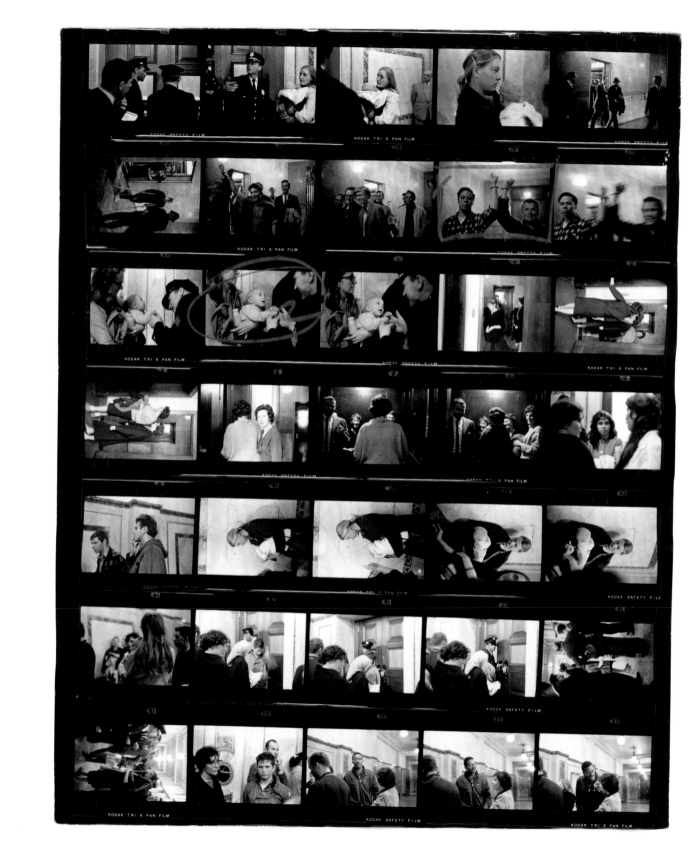

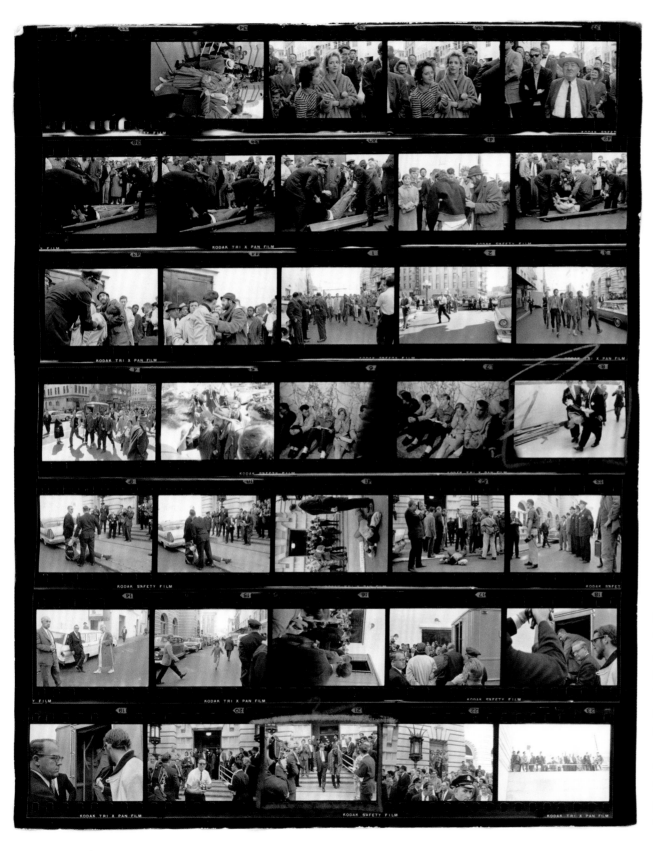

Everyman Nuclear Protest Demonstrations, San Francisco, 1962. *Everyman* was the name of a boat built in 1961 by Bay Area peace movement activists. They intended to sail into Pacific Ocean nuclear test zones to protest nuclear testing. On May 27, 1962, the boat sailed out past the Golden Gate Bridge, only to be stopped by the U.S. Coast Guard. The protesters were arrested and jailed for thirty days.

This proof sheet shows the demonstrations held to protest the jailing of the *Everyman* crew and also to protest nuclear testing. With his camera, Marshall captured the protesters, in particular Ira Sandperl, who was an anti-war protester and also very involved in the Free Speech Movement with Joan Baez.

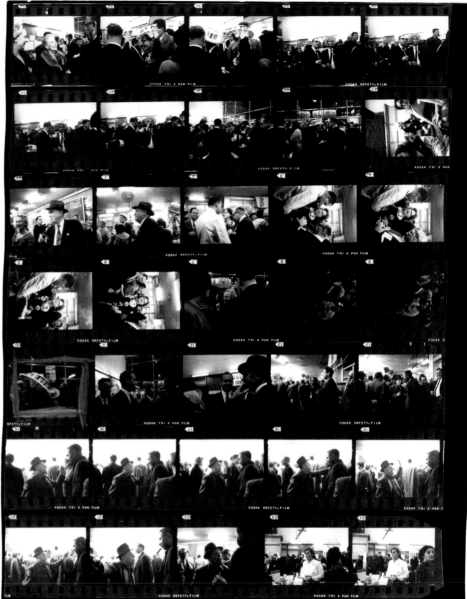

The 1960 United States presidential election in California, at San Francisco's Democratic Headquarters for the nominee, Senator John F. Kennedy. California voted for the Republican nominee, Vice President Richard Nixon, and his narrow victory over Kennedy was the closest of the states Nixon won in 1960.

ODETTA and ELIZABETH COTTEN, joyful at the rare opportunity to see each other backstage at the Berkeley Folk Festival in 1978. The great Odetta, a.k.a. "The Voice of the Civil Rights Movement," is cited as the key inspiration in the folk revival of the 1950s and 1960s. She was also a major influence for Bob Dylan, Joan Baez, Janis Joplin, and Mavis Staples. Elizabeth Cotten wrote "Freight Train," honed the left-handed guitar style known as "cotten picking" and never played anywhere but in church until she was in her sixties, when she was discovered by the Seeger family, for whom she worked as a housekeeper.

232

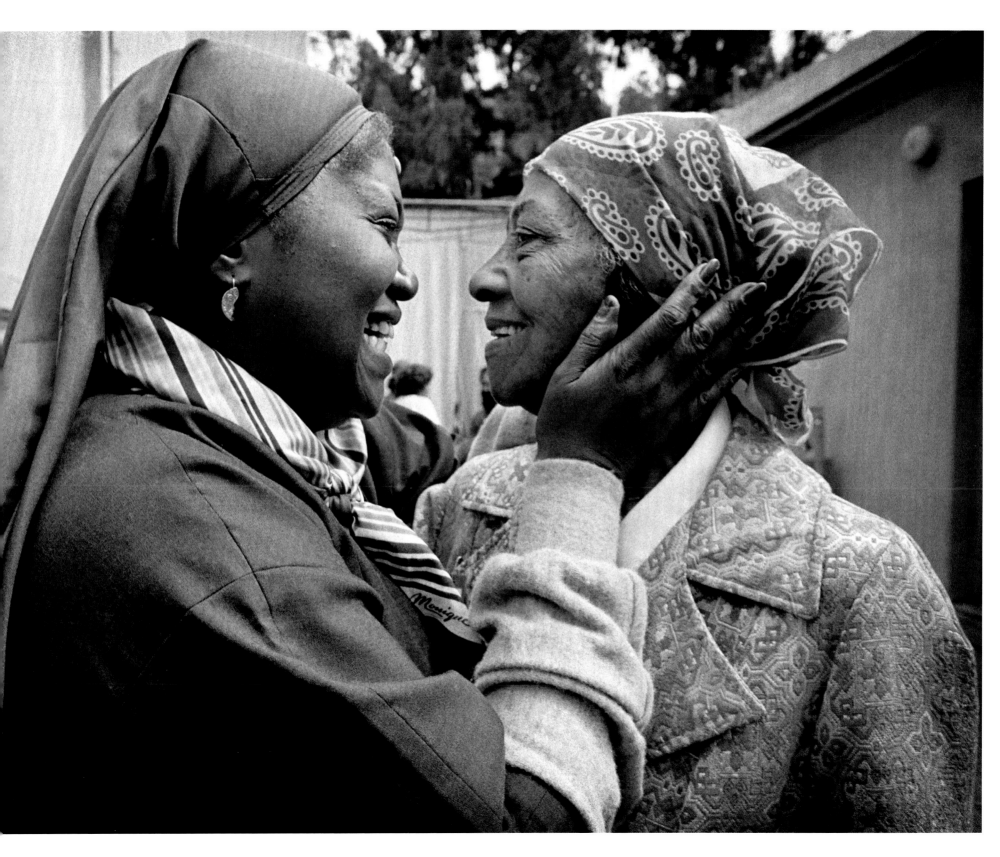

JIM MARSHALL reflected in the mirror while photographing
ANDREW WOOLFOLK, saxophone player for Earth, Wind, and
Fire (left) and VERDINE WHITE, bass player for Earth, Wind,
and Fire (center), circa 1970

MARSHALL photographing BUDDY GUY and JUNIOR WELLS,
1970

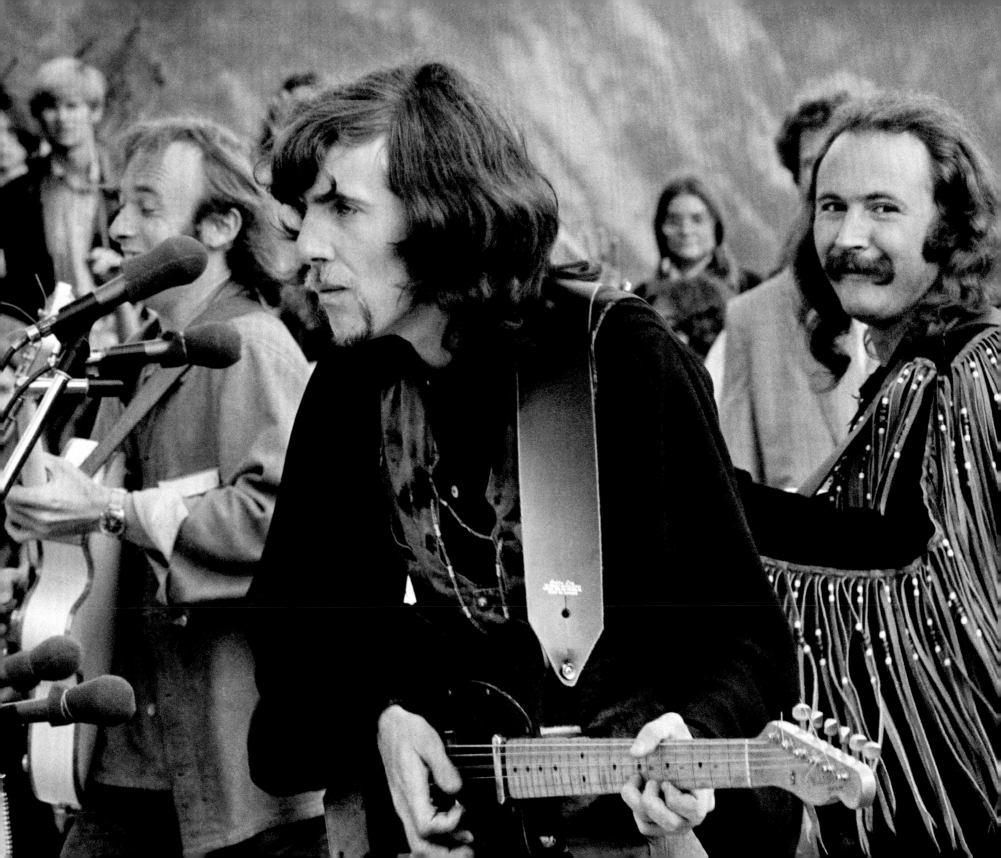

Jim Marshall had an amazing ability; he was *PUSHY*, but in a really *HUMAN* way. Every artist that he shot knew that Jim wanted the best shot of them, he always wanted that. . . . Artists trusted him. They knew he wasn't going to ask questions like, you know, who you slept with last night, and what color socks have you got. . . . People *TRUSTED* Jim Marshall, and I think it shows in his work.

GRAHAM NASH

CROSBY, STILLS & NASH, Big Sur Folk Festival, Big Sur, California, 1969

THE KID AND THE OLD MAN

MICHELLE MARGETTS

Michie—

For us there will always be time—now & from before & for always—I really did love you—from before you were born—we shall always be the kid & the old man—just a note to tell you once again how much I love you.

—James

I MET JIM MARSHALL IN MARCH OF 1984. I was a journalism student at San Francisco State in need of a last-minute subject for a course assignment, a "Whatever Happened to . . ." profile. I was twenty and basically clueless about a lot of things. Like, who the hell was Jim Marshall?

Another student who knew of Jim's work and his "dark side" suggested him as a subject after my first interviewee fell through.

He ran down a list of Jim's highlights and lowlights: sorta famous; more importantly, *infamous*; into guns and coke and booze. The litany continued—Jim was maybe a genius and the best music photographer who ever lived, having photographed Woodstock, Jimi Hendrix, Miles Davis, Janis Joplin, Bob Dylan, the Beatles' last concert, six hundred album covers, etc. He had just got out of jail for a gun beef with some neighbors in his Union Street apartment building (incorrect: he had just been released from a work furlough program); he was on probation and perhaps homeless, banned from ever stepping foot in his Union Street digs (incorrect: he never was on probation and was now living in a great apartment on 16th Street); and he was a paranoid, impulsive asshole (very correct).

Even if I could find this Jim Marshall, I was skeptical about whether he would agree to speak to me, a lowly journalism student. But I was intrigued as hell.

MICHELLE MARGETTS by Jim Marshall, San Francisco, 1984

I began a fruitless search for him with the probation department and parole officers. Out of desperation, I called 411—I mean, what paranoid felons are listed in the phone book? Two minutes and one forwarded number later, the phone picked up on the second ring and a forceful rasp I would come to know and love—and sometimes dread—said, "YEAH lo!"

Shocked to learn that it was, in fact, the correct Jim Marshall, I stammered out the gist of my call. Jim barked out rapid-fire: "Haven't you heard of the White Pages? Of course I'm listed, why wouldn't I be! You call yourself a journalist! Not so fast. How old are you? Sure, I'll meet you, but what do you look like? Cadillac Bar. Downtown. Three p.m. Don't be fuckin' late!!"

He brought a beat-up Kodak Ektacolor eleven-by-fourteen-inch photo paper box full of black-and-white proof sheets to our first meeting. "I'm thinking about making a poster," he said, "as my comeback: Jim Marshall Shoots People, with all these killer shots." He had it figured out, how you can get ten images across it and fourteen down. He'd designed it all in his head, before he'd even shown it to an art director.

Jim had been out of work furlough for five weeks, and he literally couldn't make rent. He claimed he knew the precise number of ignition turns he had left on his ancient Ford Ranchero—it was ninety-three.

I didn't have the guts to tell him I'd never heard of him. He scooted his chair closer and ordered us green margaritas (for St. Patrick's Day). He kept picking at his cuticles when he wasn't trying to hold my hand. I slowly flipped through the proof sheets, with hero shot after hero shot circled in yellow and red grease pencil. I could not resolve the strange, horny little man with the Leica over his shoulder and the hundreds of transcendent portraits I was seeing. And I could see, deep in that all-appraising gaze Jim was famous for, that this was big trouble. The very definition of "conflict of interest." Journalism 101, but Jim didn't care. He was in love.

And he was determined to pull out all the stops, including walking me to my car, even though it was parked right outside the bar and it was still broad daylight. I was getting tense, thinking this old fuck was going to try to kiss me, and I'd have to knee him in the 'nads. But as I turned around to thank him again and ask about the timing of a follow-up interview (now that I seemed to have passed the audition), he leaned up at me and very gently caressed my cheek with the back of his left hand. He said he looked forward to our interview on Saturday and walked away.

Later, he crowed to anyone who would listen that the "hand thing" was a move he'd seen James Dean do to Julie Harris in one of his favorite movies, *East of Eden*.

I wrote the profile and tried (unsuccessfully) to keep Jim, and his hands, at arm's length. My professor asked for a few rewrites and gave me an "A." The profile was slated to be the cover story of the campus quarterly I was art directing, set to run with a portfolio of Jim's greatest hits.

We figured out which photos to use and what was going to be the cover. The deadline was getting close, and then Jim pulled the Jim card. He tried to use the photos to manipulate me, threatening to pull them if I didn't tell my family that he and I were in love. He kept saying, "I don't want to be with you in the shadows."

They say sunlight is the best disinfectant. I came to my senses and pulled the story. I went to my editor and John Burks, my advisor and publisher of the campus magazine. I said, "I need to confess something, I'm having a relationship with this guy, and we're not running this article." What I learned, and of course, every journalist needs to learn is, you can't really cross that barrier. You are going to be a lover writing about the person you are sleeping with, or you are going to be objective, however you define that, and view this person with all their warts. You cannot have it both ways; it's impossible. To this day, that article has never been published.

INSTEAD, I CALLED JIM'S BLUFF and went for the relationship. The thing that always made me love Jim, no matter how much I wanted to kill him, was that he was the first person to convince me I could go to New York and make it there. Even though he was asking me to marry him every third day, he really wanted me to go to New York. The best part of him wanted me to find out who I was supposed to be. And deep down, he knew it wasn't Mrs. Jim Marshall.

Since we were such an odd couple, Jim delighted in finding things we had in common: We both hated onions, loved Levi's 501s, and swore by Colgate toothpaste. We liked Grey Flannel cologne, Brooks Brothers button-downs, Bass or Cole Haan penny loafers, and Basic soap. A coffee purist, Jim loved to grind Celebes Kalossi blended with French Roast coffee beans for us in the morning—he used a classic pour-over glass Chemex carafe. I still have a Braun coffee grinder he gave me.

The twenty-eight-year age difference was more curse than blessing, and our basic temperaments were far too combustible to make it as a couple. What I really wanted was for Jim to take everything that was good and wise in his brain—all that he knew about life, love, the world, the arts, photography, editing, and writing—and just shove it into mine. And he did his best to oblige.

He gave me Maxwell Perkins's biography. He had me read *Let Us Now Praise Famous Men*. He told me about W. Eugene Smith, James Agee, Walker Evans, Dorothea Lange, Roy DeCarava, Jill Freedman, and Magnum Photo Agency. He gave me *The Family of Man*, Jerry Stoll's *I Am a Lover*, and poetry from the 1960s, and he held forth on William Blake and Lawrence Ferlinghetti.

As a former race driver, Jim taught me some tricks to navigate the mean streets of San Francisco: how to never end up idling on a steep hill at a light with a stick shift; how to go into a curve low and come out high; how to watch the left front tire of the car to your right to anticipate when it might merge; and mostly how to look far down the road, as far as you could, so that nothing surprised you.

Jim wasn't a mechanic, but he was mechanically minded, and he feared all things digital. He loved cars, guns, and cameras,

as everybody knows. But what he loved was elegant (i.e., simple) design, reliability, and explicability. He could always explain to me, if I asked, what was going on with his truck, or what was going on with his camera. He could put a new roll of film in his camera one-handed and faster than anyone I ever saw. He was a gearhead.

I have a mostly blue-collar background. I grew up as a plumber's daughter, with carpenters, mechanics, warehouse-men, and steelworkers. And that helped me really understand and appreciate Jim, whereas a lot of people—including himself—judged him for not being from the posh side of the hill.

Jim was very class conscious. When some Marin frat boy with a pink button-down came around in a tricked-out Mercedes, Jim could be a fanboy, using the commonality of the car to connect, but it was nearly obsequious. I'd ask him, "Why are you being so over-the-top ass-kissy to that guy?" And he would grimace and give me the side eye, pretending he didn't know what I was talking about. But he also knew these guys were potential collectors of his work.

Jim made his comeback in the mid-1980s by developing a roster of regular collectors and sporadic photo shoots that kept the lights on. But he didn't feel he deserved any of it, so he sabotaged a lot. Before the first gallery show that came together when we were a couple, he almost pulled out at the very last second because he didn't have his own wall of work. I had to literally drag him into this gallery. He was upset, because no matter how wonderful the show might be, he knew it was never going to be enough. He had that hole in him that just seemed to be unfillable.

He talked a lot about his mom with me. She was still alive, but they were completely estranged because of the way Jim's second wife, Rebecca, had to leave him. Rebecca was really, really close to his mom, apparently, and she had to, essentially, vanish because Jim was just a degenerate cokehead at that point. He had a lot of guns, and probably a lot of not-great people around him. The way Jim told me, Rebecca left one day for a work trip with one suitcase. She took twenty thousand dollars, left him a note in his sock drawer, and never came back. A year later she sent divorce papers. He spiraled out of control. That was two years before we met.

Jim wouldn't talk much about his dad. He told me his father spoke fourteen languages, was an alcoholic, and was probably a spy during World War II. He told me that his dad would hit him, and that the last time he hit Jim was when they were eating

dinner at their apartment in the Outer Richmond. Jim said, "He took my head, and he smashed it down on the kitchen table." He knocked a tooth out, so Jim had a fake front tooth. Jim had hit puberty, but sometimes I wasn't sure how much further along he'd gotten. Maybe that one smash to his head on the table froze him in place.

I don't think Jim's mom was integrated into American culture. I never met her, but I don't think her language skills and English were tremendous. She worked in a laundry; she had a few different jobs. He was mortified at her lack of sophistication, and this insecurity propelled him toward that preppy thing.

I DEFINITELY KNEW THAT I WANTED JIM in my life, but I didn't want all the rest of my life to be vaporized. It put a big rift in my family for a couple of years. It was only about two years that he and I were together, and we were probably off more than we were on. He wouldn't really let me break up with him, and he was relentless. I said, "Don't call me." He asked if he could write, and then the five-by-seven-inch yellow legal pads covered in his telltale handwriting started to show up at my

dorm mailbox. And flowers. It was a heady experience to be in Jim's emotional crosshairs.

I also continued to want to have the experiences Jim offered and meet the people Jim knew. I got to go backstage at Santana concerts; I met Mimi Fariña, Joan Baez, and Mary Travers of Peter, Paul, and Mary. There are hundreds, maybe thousands, of stories and people that I wouldn't have in my life without him. And even in that down, dark time, it was really exciting to be around him. And frustrating. The worst thing I ever wrote to Jim, after I had been in New York for a few months and he was being a real dick, was this: "You are a rock and roll suicide that never died."

Jim was very conflicted when I met him about how the music business had evolved. I didn't fully understand what it took to document Woodstock the way he did. It would bounce off my forehead a lot, how deeply wounded Jim was to be lumped in with all the paparazzi. And he would go absolutely psychotic if he was asked to stand in a pit, "like cattle," with a bunch of other photographers for only three songs and then herded out of the venue. We went to a TV talk-show taping with the famous paparazzo Ron Galella, who stalked Jackie O. I thought Jim was going to try to strangle him, but he just asked

Galella a really pointed question, his voice shaking with rage, about trust and how Galella could live with himself when he had betrayed so many people. Galella didn't have much of an answer.

Jim couldn't hear very well at that point. He was mostly deaf in one ear, and his memory was getting shaky. He always had a black Sharpie with him, and one of those five-by-seven-inch yellow legal pads, which he kept in a beautiful leather holder with a "Gort" sticker on it (from his favorite movie, *The Day the Earth Stood Still*). He would write down everything he had to do for the day: Take in the laundry, buy dental swords, prep for Joan Baez shoot, and threaten that guy who owes him money. He could be extremely methodical and obsessively thorough.

I have boxes of these little yellow legal pads, many of which he wrote during our "dark times." But many he mailed to me in the years after I went to New York in June of 1985. Here is text Jim scratched out on some pages, outlining a seminar he hoped to give one day:

> I think that sometimes photography in schools is too formulaic and far removed from the reality of day-to-day working photographers. I feel all of this work happens in concert with the open exchange of ideas and philosophies, and we all should be proud of it, and all try to elevate standards of our profession or our vocation.
>
> What I would like to do in a one-day seminar is to show my work from various aspects of my career, discuss the photographs, and look at the portfolios of the people attending. To discuss ethics and values, personal trust, not the business but how one can apply all their skills to the commercial world. Not to compromise when people allow you into their lives with a camera.
>
> To try to explain the difference between a fine photograph, perhaps taken at a tense or very private moment, and perhaps when to back off and not photograph. It is a difficult decision. I feel an open discussion of this could be very rewarding, and perhaps change some people's way of photographing without intention. It is a fine line.
>
> This will not be a technical class, yet I shall not hesitate to berate sloppy craftsmanship. We do what we do. I would like to keep a loose structure to the day and

be open to any and all constructive ideas. In photojournalism, to become 99% involved, yet leave 1% detached so one can function, 1% can work the mechanical thing called the camera. To not let this machine come between your vision and feelings and what ends up on film.

AS I BECAME A WEB PRODUCER, I learned more and more about databases and digital design, the way links connect, and the way tangents and conflicts can lead to intrigue and action. And I realized that this was the way Jim's brain worked, too. He linked everything naturally and dove right in. He could go up to strangers, introduce himself, and ask the most blatant stuff: "Are you Jewish? Where are you from? You have a big nose for a Protestant. Oh, buy this Jew a drink." And ten minutes later "this Jew" is buying seventeen signed prints from him, and isn't Jewish, by the way. I saw him do this countless times in his apartment, in my loft, in living rooms, in the best restaurants and bars in San Francisco and New York. Anywhere the world found him or he found it.

It's been more than thirty years since our first meeting and the first crucial lessons I learned from Jim. But there were many, many more dispensed over the years. Listen to your instincts. Be true to yourself. Don't bullshit. Keep it simple. Know your equipment. Respect your subject's trust. Get closer! Protect your work. No. Matter. What.

I would say that I miss Jim, but I can't. He's in my heart and head. His framed work covers our walls: the first iconic John Coltrane portrait, the only image of Janis Joplin and Grace Slick together, the only photo of Thelonious Monk with his family, a rare partial frame of Jimi Hendrix singing in Golden Gate Park, so in focus that you see a tiny strand of spit attached to his mic. They are all such intimate moments that could have been mere snapshots, or out of focus, or sappy images you've seen a hundred times, and yet in Jim Marshall's ravaged hands these pictures have become the enduring truth.

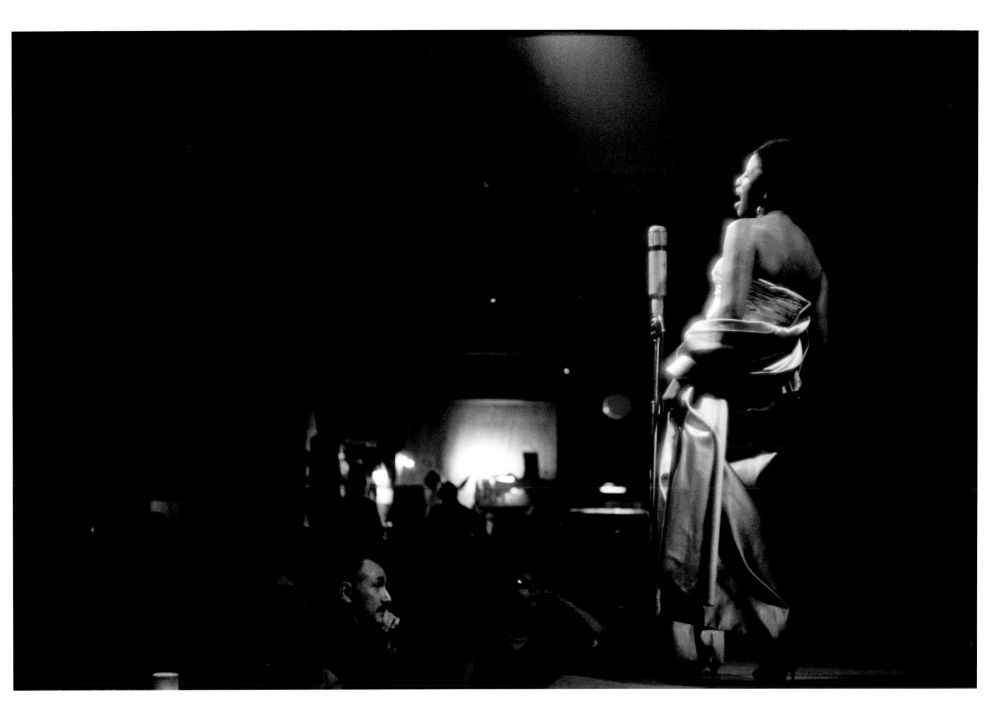

MIRIAM MAKEBA, night club in New York, 1960. Born in South Africa and known as "Mama Africa," Makeba popularized African music in the United States and globally. She campaigned against apartheid feverishly, for which her citizenship and right to return to her home were revoked. She returned in 1990, after Nelson Mandela's release from prison.

JIM
THE POET

MICHELLE MARGETTS

As driven and talented a photographer as Jim was, I think deep in his heart it wasn't images he was really in love with, it was words. It's the only way I can explain his incredible affinity for writers, lyricists, and especially poets. Of course, it didn't hurt that Jim spent his youth in San Francisco, which in the 1950s and 1960s was practically exploding with creative energy. It was unleashed, free, uncensored, and roaming the streets looking for sounds and images with which to collide. And so was Jim.

The wonderful shot on the following page shows all the Beat poets and artists in front of Lawrence Ferlinghetti's City Lights bookstore in 1965. In fact, I believe that is Ferlinghetti in the shadows under the umbrella right in front of Allen Ginsberg.

More than once, Jim made fun of his teenage and twenty-something self, saying he was "that pretentious asshole wandering around North Beach with a battered paperback copy of Camus's *The Stranger* in his back pocket." This is, yet again, a moment when I would like to ask Jim so many things: Did you ever really read the book? How did it affect you? Do you feel differently about it now, fifty years later? And so many, many more questions that rattle unanswered in my noggin. Who knows, maybe Jim bought his copy of *The Stranger* at City Lights.

City Lights Books at night, North Beach, San Francisco, 1968

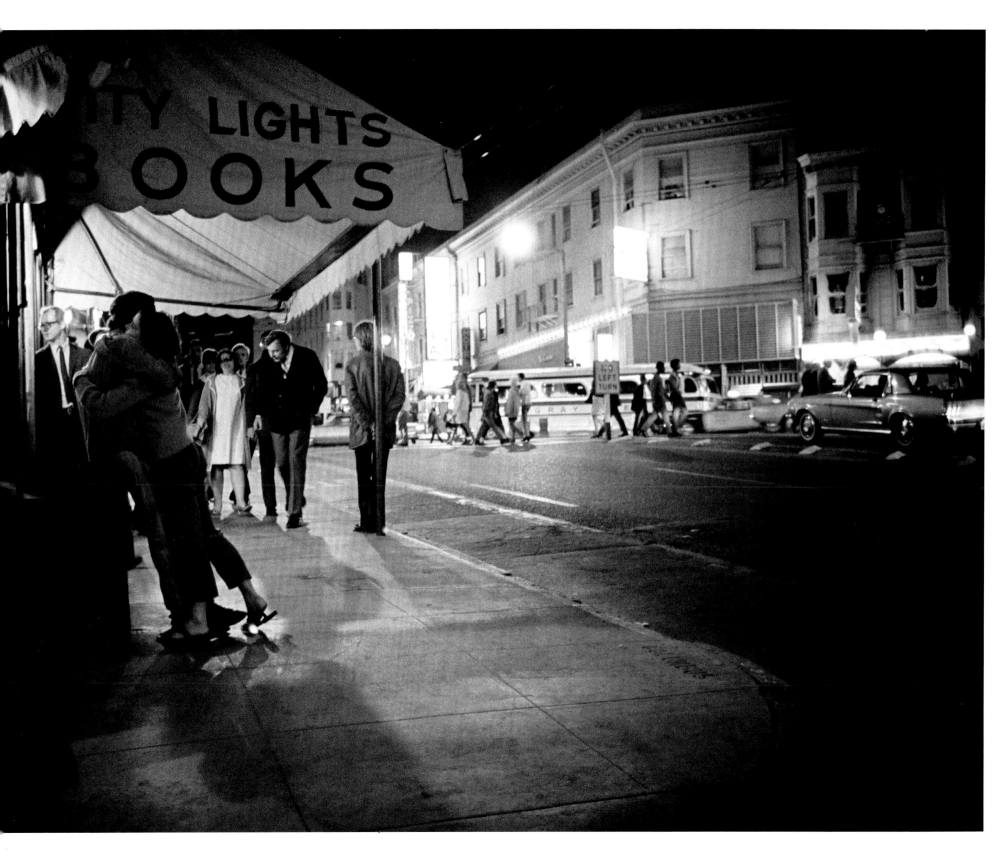

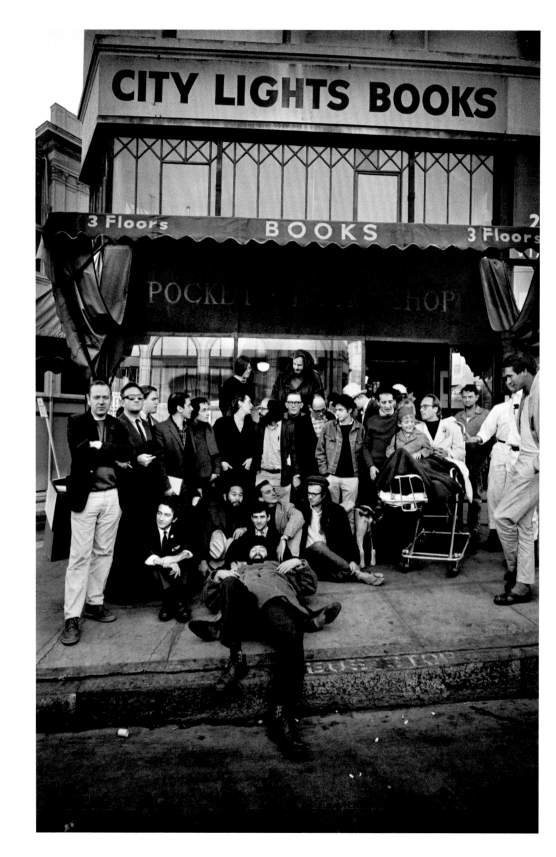

Poets and authors outside City Lights Books, North Beach,
San Francisco, 1965

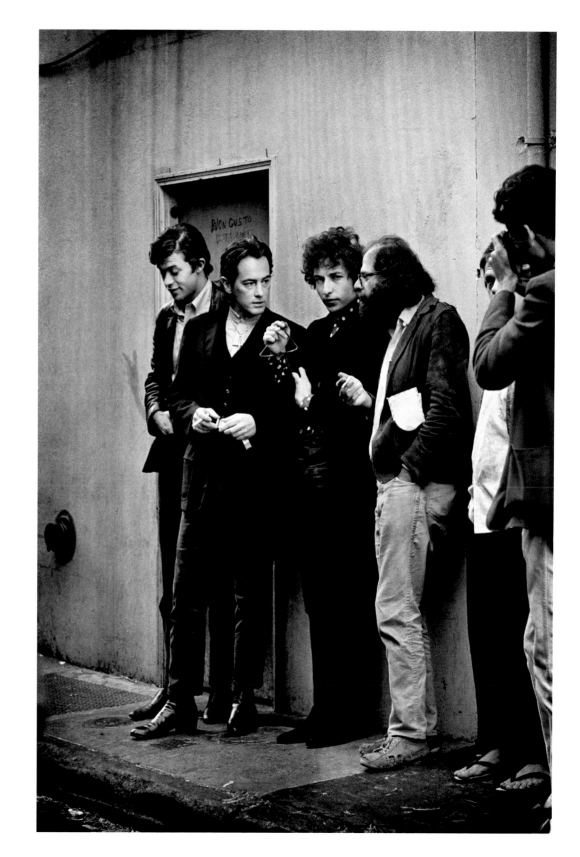

ROBBIE ROBERTSON, MICHAEL MCCLURE, BOB DYLAN,
and **ALLEN GINSBERG,** North Beach, San Francisco, 1965

WILLIAM
SAROYAN

MICHELLE MARGETTS

Another 1963 assignment for the *Saturday Evening Post* saw Jim capturing an ebullient William Saroyan at the famed Algonquin Hotel in New York City. This was the second time Jim had bonded with Saroyan; the first was in Paris. It seems they hit it off and discovered a fair amount in common: Saroyan, an Armenian orphan from Fresno with strong agricultural roots, and Jim, raised mostly by his mother, a Persian Assyrian who also was connected to farming families in the San Joaquin Valley.

Jim really was, first and foremost, an American; he would pronounce it sort of like *'merakin* with an aw-shucks Southern/ Western accent. But that adjective barely got out of his mouth before he stressed that what he *really* was, was *Assyrian*, descended from ancient, venerable tribes. He could even speak a passable version of Aramaic, the Semitic language known since the ninth century.

One of the very few times I saw Jim express true regret about his body of work was around the fact that he had not documented "where he was from like Saroyan had." I remember him late at night, head in hand, moaning about how he'd blown his chance, they were all dead, and it would never be the same.

WILLIAM SAROYAN at the Algonquin Hotel, New York City, 1963 252

Memo from
OGDEN NASH

For Jim Marshall—
May his photography
be impartial.
Hopefully—
Ogden Nash

2/10/64

Personal note from Ogden Nash

Jim's assignments for the *Saturday Evening Post* stand out from his incredibly productive few years in New York City. This proof sheet, opposite, shows **OGDEN NASH,** the American poet, novelist, and lyricist—and apparent chain smoker, as he is never without a cigarette in Marshall's entire shoot.

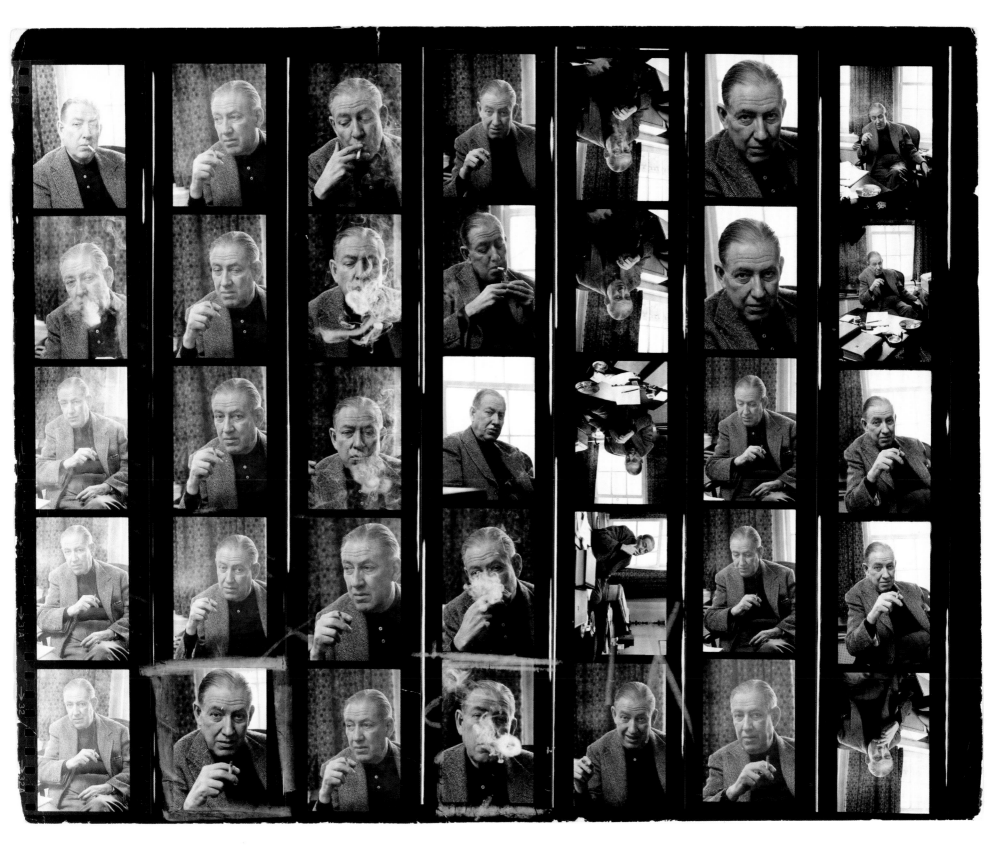

I FIRST MET JIM at a pop/rock festival on May 18, 1968. There was this guy in a corduroy jacket with a hat on and [what] looked like a three-day growth of beard. He was pretty aggressive, giving people shit and marching around with five cameras around his neck. And, at some point, some fraternity guy had pissed him off, so Jim pulls a knife on him and the [guy] almost shits his pants. . . . I said, "Hey man, is that knife real?" And Jim turns to me and puts the knife up under my throat, and he goes, "Yes, motherfucker, it's real," and then reaches back into his waistband and pulls out a gun and says, "And so is this." And I said, "Hey man, who brings a gun and a knife to a rock concert?" He said, "I do." I said, "Who are you?" He said, "I'm Jim Marshall, motherfucker. Who the fuck are you?" And we have been friends ever since!

MICHAEL ZAGARIS

THE DAY THE EARTH STOOD STILL

MICHELLE MARGETTS

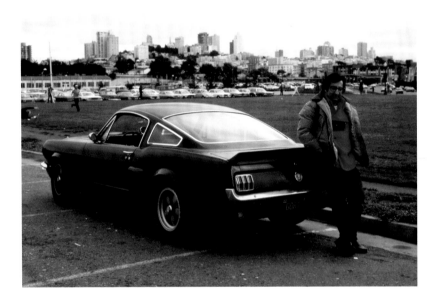

When I met Jim in March of 1984, he was down on his luck. Instead of a Spitfire or Jaguar, Jim was driving "Truck," a venerable Ford Ranchero. Jim was very loyal to that car-truck hybrid, especially because he could get commercial plates, allowing him to park in yellow loading zones in San Francisco's notoriously impossible-to-park-in commercial areas.

But it was another kind of Ford that he was truly in love with, and heartbroken about: the Shelby Mustang GT350. I believe he had two Shelbys, both made in 1966. Both had the vanity plate "GORT," after the robot in the classic 1950s sci-fi movie *The Day the Earth Stood Still*, Jim's absolute favorite movie of all time.

It was that second Shelby that Jim had to sell to pay his lawyer's fees after the gun bust in 1983, and, as he put it, "Keep my ass out of jail." You could tell he pined for that car, which he had so perfectly customized for himself, with a custom British-racing-green paint job, Boss 309 engine, Hurst shifter, Recaro seats, and Nardi wooden steering wheel.

JIM MARSHALL with his beloved Shelby Mustang "Gort" at the Marina Green, San Francisco, circa 1983

MARSHALL with "Truck" on a Highway 101 off-ramp, San Francisco, circa 1985

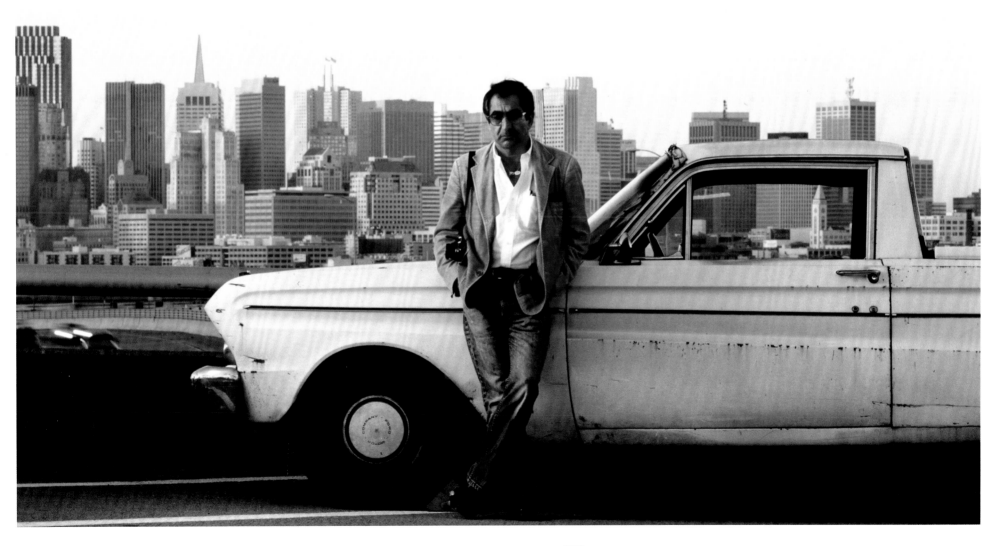

JIM MARSHALL and **KRIS KRISTOFFERSON**, early 1970s

This is one of Marshall's favorite portraits: a moody, sexy shot
of **KRIS KRISTOFFERSON** in a Los Angeles hotel on a long-
forgotten Sunday in 1970. Marshall held Kristofferson in the
highest regard. He thought of him as a true Renaissance man—
Rhodes scholar, star athlete, helicopter pilot, the list goes on and
on—and especially admired his songwriting and easy charisma.

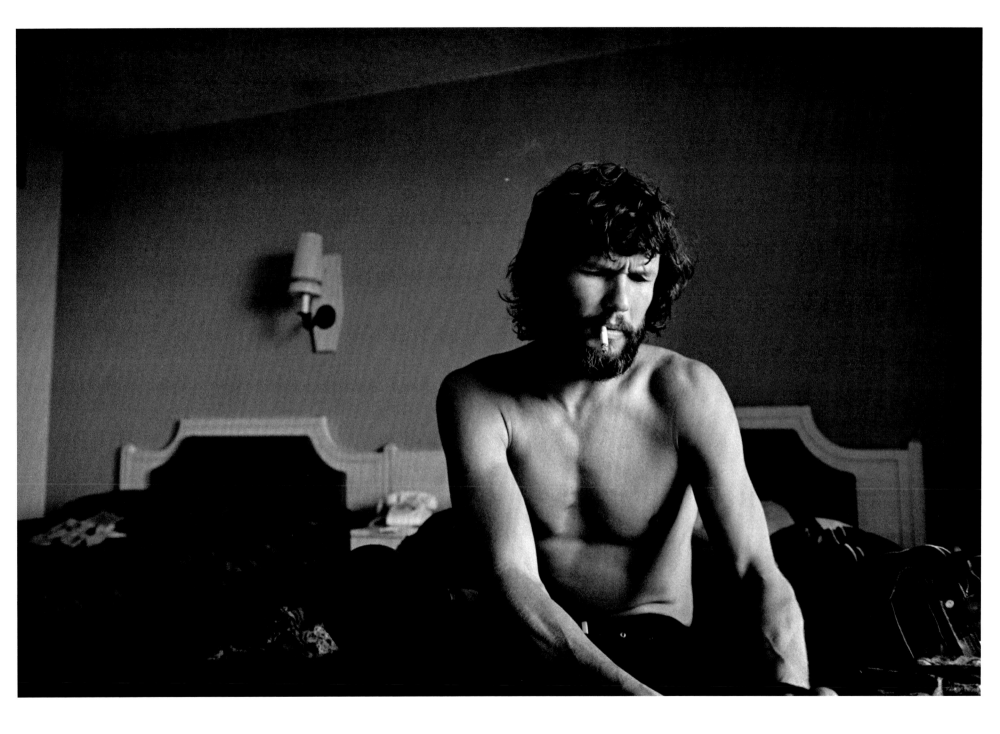

MILES DAVIS

MICHELLE MARGETTS

Jim admitted that he was in awe of Miles Davis. I think he used the word "starstruck." And Davis, a notoriously cantankerous individual, was far less approachable than the mellow, diffident John Coltrane, who took an instant liking to Jim. You can see it in the way Jim's work with Davis progresses, starting with live shots and quick grabs backstage, Davis seemingly oblivious to Jim's presence.

This is how I remember hearing one of Jim's favorite Davis stories, told ruefully even decades after it happened: He was walking by Davis backstage and got the bright idea to make conversation. I paraphrase: "Hey, Miles, why do you play a green trumpet?" To which the take-no-prisoners Davis retorted, "Motherfucker, why are you asking me about the color of my trumpet? I don't ask you why you are using a black camera!" Jim flinched when he first told me that story, even though it had been two decades.

Thankfully for all of us, Jim just had to give connecting with Davis one more try, this time leading with his one true strength, his work. At another event, Davis was hanging out offstage surrounded by friends, bandmates, handlers, and the like. Jim had brought along one of his favorite portraits, a print of John Coltrane, and gave it to Davis. When Davis saw the print he flipped out, went over to Jim to thank him, and told him that Coltrane was one of his favorite musicians. Davis looked Jim dead in the eye with those crazy laser beams and asked, "Why don't you ever take pictures like that of me?" To which Jim replied, "Why don't you let me?"

Jim sometimes referred to his photo of Davis in the ring as "Don't Hit Me in the Mouth, I Gotta Play Tonight," which was apparently what Davis would tell his sparring partners at Newman's Gym before they tussled. It was unusual that Miles would let Jim, or *any* photographer, shadow him during his workouts, which he viewed as sort of a sacred part of his regimen.

I also love the color shots of Miles at the groundbreaking Isle of Wight music festival in 1970, especially the shot of Miles grinning (pictures of a genuinely happy Miles are so rare!).

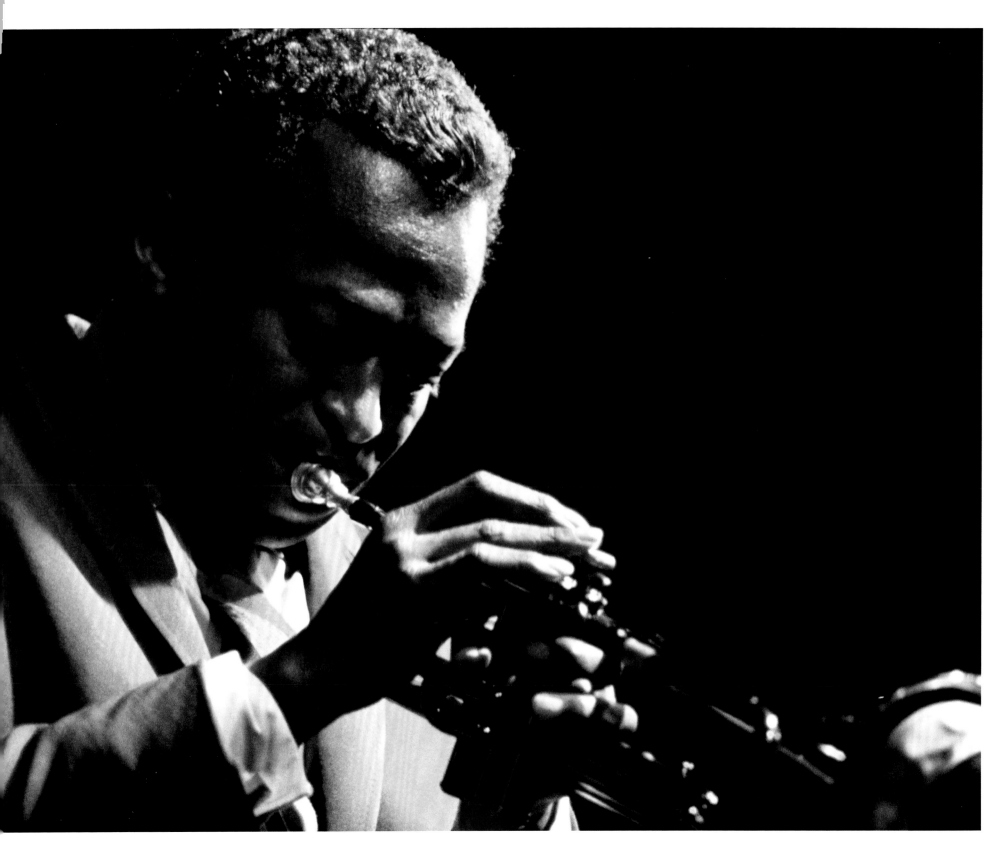

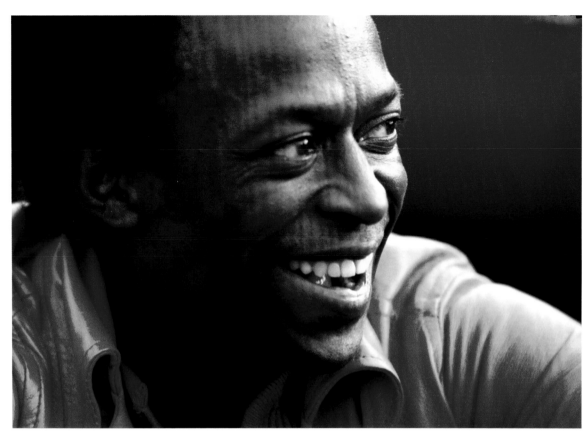

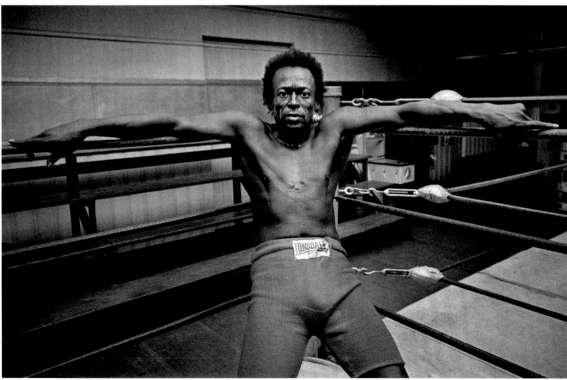

MILES DAVIS at the Isle of Wight Festival, Newport, United Kingdom, 1970

DAVIS in the boxing ring at Newman's Gym, San Francisco, 1971

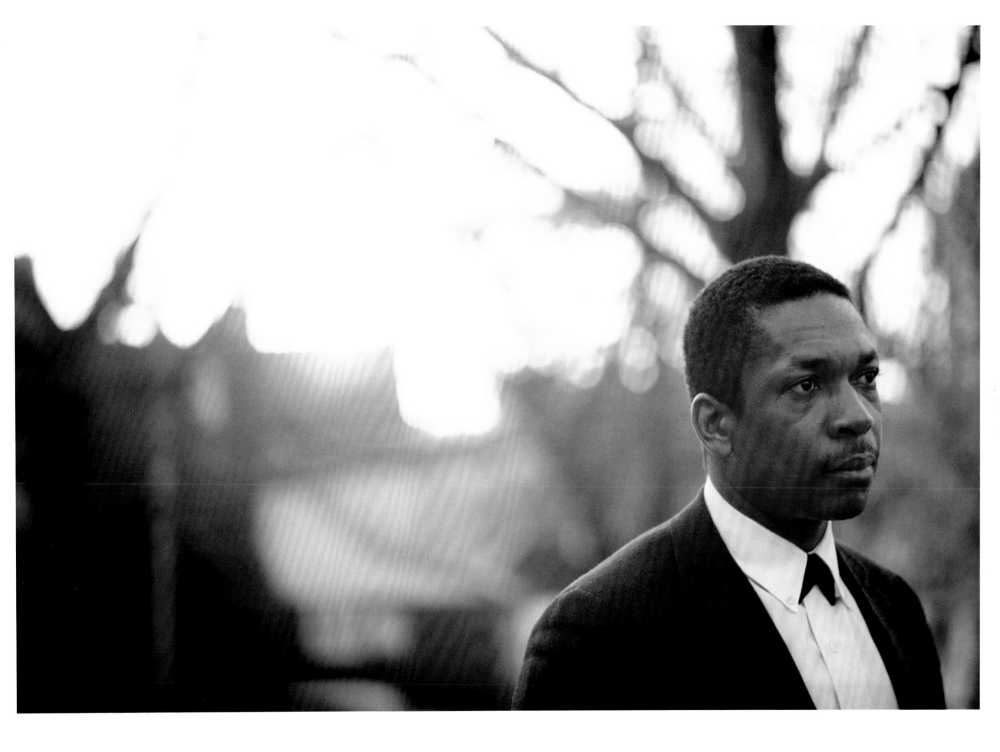

JOHN COLTRANE outside his house in Queens, New York, 1963

THE CARE AND FEEDING OF JIM MARSHALL

AMELIA DAVIS

I MET JIM IN 1998 at my childhood best friend's thirtieth birthday party. Her father was one of Jim's attorneys. She called him Uncle Jim, but for some reason I had never met him before that night. I studied photography at U.C. Davis, and it was all about Helen Levitt, Henri Cartier-Bresson, and Robert Frank. I had no idea who Jim Marshall was.

This little man with a Leica 'round his neck made eye contact and came right over to me, saying, "Hi, I'm Jim Marshall, who are you?" I told him I was a photographer working on a book about breast cancer survivors because my mother had breast cancer. I was going through the journey with her photographically. He said, "Wow, I think that's really important. I know a lot of my friends have had breast cancer, and a Thanksgiving turkey looks better than what they do to these women. However I can help you, I'd love to."

Then we discovered I lived a block away from his 16th Street apartment. He'd been checking me out the whole time, but all of a sudden he looked at me extra closely and said, "Wait a minute, are you gay?" I said I was, and he lamented that he was always attracted to gay women or married women. I looked at him and said, "That's your problem, not mine." He laughed really hard and told me he thought we were going to be really good friends.

Before long, I became his assistant. I remember the first time he showed me his apartment. I looked down this long hallway and on the walls were Johnny Cash flipping the bird, the Beatles coming off the stage at Candlestick Park, Jimi burning his guitar, so many iconic images he had taken. He was staring at me as I said, "Oh my God, I had no idea that this was you." And he laughed: "Yes, that's what I thought, but that's why I liked you."

Jim was not photographing very much anymore. I was more office manager than photo assistant, organizing his archive,

AMELIA DAVIS by Jim Marshall, 1998

coordinating his gallery shows and print sales, scheduling and attending meetings with clients. Basically, Jim's "Girl Friday."

WHEN I FIRST STARTED WORKING FOR HIM, I had just been diagnosed with multiple sclerosis. Jim had no idea what MS was. "What the fuck is that?" he said. So I explained to him I was self-injecting every other day. He got to see what it was like for somebody living with a chronic illness and trying to work, and he became very supportive of me and everything I did regarding MS.

Also, my mother had just died. My dad died when I was seven, so my mother had been both a mother and a father at that point in my life. She was a huge force, an intelligent, witty, talented, beautiful woman who always had to be the center of attention—and she swore like a sailor. There was a big hole in my life for that kind of person, and Jim was very similar to my mother in that he was this larger-than-life personality, with real talent, humor, and a colorful, abrasive vocabulary.

In our lives we meet people at the right time; there's no coincidence. I really believe in fate. Jim needed me just as much as I needed Jim at that point in our lives, and that's why we bonded so much and really loved each other.

I've been with my wife Bonita for twenty-eight years now, so we were together when I met Jim. Bonita also became a good friend of Jim's. Jim and I were very emotionally intimate without any sexual tension. He was able to really open up and share feelings with me knowing that he could be vulnerable and it would be OK.

WHEN I STARTED WORKING FOR JIM, he was in a good place and a not-so-good place. He was in his late sixties, and he was still hooked on cocaine. It was very destructive and one of those things that he couldn't get away from. He would lock himself up alone in his apartment, do an eight ball, and then, to come down after the cocaine, take two Ambien sleeping pills, two Benadryls (just in case the Ambiens didn't work), some wine and half a bottle of whiskey. And he woke up in the morning, usually without a hangover!

Anybody else who did that would be dead, but not Jim. I would not tolerate that kind of behavior from any of my other friends, and I can't explain why I tolerated it with Jim. But for me, there was this vulnerable, caring person inside him, and he was abusing because he wanted to escape. Jim was miserable

This page: **JIM MARSHALL** and **AMELIA DAVIS,** San Francisco, 2000. Photo by Terry Heffernan.

Opposite: **MARSHALL** and **DAVIS,** San Francisco, 2006

because he was no longer shooting, and alone because of his drug addiction. I stayed because I wanted to let him know that somebody in his life really cared and would come back no matter what.

And he had this incredible body of work. It wasn't just music, it was civil rights, human rights, anti-war protests; you name it, Jim documented it. He seemed to be everywhere that mattered. Seeing those pieces of history that only Jim could capture, I didn't want him to die. I thought it was really important for him to stay alive and share those experiences with the world, so I stayed.

Not to say that we didn't have a lot of fights. Jim would be very verbally abusive: "Fuck you, you asshole, you dumb cunt." For me it was no big deal. He would yell at me, and I'd swear at him back: "Fuck you, Jim, don't say that to me, how dare you." It usually took him aback that I could give as good as I got.

From my perspective, I did quit twice. Jim said we just had "two arguments." But I did quit, and I think that scared him. The first time, he was just being such an asshole, crazy and abusive, and still doing the coke. I told him I was done. I went out and slammed the door—BOOM—and the whole building shook. If he was sorry, he would have to come groveling to me. We didn't talk for two weeks.

Then 9/11 happened. My sister—whom Jim knew and really, really liked—is an emergency responder. She was at Ground Zero when 9/11 happened, and Jim was one of those people who called me. "Davis," he said (which is what he always called me; I have no idea why), "is your sister OK? Is Liz OK?" I said, "Liz is fine, thank you for asking. You know, I was able to locate her and talk to her, and she was OK." There was this big silence, and then he said, "Will you please come back and work for me?" He told me how sorry he was, how much he needed me. I set some new ground rules about the abusive language and agreed to show up at nine the next morning. He truly was a part of my life.

I was with Jim for the last thirteen years of his life. I think I got Jim when he was much mellower, for sure, because I've heard all the stories from when he was younger. He'd had a lot of time to reflect on his life and regret some of his choices. I don't think he regretted his life, because he'd lived it the way he wanted to live it. But there were things along the way that he wished he hadn't done.

He was still very destructive with drugs and alcohol, but he was also reflective about what he had done and who he had hurt. We talked a lot about that. Jim never responded to nagging; to him it was just noise. One day I just went up to

Jim while we were working, and he said, "Don't nag me!" I told him I wasn't going to nag him, but that I loved him very much and I was going to miss him when he was gone. And I just walked out.

The very next day he stopped cold turkey, unbeknownst to me. And although he still drank, he did not do coke for the last four years of his life. He said it was because of what I said to him, even though he told other people that he was tired of my nagging him. I guess he never realized that he would be missed. There are a lot of other people who cared about Jim and who would miss him as well. But I don't think he realized what an influence and a personality and a friend he was to people. He felt so alone, but a lot of people cared about him.

BACK WHEN HE WAS DOING COCAINE and just crazy, he would lock the door from the inside with a deadbolt, so no one could get in. I knew that when that lock was on, Jim was on a bender and I should just go home. He'd call me when he was done.

I was struggling and I needed work; every penny counted. He obviously knew he was going to go on a bender, but he wouldn't tell me, and I got sick of it after a while. "I can't stop you from doing this," I said. "I know that. But if you're going to do it, you need to let me know so I can plan something else."

He started writing notes and taping them to the outside of the door. He wrote them after he was fucked up. Some of them are so funny: "No work today, I'll pay to mow" on a little three-by-five-inch card. This is the best one: "MDW bus today." He obviously had just done a line of coke, or cut it, so he wrote his note on a stamped envelope and used a piece of heavy-duty packing tape, and then he left the razor blade that he cut it with trapped on the end of the packing tape and the envelope. I have no idea what he was trying to say.

He also would write really sweet notes to me when he wasn't fucked up and just leave them around for me to find. One said, "Davis, love you." Another said, "AD, not only do I love you very much, I trust you with no exceptions, love you, Jim. PS, I'm so very lucky to have you as a friend and assistant, never an employee, an assistant and a friend."

So that was my life with this crazy man, Jim Marshall. We helped each other a lot, and I do miss him quite a bit. But he's around me all the time because he left me his children. Jim never had kids; his photographs were his children. They were his life, 24/7. His first and only true love was photography. Anybody

else was second fiddle. I think that's why he was never able to have a real, long-lasting relationship.

He used to say, "The only person that I trust to take care of my children when I'm gone is you." I protected Jim's legacy during the thirteen years I worked with him. Sometimes I was overprotective, and Jim would say, "Davis, chill out." I would let him know when people were taking advantage of him and his work. He didn't always like to hear that but knew I was right.

WHEN I FIRST STARTED WORKING FOR JIM, the music business had completely changed from what he had known in the 1960s and 1970s. There were managers, there were handlers. Every venue had a pit where the photographers sat, shooting up at the musicians, so everybody's photographs looked the same. Some of the musicians even wanted to keep the copyright to photos of them. Jim said, "Fuck no, this is not how I work." He put his cameras down.

So by 1998, he was only photographing people if they asked him to. Younger artists who knew Jim's photos and admired him—Lenny Kravitz, John Mayer, and others—wanted to claim they had Jim Marshall shoot them. Jim would demand to be allowed to photograph them with no restrictions, no managers, and no handlers—true all-access.

Velvet Revolver was playing at the Warfield in San Francisco, and they really wanted Jim to do some live photographs because he was friends with Matt Sorum, the drummer. So he got all-access. So here was this little old man in his penny loafers, his jeans, his corduroy jacket, and his Leica, jumping around the stage with Velvet Revolver. Everybody was asking, "Who's that grandpa? Why is he up there?" At one point Slash turned to Jim, away from the audience, and mimed strumming the guitar, and Jim—click, click, click—got the photo. It might look like a random moment and Jim getting lucky. But actually Jim knew Slash's dad, Anthony Hudson, who had made album covers for Neil Young and Joni Mitchell. Jim and Slash had a connection from when Slash was a kid, and that's the kind of moment of open trust and love that Jim depended on.

IN HIS FINAL YEARS, Jim made many books, sold his photos thorough big-time agents, had gallery shows, and started to get the recognition that he deserved for his photography. We did a lot of work in his archive: We would go through the photos, and

he would talk to me about them and about things that he had done. If a gallery had ordered a photograph, I would pull the negative, get it printed, take it to the framer, and ship it.

As he aged, I think I became Jim's security blanket. Once, when he was still doing cocaine, one of the galleries had ordered a print and had even paid for it when Jim went on a bender. The gallery was calling and demanding the print. Jim just didn't give a fuck. I opened the door to his apartment, really angry, and said, "We've got to get this photograph." In the bedroom, I found Jim on the floor, the TV on the floor, smashed, and the window smashed, too. Jim looked at me and said, "Davis, you need to buy me a new TV today!" I said, "Ya think!"

Forget nine lives, Jim had twenty-four lives. He had gotten really fucked up, grabbed the TV to stabilize himself, knocked it over, and gone over after it. His arm went through the bedroom window and back again. Anybody else's arm would have been slashed by the glass. Jim? Not a scratch. Then he just decided to sleep on the floor where he fell. But I did get the print, made him sign it, and sent it to the gallery.

JIM WAS SUCH AN INTENSE PERSON, and he was so complicated. He could be the biggest asshole and the next minute the sweetest guy in the world. He would say things to people that you would only think in your head; he could not edit himself at all. It got him into trouble a lot because he would just blurt these vile things out.

I never had children, but reflecting on it now, I realize I did have a child, and his name was Jim Marshall. He was an addict, and he was my man-child. At Jim's memorial service at the Great American Music Hall a few months after he passed away, I didn't want to give a whole speech. I just wanted to describe him very simply. The words I chose were: unpredictable, predictable, erratic, compulsive, impulsive, neurotic, paranoid, fiercely loyal, compassionate, tender, endearing, irrational, sensitive, cantankerous, naive, innocent, childish, selfish, giving, a genius, eccentric, caring.

BROADWAY
JIM

MICHELLE MARGETTS

Another secret about Jim and his poetic passions: He loved theater and musicals, seemingly the sappier, the better. It's not something he broadcast much—I would hazard a guess that he didn't go share just how much he *loved* Carol Channing or a great Cole Porter number or Rodgers and Hammerstein's work with his mechanic or the guys he got his guns from. But if he thought you were receptive to the power of it all, he'd definitely bend your ear.

There was so much more to Jim than the rock 'n' roll, hard-living lunatic genius. That's one aspect of his life, and there's ample evidence for it, but dig a little deeper and you'll see a lovely sap willing to make a fool of himself at the drop of a hat, especially after he'd had a glass or two of whatever high-end whiskey or scotch he happened to favor that month.

Jim was never ashamed to wear his emotions on his sleeve, and he was hugely sentimental, almost comically so. Jim liked a great song, sure, but he also seemed to dig the poetry, catharsis, and pathos at the heart of most remarkable theater, musical and otherwise. And if, at its core, there was a love story full of betrayal, heartbreak, and redemption, hey, so much the better. I think it was as close to therapy as Jim would let himself get.

Thank-you note from Carol Channing, 1962

CAROL CHANNING in her dressing room for the Broadway show, *Hello, Dolly!*, New York City, 1964

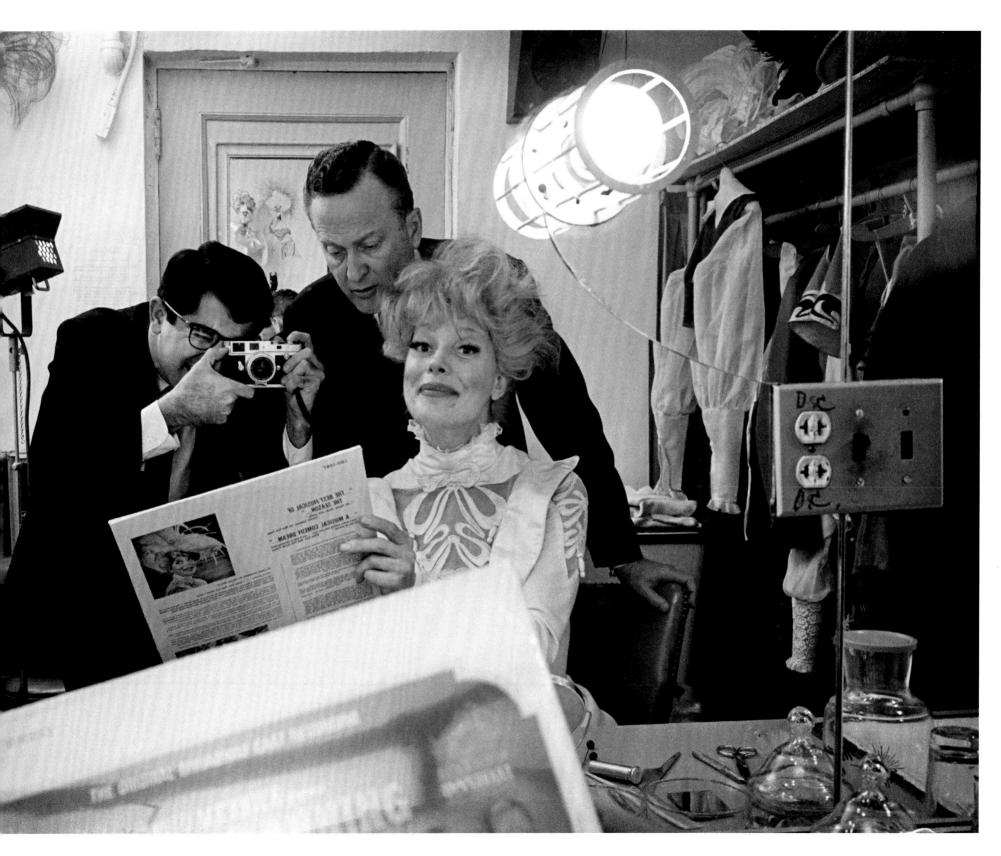

ONE ENCHANTED EVENING

AMELIA DAVIS
with *MICHELLE MARGETTS*

Jim just loved certain musicals, like *South Pacific,* especially the song "I'm Gonna Wash That Man Right Outta My Hair." I mean he was just crazy about that show. So in January 2009, there was a revival here at the Curran Theatre, and Bonita and I surprised him with tickets for Christmas. He had seen that it was coming to town, and he kept saying how great it would be to go. But for the thirteen years that I knew him, he would talk about going to movies and shows but then lose heart. The only way he would do it was if somebody went with him.

I remember he even put his hearing aids in that night, which meant it was a very special occasion. I kept looking over at him and he was just humming and singing along, tears streaming down his face. It was crazy how much he loved it!

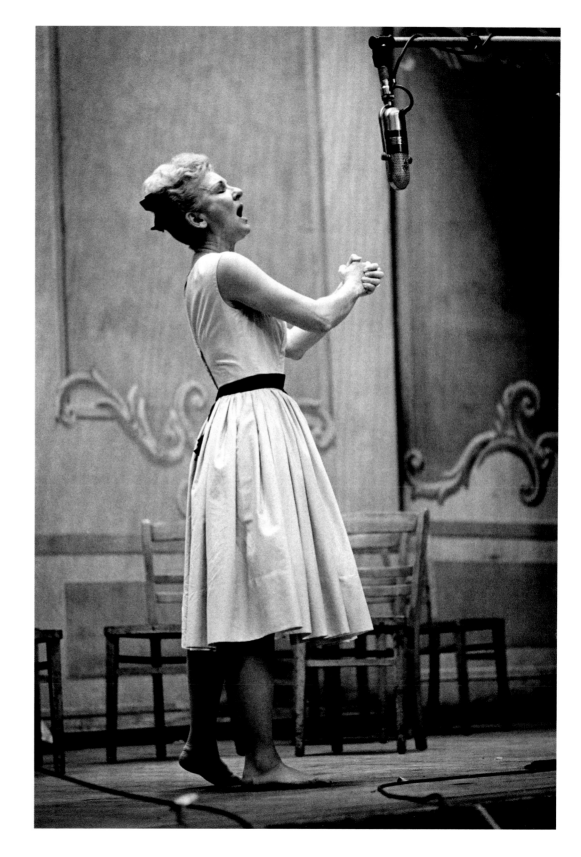

MARY MARTIN in the recording studio for the musical *Jennie,*
New York City, 1963

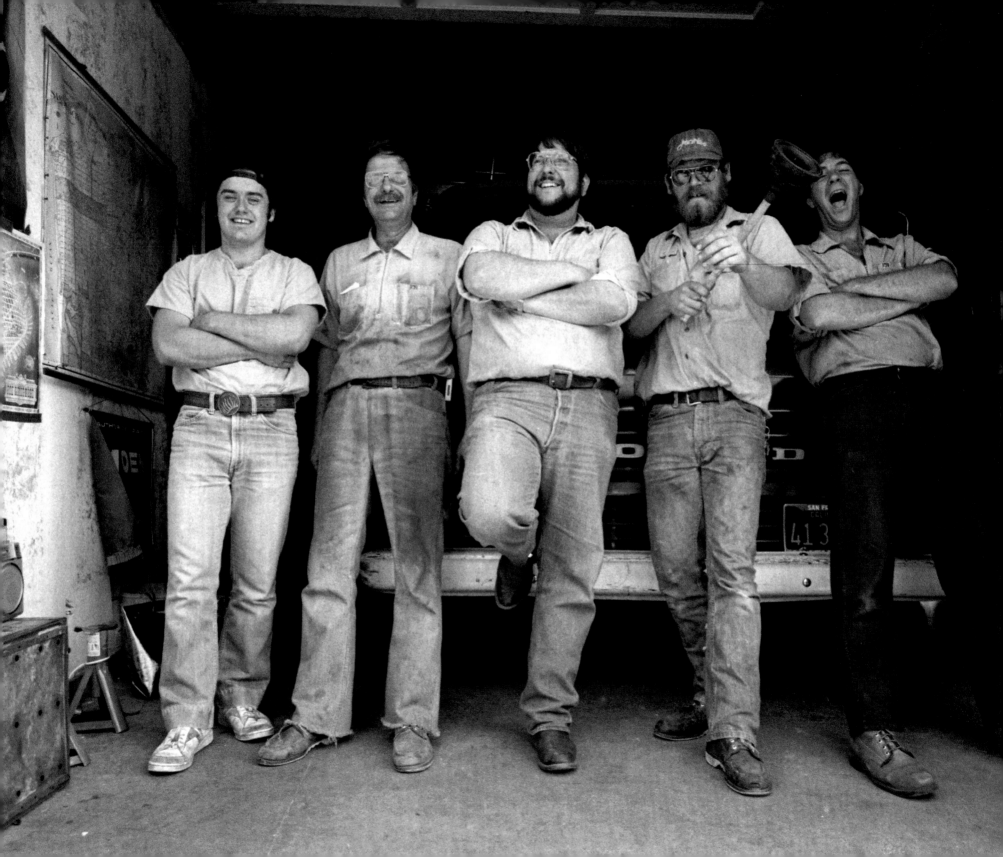

IN 1982, Jim came by my plumbing shop and took a picture of me, my cousin, my brother [who] was working at the time, and two other brothers that were working for me, leaning in front of one of my trucks. . . . We were plumbers, but Jim made us look like rock stars.

KEN VALENTE

KEN VALENTE and the plumbers, 1982

JIM, JOHN COLTRANE, AND PRESIDENT OBAMA

MICHELLE MARGETTS

One of the very first prints that Jim ever gave me was a portrait he took of jazz saxophonist John Coltrane in 1960.

Most people who know of Jim's legacy think his career shooting musicians began in the folk and rock worlds of the early 1960s. His real break came some years earlier photographing relatively unknown but crucially important black musicians in North Beach jazz venues such as the Jazz Workshop.

There was a major difference between the persona Jim showed the public—ultra conservative, gun-toting, racism-spewing, lower-class hating, right-wing nut job—and the real Jim, who was the perpetual outsider looking intensely at the world from behind the mask. Lucky for all of us, Jim learned to take the mask off and hide behind that Leica M4 instead. That was the Jim who loved Coltrane, Miles Davis, and Thelonious Monk, and who was loved in return.

After a gig one evening in San Francisco in 1960, Coltrane asked Jim, "How do you get to Berkeley?" He had a meeting with the *San Francisco Chronicle*'s legendary music critic Ralph Gleason at his Berkeley Hills home the next day, and he had no clue how to get there. Gleason's bona fides are too numerous to mention (he was the first jazz critic at a U.S. daily newspaper, came up with the Monterey Jazz Festival concept, gave Jann Wenner fifteen hundred dollars to start *Rolling Stone*, etc.). Jim was well aware of Gleason's crucial role connecting music, culture, and politics. Sensing the import of the moment, he offered to drive Coltrane to Gleason's and was allowed to stay and shoot . . . and the rest is history.

For the better part of two decades a bit of that history has lived on my walls, lucky gal that I am. A similar Coltrane portrait lived on a wall at the White House. Jim received a wonderful photo snapped by a White House photographer of President Obama studying the Coltrane portrait intently. On the mat overlay the president wrote: "To Jim—I'm a big fan of your work . . . and Coltrane!"

I will never forget the look on Jim's face when he looked at that photo of his president studying the Coltrane portrait. There was no mask, no barrier. I just saw awe, humility, and incredible colorblind, bipartisan joy. Jim looked like he had finally come home.

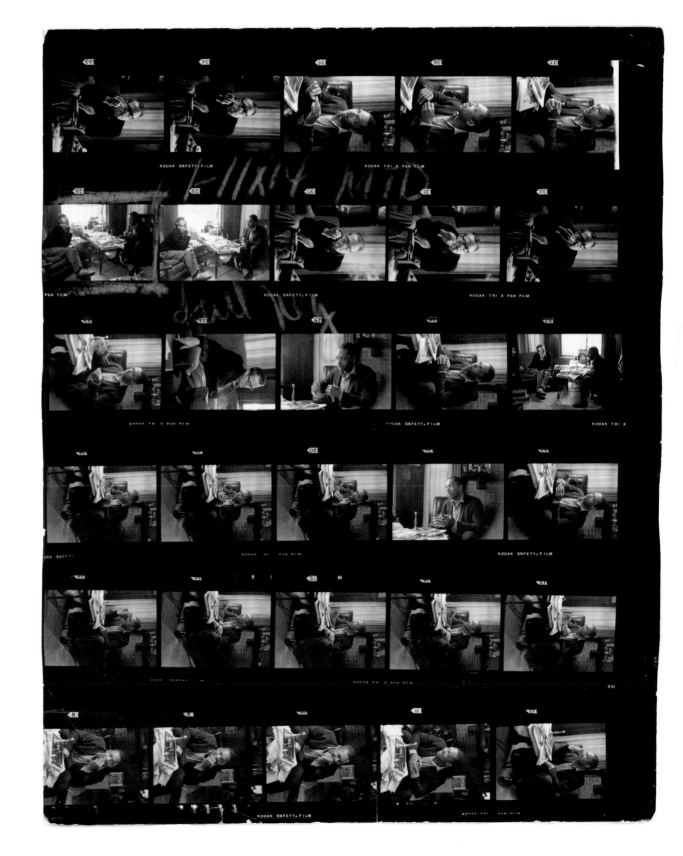

JOHN COLTRANE being interviewed by the
San Francisco music critic **RALPH GLEASON**
at Gleason's home in Berkeley, California, 1960

WELL, it would have to be that iconic photo of John Coltrane not playing, but thinking. This is something that I feel is so special about [Jim Marshall's] photography. He's one of the photographers that realized that sometimes musicians are more interesting when we're not performing and we're thinking about the music, when we're communicating with each other—and he captured that.

KAMAU KENYATTA

JOHN COLTRANE at Ralph Gleason's house in Berkeley, California, 1960

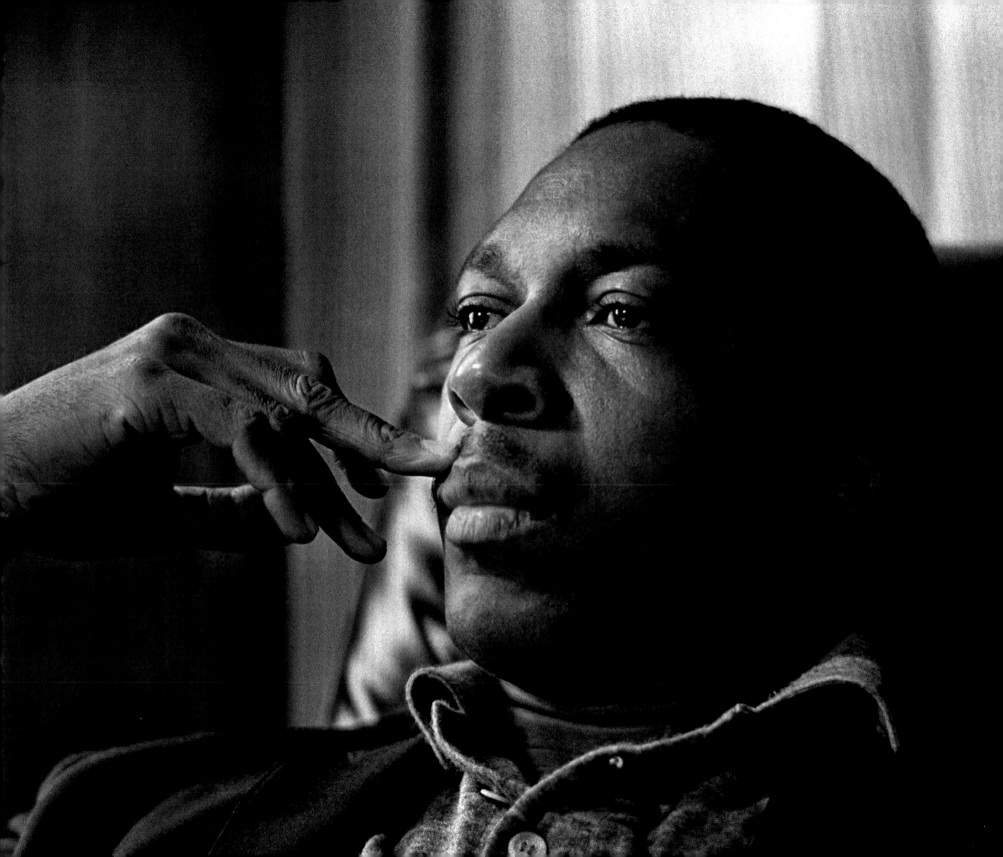

ACKNOWLEDG-MENTS

A BIG THANK YOU to everyone at Chronicle Books for seeing the importance of this book as a celebration of Jim Marshall's life and as the companion book to our feature documentary, *Show Me the Picture: The Story of Jim Marshall*. Mirabelle Korn and Bridget Watson Payne were great to work with on this, as was the entire team at Chronicle: Michele Posner, Allison Weiner, Steve Kim, Erin Thacker, Sarah Lin Go, Diane Levinson, and Miriam Gordis. And thank you to Nion McEvoy for asking us to come back to the family at Chronicle Books, where Jim published his first book, *Monterey Pop*.

Thanks to all of the contributors to this book who shared not only their views and insights, but also their love for Jim Marshall and his enduring legacy: Joel Selvin, Michelle Margetts, Karen Grigsby Bates, and Meg Schiffler. Thank you to Garnell Boyd and Dickerman Prints for always making Jim's photographs look the way he wanted them to.

This book is very much an inspiration and the heart and soul of our documentary, *Show Me the Picture: The Story of Jim Marshall*. Thank you to everyone, no matter how big of a part or small of a part you played in making the documentary happen:

Jackie Cuneo and Michele Borg for being the very first supporters to sign on.

Nick Simpson who went above and beyond to make this happen.

Clarence Pimentel Jr., Greg Kogan, Sofie Liao, Larry Levy, Nion McEvoy, Frank Caufield, Bruce Talamon, Allen Burry at Michael Douglas's office, Michael Jensen of Jensen Communications, Josh Matas, John Carter Cash Management, Sean Dana, and Theron Kabrich and Jim Hartley of San Francisco Exchange Gallery: Thank you for your support.

Bruce Talamon, Michelle Margetts, Joel Selvin, Michael Zagaris, Michael Douglas, John Carter Cash, Jeff Rosenheim, Jorma Kaukonen, Galadrielle Allman, Peter Frampton, Graham Nash, Anton Corbijn, John and Kathy Poppy, Ken Valente, Eileen Hirst, Sheriff Mike Hennessey, Elaine Mayes, Paul Ryan, Jeff Garlin, Jeff Stern, and Hugh Brown: You all gave wonderful insights and amazing stories helping me keep "The Legend" alive.

Thank you to the amazing Tatiana Kennedey, Alfred George Bailey, Adam Biskupski, Nicolas Sampson, Arno Hazerbrock, Christos Michels, Ian Arber, Dennis Mabry, Submarine Entertainment, and Film Constellation, which brought "The Legend" to the big screen.

Finally, to my heart and soul, Bonita Passarelli: You kept me grounded and sane. I would have never been able to do any of this without your support and love.

THE AUTHORS

AMELIA DAVIS, owner of Jim Marshall Photography LLC, was the longtime personal assistant to legendary photographer Jim Marshall. Upon his death in 2010, Marshall left his entire estate to Davis to carry on his legacy. Since his passing, Davis has edited five Jim Marshall monographs and curated yearly photographic exhibitions of Marshall's work. Davis, a San Francisco–based award-winning photographer, has three books of her own: *The First Look* (about breast cancer survivors), *My Story: A Photographic Essay on Life with Multiple Sclerosis* (about living with MS), and *Faces of Osteoporosis* (about osteoporosis).

KAREN GRIGSBY BATES is a correspondent for *NPR News*, where she covers race, ethnicity, and cultural issues as part of the *Code Switch* team. She is the author of two novels and a bestselling etiquette book, and her work has appeared in the *Los Angeles Times*, the *New York Times*, *Vogue*, and the *Guardian*. Bates is a contributor to several anthologies and to the award-winning civil rights series *Eyes on the Prize*.

JOEL SELVIN has covered pop music for the *San Francisco Chronicle* since shortly after the Civil War. His writing has appeared in a number of other publications that one would think should have known better. People all over the world are still pissed off about things in the seventeen books he has written.

MEG SHIFFLER is the director and chief curator of the San Francisco Arts Commission Galleries. In 2017, she worked closely with the Jim Marshall Archive to curate the large-scale exhibition *Jim Marshall's 1967*, which will travel globally for the next five years. For the past twenty years, her curatorial work has centered on building a dialogue between contemporary art and social, civic, and political issues. She currently lives in Oakland with her partner and son, and always makes time to see live music.

As an award-winning San Francisco State journalism student, **MICHELLE MARGETTS** came to interview Jim Marshall for a magazine assignment in 1984 and got way more than she bargained for . . . a crazed May–December relationship, a crash course in ethics, and intense creative and career inspiration. She took Jim's advice and went to New York City, where she had a two-decade career as a proficient music journalist, copyeditor, freelance writer/designer, and web producer. More recently, upon Jim's passing, she wrote the comprehensive blog for Jim Marshall Photography LLC. She now lives in Oakland with her wonderful husband, Dan, and loves music, film, photography, and the Golden State Warriors.

INDEX

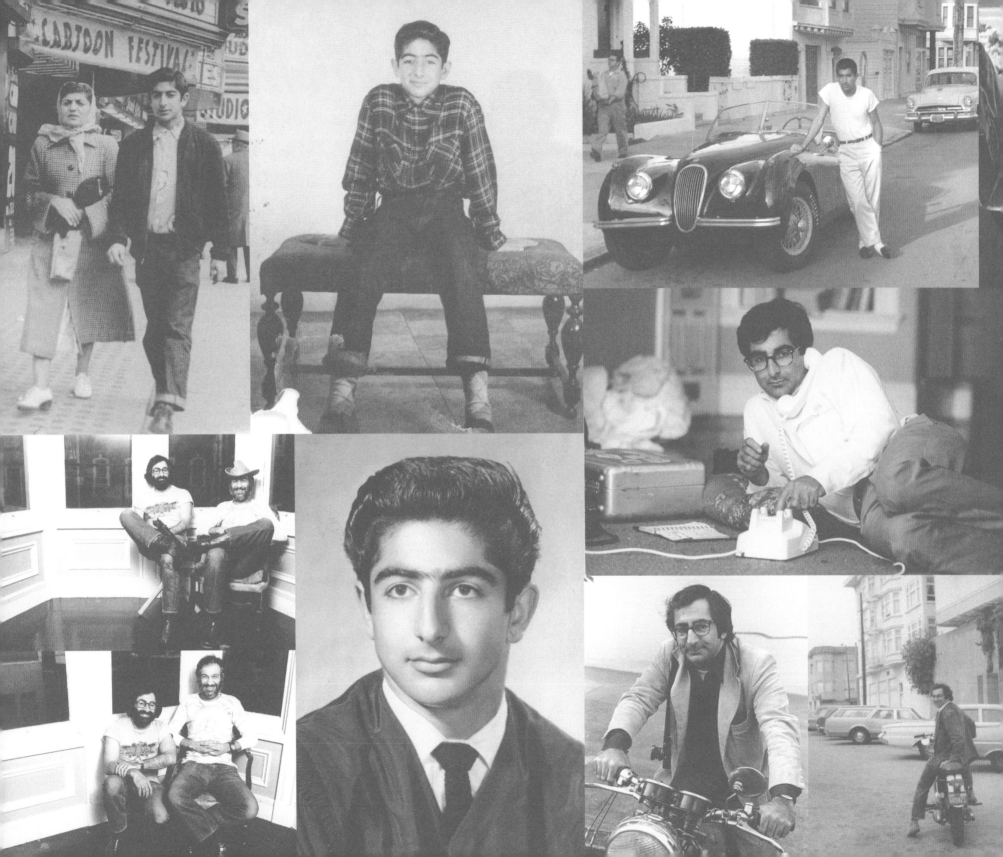